THE HERITAGE OF
JAPANESE
ART

THE HERITAGE OF JAPANESE ART

Masao Ishizawa

*

Teizō Suganuma

*

Ichimatsu Tanaka

*

Chisaburō Yamada

*

Yūzō Yamane

*

Yoshiho Yonezawa

*

Itsuji Yoshikawa

KODANSHA INTERNATIONAL
Tokyo • New York • London

PHOTO CREDITS: Benrido Co. Ltd., 13, 68, 69; Egawa Museum of Art, 133; Eisei Bunko Foundation, 64; Gakken K.K., 15, 27, 37-39, 70; Isonokami Shrine, 4; Kuniaki Nakagawa, 146; Manshichi Sakamoto, 10; Mikihiro Taeda, 147, 148; MOA Museum of Art, 120, 128; Museum Yamato Bunka-kan, 9, 60, 61, 75, 78, 86, 93, 110, 129; Nezu Art Museum, 77, 98, 127; Taikichi Irie, 14, 21, 31, 34; Tasaburō Yoneda, 29; Tazō Nagano, 67, 83; Tokugawa Reimeikai Foundation, 53; Tokyo National Museum, 19, 118, 121, 153.

Text and captions adapted from *Art Treasures of Japan*, published by Kokusai Bunka Shinkō-kai, Tokyo, 1960

Distributed in the United States by Kodansha America, Inc., 114 Fifth Avenue, New York, N.Y. 10011, and in the United Kingdom and continental Europe by Kodansha Europe Ltd., Gillingham House, 38-44 Gillingham Street, London SW1V 1HU. Published by Kodansha International Ltd., 17-14 Otowa 1-chome, Bunkyo-ku, Tokyo 112, and Kodansha America, Inc.

Printed in Japan by Dai Nippon Printing Company, Ltd.

LCC 81-80995
ISBN 0-87011-481-6
ISBN 4-7700-0969-0 (in Japan)

First edition, 1982

91 92 93 10 9 8 7 6 5 4 3 2

Library of Congress Cataloging in Publication Data
Main entry under title:

The Heritage of Japanese art.

Text and captions adapted from: Art treasures of Japan / edited by Yukio Yashiro. Tokyo: Kokusai Bunka Shinkokai, 1960.
 Bibliography: p.
 Includes index.
 I. Art, Japanese—Addresses, essays, lectures.
I. Ishizawa, Masao, 1903- II. Art treasures of Japan.
N7350.H47 1982 709'.52 81-80995
ISBN 0-87011-481-6 AACR2

CONTENTS

INTRODUCTION

Japanese art may be regarded as an exquisite flower on a branch of the giant tree of Oriental culture, whose roots have spread throughout the vast Asian continent. In many aspects, Japanese art may be called unique since it is a reflection of how the Japanese people feel in everyday life, coupled with a sense of form and an aesthetic sensitivity that developed in a country characterized by delicate seasonal changes.

A review of Japanese history reveals that Japan was constantly influenced by new cultures from Asia, and these were readily adopted and assimilated by the Japanese people through their keen sensibility to beauty, and developed into a peculiarly Japanese form. At the present time, Japan is again feeling the effects of influences of civilizations not only of Asia but of the entire world, and this has resulted in considerable creativity among its people. And we, in turn, are making every possible effort to present our art heritage so that it may be enjoyed and appreciated by all people of the world.

Western interest in Japanese art dates back to the nineteenth century, when traders brought to Europe and America various Japanese craft objects, which aroused a lot of curiosity. In this way the "picture books" and the *ukiyo-e* ("pictures of the floating world") woodblock prints came to be popular in Europe. This coincided with the huge success of Puccini's opera *Madame Butterfly*, with the result that Europeans and Americans alike were eager to learn about Japan and its culture, even though their interest lay principally in the exotic and the romantic. Thus, in the West, the prints of Harunobu (1725–70), Utamaro (1753–1806), Hokusai (1760–1849), and Hiroshige (1797–1858) came to be highly esteemed and were considered representative of all Japanese art. Moreover, as the small and delicate carvings of *inrō* (medicine containers) and *netsuke* (toggles), articles used in daily life during the Edo period (1603–1868), were often depicted in these woodblock prints, they were also considered representative of Japanese art. Even today they are still immensely popular in the West. Ultimately, however, this rather limited view was replaced by the realization that the greatest and most typical works of Japanese art had been neglected.

In time, the number of Western specialists in Japanese art with a broader, less biased knowledge increased, and due to the efforts of scholars and collectors in Europe and America, Japanese art came to be appraised in wider terms. Research institutions of Oriental and Japanese art multiplied, and the large number of scholars engaged in Japanese studies published the results of their research, thus promoting a better understanding of Japanese art.

World War II served as a turning point, since thereafter the distance separating East from West seemed lessened, and the Orient in general and Japanese art in particular came to be studied with more enthusiasm everywhere. Along with accurate historical data drawn from the study of old documents, efforts were made to analyze and interpret the various styles by a strict study of the works themselves. The result has been a deepening of our knowledge of important works of art.

An increasing number of masterpieces are being introduced to various parts of the world, and a good many works that won the appreciation of scholars after World War II are now being exhibited abroad. These choice pieces are very useful since they enable other people to come to know the art of Japan, but they are, of course, insufficient to reveal its full range.

This volume tries to convey the main constituents of Japanese art and is based on a chronological approach. The works illustrated have been selected by specialists in the various fields. The historical survey, originally published in *Art Treasures of Japan* (2 vols., ed. Yukio Yashiro, published by Kokusai Bunka Shinkōkai, Tokyo, 1960), which is now regarded as something of a classic, has been published by permission of the Japan Foundation. Finally, we would like to take this opportunity to express our gratitude for the great help and advice we received in the preparation of this book.

MAP OF JAPAN

HOKKAIDO

Sapporo

Hakodate

Aomori
AOMORI

IWATE

Akita Morioka

AKITA

JAPAN SEA

YAMAGATA MIYAGI

Yamagata
Sendai

Niigata Fukushima

NIIGATA FUKUSHIMA

ISHIKAWA Toyama Nagano TOCHIGI HONSHU

GUMMA Utsunomiya Mito

TOYAMA Maebashi IBARAKI

Kanazawa SAITAMA

NAGANO Urawa Chiba

FUKUI Fukui GIFU Kōfu Tokyo CHIBA

Yokohama TOKYO

KYOTO SHIGA Gifu Kamakura

TOTTORI Ōtsu Nagoya Shizuoka KANAGAWA

Matsue Tottori Kyoto AICHI YAMANASHI

SHIMANE HYŌGO SHIZUOKA

OKAYAMA Kobe Nara Tsu

HIROSHIMA Osaka MIE

YAMAGUCHI Okayama NARA

Hiroshima Takamatsu

KAGAWA Wakayama

Yamaguchi Tokushima WAKAYAMA

FUKUOKA Matsuyama OSAKA

SAGA Fukuoka EHIME Kōchi

Saga ŌITA KŌCHI TOKUSHIMA

NAGASAKI Ōita

Nagasaki Kumamoto SHIKOKU

KUMAMOTO MIYAZAKI

Miyazaki *PACIFIC OCEAN*

Kagoshima KYUSHU

KAGOSHIMA

Naha

OKINAWA

1

THE ARCHAEOLOGICAL AGE

The origins of the Japanese people are not certain, and the true source of their culture is likewise obscure. However, it is customary to begin discussion of the history of Japanese art with the early Paleolithic Age, because the earliest art forms found in the Japanese archipelago belong to that time. The period from early Paleolithic times until the mid-sixth century, when the tide of Buddhism began to flow into Japan, covers several thousand years and is called for the sake of convenience the Archaeological Age. This epoch is usually divided into three periods: the Jōmon Pottery Culture; the Yayoi Pottery Culture; and the period of the Ancient Burial Mounds, or Tumuli. In this book they are referred to in abbreviation as the Jōmon, Yayoi, and Tumuli periods respectively.

The Jōmon Period

Recent research has determined that in the early part of the Stone Age in Japan there was a pre-pottery period—an age in which the art of making pottery was not yet known—but detailed information about this period awaits further study. The first period with which we are concerned is the Jōmon period, in which earthenware with the imprint of ropes (*jōmon*) on the surface, termed Jōmon pottery, was made and used. Artifacts of the Jōmon period have been found in almost all parts of Japan from Kyushu to Hokkaido, and are classified by their styles into several different groups. They are mostly found at ancient dwelling sites and, from other objects found together with them, are judged to be from a time when people lived by hunting and fishing and had not yet learned to cultivate crops. A recent examination of the radioactive carbon content of some objects from Jōmon sites suggests that they are probably not less than fifty centuries old, which provides a clue for future studies on the beginnings of the Jōmon culture. The end of this period is generally taken to be about 300 B.C.

Jōmon pottery found in the valleys of the mountainous regions of central and eastern Honshu abounds in pieces which are profusely decorated, with the ornamentation showing most unusual linear curves and coils, and often a quite violent change of plane (Pl. 2). The same districts also produced clay figurines (*dogū*; Pl. 1), which are sometimes almost shockingly fanciful pieces of sculpture and were perhaps the symbols of primitive magical religion. Some archaeologists believe that a connection can be traced between these earthenware artifacts and the primitive art of the aborigines of, for example, New Guinea and Melanesia. They are certainly notable among the primitive art of the Orient for their remarkably bold plastic forms and for their unrestrained fancifulness verging on the grotesque. They are believed to date from the middle part of the Jōmon period, but it has still to be explained why these manifestations of the Jōmon culture at its best were produced in districts of Japan where the influence from the Asiatic continent must have been relatively weak.

The practice of making earthenware objects and figurines of this kind was in the course of time extended to the northeastern region of Japan (Tōhoku), where the Jōmon tradition remained strong even in the following Yayoi period. Specimens from the last part of the Jōmon period, however, though technically more advanced, lack the impressive originality of the earlier pieces and show some loss of plastic effect.

The Yayoi Period

It was in about 300 B.C. that the inhabitants of the Japanese islands, who until that time had been hunters and fishermen, turned to agriculture (rice cultivation), and this spread eastward from the regions in the extreme west of the archipelago. This abrupt change in the way of living is attributable to continental influence. The Han in China had by this time entered the Iron Age, and the strong impetus of the new culture, spreading toward all neighboring areas, reached as far as the Japanese archipelago. Bronze culture had begun to influence Japan by about the first century B.C., and this was followed very closely by the iron culture. The inhabitants of Japan thus moved in a rather short space of time from a precarious food-gathering way of life to the more settled and safer life of agriculture, from the Stone Age to the Metal Age, and

from a most primitive form of society to a class-system society. Coincidentally, many small states ruled by local clans evolved in various parts of the land.

This new period is called the Yayoi period because it gave birth to a new kind of pottery, termed Yayoi, which was entirely different in style from the earlier Jōmon. The Yayoi culture covers a span of roughly five hundred years from about 300 B.C. to about A.D. 200. In contrast with the Jōmon pottery and its emphasized surface decoration and heavy vigorous design, Yayoi pottery stressed simplicity and refinement of form instead of ornamentation. Some scholars believe that the makers of these distinctly separate types of pottery belonged to two different races. This theory is opposed by another, which has recently gained wider acceptance, holding that the difference between the two types of wares is due to the marked change in the way of life of the people and to the influence of continental culture rather than to a difference of race. Whichever interpretation is correct, the fact remains that the artistic trend observable in the Jōmon culture was submerged by that of the Yayoi, and thereafter the main current of Japanese cultural development moved in the general direction set by the Yayoi culture.

The manufacture of Yayoi pottery started in Kyushu and spread eastward to the region of Kyoto and Nara, and still further to the central part of Honshu, where, in the area around the present city of Nagoya, it attained one of its most graceful forms. That the Yayoi people had direct contact with continental culture is demonstrated by the fact that many bronze artifacts, such as Chinese mirrors of the Former Han dynasty as well as swords, spearheads, and *dōtaku* ("bronze bells"; Pl. 3), have been found in regions where the Yayoi culture flourished. It is curious, however, that while bronze swords and spearheads have been excavated mainly in the northern part of Kyushu, the bell-shaped bronzes known as *dōtaku* are found mainly in the area around Kyoto and Nara.

The Tumuli Period

Community-states ruled by local clans appeared in great numbers in various regions during the Yayoi period and in time came under the unifying influence of more powerful clans, who, in turn, gradually consolidated their military and administrative power through the progressive absorption of continental civilization. In about the second half of the third century A.D., a joint government of great clans—the embryo of the Japanese nation—was established in Yamato (present-day Nara Prefecture), and from about that time it became the custom of the clans to build huge tumuli over the graves of their chieftains. The idea and manner of building such tumuli were introduced from the continent, but after the several clans were brought under the single rule of the Yamato government in about the fourth century, the spiritual and political power of the supreme leader of the clans, the emperor, became so firm and extensive that the tumuli of Japanese emperors sometimes surpassed even those of the continent in scale. The grandeur of the great Japanese tumuli may be measured by the tombs of emperors Ōjin and Nintoku in Osaka Prefecture, which are believed to date from the early fifth century. These tumuli, of the form known as "rectangular-front, circular-back" (*zempō kōen*, or keyhole-shaped), are enormous mounds, surrounded in some cases by as many as three lines of moats.

An insight into the cultural aspects of the Tumuli period is provided by the tumuli themselves and the art objects connected with them, as well as by historical descriptions and legendary stories preserved in the *Kojiki* (*Record of Ancient Matters*). Fortunately for our studies, it was customary for the people of the time to put numerous personal ornaments, treasures, armor and weapons, and other funerary offerings in the burial chambers under the tumuli. The majority of existing specimens are objects made of such durable materials as beads, metalwork, and Sue pottery. Metalwork objects include Chinese bronze mirrors of the Han and Six Dynasties periods and Japanese imitations of them. The technique of bronze casting had progressed from the Yayoi period, but the quality of the bronze used for the imitative mirrors was inferior to that of imported ones because of the lower tin content. In addition to the faithful copies made by taking matrixes from Chinese originals, examples are seen in which the designs, being roughly imitated by Japanese craftsmen who perhaps could not fully understand the symbolism, are summarily simplified or altered in a very odd way. Sometimes, however, mirrors of peculiarly Japanese form or design were produced. Examples are the *rei-kyō* ("bell mirrors") with four, six, seven, eight, or ten bells along the rim; mirrors with designs of houses, of hunting scenes, or of geometric patterns composed of straight lines and arcs (Pl. 5). Besides mirrors, other kinds of metalwork have been found under the tumuli, such as weapons, armor, horse trappings, and personal ornaments. Some of these objects show new skills and techniques, including line engraving, pierced work, inlay, filigree work, and gold plating, which were learned from the continent and applied to various kinds of art objects. While they show some technical immaturity, they provide ample evidence that the technical foundation for the remarkable progress in metalwork which was to occur during the following period was already laid during these times.

Sue pottery, a new type of earthenware, was fired at a high temperature by a technique

introduced from Korea during the mid-fifth century. This hard, high-fired ware was evidently received favorably by the upper classes, since large quantities have been found in tumuli graves. Prior to the appearance of Sue ware, a type of pottery known as Haji ware, which developed from Yayoi pottery, seems to have been widespread and remained in practical use among the lower classes even after the introduction of Sue ware. This Haji pottery, however, was obviously an inferior and rather unattractive ware even for everyday vessels, while Sue ware, in addition to its technical superiority, inspired the creation of many new shapes and elaborate decorative forms (Pl. 7).

The most interesting of the relics from the Tumuli period are *haniwa*, terracotta tomb figures placed on the tumuli. Some of them are just cylinders, but many are figures of humans (Pls. 8, 9) and animals, as well as models of houses (Pl. 6), furniture, and different kinds of objects illustrating life in those times. As to the origin of *haniwa*, there is a theory that cylinders of fired clay, originally arranged along the foot of the mounds to prevent the soil on the slopes from collapsing, became increasingly ornamental with the passage of time and finally developed into representational figures. For such a development, however, there must have been some motivating factor. Some consider that they were inspired by the funerary customs of the continent. It was the practice in China, in order to "comfort the lives of the dead in the graves," to put in the burial chambers funerary offerings (*ming-ch'i*) such as figures of humans and animals, together with reproductions of houses and other objects that were associated with the dead, and also to place stone images of men and animals around and in front of the tombs as eternal attendants and guardians of the dead. However, just as the Japanese tumuli were not mere imitations of continental ones, so the *haniwa* differ from both the Chinese *ming-ch'i* and the stone statues of men and animals outside the tombs.

The fundamental difference between the tomb figures of the two countries is perhaps in the manner of representation. While the naturalistic Chinese tomb figures of the Han and Six Dynasties periods reveal acute observation and an austere pursuit of plastic form, Japanese *haniwa* figures are characterized by an instinctive, rather sentimental approach to nature, and by a naive, almost artless grasp of the characteristics of their subjects expressed in a manner that is very endearing. In fact, it is possible to see in the *haniwa* figures the same aesthetic sensibility that is revealed in Yayoi pottery. Less civilized inhabitants of the Kantō plain lent their *haniwa* a free, bold, and unsophisticated air.

As for examples of graphic art in the Tumuli period, in addition to the line relief pictures on metalwork objects already mentioned, there are a number of paintings in color decorating the interiors of tombs, chiefly in the Kyushu district. Manifesting the influence of grave decoration in China and Korea, they show such geometric motifs as circles (Pl. 10), triangles, "straight lines and arcs," as well as human figures, horses, weapons, and boats. Their forms are very simple and their coloring does not indicate any notable progress from that seen on some Yayoi pottery.

The makers of artifacts of the Tumuli period, besides being engaged in agriculture, were organized into groups of craftsmen of specialized categories. Their techniques were handed down the family from one generation to the next and became increasingly refined with the passage of time. Among these craftsmen were many immigrants from the continent and their descendants, and there seems to have been incessant rivalry between the advocates of conservative techniques and the progressives. It is important to appreciate that the techniques and the aesthetic sense thus developed and polished through competition over several generations enabled the newly imported Buddhist arts of the following period to make such rapid and dramatic progress.

2

THE ASUKA PERIOD

From the mid-sixth to the thirteenth century Buddhism was the inspiration and the guiding spirit of Japanese art through all its changing aspects in different periods. The period here termed the Asuka covers about a century from the mid-sixth to the mid-seventh century and may otherwise be referred to as the early Buddhistic period.

Buddhism, which originated in India in the last part of the sixth century B.C. was transmitted about the beginning of the Christian era to Central Asia, from where it was brought along the Silk Road, reaching China during the first century A.D. We know that Buddhism was making headway in the Tartar countries of northern China and even in Korea during the fourth century, and it was certainly flourishing in the Chinese kingdoms of Northern Wei and Liang during the fifth and sixth centuries (the latter part of that period is often referred to by Japanese scholars as the Six Dynasties, but it is perhaps better named the Northern and Southern Dynasties). In Japan, as early as the Tumuli period numerous immigrants entered the country from China and Korea. There must have been Buddhists among them, but Buddhism seems not to have had an important influence until after A.D. 538, when, according to the ancient chronicles, the king of Kudara (Paekche), one of the three kingdoms existing at that time in the Korean peninsula, presented a gilt bronze statue of the Buddha to the court of Japan, together with some Buddhist scriptures and a letter praising the new faith. Thereafter, the king of Paekche continued to send Buddhist images and sutras to Japan, and under his encouragement a number of monks and nuns, architects skilled in the building of temples, and artists and craftsmen of sacred images and ritual objects crossed over to Japan. Later on, Buddhist images were presented to the Japanese court by the two other Korean kingdoms, Silla and Koguryŏ. Buddhism quickly made gains among leading Japanese families largely owing to the support of the influential Soga family, but it met with opposition from supporters of the long-established native religion, whose essentials were a combination of polytheistic nature worship and ancestor worship. There were also political as well as spiritual troubles to be overcome before the new foreign faith was able to take root in Japanese soil.

The person principally responsible for the promotion of the policy of adopting Buddhist culture and importing the new continental civilization was the remarkable Crown Prince Shōtoku (Shōtoku Taishi), who became regent in A.D. 593. Not only was he a good Confucian scholar but he also had a deep understanding of the doctrines of Buddhism. Combining the two roles of the chief patron of Buddhism and the prince regent, Shōtoku Taishi aimed at adopting the great philosophical system of Buddhism as the main spiritual support for the new constitutional reform. He opened official communications with the Sui dynasty of China and strove to import Chinese culture direct, instead of through Korea. His attempt to promote the ethics of the Japanese nation through Buddhism seems to have been inspired by the system in force in Sui China. The policy established under his guidance was maintained and intensified until 645, when a statutory system, based upon the principle of state ownership of land and with emphasis on the assimilation of Chinese culture, was successfully introduced by Prince Naka-no-Ōe (later Emperor Tenji) and his followers. From about that time the spread of Buddhism was actively encouraged by the imperial court.

During the Asuka period, nearly fifty Buddhist temples were established in the Kinki district centering around Yamato province, including Asuka-dera (Gangō-ji), built by the Soga family in about A.D. 600, and Shitennō-ji and Ikaruga-dera (Hōryū-ji), both established by Prince Shōtoku. While temples founded in the following Nara period were chiefly governmental institutions, those of this period, established in great numbers within a century or so after the introduction of Buddhism, were for the most part private undertakings by influential individuals or heads of clans. They were, besides being institutions of religious teaching, centers for the dissemination of the newly imported culture from the continent.

The primary objects of religious devotion in contemporary Buddhism were the images of Buddhas and the sutras. The main buildings in a temple were the central front gateway (*chūmon*), the pagoda (*tō*) containing the sacred relics, the golden hall (*kondō*) housing the principal Buddha

image, the lecture hall (kōdō), where sermons on the sutras were given, the sutra repository (kyōzō) for the safekeeping of the sacred scriptures, and the bell tower (shurō or shōrō), which served as a means of announcing the times of rituals and services. The orderly arrangement of these buildings, the dignified beauty of the many-storied structures built in continental style with tiled roofs and red-painted circular pillars, the awesome statues and brightly colored paintings which they contained, and the pompous rites observed in the gorgeously decorated halls—all these must have been sights of great wonder to the unsophisticated Japanese people of the time. Craftsmen, including the earlier immigrants with their descendants and pupils, must have worked under the guidance of experts in new techniques who arrived during this period—mainly from the Korean peninsula but also from China through Korea—for the construction of temples and the making of sacred images.

The first Buddhist temple in Japan was probably Asuka-dera (also known as Hōkō-ji or Gangō-ji), built by the Soga family. This temple, which was completed in the beginning of the seventh century, was constructed by architects, tile makers, and other craftsmen from the Korean kingdom of Paekche especially to house the gilt bronze statue of Shaka (Śākyamuni) cast by Kuratsukuri-no-Tori, a descendant of a Chinese who had emigrated to Japan. This statue, though much damaged, still exists at Asuka.

Hōryū-ji, the oldest surviving temple in Japan, can boast many buildings that retain the architectural style of the Asuka period in addition to the Kondō, the oldest wooden building in the world. There have been repeated discussions since the late nineteenth century about the precise age of the present Hōryū-ji, and the problem still remains unsettled. It is, however, generally accepted that the present temple was reconstructed toward the end of the seventh century after the original was destroyed by fire in A.D. 670, but that the older style was followed faithfully at the time of the reconstruction. Another example of the architectural style of the Asuka period is the Tamamushi Shrine in Hōryū-ji (Pls. 16, 17). The essence of Asuka period architecture, judging from these examples, is that although introduced into Japan from Korea, it followed the clean and simple style of the architecture of sixth-century China.

Similarly, Buddhist sculpture in the Asuka period, broadly speaking, followed the style of the Northern and Southern Dynasties of China. It was during this period (386–589), so far as we can tell from surviving examples, that Chinese Buddhist art burst into its first brilliant flowering. The favor which Buddhism enjoyed under the earliest dynasty in the north, the Northern Wei (386–534), lent a strong impetus to early Buddhist stone sculpture, of which we still have marvelous specimens in Yün-kang, Lung-men, and other cave-temples in China. We must add to the same category the early Buddhist statues in clay of the Tun-huang caves. This Northern Wei style was the source of inspiration for all subsequent developments of Buddhist sculpture in China during the Northern and Southern Dynasties, in Korea during the Three Kingdoms period, and ultimately in Japan of the Asuka period, having been transmitted via Korea. One manifestation of the local differences in China during the Northern and Southern Dynasties which should not be neglected in its relation to Japan is the sculptural style of the Southern Dynasties, because the first great sculptor of Japan in the Asuka period, the Kuratsukuri-no-Tori referred to earlier, was the grandson of a Chinese craftsman of the Southern Dynasty, Liang, who emigrated first presumably to Paekche in Korea and subsequently to Japan. For an adequate analysis of the continental influences on Asuka sculpture, therefore, we ought to know more about the Liang style of China, and the style of Paekche statuary, which must have been quite closely related to the Southern Dynasties style. Of these two styles, however, because reliable surviving examples are few, we still know so little that we must refrain from elaborating on their possible influence on Asuka sculpture in Japan.

Having touched on the situation of Buddhist sculpture of the continent at a time contemporary with the birth of Japanese Buddhist art, we must now turn to Asuka sculpture itself. The most striking thing is the evidence of the astonishing forward leap by which Japanese artists advanced from their naive and primitive stage of technical and artistic development of the Archaeological Age to a highly developed sculptural skill equaling that of the continent. Even conceding that much early work must have been done under the guidance and with the collaboration of foreign artists, the rapid production of such first-class Buddhist images as those of Hōryū-ji in a land where up to then the art of sculpture had not developed beyond the primitive haniwa, and at a time when the cultural level of the surrounding areas had hardly evolved from the archaeological Tumuli period, can only be described as spectacular.

Among Asuka sculptures, two works which show the influence of the earlier Wei types, though not necessarily of the very earliest Northern Wei, are the most famed of the Hōryū-ji statues, the bronze Shaka triad of the Kondō (Pl. 11), made by the sculptor Tori, and the carved wood Kannon in the Yumedono, or "Dream Hall" (Pl. 12). These masterpieces possess the virile severity and dignity of the early Northern Dynasty style. Two other famous sculptural works of the Asuka period—the bodhisattva of Chūgū-ji (Pl. 14) and the Kannon, popularly called the "Kudara Kannon" of Hōryū-ji (Pl. 13), both of which are sculptured in wood and known for

the sweet and tender nobility of their expressions—are markedly different in style from the work of the sculptor Tori and seem to show influence of the rather later Northern and Southern Dynasties styles, with the possible addition of a Korean flavor.

It should be noted that even as early as the Asuka period, although the principal material for sculpture was bronze, following the manner of the continent, the predilection for wood, which in later periods was to lead Japan to a position of preeminence in the art of wood sculpture, had already begun to express itself.

There is little to be said about the painting of this period, because surviving examples are so few. The paintings on the Tamamushi Shrine (Pls. 16, 17) and the picture embroidered on the Tenjukoku Mandala in the temple of Chūgū-ji attest to the influence of the Northern and Southern Dynasties style. The Tamamushi Shrine paintings are of special interest as they reflect an even earlier style, reminiscent of the Later Han. In this period of Buddhist art, painting seems to have been regarded mainly as a means of illustrating the life of the Buddha or the teachings in the sutras.

The craft of textile making, which up to the introduction of Buddhism had been confined to the production of cloth for everyday use, made great progress under the stimulus of Buddhism, and within a short time gorgeous materials with intricate patterns were produced for Buddhist temples, for the court, and for noble families. Metalwork had achieved a fairly advanced state of development during the previous epoch, but greatly improved techniques were introduced from the continent by the new immigrants. The beautifully cast bronze statues and halos, the openwork and engraving on ceremonial crowns (Pl. 12), ritual objects (Pl. 19), and other works all testify to the great technical improvements made during this period. It may be inferred from the steady progress in decorative arts and crafts that throughout this period there must have been an uninterrupted flow of immigrants from the continent, bringing to Japan new techniques and materials. The creations of this new Buddhist art were, of course, entirely different in nature from the earlier native culture of Japan. But the movement was supported by the enthusiasm with which the ruling class of the time embraced the new and exciting continental civilization.

3

THE NARA PERIOD

The term Nara period is used throughout this book to refer to the period of one and a half centuries from A.D. 645, the year in which the Taika Reform took place, to 794, when the capital was transferred from Nara to Heian (present-day Kyoto). This period is customarily divided into the early Nara, or Hakuhō, and the late Nara, or Tempyō, periods, with the year 710 marking the division. This was the golden age of Japanese Buddhist art.

The Taika Reform, the achievement of Prince Naka-no-Ōe (later Emperor Tenji), the courtier Nakatomi-no-Kamatari (founder of the Fujiwara family), and their associates, was an extension of Prince Shōtoku's policy of establishing a nation on the Chinese model, with a unified code of administration based on the principles of state ownership of land and centralization of authority. The position of the emperor and the authority of the central government were greatly enhanced during the reigns of Emperor Temmu (r. 673–87) and the Empress Regnant Jitō (r. 687–97). The latter was responsible for the construction, from about 691, of the first permanent capital in Japan, Fujiwara-kyō, which was laid out in the manner of the Chinese prototype. With growing emphasis on the concept of the country as a national entity, the promotion of Buddhism as the national religion was stressed, and Buddhist temples were built one after another as national undertakings. The reigns of Emperor Temmu, Empress Jitō, and Emperor Mommu witnessed the construction in the new capital of temples unprecedented in scale, such as Dai-kandai-ji (Daian-ji) and Yakushi-ji; and the influence of early T'ang art became increasingly apparent in the architectural styles of these temples and of the statues which they contained. At the same time, together with imported fine arts and techniques associated with Buddhism, *waka*, a traditional Japanese form of poetry, flourished in Fujiwara-kyō. Altogether the early Nara period was an epoch of remarkable cultural attainment.

In 710, the court moved to a new capital, Heijō (Nara), built by Empress Regnant Gemmyō on an even greater scale than Fujiwara. The city was modeled after the T'ang capital of Ch'ang-an, with the Imperial Palace at the center of the northern end and the streets laid out in a regular checkerlike plan toward the south. Great temples formerly located in the old capital, including Daikandai-ji (Daian-ji), Yakushi-ji, and Kōfuku-ji, were transferred to Heijō. In this period, the rapid introduction and assimilation of many aspects of the great T'ang civilization was furthered by the direct import of Chinese art and culture through large groups of returning Japanese who had been sent to China by the Japanese government. In this way, Japan became one of the outposts of the supranational cultural system of East Asia, of which T'ang China was the nucleus.

The national policy of encouraging Buddhism as the spiritual support of the country reached its height under Emperor Shōmu. He issued an order in 741 for a *kokubun-ji* (provincial official temple) to be built in each province throughout the country under the overall jurisdiction of the magnificent Tōdai-ji, the principal official temple. This great temple, with its Kondō ("Golden Hall") measuring 86 meters in frontage and 50.5 meters in depth and housing a colossal bronze statue of Rushana Butsu (Vairocana) almost 16 meters in height, was completed in 752. The making of the Great Buddha in the capital and the construction of *kokubun-ji* in all the provinces was inspired by a fervent desire on the part of secular leaders of the time to create in Japan the ideal Land of the Buddha. From about the time of Emperor Shōmu, the administrative system, so enthusiastically adopted in its entirety from T'ang China, had begun to disclose grave weaknesses, and a struggle for power among the leading aristocrats ensued. It was perhaps in the hope of distracting the contending groups from their feuds that the rulers forced attention on religion and religious works. This would account in part for the remarkable zeal of the imperial court in encouraging Buddhism.

Following the construction of Tōdai-ji, which was a tremendous undertaking drawing upon the combined resources of the nation, Saidai-ji was built between 765 and 771. In 754 the Chinese priest Ganjin (Chinese: Chien-chên) had arrived in Japan, and Tōshōdai-ji was founded for him and by him. At about this time, however, there was an outcry against this reckless kind of expenditure by the government on account of the heavy burden it imposed on the people.

The Buddhist religion, moreover, was alleged to be too involved in politics. But politics apart, there is no question that the span of some seventy-odd years while the capital was in Nara was the most radiant period in the history of Japanese Buddhist art.

In the late Nara, or Tempyō, period, the brilliant T'ang mode was very much in fashion, not only in purely Buddhist art but also in the decorative art that adorned the dwellings of the nobility. Evidence of the splendor of these appointments is provided by the numerous personal objects of Emperor Shōmu preserved in Shōsō-in, a repository that originally belonged to Tōdai-ji and has fortunately survived virtually intact. In literature, however, traditional Japanese *waka* poetry enjoyed favor, and it was at this time that the *Man'yō-shū* (*Collection of a Myriad Leaves*), an anthology of about 4,500 poems composed in and before this period, was compiled. It was also during the late Nara period that the earliest Japanese histories, the *Kojiki* (*Record of Ancient Matters*) and the *Nihon Shoki* (*Chronicles of Japan*), were compiled.

Sadly, few examples remain of the many Buddhist temples built during these times. The early buildings of Hōryū-ji, formerly attributed to the Asuka period, are now considered by most scholars to be reconstructions made about the end of the seventh century; yet as the style faithfully followed that of the original buildings, they cannot be considered as representative examples of Nara period architecture.

Tōdai-ji, the outstanding example of Buddhist architecture on the grand scale, was built in the late Nara period. It was destroyed by fire in the late twelfth century, and the present Kondō, housing the Great Buddha—the last of several reconstructions—was erected toward the end of the seventeenth century. Although the grandeur of the original Kondō of the Nara period can hardly be visualized from the appearance of the present building, at least its enormous size is not much altered. The breadth is a little narrower, but it is still the largest wooden building in the world.

Certain innovations in the layout of temple buildings of this period may be noted. During the first part of the early Nara period, the Hōryū-ji system, with a *kondō* and a pagoda standing side by side on a right-left (east-west) line, was adopted more frequently than the Shitennō-ji system, with a pagoda and a *kondō* one behind the other in a north-south line. At about the time of the construction of Yakushi-ji appeared what may be termed the Yakushi-ji system, which favored placing two pagodas symmetrically on a right-left line in front, that is to say, on the south side, of the *kondō*. This system, examples of which are also to be found in temple design of the Silla period in Korea, probably had its origin in T'ang China. Other innovations that made their appearance in the late Nara period were the Tōdai-ji system, with two pagodas in symmetrical positions on both sides of and outside the central front gate (*chūmon*), and the Daian-ji system, with two pagodas outside the outer front gate (*nandai-mon*). It is probable that these developments of the Yakushi-ji system also followed patterns set by the religious conventions of T'ang China.

In the first half of the early Nara period, that is until about 680, sculpture developed along the several different lines popular during the Asuka period, whose origins lay in the Chinese styles of the latter half of the sixth century. After about 680, sculptural concepts and technique seem to have made great advances. Naturalistic portrayal of the human form became possible, and statues were rendered with more animation and more human expression. The head of a Buddha in Kōfuku-ji dating from 685 (Pl. 20) is a particularly fine example of this period.

The dating of the Yakushi Nyorai in the Kondō of Yakushi-ji (Pl. 21) is controversial, one theory ascribing it to about 697 and another to about 718. It is one of a trinity of dignified, powerful statues showing strong T'ang-style influence of the late seventh century, but possessing nonetheless a unique beauty of its own. In the realistic portrayal of the fully developed, heavy bodies and in the naturalistic representation of details, the work far surpasses anything that had come before.

From about the year 700 the ever-increasing importation of new styles from T'ang China was paralleled only by the ability of Japanese artists to assimilate foreign elements and incorporate them into their own creations. Under the direct influence of this rich T'ang art at its fullest flowering, Japanese sculpture of the late Nara (Tempyō) period became still more naturalistic and mature, and magnificent in its detail. This may be seen clearly in those masterpieces of clay sculpture, the statuettes in the pagoda at Hōryū-ji (Pl. 22), in the dry-lacquer figures of the Eight Guardians (Pl. 25) and the Ten Great Disciples of Buddha (Pl. 26) of Kōfuku-ji, in the eighth-century statues of the Hokke-dō Hall at Tōdai-ji (Pl. 23), and in the Four Deva Kings of the Kaidan-in, also at Tōdai-ji (Pl. 24). The Great Buddha of Tōdai-ji, consecrated in 752, must once have been a superb monument expressing in material form the idealistic concept of the Supreme Buddha, but it has lost its original splendor in a succession of calamitous fires which destroyed the greater part of the huge figure. The only part of the original statue still remaining is a portion of the large lotus pedestal, the accomplished workmanship of which provides an indication of what a stupendous work of art the lost colossus must have been.

The casting of the Great Buddha of Tōdai-ji marks the peak of late Nara period sculpture,

the succeeding epoch being one of gradual decline. The statues of the latter part of the eighth century tend to be stereotyped and veer toward mediocrity, with expressions becoming either monotonous or exaggerated. An important and interesting new feature of this period, however, was the advent of portrait sculpture. The seated statues of the priests Ganjin in Tōshōdai-ji (Pl. 29) and Gyōshin in Hōryū-ji are masterpieces of this kind.

In addition to bronze and wood, which had been in use from Asuka times, the techniques of making statuary in clay and dry lacquer (*kanshitsu*) were imported anew from the continent during the Nara period. Lending themselves to naturalistic representation, the new techniques became so fashionable that they formed the principal materials of Nara period sculpture. Their all but complete disappearance with the end of the Nara period presents an interesting problem for historians.

Sculpture in stone enjoyed great favor on the continent but did not flourish in Japan, probably because stone suitable for sculpture was scarce owing to the volcanic origin of the country.

The famous wall paintings of the Kondō of Hōryū-ji (Pl. 30), which were almost completely ruined by a fire in 1949, were representative of the finest pictorial art of the Nara period. They were painted in color on a grand scale under the direct influence of T'ang China, then at the peak of its cultural development. The subjects were the Pure Lands of four Buddhas and the figures of eight bodhisattvas, and the paintings were thought to have been executed at, or shortly before, the beginning of the eighth century after the reconstruction of the Kondō. With their imposing composition, the noble grace of the figures, the spiritual depth of their expressions, and the brilliant decoration extending to the smallest detail of the composition, they were universally acclaimed as the finest masterwork of Japanese painting and one of the great treasures of mankind. A comparison of the Hōryū-ji wall paintings with the murals in the grottoes at Tun-huang permits us to infer that the T'ang painting introduced to Japan was equal to the best Chinese art of the time.

In late Nara times, Japanese painting continued to make progress under the continuing influence of T'ang China. After the completion of the wall paintings in Hōryū-ji, it became a frequent practice to make large-scale representations of Buddha's Pure Land. In addition to these large-scale representations of Buddhist cosmological concepts, there were also portrayals with smaller dimensions of single deities. The image of Kichijō-ten in Yakushi-ji (Pl. 31) is an exquisite example and depicts the goddess as an elegantly attired T'ang lady with the most delicate drawing and coloring.

Generally speaking, Buddhism was the sum and substance of the art of this period, but themes such as genre scenes or landscapes were also favored by the aristocrats in Nara, and records of the time mention screen paintings on various subjects. Even in such paintings, however, the T'ang influence was obvious. Drawing in black monochrome lines was also practiced. In the use of color, the polychromatic *ungen* coloring, in which different colors were arranged in layers of graduating shades as in a rainbow, was very much in fashion. This, too, originated in T'ang China but as it suited aristocratic taste, it continued to be used in Japan until much later times.

The Nara period also witnessed remarkable developments in the decorative arts, as may be seen from the more than ten thousand specimens of Buddhist ritual objects, tableware, musical instruments, games, writing materials, weapons, and furniture preserved in the Shōsō-in Repository. Some of these were no doubt imported, but many have been proved to be Japanese works, which seems to show that the Japanese succeeded in mastering the highly advanced techniques to the point where their works were almost indistinguishable from imported articles.

Among the numerous examples of textiles in the Shōsō-in it is virtually impossible to determine which are Japanese and which of continental origin. Decorative motifs include such novel and exotic designs as flowers-and-birds and hunting scenes. They illustrate how eagerly the Japanese aristocrats of the time imported superior Chinese fashions and had them copied in Japan, and how they loved decorative beauty. The Shōsō-in is indeed a treasure house of the art of the Nara period in Japan, but it also provides us with an unimaginably rich collection of the art of all the countries in the T'ang cultural sphere, from Persia eastward.

From what we have discussed we see that during the Nara period, under the impetus of the great creative outburst of T'ang China, the arts and crafts of Japan—both Buddhist and secular—made spectacular progress. Other than in literature, however, where the native spirit found expression in traditional *waka* poetry, the forms and styles employed were still basically continental in concept, and art truly Japanese in character had yet to make its appearance.

4

THE HEIAN PERIOD

The Heian period covers approximately four centuries from 794, the year in which the court moved to a new capital at Heian-kyō, to 1185, when the power of the Taira (Heike) clan was dissipated and the country came under the rule of the military government established by Minamoto-no-Yoritomo at Kamakura.

At the beginning of this period and throughout the ninth century, Japanese culture and art remained firmly under the influence of T'ang China, but with the decline of T'ang power and the abandonment in A.D. 894 of diplomatic intercourse with China, the culture of Japan began to change character and develop a more independent national spirit. The period of about three hundred years when Japan was isolated from the continent from the beginning of the tenth century saw the emergence, under the enlightened patronage of the court and aristocracy, of a truly national art quite different from that of the ninth century. With the year 894 as the watershed, therefore, the Heian period is subdivided into the early Heian (also called the Kōnin or Jōgan) and the late Heian, or Fujiwara, periods.

The Early Heian Period

Administratively, the statutory system of government adopted from T'ang China carried on well into the ninth century, and the aristocracy continued to be attracted to the study of Chinese art and literature. Superficially, therefore, Japanese society in the early Heian period differed little from that of the previous Nara period, but, in fact, changes of substance were taking place both in politics and in culture. Emperor Kōnin (r. 770–81), in the last part of the Nara period, had abolished the long-established custom under which the national resources were lavishly disbursed for building temples and making statues. Until shortly before his reign it had been the practice to give important positions to Buddhist priests or men of the nobility who had some special connection with the imperial court, but favoritism of this kind, often the cause of political disturbances, was rejected by Emperor Kōnin. His reforms were given full support by his successor, Emperor Kammu (r. 781–806), who even transferred the capital from Nara to Heian-kyō, away from the overwhelming influence of the Buddhist clergy. In considering the cultural trends of this time, the fresh invigorating spirit obtained through moving the capital should not be overlooked.

Another factor of great importance was the changed nature of imported T'ang culture. The Chinese civilization which had entered Japan during the previous period was that of the golden age of T'ang, and although the outward manifestations of Chinese culture continued to flow into Japan at this time, these began to reflect the decadence of the later T'ang age, with the result that the Japanese no longer regarded T'ang culture as the sole and unquestioned source of models and ideas to be assimilated uncritically. Instead, they began to regard T'ang culture as providing the source materials from which a more graceful culture of their own could be developed. Evidence of this is afforded by the fact that many noblemen of the time wrote fine poems in Chinese of their own creation, borrowing only the poetic form from China.

A similar thing happened with Buddhism. Up to the latter part of the Nara period, there was apparently no great urge on the part of the Japanese to inquire very deeply into the inner meanings and philosophy of Buddhism, but from shortly before the beginning of the Heian era a new tendency made its appearance. People were no longer satisfied merely with the outward panoply of the religion and the splendor of the temples, but began to search for something more spiritual. Numerous indications of this may be found, and the new direction of Japanese Buddhism was ultimately determined when the Japanese priests Saichō and Kūkai visited T'ang China to study Buddhism and brought back to Japan the two new sects of Tendai and Shingon, at that time the most thriving schools of Buddhism in China. Saichō founded Enryaku-ji on Mt. Hiei, near Kyoto, and began to propagate Tendai Buddhism, while Kūkai labored to spread Shingon, making Kyōōgokoku-ji (also known as Tō-ji) in Kyoto his base in the capital, though he also founded Kongōbu-ji on Mt. Kōya—some distance away in the province of Kii (now Wakayama Prefecture).

Esoteric Buddhism was a combination of Buddhism with Brahmanism and other ancient folk religions of India. The magical elements of those Indian religions enriched its ritual, and its sacred images came to include divinities and demons grotesque in form and demeanor and quite different from earlier Buddhist icons. Prior to its establishment in Japan, Esoteric Buddhism went through various stages of development. It came into vogue about the seventh century in India and its neighboring countries, and from there it reached China early in the eighth century. Some rudimentary elements of Esoteric Buddhism had even reached Japan as early as the Nara period, and their magical aspects had become intermingled with the popular religion of Japan.

Unlike earlier sects of Buddhism in Nara which, as befitting orders of the state religion, had laid great importance on artistic splendor and ceremonial, both the Tendai and Shingon schools had the nature of religious brotherhoods bound together by faith, concentrating their efforts on doctrine and seeking both spiritual and financial independence from politics. Shingon was a sect founded on highly mystic principles, employing a ritual which sometimes approached the magical. Tendai was originally an Exoteric sect, but gradually it adopted Esoteric aspects and came to be called Tai-mitsu (Tendai Esoterism) to distinguish it from Shingon, which was termed Tō-mitsu (Tō-ji Esoterism). The replacement in popular favor of the earlier Exoteric sects of Nara by these two Esoteric schools of Heian Buddhism brought about sweeping changes in the practice of religion and in Buddhist art.

The main tenet of Esoteric Buddhism was that the way to the realization of the highest ideals of faith could be reached only through intensifying man's actual experiences in this world by stern self-discipline, by concentrated study of the profound doctrines, and by the observation of symbolic religious services and rituals. These religious services and rituals had far greater significance for Esoteric than for Exoteric Buddhism as they were full of mystery, magical invocation, and exorcism rites. The aristocrats, preoccupied as they were with such worldly desires as promotion for themselves or members of their families, the increase of their private estates, or the downfall of their enemies, were easily persuaded of the effectiveness of the mystic Esoteric ritual and eagerly welcomed the new sects. For their part, the priests of both the Tendai and Shingon sects, spiritual, even idealistic though they may originally have been in their tenets, could not resist courting the patronage of the aristocracy, and eventually their most important activities came to be the recitation of special prayers and the performance of rituals for the welfare of the nobility, to the detriment of their own religious ideals. While Esoteric Buddhism thrived under the patronage of the upper classes, its magical rites thus tended to become increasingly elaborate and luxurious.

Numerous images of deities, both in sculpture and in painting, were necessary in these religious observances. Of primary importance were the Ryōkai Mandalas, which gave visual form to the mystic arrangements of Buddhist deities in cosmological synthesis. Following these in importance, were the Besson ("Individual Deities") Mandalas, showing groups of related deities arranged around particular Buddhas or bodhisattvas, and so on down through the pantheon to the images of Myō-ō (rājas, or kings; Pl. 44) of terrifying demeanor with the plurality of heads, eyes, hands, and feet peculiar to Esoteric Buddhism. This large pantheon of divinities for the rituals had to be made in conformity with an elaborate iconography prescribing the physical features, poses, mudrās (finger positions with symbolic meanings), and other attributes of each deity. The sources of that iconography were the numerous line drawings of Buddhist divinities brought back by Saichō and Kūkai and other priests who followed them to T'ang China, though they were added to and frequently modified in later times.

Up to the Nara period most of the principal Buddhist temples had been built and maintained as national institutions, but the temples of the early Heian period were fundamentally different in that they seldom depended upon official financial support. Another feature of these temples, exemplified by Saichō's Enryaku-ji or Kūkai's Kongōbu-ji, was that they were built at quiet, sequestered places deep in the mountains. Generally smaller in scale and with much simpler buildings, they were primarily intended as austere centers of religious self-discipline. The building of modest temples throughout the country coincided with the rise of powerful land-owning clans who lived for the most part not in the capital but on their country estates, and it may be ascribed in part to the evangelizing work of eminent priests who frequently went on missions to distant places. Many of the privately established local temples, unlike the official kokubun-ji of the Nara period which were constructed in provincial capitals, were set on mountains famous for their natural beauty, or at places sacred in popular faith, so that the local gods were replaced by, or identified with, the new Buddhist deities. In this way Esoteric Buddhism made a positive contribution toward bringing about the unification of Shintoism and Buddhism.

While a majority of the Buddhist sculptural works of the previous periods were of bronze, dry lacquer, or clay, in the early Heian period wood sculpture predominates. This phenomenon may be accounted for by the abundance of fine wood in the country, the relative scarcity of

bronze, the high cost of the dry-lacquer technique, and the discovery that clay was not a very durable material in a climate as humid as Japan's. We have already remarked that the newly imported Esoteric Buddhism required a great variety of Buddhist images. This led to an increased demand for statues, so it is not surprising that wood sculpture, which could be made throughout the country because the material lay to hand everywhere, became a flourishing art in the Heian period.

The sculptural style of the Esoteric doctrine laid greater importance on symbolic representation than on beauty of form, and aimed to express the spiritual powers of the different divinities by endowing them with massive, powerful bodies, exaggerated attitudes, appealing or menacing gestures and expressions, and an enchanting and almost sensuous representation, rather than by naturalistic portrayal. This preoccupation with the expression of an inner spirituality encouraged the development of a unique type of wood sculpture. Using solid blocks of wood hewn from great aged trees, themselves regarded by people of the time as something sacred, the sculptors carved mysteriously beautiful figures with wonderfully precise chiseling. The flowing beauty of this sharp chisel work is well conveyed by the name given to the prevailing manner of carving the folds of the draperies—*hompa shiki* ("rolling-wave style"), which takes the form of parallel running folds that resemble the alternate crests and troughs of surging waves (Pl. 33).

The characteristics of this early Heian wood carving existed in embryonic form even during the last part of the Nara period, and they came to be generally adopted in this period not only for statues of Esoteric Buddhism but also for those of Exoteric Buddhism (Pl. 35) and so are evidently not attributable solely to the influence of Esoterism. They can also be interpreted as an outcome of the tense unsettled spirit of the age, a product of the conflict between the still lingering tradition of the previous period and the reaction against it. It seems as though Japan must have been infected by the mood of the middle and late T'ang periods, when a similar uneasiness and gloom prevailed. It is conceivable that the sensuous aspect of early Heian sculpture derived from the Indian elements with which Esoteric art was so richly imbued.

An important event in Japanese art history at about this time was the appearance of Shinto sculpture. Although Shinto sanctuaries were modeled after the primitive dwelling houses of Japan, they did not originally house any statues of divinities, since according to the tenets of Shinto it would have been blasphemous to make images of divine beings. After Shintoism came under the influence of the doctrines of Tendai and Shingon Buddhism, however, it took on a more systematic religious form and began to imitate the Buddhist practice of carving statues of divinities and placing them in shrines. Shinto statues, accordingly, followed the style and technique of contemporary Buddhist sculpture in wood (Pl. 40).

Examples of paintings of this period are few, and they are almost always connected with Esoteric Buddhism. Paintings dealing with Exoteric Buddhist subjects must also have been produced, but unfortunately no example has survived. The paintings of Esoteric Buddhism, being subject to strict iconographic rules, were all executed in imitation of Buddhist paintings or religious drawings which had been brought back from China.

It will be apparent from what we have described that iconography was as important to Esoteric Buddhism as its doctrine; and training in the iconographic portrayal of Buddhas and bodhisattvas seems to have been an indispensable qualification for priests of the Esoteric sects. Because the elaborate iconography was so difficult for outsiders to comprehend, the artists responsible for Esoteric Buddhist paintings were generally men who belonged to one of the temples of the sects, and it was customary for these artists, known as *e-busshi* ("painters of Buddhist images"), to be ordained into the priesthood. Certainly very eminent priests could themselves paint sacred images, or at any rate could instruct the *e-busshi* how to paint them, introducing new iconographic forms based upon the appearance of the divinities as revealed to them in visions. In this respect, the Buddhist paintings of this epoch were quite different from those of the Nara period, which were executed by professional artists or craftsmen working in officially supported institutions.

From literary sources we know that secular paintings became increasingly fashionable in the imperial court and among the nobility of the early Heian period. Subjects were mostly Chinese figures and Chinese-style landscapes, and they were strongly flavored with the artistic style of T'ang. These paintings seem to have been the work of artists belonging to the art academy (*e-dokoro*) of the imperial court; they were probably painters who had worked during the Nara period in official institutions, or their descendants. It is not without interest that these naturalized foreigners and their descendants, who had been the leading figures in art during the previous Nara period, were displaced in the early Heian period by native Japanese artists who monopolized the main current of religious painting. In the late ninth century, parallel with the vogue for native *waka* poetry, which had begun to replace Chinese poetic forms, Japanese-style subject matter came into use in secular art, supplementing the earlier Chinese motifs. This tendency was to become still more evident in the late Heian period.

As Esoteric Buddhism continued to flourish, the demand for ritual implements and objects

increased, and the arts and crafts concerned with their manufacture enjoyed greater importance. In general, it may be said that both the fine and applied arts of the early Heian period were principally under the influence of, and shared the process of evolution of, the art of T'ang China. However, a more profound understanding of the spirit of T'ang art, together with the attainment of technical maturity, paved the way for the rise in the coming generation of more genuinely Japanese arts and crafts.

The Late Heian Period

The three hundred years of the late Heian period, extending from the tenth to the twelfth centuries, saw the virtual abandonment of the old system of government by administrative codes and its replacement by a regime in which full sovereign power was exercised by members of the Fujiwara family, acting successively as regents. In art it was a period when the earlier adherence to Chinese inspiration was gradually discarded and new Japanese criteria of beauty were created.

The tenth century proved to be a new age in Eastern Asia. In China, the T'ang state with all its vaunted grandeur and glory finally collapsed, to be replaced, after an interval marked by intermittent civil wars during the period known as the Five Dynasties, by the newly risen Sung dynasty. In Sung times China was no longer a magnificent empire reigning over vast domains and territories. It had become a nation much diminished in scale and confined to China proper, and its culture tended to be introspective with essentially Chinese features. Thus the peoples of East Asia, including Japan, who had formerly been included in the T'ang cultural sphere, tended thenceforth to develop along more independent lines.

As previously noted, administrative policy during the ninth century was firmly dedicated to the restoration of the authority of the emperor through the principle of state ownership of land, and the ruling class of the time was imbued with a constructive and progressive spirit. As time went on, however, the rigid political theory and forms borrowed from T'ang China proved unequal to the challenge offered by changing aspects of society and the national economy. Among the court nobility whose influence was steadily growing through increased holdings of land, the powerful Fujiwara family (which sprang from the Nakatomi, a clan long associated with the imperial court) was outstanding, and in the tenth century attained a truly commanding position in the state. Thereafter, until the late twelfth century, the government of the country was in the hands of successive members of this remarkable family. The Fujiwara as a rule achieved their ends not by violence but by the ruthless political pressure which they were in a position to apply, mainly through their policy of marrying Fujiwara daughters to the emperors so that they became related to the imperial household; in this way they could enthrone and remove emperors at will. The aristocracy had little interest in foreign policy: after the 894 decision to cancel the plan of sending an envoy to the T'ang court following the upheavals that accompanied the swift decline of T'ang power, they never reopened official communication with China, although Chinese traders visited Japan frequently in the following Sung dynasty. Naturally the deeply rooted esteem for Chinese culture and art did not cease, but it was little more than a vague admiration. Sung influence, therefore, emerged only intermittently in certain aspects of Japanese art.

The Fujiwara reached the height of their power at the beginning of the eleventh century. Since by this time the business of ruling the country had become hardly more than a family affair and since official contacts with the outside world were all but nonexistent, the privileged Fujiwara statesmen were not obliged to make a distinction between official and personal affairs. They were devoted to the maintenance of court protocol and formalities; their main duties amounted to little more than deciding official appointments, besides attendance at religious rites and seasonal merrymaking parties which had become important court functions. Architecture, the fine arts, and the decorative arts, all stimulated by the patronage of an enlightened aristocracy demanding the tasteful embellishment of their dwellings and places of worship, made remarkable progress. The culture of this period clearly manifests the refined taste of the nobility and in particular that of the court ladies.

While the Fujiwara and their aristocratic contemporaries in the metropolis of Kyoto were devoting themselves to a life of pleasure, neglecting both their secular and religious duties, corruption of local government in the provinces became widespread, with provincial governors enriching themselves at the expense of local landowners. To counter the extortions of these voracious officials and to defend their rights and properties, some of the wealthier provincial notables began to raise their own armed forces, and the lesser landed gentry and some of the poorer farmers put themselves under their protection. The local governors and their officials were for the most part minor members of the imperial family or lesser noblemen who had been unsuccessful in the metropolis. Some of them gained enormous riches and returned to Kyoto; others preferred to stay in the provinces where they became powerful landowners and leaders of the new warrior class. Their power increased gradually until by the second half of the eleventh

century they had grown influential enough to offer a threat to the dominating portion of the Fujiwara family, whose power began to decline correspondingly from about the end of the century. Thereafter until the mid-twelfth century Japan passed through an unsettled period of government termed *insei* (administration by a retired emperor), in which successive emperors retired from the throne and became priests, although retaining in varying degrees effective sovereign power. The *insei* system, which was supported by those nobles of the lower rank who had amassed riches as local officials, depended largely on the military strength of such leading warrior clans as the Genji (Minamoto family) and Heike (Taira family). The Taira clan, in particular, greatly enhanced its power during the *insei* period, with Taira-no-Kiyomori ousting the Fujiwara and securing for himself virtual control of the country, though ruling in the name of the emperor according to the pattern set by the Fujiwara. The Taira regime, however, proved to be only a brief interlude between the aristocratic rule of the Fujiwara family and a form of feudalistic military government established toward the end of the twelfth century by Minamoto-no-Yoritomo, leader of the Minamoto clan, who finally won a decisive victory over the Taira.

Thus Japan during these three centuries passed through several different political regimes. In art and culture, however, the dominant influence throughout this epoch was that of the noble Fujiwara family, who, rising to supreme power during the tenth century, brought to bear on the arts and crafts of the times their elegant aristocratic taste, which reached its perfection in the first half of the eleventh century and remained representative of Japanese art throughout the remainder of the Heian period. The minor gentry who were the supporters of the several *insei* regimes and the Taira rulers who rose to power from the warrior class were little more than imitators in matters of art and culture, and made no significant cultural contribution except for the addition in later times of an extreme refinement. The most important aspect of this period of Japanese art is that native artists freed themselves from the sway of Chinese influence long dominant in the country and created new, predominantly Japanese forms of beauty. As three outstanding examples we may cite, in architecture, the Shinden style of dwelling houses; in painting, the *Yamato-e*; and in calligraphy, the *kana* syllabary, consisting of simplified Chinese characters. These new types of art, promoted and fostered by the court nobles centering about the Fujiwara family, lack the grand style, power, and impressive construction of former ages, but they are distinguished by a certain grace and refinement which evidently struck a sympathetic chord in the Japanese people as a whole. As compared with the earlier periods, changes in style show up most clearly in Buddhist art. The strong, rather stern, representations of former ages disappear, giving way to the same kind of harmony, delicacy, and gracefulness as found in Shinden architecture, *Yamato-e*, and *kana* calligraphy, and equally reflecting the aristocratic taste of the Fujiwara. These changes from continental to native styles of art were the outcome of a gradual evolution during the tenth century. In the following paragraphs let us examine the characteristics and briefly follow the development of architecture, sculpture, painting, and the decorative arts during this period.

As already noted, the early temples of Esoteric Buddhism established during the ninth century were austere places intended for priestly self-discipline. They were usually small and built on remote mountainsides with the buildings arranged more or less haphazardly to conform with the natural features of the site. By the late Heian period, however, Esoterism had lost its initial idealistic fire and had degenerated into a more materialistic religion whose primary function was to conduct ritualistic services and exorcism for the upper classes. Through their special connections with the highest classes of society the Esoteric sects thrived: Shingon enjoyed the patronage of the imperial family, Tendai that of the Fujiwara. Over successive generations new Esoteric temples were built by members of the imperial court and by Fujiwara noblemen in the city of Kyoto and neighboring areas. The temples built in the metropolis naturally tended to be larger in scale, and the layouts of the buildings were frequently as regular as those of Exoteric temples of ancient times. The majority of the religious buildings of this time have been destroyed, and the only surviving examples are the Five-storied Pagoda of the mid-tenth century at Daigo-ji, a temple associated with the imperial family, and the Phoenix Hall (Hōō-dō) of Byōdō-in, built in the mid-eleventh century by Fujiwara-no-Yorimichi. The Phoenix Hall is a graceful building displaying the characteristics of religious architecture of the Fujiwara era. In its architectural style and garden, it bears a striking resemblance to the dwellings of the nobility of the time. This habit of building Buddhist temples in the manner of domestic architecture increased with the passage of time and became an important characteristic of Fujiwara period Buddhist architecture. This in turn was one of the reasons why Buddhist architecture, which previously had been mainly foreign, became strongly Japanese in character.

After the decline of Fujiwara power in the late eleventh century, an increasing unease in the present world made the nobles place their faith even more firmly in the promise of the Pure Land. The ever-increasing social disturbances of the time created a widespread notion that the prophecy of Mappō, or the period of the "end of Buddha law"—the extinction of Buddha's rule—would come to pass in Japan in 1052. Stemming from the belief that the only hope left

for sinners was salvation through Amida (Sanskrit: Amitābha), the Jōdo (Pure Land) faith spread rapidly from the upper classes down to men and women of all classes and occupations, and from the metropolis of Kyoto to distant provinces. It became the vogue among the nobility to build an Amida-dō ("Amida Hall") in the compound of their house, and to include an Amida-dō in any temple which was built, a practice typical of all classes.

Broadly speaking, however, Buddhist architecture in the twelfth century became over-decorated and elaborate, departing from the simplicity of form and decoration of architecture in earlier periods.

The style of architecture known as Shinden refers to a new type of dwelling house which seems to have been evolved to meet the tastes of the Heian aristocracy in about the mid-eleventh century and whose appearance may be reconstructed with fair accuracy from the diaries of noblemen, from scroll paintings (Pls. 53–58), and also from the buildings of Kyoto Imperial Palace, in which the Heian style is faithfully followed. Aristocrats also built villas in the Shinden style in scenic places and strove to achieve that harmonious blending of buildings with nature which has come to be considered as one of the most successful features of Japanese architecture.

Buddhist sculpture continued to be carved in wood, following the tradition of the ninth century. Technically, however, there were changes, for while early Heian wood sculpture had been executed exclusively in the *ichiboku* ("single wood block") method, in which a statue was carved out of a single large block of wood (in exceptional cases the projecting parts of a statue being carved separately and joined to the body), in this period a more advanced method termed *yosegi* ("assembled wood blocks") was invented, in which the head, the main parts of the torso and the back, the right and the left parts of the body, the arms or forearms, and the knees (in the case of a statue in a seated pose) were carved from separate blocks and then joined together. The *yosegi* technique seems to have been perfected about the middle of the eleventh century.

It is not yet determined whether the adoption of this technique was the result of empirical developments by Japanese wood-carvers over the years or whether it was invented in China. There are good grounds, however, for the belief that the systemization of the *yosegi* technique and the formulation of technical rules for its employment were achievements of the great wood-carver Jōchō. Certainly, after him this type of statuary became predominant in Japanese wood sculpture. The *yosegi* method was truly an epoch-making technical innovation; apart from the great advantage that statues made in this way did not easily crack because of a hollowed space inside, it enabled the artist to select the wood so that the best grain would appear in appropriate parts of the statue, beautiful to look at and easy to carve. The new method, moreover, by overcoming limits on size formerly imposed by the material, made possible the construction of large statues and also the concurrent production of many statues through the division of labor and the adoption of a kind of assembly-line system. It was the capacity to turn out sculpture by this near mass-production method that enabled the sculptors to satisfy the almost frantic demand of the nobility for Buddhist statues in the twelfth century. Regrettably, however, this convenient technique led inevitably to a decline in sculptural quality, with the result that sculpture of the late Heian period tended to be preoccupied with the skillful carving of superficial details.

The sculpture of the tenth and early eleventh centuries, prior to the invention of the *yosegi* technique, belongs to what may be termed a transitional period. From about the middle of the century, statues with delicately modeled bodies and sweet meditative expressions began to be made, and this type became increasingly in evidence toward the early eleventh century. At this juncture, Jōchō appeared, and it was his genius which lent impetus to this sculptural style.

Jōchō achieved distinction as the chief of the artists responsible for making statues for Hōjō-ji, the great temple founded by Fujiwara-no-Michinaga, the head of the Fujiwara family, then at the height of its prosperity. Thereafter he produced statues for other temples associated with the Fujiwara family and with the imperial court, and was ultimately rewarded with the ecclesiastical rank of Hōgen, the first honorary title ever conferred on a sculptor. The style of this great sculptor is exemplified by the statue of Amida Nyorai in the Phoenix Hall at Byōdō-in (Pl. 37). It is said that this statue was praised by people of the time as being "flawless as the full moon." The image is indeed remarkable for the perfect proportions of all its parts, which form a superbly balanced whole wherein beauty of form and depth of sentiment do not conflict but harmonize. It is hardly surprising that the Fujiwara aristocracy thought so highly of Jōchō who, as the creator of this type of Amida, may be said to have achieved the perfect Japanization of Buddhist sculpture. With the advent of this kind of image, however, creative sculpture seems to have waned, giving prime place to painting.

The precedents set by Jōchō opened the way for a rise in the social position of sculptors, and from the second half of the eleventh to the twelfth century his descendants and pupils continued to carve statues of the type which he popularized to meet the great demands of the aristocracy (Pls. 38–39). However, a new movement against the oversentimental tendencies of the later sculptors of the Jōchō school appeared in the mid-twelfth century among sculptors in the Nara

area, whose connections with the Heian aristocracy were only slight. This movement, launched by Unkei and his followers, was characterized by a masculine and vigorous style, and was destined to take the lead in the renaissance of Buddhist sculpture in the Kamakura period.

Buddhist paintings were produced in great numbers, either as objects of worship for special rituals or as decoration for the walls and wooden panels of religious buildings. Their variety of subjects is wide. Some are related to the older Exoteric Buddhism and others to Esoteric Buddhism, while yet others are inspired by the new belief in the doctrine of Jōdo, or the Pure Land, which arose from the teachings of the Tendai sect. Exoteric subjects are represented by illustrations of the life of Shaka, among which the most remarkable are perhaps the Nirvana (Pl. 43) and the Resurrection in Fukuoka Art Museum; and by portraits of patriarchs of the sects (Pls. 51, 52) and of holy disciples. But the main motive for Buddhist paintings in this period was provided by the teachings of the Shingon and Tendai sects. Paintings in this category, as we have mentioned, include the Ryōkai Mandala, which provides a fundamental source of the iconography of Esoteric Buddhism, and the mandalas known as Besson ("Individual Deities"), which show smaller groups of deities centered about some particular Buddha. Separate images of Buddhas and bodhisattvas (Pl. 48), of *rājas* (*myō-ō*; Pls. 44, 46) and of *devas* (*ten*; Pl. 45), which served as objects of prayers for some special purposes, also abound. A fervent belief in the *Hoke-kyō*, or *Lotus Sutra* (*Saddharmapuṇḍarīka-sūtra*), which like the worship of Amida arose from Tendai teachings, created a demand for artistic representations of Fugen Bosatsu because this divinity was the protective bodhisattva of the sutra. In this effeminate age Fugen was usually represented as a figure of feminine grace (Pl. 48). The representation of the Pure Land, or the Paradise of Amida, began as early as the Nara period. In the Heian period, however, the Pure Land faith went one step further with the propagation by the priest Eshin of the romantic concept that at the death of the faithful, Amida himself, accompanied by a retinue of heavenly beings, would come down from heaven to receive the departing soul into his paradise with celestial music and with lotus petals falling from the sky. This fanciful concept of Amida welcoming the departing soul to paradise was illustrated in many *raigō* paintings (Pl. 49), which were popular in the Heian and Kamakura periods.

The *raigō* scenes on the doors of the Phoenix Hall in Byōdō-in (1053) and the Nirvana of Kōya (1086; Pl. 43) are the two standard examples of eleventh-century painting. With their extremely delicate and graceful representation they attest to the heights which the Fujiwara style had then attained. At this stage, the T'ang manner had been perfectly assimilated, and the art of Japan was imbued with a new and independent spirit reflecting the character and taste of Heian nobility. Another masterpiece, which on stylistic grounds is datable to the eleventh century, is the Blue Fudō in Shōren-in (Pl. 42).

The same sweet style, reflecting the sentimental tastes of the Fujiwara continued in favor until about the end of the twelfth century, and the later works of this period are represented by the Twelve Devas and the Five Great Rajas in Kyōōgokoku-ji (1127; Pl. 44), the Kujaku Myō-ō (Pl. 46), the Fugen Bosatsu (Pl. 48), and Kokūzō Bosatsu in the Tokyo National Museum, all of which are attributable to the twelfth century. They are delicate and very pretty paintings, and the decorative patterns in color and with *kirikane* ("cut gold leaf") on the clothing of the divinities and other parts are examples of good taste. But in the second half of the twelfth century, emphasis on decoration seems to have gone rather too far, and this led to a return to the religious austerity of former days. This new tendency, favoring strong linear drawing and simple coloring, prepared the way for new developments in the following Kamakura period.

The Buddhist paintings of the Heian period were in the main painted by *e-busshi* ("painters of Buddhist images") belonging to the leading temples of different sects. There were also a few court painters who were good at Buddhist subjects, while the *e-busshi* often worked on secular subjects. In addition to the work of professional painters, some excellent painting was done by high-ranking priests, notably those belonging to the Esoteric sects. In the course of their religious training they were required to master the difficult Esoteric iconography, and no other method could be so effective as the continual copying of famous Buddhist images of the past. The priests—Eri in the ninth century, En-en in the tenth century, and Kakuyū (popularly known as Toba Sōjō) in the twelfth century—who are known as distinguished painters of Buddhist subjects no doubt gained their experience in this way. In the twelfth century, a demand arose for new compilations of old iconographical documents, and priest-painters belonging to many different monasteries were kept busy hand-copying old paintings and drawings of divinities, with the result that some talented artists appeared among them. Constant practice in rapid linear drawing which they obtained by copying old images gave rise to a new style of painting in the second half of the late Heian period.

A group of secular artists, known as *e-shi* (literally, "master painters"), who belonged to the *e-dokoro*, or academy of painters, enjoyed the patronage of the court. They painted subjects for the interiors of imperial residences and for government establishments. In addition to the professional painters, some of the nobility were quite good amateur artists, for in the second

half of the tenth century when aristocratic culture was at its height, painting, like literature, music, and calligraphy, was considered a necessary accomplishment for a nobleman.

The Shinden-style dwellings of the aristocrats had few permanent partitioning walls in the interiors and had to be provided with extra partitions in the form of sliding doors and folding screens to make them habitable. It became the fashion to have these doors and screens decorated with paintings, leading to an enormously increased demand for "partition paintings" (*shō-hei-ga*), which thus became the main field of activity for professional court artists. Formerly, the subject matter of such paintings had been almost exclusively Chinese, because that was regarded as a mark of scholarship and taste, but Japanese-style subjects had been introduced toward the end of the ninth century, and painting in the Japanese manner became increasingly fashionable during the Fujiwara period. Paintings of Chinese subjects were invariably associated with Chinese literature, and it was not unusual to inscribe some passage from the classics within a cartouche on the painting itself. Similarly, paintings of Japanese subjects were frequently inspired by *waka* poems and often included a poem inscribed in a similar manner. The Chinese paintings, or *kara-e*, were generally used for the decoration of more public places and for official occasions, while the Japanese-style paintings (termed in contrast *Yamato-e*, Yamato being the ancient name for Japan) were used for more intimate places and occasions. The most usual subjects of *Yamato-e* screen painting were *tsukinami-e* ("pictures of the months") and *shiki-e* ("pictures of the four seasons"), both inspired by *waka* poems about nature and mankind in the twelve months of the year and in the four seasons; and *meisho-e* ("pictures of famous places"), depicting beautiful scenery whose praises were sung in *waka* poems. Both types of subject were characterized by a happy merging of man and nature. Gradually the court artists showed an increased preference for subjects taken from the nascent literature of Japan, and although painting in the Chinese manner continued, the style underwent a subtle change as it was adapted to suit now independently established Japanese taste. The sliding doors and folding screens which surrounded and adorned the intimate life of the Heian nobles in the interior of their palaces and residences provided an ideal medium for the new Japanese style of painting with its regard for nature and its sentimental view of life. It is not exactly clear when the native style of screen painting began to supplant *kara-e*, but it is evident that by the middle of the twelfth century screen paintings in *Yamato-e* style outnumbered those of *kara-e* style both for official and private purposes. The earliest existing example of the eleventh-century *Yamato-e shō-hei-ga* style is provided by the scenes of the various seasons in the backgrounds of the *raigō* paintings on the doors of the Phoenix Hall at Byōdō-in. The landscape screen known as the *Senzui-byōbu* in Kyoto National Museum (Pl. 50), a rare surviving example from the eleventh century, is a specimen of *kara-e shō-hei-ga*, which in its description of nature appears to have taken something of contemporary *Yamato-e* style.

While the oversized *shō-hei-ga* served primarily as interior decoration in large aristocratic houses, painted illustrations of stories or poems in the form of long horizontal handscrolls or of picture albums were also highly appreciated by the Heian nobility. The practice of painting pictures in the form of scrolls had existed in China from early times, and even in Japan as early as the Nara period there was the illustrated *Inga-kyō* sutra (Pl. 32), with paintings in the upper half to illustrate the text of the scripture written in the lower half. The development of *Yamato-e* scroll paintings dealing with Japanese literary romances and legendary stories, in which the text written in *kana* calligraphy alternated with illustrations painted in Japanese style, made remarkable strides in and after the tenth century. "Illustrated romances" (*monogatari-e*) were sometimes in the form of booklets, but those in horizontal handscroll form seem to have been more popular. The *E-awase* ("Picture Contest") chapter of the *Genji Monogatari* (*The Tale of Genji*) tells of the admiration for *monogatari* scrolls in the early eleventh century. It is made clear in that chapter that it was a common pastime among men and ladies of the court to bring to their assemblies scroll paintings illustrating such literary works as the *Taketori Monogatari*, *Ise Monogatari*, *Utsubo Monogatari*, or the like, and to compare their artistic value. These scrolls, in which the text was handwritten by noted calligraphists and the painting executed by famous court artists on exquisitely decorated paper, were intended to be appreciated both for the painting and the calligraphy. Later, noblemen and ladies sometimes amused themselves by painting scrolls of this kind. Other types of art which they enjoyed were *uta-e* ("picture poem") and *ashide-e* ("reed-manner picture"), both of which were small-sized paintings on single sheets of paper or on folding-fans, or sometimes in booklet form. The *uta-e* consisted of a *waka* poem written in the *kana* syllabary accompanied by a pictorial interpretation and was meant to be appreciated for its literary, calligraphic, and artistic value. The *ashide-e*, with a few words from a poem written in cursive script and scattered half-concealed in the picture, was a highly sophisticated sort of artistic puzzle in which the literary meaning, the writing, and the painting together constituted a witty graphic design.

It is not possible to trace the beginnings of *monogatari* scroll painting because there is no surviving example dating from before the twelfth century. The earliest known specimen is the

Genji Monogatari E-maki (Pl. 53), which dates from the first half of the twelfth century. This is a superb work demonstrating a style already fully accomplished. In form, it consists of alternate sections of calligraphic text and illustrations. The text is written in *kana* by leading calligraphists of the time on paper luxuriously decorated with colors and with gold and silver. The exquisitely harmonious effects of the writing and the paper decoration call to mind the "Collected Poems by Thirty-six Poets" (*Sanjūroku-nin-shū*). The illustrative sections of the painting, attributed by tradition to Fujiwara-no-Takayoshi but probably executed by the painters of the imperial painting studio (*e-dokoro*), show men and ladies with faces treated in the characteristically summary manner known as *hiki-me kagi-hana* ("a line for the eye, a hook for the nose"). As most of the scenes are enacted indoors, the artist used a unique type of panoramic perspective, technically termed *fukinuki yatai* ("roofless house"). Highly stylized and decorative, these richly colored paintings successfully convey the ordered sentimental atmosphere of aristocratic life of the time. This kind of pictorial style is thought to have developed from the amateurish painting of *monogatari* pictures indulged in by the patricians and their ladies. It was therefore full of a sensuous beauty and sentimentality, just as the literature of the time, which also owed much to court ladies. The *Nezame Monogatari E-maki* (Pl. 61) is a scroll painting which follows the tradition of the Genji scrolls, and the same manner of painting is to be found for the cover-backs of decorated sutras which were produced in large numbers in this period.

In contrast, the *Shigi-san Engi E-maki* (Pls. 54, 55), considered to date from the second half of the twelfth century, is a masterpiece of another kind of scroll painting. The subjects of this set of three scrolls are not court romances, but an altogether coarser kind of anecdote containing more plebeian elements. The painting does not depend so much upon the charm of rich colors as on the effective use of eloquent linear drawing enlivened with a color wash, and the scrolls are not made up of brief illustrations alternating with a calligraphic text but form continuous scenes, which make the story easy to follow. The author of the Shigi-san scrolls is not known, and they have been variously attributed to one of the court artists (*e-shi*) who were employed for the painting of screens and to a priest-painter (*e-busshi*), but at this time the styles of court and religious artists had drawn close together so it is difficult to reach a conclusion. It can, however, be said that the lusty plebeian flavor of the scenes and the skillful free linear drawing indicate a new departure.

Scroll paintings in the rich ornamental style of the *Genji Monogatari E-maki* were eventually supplanted by the *Shigi-san Engi E-maki* type, and the scroll paintings of the Kamakura period illustrating the legends or histories of local temples or shrines, which were produced in quantity, were almost exclusively of this type. Another great masterpiece of scroll painting, the *Tomo no Dainagon E-maki* (more popularly known as *Bandainagon E-maki*), which is a little later than the Shigi-san scrolls, is attributed to Tokiwa Mitsunaga, the court painter. This scroll illustrates a tragic story of political intrigue and is remarkable for its vivid portrayal of crowds of excited people. The scrolls of frolicking animals (Pls. 56, 57) of the *Chōjū Giga* are in a different category again. They are eloquent and lively line pictures in monochrome of animals in a scenic setting, and they were probably the work of priest-painters in a playful or satirical mood.

The decorative arts of this time also flourished through the patronage of the nobility, who, eager to embellish their palaces and temples and to live among beautifully ornamented furniture and household requisites, encouraged and supported skilled artisans of metalwork, lacquerware, and other kinds of applied arts. Under the influence of these aristocratic patrons the exotic and elaborate designs of T'ang were refined into pretty, simplified ornaments, and decorative subjects shifted from the symmetrical regularity of Chinese types to the unrestrained and naturalistic treatment of flowering plants and birds.

Lacquerware ornamented with *maki-e* (gold lacquer decoration) was a specially happy achievement of this time. The shapes manifest a highly developed sense of form, and the gently curving and flat surfaces were often decorated with elegant patterns in gold and silver *maki-e*. Mother-of-pearl inlay work, a continental technique imported during the Nara period, was also employed in beautiful combination with *maki-e* (Pls. 62, 64). The special beauty of the metalwork of this period can perhaps be best appreciated in the ornamental designs on the backs of bronze mirrors. In ceramic production, while volume was not yet very great, the technique of glazing with wood ash seems to have been established, and incised decoration on the surface of pottery vessels was sometimes done.

As we have seen, the Fujiwara nobles and ladies seem to have passed their days chiefly in pursuit of an aesthetic life, striving to introduce their love of elegance and beauty into the surroundings of everyday living, with the result that the works of this period include some of the finest of all Japanese art. The creative tide of the Fujiwara period rose to a peak during the eleventh century, and the twelfth century marks the beginning of a steady decline characterized by overelaborate decoration and emphasis on unimportant detail. The second half of that century saw the rise of a new spirit demanding a more virile artistic expression, which was to bear fruit in the subsequent Kamakura period.

5

THE KAMAKURA PERIOD

The medieval period in Japan lasted from the end of the twelfth century to the middle of the sixteenth. In this period, the effeminate sentimentality of Heian society was swept away by a powerful samurai, or warrior, class, which formed the central social group of the new regime, and all culture and art became subject to its tastes and preferences. Although this should not perhaps be described as a sharp break in tradition since traditional arts were continued under the new leadership, it represented an entirely new departure, because the art of earlier times had always followed the cultivated tastes of the court and aristocracy. In marked contrast to the earlier art, characterized by a spirit of harmony and grace, the new art of the medieval period is distinguished by the feeling of force inherent in it. The development of this medieval art may be divided into two periods: the Kamakura period, extending from the end of the twelfth to the early fourteenth century, and the following Muromachi period, which ended in the late sixteenth.

In 1185, Minamoto-no-Yoritomo, who had seized power in the country by force of arms, deliberately refrained from setting up his headquarters in the old capital of Kyoto, the former center of court life, culture, and learning, and instead established his capital in Kamakura some three hundred miles to the northeast. The regime (*bakufu*, or "military government") founded by Yoritomo in Kamakura lasted until 1333, when it was overthrown by the Emperor Godaigo. During the first part of this period of military rule and, in fact, until the middle of the thirteenth century, the old aristocracy still retained considerable influence both in politics and in culture, but the failure in 1221 of an attempt by the imperial court to restore its hegemony by military force and the defeat of the imperial troops at the hands of the *bakufu* led to the ultimate collapse of the power of the old aristocracy. In its place there grew a spirit which was more vigorous, masculine, and realistic, in keeping with the militaristic nature of the new rulers.

Together with this violent political change, a number of other factors must be taken into consideration in any attempt to explain the cultural and artistic motivation of the Kamakura period. The first of these was the rise of new religious sects. In ancient Japan, the Buddhist religion had been almost entirely dependent for its support on the court and the aristocracy, who built and endowed temples, monasteries, and nunneries as splendid and magnificent as befitted their wealth and prestige. With the decline of aristocratic society in the Kamakura period, the religious orders began to propagate simpler creeds and to cast their net wider to attract people of all classes; the Jōdo sect in particular prospered remarkably at this time, with its promise of easy salvation for rich and poor, aristocrat and warrior alike. The Jōdo, or Pure Land, which was the ultimate paradise for all followers of this new sect of Amidism, was frequently represented in richly colorful paintings as a somewhat worldly place.

Another important religious development which took place at about this time was the introduction from China of the Zen sect of Buddhism, which fitted in precisely with the mental attitude of the samurai class. The Zen sect rejected relic and image worship and substituted stern spiritual discipline. It taught that true religious experience should be sought in everyday life and that Enlightenment could be attained through meditation. This attitude had a profound effect upon art. Unlike the Jōdo sect and others which encouraged the colorful painting of splendid scenes of paradise or of beautiful Buddhas and bodhisattvas in a land of eternal spring, the priest-painters of the Zen sect produced severe works in black and white illustrating the practice of priestly austerity.

Another factor which played an important role in shaping art of the time was the resumption of commercial and cultural contacts with Sung China so that the advanced continental culture once again began to flow strongly into Japan.

The first and perhaps greatest single cultural work undertaken by the society which emerged from the political and military struggles of the late twelfth century was the restoration of the great Buddhist temples and monasteries of Nara, which had been largely destroyed in the wars against the Heike clan. The rebuilding of Tōdai-ji, with its Great Hall and colossal bronze

Buddha, was successfully undertaken at the instigation of the priest Chōgen (died 1195) with the active support of the commander-in-chief, Shogun Yoritomo. Kōfuku-ji was similarly restored to its former glory. In this project a great number of artists and craftsmen were employed in the architectural design and decoration as well as for sculpture and other arts. Restoration work on such an enormous scale necessitated a serious reassessment of the great art of the Nara period, and the result was to bring about what might well be described as a renaissance in Japanese art comparable with the Italian Renaissance of the fifteenth and sixteenth centuries.

Unlike the wa-yō ("Japanese style") architecture that had prevailed until the end of the early period, whose principal feature was its simplicity, Chōgen introduced the daibutsu-yō style of south China. Grand and elaborate, it made liberal use of a bracket-system called sashi-hijiki ("insertion brackets") and other distinctive devices, but it quickly fell into disuse after Chōgen's death, partly because of the structural difficulties inherent in it.

After the middle of the thirteenth century a great many temples of Zen Buddhism were erected at Kamakura, the best known of which are perhaps Kenchō-ji and Enkaku-ji. These featured the so-called kara-yō ("Chinese style") of architecture, newly introduced from north China.

Apart from Buddhist architecture, a distinctive type of domestic architecture emerged during this period for the residences of the military class. It was based on the shinden-zukuri, a style associated with the aristocratic courtier's residence of the past, but was considerably modified to suit the practical purposes of the samurai class.

In sculpture, following the precedent set by Jōchō, the great master of the previous Heian period, his descendants and pupils usually combined their efforts in joint workshops. Because of the greatly increased demand for Buddhist images during the twelfth century, the number of sculptors and the workshop groups to which they belonged increased. There were two principal schools of sculpture at the end of the twelfth century: the Kyoto group and the Nara group. Sculptors at the workshops in Kyoto and its vicinity tended to follow the graceful forms and expressions of the Jōchō tradition, while those who belonged to workshops in and around Nara were attracted to the classic style of ancient Nara sculpture. Naturally enough, it was the Nara sculptors who were principally engaged for the restoration of Tōdai-ji and Kōfuku-ji, and as the work proceeded it was to them that the honor went of creating the new Kamakura-style sculpture. Among these talented sculptors the best known were Unkei and Kaikei, followed by Unkei's disciples Jōkei and Kōben and his son Tankei.

Unkei (died 1223), son of the great master Kōkei, inherited his father's genius and was the leading artist of the school. With the obvious intention of reviving the spirit of the great sculpture of the Tempyō period, he created a new style, energetic and free, which broke away from the lifeless, conventionalized manner of the late Heian period. Among the best-known works of Unkei are the Dainichi Nyorai (Vairocana) of Enjō-ji and the idealized portraits of Muchaku (Asaṅga) (Pl. 69) and Seshin (Vasubandhu) in the Hokuen-dō (North Octagonal Hall) of Kōfuku-ji. In collaboration with Kaikei and others, he is also responsible for the two colossal figures of Niō (Kongō Rikishi) in the Nandai-mon (South Main Gate) of Tōdai-ji. Kaikei (early 13th century), who was a pupil of Kōkei, Unkei's father, played a role as important as that of Unkei himself in the replacement of sculpture for the temples in Nara, and is said to have been particularly influenced by the sculptural styles of Sung China, which at this time were beginning to reach Japan.

Chōgen, the chief promoter of the restoration of the Great Buddha, had twice visited Sung China. To supervise the recasting of the great bronze image, he invited to Japan Ch'ên Ho-ch'ing, a Sung bronze-caster. There is good reason to believe that this Chinese artist was accompanied by a number of his compatriots, through whom an extensive knowledge of styles and techniques of Sung China may have reached the sculptors of Japan. Their influence is reflected in the naturalistic rendering of facial features in Japanese wood sculpture of this time, as well as in the details of clothing and the new and novel technique of inserting gyokugan (crystal or glass eyes) into the head. Another development which may be attributed at least in part to the influence of Sung China was the vogue for lifelike portrait sculpture, especially of famous priests. The new sculptural style spread from Nara to Kamakura, the seat of the new military government.

The painting of the Kamakura period was for the most part religious or at least concerned in some way with religion. Painters, who were attached to temples in the same way as the sculptors, produced paintings on religious themes as objects for worship in Buddhist rituals and in ceremonies such as the inauguration of new temples. Their works adhered closely to the canonical forms handed down from Heian times, but a new spirit of realism is observable in them.

A favorite subject of Buddhist painting of earlier times which continued to enjoy wide popularity throughout the Kamakura period showed the "coming" (raigō) of Amida (Amitābha) Buddha to this world with his followers from the Western Heaven, where the "Pure

Land of Paradise" is supposed to exist, to comfort the dying believer and to transport his soul to paradise. These paintings were based on visions said to have been experienced by the great priest and mystic Eshin (942–1017), the principal exponent of the *raigō* doctrine. A number of great masterpieces of *raigō* painting of the Heian period fortunately survive (Pl. 49), but with the wider spread of Amidism through the preaching of the great priests Hōnen and Shinran, who propounded the concept of *nembutsu*, whereby the mere invocation of the name of Amida was sufficient to ensure salvation, the *raigō* pictures showing Amida's bountiful countenance and tender gestures became even more sought after. Developments also took place in the manner of depicting the *raigō* itself. The stylized tranquil and idyllic landscape in the background of traditional *raigō* pictures gradually came to be replaced by more realistic scenes of nature, and the procession of the heavenly host riding the clouds through the sky quickened its pace. Amida and his accompanying bodhisattvas tend to be shown standing, instead of sitting on the clouds as in earlier works, and their facial expressions are much more humanly expressive (Pls. 72, 73).

Another subject which occupied the painters of religious works during this period was the illustration of scenes of the Buddhist hells, depicting in lurid detail the tortures of the damned (Pls. 79, 80). They were evidently intended to persuade sinners to turn from their evil ways before it was too late, and no doubt they could also be enjoyed with a certain sense of satisfaction by the pious.

A third type of religious painting which, though of older origin, flourished in the Kamakura period was the *suijaku-ga*, which attempted to illustrate a reconciliation between native Shinto and imported Buddhism. The *suijaku* doctrine, which held that the old Shinto divinities were manifestations of Buddha and the Buddhist saints, had been accepted to some extent as early as the Nara period, and after that time Shinto shrines and Buddhist temples were frequently built in close proximity to one another and the priests of the two religions often lived together on good terms. The *suijaku* paintings were evidently commissioned to promote religious harmony. As Shintoism is very much akin to nature-worship, Shinto gods often being personifications of mountains, waterfalls, rivers, or the like, *suijaku-ga* often turned out to be landscape paintings, representing in a naturalistic way scenes in the precincts of Shinto shrines. In this way, *suijaku* pictures played an important role in the development of Japanese landscape painting (Pls. 75, 77).

Mention must also be made here of portrait painting, another new development of the age. Of course, portraits of a kind had been painted since early times, but the Kamakura period saw the production of high-quality portraits of nobles called *nise-e*, literally "likenesses," drawn by the painters in the service of the imperial court (Pl. 76), and also portraits of an altogether new style termed *chinzō*, portrayals of Zen priests that appeared after about the middle of the Kamakura period.

However, the most noteworthy of all the kinds of painting associated with the Kamakura period are undoubtedly the *e-makimono*, or scroll paintings. Painting on scrolls had been known from very early times, and such masterpieces as the *Genji Monogatari E-maki* (*The Tale of Genji Scroll*) and *Shigi-san Engi E-maki* (scroll paintings of the history of the Shigi-san temple) were produced before the end of the twelfth century. But in the Kamakura period the demand for this pictorial form of art increased, and to satisfy it many scrolls were painted on a great variety of subjects, both religious and secular.

These scroll paintings may be classified in several different ways according to subject, but from the technical point of view it is possible to distinguish two main groups. One group is concerned with the romantic stories of classical literature, dealing with nobles and court ladies and executed in the traditional technique of the time. Scrolls of this type, which are called *tsukuri-e* ("made-up pictures"), are heavily colored with variegated pigments applied on very fine line drawing, with the result that they are exceedingly elegant, sentimental, and feminine (Pl. 81).

The other group, in which color is subordinate to eloquent drawing executed with accomplished brushwork, is by contrast free, dynamic, and masculine. Scrolls of this kind often represent historical or legendary accounts of the establishment of shrines and temples and include scenes of the common people of the countryside. Frankly plebeian in character, they were used as propaganda material by the new popular religious sects that grew up during this vigorous age through their appeal to the uneducated but newly awakened masses.

In the realm of applied art, techniques in general became even more polished and elaborate than in the preceding period. The refined aristocratic taste of Heian times was reinforced by the new vigor of the warriors and emphasis came to be laid on beauty of form rather than on decorative grace, which had been the keynote of applied art in the preceding age.

In the previous period, the arts of *maki-e* (gold lacquer) and metalwork had reached their peaks of achievement under the patronage of the Heian aristocracy. This tradition was inherited by the artists of the Kamakura period, who exploited the old techniques and strove to

attain even more novel effects. In *maki-e* in particular, the ancient technique of *raden* (mother-of-pearl inlay) was much favored and stimulated the production of many excellent works. The techniques of *togidashi maki-e* ("burnished *maki-e*"), *hira maki-e* ("flat *maki-e*"), and *taka maki-e* ("high-relief *maki-e*") were further perfected and a method of covering the entire lacquer surface with gold dust was introduced.

In metalwork, the outstanding development was an improvement which made possible the production of many different kinds of Buddhist ritual objects and other utensils for daily use. The casting of large images of Buddha had for some time been a forgotten art, but it was revived at Tōdai-ji under the guidance of Chinese casters who cooperated in the reconstruction of the Great Buddha. The experience gained at that time enabled Japanese artists to cast the Great Buddha statue at Kamakura.

Finally the ceramic industry continued to prosper in Seto and adjacent areas (Pl. 84), and ever since the Kamakura period the Seto kilns have occupied a dominant position in the Japanese ceramic industry. Indeed, the very word *Seto-mono* has come to be accepted in Japan as a generic term for pottery and porcelain wares.

6

THE MUROMACHI PERIOD

After the fall of the Kamakura military government, or shogunate, in 1333, military factions again divided the country. Final victory fell to the Ashikaga party whose leaders thereafter took the title of shogun and established their headquarters in the Muromachi district of Kyoto. The period of Ashikaga rule lasted for more than two hundred and fifty years and falls into two phases divided by the Ōnin War, which ravaged the Kyoto area in the middle of the fifteenth century. After this war, Ashikaga power weakened and influential feudal lords vied with each other in the provinces, leading eventually to a period of political turbulence and civil war known generally in Japan as the *Sengoku jidai*. Distinct differences may be observed between the art and culture of the first and second halves of the Muromachi period: in the first period, art was pronouncedly Chinese in manner, supported by Zen Buddhism in its purest Chinese form, while the late Muromachi period saw the development of a new Japanese style which, however, owed its inspiration to those same Chinese forms of art introduced with Zen in the earlier periods.

From about the middle of the Kamakura period, a succession of Zen (Chinese: *ch'an*) monks of Sung China had come to Japan, and gradually they were successful in winning over to Zen Buddhism the leading men of the metropolitan government. As a discipline of self-knowledge and self-control, Zen exercised on the military caste a fascination which was reinforced by the absence of ceremonial and by the frugal habits of the Zen priesthood. Their zeal in building Zen monasteries in the more important centers throughout the country enabled the Zen monks to exert increasing influence not only over government officials and the military classes, but even on ordinary people. This tendency became even more marked after the early Muromachi period, which saw the domination of the intellectual and religious life of the country by Zen philosophy. Ashikaga Takauji, the first Ashikaga shogun, appointed the Zen priest Musō Kokushi Soseki as his spiritual adviser. Later shoguns followed this example and always had by their side Zen priests, usually followers of Soseki, who in this way were in a position to influence all aspects of national life, including culture and the arts.

During the Kamakura period, temple buildings had been planned and constructed mainly in the Chinese style, but in the Muromachi period, with the wider dissemination of Zen culture throughout the country, the style gradually changed. Although the principal influence continued to be emphatically Chinese, the *daibutsu-yō* (Chinese) style of the early Kamakura period and the *wa-yō* (Japanese) style that had been perfected still earlier were frequently incorporated in the architectural planning of new temples, and a "Zen style" emerged which ceased to be entirely continental and became increasingly Japanese in appearance.

The dwelling houses of the warrior class and priests of the later part of this period are distinguished by a novel architectural feature called the *tokonoma*. This is a small alcove in a room where paintings and artistic objects can be displayed and which becomes in effect the focal point of the decoration. The *tokonoma* derives from three distinctive interior features of the so-called *shoin-zukuri* style of domestic architecture developed in the Muromachi period, namely the *toko* ("alcove"), *tana* ("shelf") and *shoin* (a wooden board for reading and writing, usually located beside the window next to the alcove).

Through the activities of numerous Zen monks, many of whom were given charge of commercial expeditions to the mainland, whence they returned with great quantities of fine Chinese products for the shoguns, the impact of Chinese art and philosophy, then strongly under the influence of Zen, began to make itself felt in almost every sphere. For example, the art of *rikka*, the arrangement of flowers in vases placed in the *tokonoma*, and the painting of hanging scrolls in black *sumi* ink for the same purpose enjoyed great vogue. At the same time, new rules for the tea ceremony were formulated to permit the intellectual appreciation of art in the company of like-minded persons over a bowl of tea. All these contributed to a new way of life and a new form of Japanese art, of which the mainspring was Zen Buddhism.

Of all these new forms, however, the most important in its effects on the development of Japanese art was *suiboku-ga*, or painting in black ink (Pls. 85–94). In China, this kind of drawing

had long been an accomplished art, but during the Sung dynasty the technique reached a height of excellence never known before, so that an ink-soaked brush became the means not merely to draw the outlines of things but also to convey through an infinite variety of tones their material quality, and eventually to express the spiritual meaning hidden in them. The Japanese were first introduced to this highly developed form of monochrome painting in the mid-Kamakura period when, following the introduction of Zen Buddhism, masterpieces of ink painting of the Sung and Yüan dynasties of China were brought into Japan in large numbers and preserved in collections of the great institutions of Zen Buddhism both at Kamakura and Kyoto. The Ashikaga family also boasted a large collection.

The shoguns retained in their service capable connoisseurs responsible for appraising and safeguarding these precious paintings and other valuable art objects brought from the continent. They also established an art academy, comparable to the *e-dokoro* (painting academy) of the imperial court of ancient times, where selected artists worked exclusively for the shogun. Among them were such gifted painters as Josetsu (active ca. 1405–ca. 1430) (Pl. 85), Shūbun (died ca. 1462) (Pl. 87), Sōtan (1413–81), and Kanō Masanobu (1434–1530). The art connoisseurs who served the shogun were also painters and included the celebrated artists Nōami (1397–1471), Geiami (1431–85), Sōami (?–1525) (Pl. 92), and others. Some of these painters were nonreligious, but generally speaking those in leading positions were Zen priests, and their works, exclusively in black and white, mainly relied for inspiration on the severe philosophy of Zen.

The great painter Sesshū (1420–1506) was a pupil of the painter-priest Shūbun. After visiting China and seeing for himself the scenery which had inspired so much of the great *suiboku* painting of the Sung masters, he returned to Japan and established a new style of landscape painting based stylistically on Chinese prototypes but was also very Japanese, relying largely on the direct inspiration of nature in his native land (Pls. 88, 89).

The academy established by the shoguns at the metropolis continued to maintain its authority even through the upheavals of the wars, but the atmosphere of Kyoto at the time can hardly have been conducive to good work, and many painters of note preferred to work in the provinces, where they experimented and created innovations. Some of these were priest-painters, but among them were also members of influential feudal families. One of the best of these painters was Sesson (1504–ca. 1589), who spent his life in northeastern Japan. Sesson developed a dynamic and energetic style with an unaffected quality markedly different from the art of Zen Buddhism prior to his time (Pl. 93).

In the academy in the metropolis during the latter part of the Muromachi period was Kanō Masanobu (Pl. 94), a contemporary of Sesshū. He and his son, the great Motonobu (1476–1559), established the Kanō school of painting. They were not, however, Zen priests but painters by profession, and after their time the arbiters of taste in painting were no longer the Zen priests but professional artists. Subsequently, the painting of the Kanō school, which had previously conformed to the prevailing severe black-and-white Chinese style, gradually returned to the more colorful Japanese manner and absorbed elements of the old *Yamato-e*. Its glorious flowering established a tradition for painters in Japan for the following four hundred years.

In applied arts, many interesting developments during this period arose from the impetus provided by the newly imported tea cult. In lacquerware, a new technique of *taka maki-e* ("high-relief *maki-e*") was invented, and was combined with the technique of *togidashi maki-e* ("burnished *maki-e*") to produce new artistic effects (Pl. 98).

The great popularity of the tea cult among intellectuals led to an increased interest in the production of fine ceramics as potters sought to imitate the accomplished pottery and porcelain of the Southern Sung and Yüan dynasties of China, which had been brought to Japan in some numbers by Zen priests. In the Seto district, which had been an important center of ceramic production since the previous period, tea bowls and other vessels for use in the tea ceremony were turned out on an increasing scale. In Mino, Iga, Shigaraki, Bizen, and Tokoname also, the kilns were actively producing pottery utensils for daily use.

Since Zen Buddhism scorned the scriptures and had no need for images, Buddhist sculpture was in decline and the only noteworthy religious sculpture produced was a small number of portrait sculptures (*chinzō*) of Zen priests. On the other hand, with the development of the Noh play in this period, many fine Noh masks were sculptured in wood, some of them of great artistic merit (Pl. 96).

7

THE MOMOYAMA PERIOD

The Momoyama period is usually understood to cover the rather short space of forty-two years from 1573, when the warlord Oda Nobunaga overthrew the Ashikaga shogunate and took over the reins of the government, to 1615, when the ruling Toyotomi clan in their turn were finally vanquished by Tokugawa Ieyasu. In cultural history, on the grounds that the Momoyama style lasted well into the early Edo period, some scholars extend the Momoyama period as far as the end of the Kan'ei era (1624–43). For the purposes of this book, however, the year 1615 is taken as the end of the period, although, for the sake of convenience, a few isolated works dating from the Kan'ei era will be dealt with in this chapter.

Although the Momoyama period lasted for less than half a century it deserves to be treated separately because it marks an extremely important phase of transition from the medieval age of Japan to the modern in the history of politics, social life, culture, and art. It is, indeed, fair to regard it as a splendid introduction to the following Edo period.

After the middle of the fifteenth century, the unified rule of the Ashikaga shogunate gradually weakened, and provincial warlords all over Japan vied with each other in the ensuing struggle for power. The unrest and confusion were terminated by two outstanding military leaders: Oda Nobunaga, who died in 1582, and his successor Toyotomi Hideyoshi, who died in 1598. Under their rigorous regimes, the quarreling feudal lords in the provinces were ruthlessly brought under control, and the foundation was laid for the peace and prosperity of the long Edo period.

The guiding spirit of the art of the Momoyama period was an enlightened humanism born of a reaction against the severely ascetic view of life which colored the art of the medieval period. Closely connected with this general change of outlook was the emergence of a movement to revive the classical art of Japan, which through its aristocratic associations contained a considerable element of hedonism.

The demand for lavish art was stimulated also by the newly evolved classes of the warriors and the wealthy merchants who had grown powerful during the civil wars and began at this time to take a lively interest in all forms of art. In fact, with the advent of the Momoyama period, Japanese art seems to have been reborn. The whole process of transcending the negative attitude of medieval art, of reviving the classical spirit, and of creating a new Japanese world of beauty out of the ferment and spiritual upheaval brought about by the first contacts between Japan and the West was truly a marvelous achievement unmatched in the national experience since the Nara period, when Japan for the first time came into close contact with the arts of East Asia.

Here some mention must be made of the far-reaching significance of the first arrival of Europeans and the subsequent communications between the Western world and Japan. In 1543 some Portuguese landed on one of the southern islands of Japan bringing with them firearms. The introduction of the new weapons radically changed traditional Japanese military tactics and contributed, as elsewhere, to the decay of the feudal system. Following the Portuguese came Spanish ships bringing with them Catholic missionaries, among them the distinguished priest Francis Xavier. At first the missionaries were welcomed by the feudal rulers of Japan, who permitted them to establish churches and seminaries in different parts of the country, and even in Kyoto. Together with the Catholic religion, other kinds of European culture and art were introduced and aroused both curiosity and appreciation. But the very success of the early missionaries engendered the suspicions of the military rulers, and after a short period of reluctant tolerance Christianity was finally suppressed, leaving to posterity only sad stories of martyrdom. Partly as a result of these unfortunate events, the subsequent autocratic rulers of Japan became very nervous about their association with the Western world, and for about two hundred and fifty years, throughout the Edo period until the reopening of Japan in 1854, the Tokugawa shogunate maintained a policy of deliberate national isolation and kept the country all but closed to Westerners and Western influence. During the Momoyama period, however, before Christianity was officially suppressed, some examples of Spanish

paintings of religious subjects must undoubtedly have been brought into Japan and were even perhaps exhibited in Catholic churches by the missionaries; these religious paintings of Spanish Baroque, with their strong realism and grandiose coloring, would have made a strong impression on the Japanese people. The sudden outpouring in the Momoyama period of large-scale decorative screen paintings full of strong colors and with gold backgrounds is difficult to explain, but it may not be too fanciful perhaps to suggest that the influence of Spanish Baroque paintings brought by the Spanish missionaries played a part in the development of this new art form.

Among the artists who worked on the screen paintings of this time may be counted such great names as Eitoku (1543–90) and Sanraku (1559–1635) of the Kanō school, who excelled in grand compositions with rich and splendid coloring (Pls. 103, 104, 111). Side by side with these great painters of the school of Kanō, their rivals Kaihō Yūshō (1533–1615), Hasegawa Tōhaku (1539–1610), Unkoku Tōgan (1547–1618), and others produced similar decorative works (Pls. 105–107). But screen paintings were rarely signed, and it is often difficult to be precise about their painters.

The taste of the rising merchant class was rather different from that of the warriors and even further removed from that of the court and the aristocracy, and it demanded still another kind of art. Toward the end of the period there emerged from the ranks of the commoners the talented decorative artist Tawaraya Sōtatsu, of whom more will be said later. In close collaboration with Sōtatsu, Hon'ami Kōetsu (1558–1637), a man of the military caste, founded the "Village of Artists" at Takagamine, near Kyoto, and this eventually became a center of the applied arts.

The rise of genre painting about this time was due to the assumption by wealthy merchants and other commoners of their new role as patrons of art. Lacking the cultivated literary tastes of the priesthood or the court and aristocracy of the old days, they wanted simply the pleasure of seeing their fellow creatures represented in naturalistic and colorful paintings.

Sketching contemporary manners in life had occupied the artists of the *Yamato-e* school from early times. Thus, the *Rakuchū-rakugai* (Scenes in and around Kyoto) (Pl. 104) and *Shokunin-zukushi-e* (Craftsmen series), which were painted in numbers in the Momoyama period, were directly traceable to the classical tradition. But many new genre subjects also began to be painted at the time. The physiognomies of the first foreigners from the West, so strange to Japanese eyes—"blue-eyed redheads" the Japanese called them—must have excited the curiosity of the country people, and screen paintings representing various aspects of their life were often made to order. They were popularly called *Namban-byōbu* (Southern Barbarian screens) because the first Europeans arrived in Japan from the southern hemisphere. The *Namban-byōbu* were evidently very popular, and they continued to be manufactured until well into the Edo period (Pl. 117).

The genre subject most favored by the Momoyama artists was, however, scenes in the gay quarters. Under the strict feudal system the gay quarters and theaters were the only places where people of all ranks could enjoy themselves with relative freedom. Consequently, these two sources became the background for the greater part of all genre paintings up to the time of the *ukiyo-e* prints in the Edo period (Pls. 119, 120).

A taste for the grand and brilliant which was the guiding spirit of Momoyama society was most apparent in the flamboyance of the ruling class and in the extravagant dandyism of the wealthy merchants. In response to the demand created by these people, the arts of textile weaving and dyeing advanced remarkably, and the extreme elegance and fineness of the costumes of the time, represented for example by the fragment of *tsujigahana* (Pl. 109), was something unknown in previous ages. Manufacture of the *kara-ori* (Chinese style of weaving) brocade of the Nishijin district of Kyoto started, this being used principally for ceremonial costumes and for Noh robes.

The brilliance of the colors and the novelty of the designs of costumes for the Noh and Kabuki theaters were matched by new advances in the fields of lacquerware, metalwork, and pottery, in which the insipid patterns of feudal conventionalism were boldly discarded and progress was made in design as well as in technique. The *Kōdai-ji maki-e* cabinet, with its freehand designs of autumnal grasses in gold on a black background, is the most typical and most famous of Momoyama lacquerware designs (Pl. 112).

The tea cult, which had originated during the Muromachi period, enjoyed an unprecedented vogue during the Momoyama period under the influence of the revered tea master Sen-no-Rikyū, and in turn the tea cult exerted an enormous influence on all forms of art connected with it. For example, during this time the *shoin-zukuri* style of architecture was brought to perfection, but the Momoyama period also saw the development of the austere tea house of the *sukiya-zukuri* style, which is free and unpretentious by contrast with the more formal and ceremonious *shoin-zukuri*. In these tea houses, the distinction between samurai and merchant was ignored as people of different classes enjoyed each other's company over a bowl of tea in

a spirit of complete equality. For such meetings of aesthetic enjoyment, the *sukiya-zukuri* tea house, utterly simple and quietly informal, provided an ideal setting.

With the spread of the cult of tea, influential and wealthy men patronized it and encouraged the production of better vessels and utensils for use at tea ceremony parties. Tea bowls, in particular, were highly prized, and their connoisseurship reached unimaginable niceties. Kilns of established fame at Seto, Shigaraki, Bizen, and Karatsu produced ever-better works. The ware that enjoyed the highest fame, however, was a new type of pottery called *raku-yaki*, first produced in Kyoto by a potter named Chōjirō. The tea master Rikyū and the warrior Hideyoshi were united in their praise of the *raku* tea bowls, which continued to be made in much the same manner throughout the Edo period and even up to modern times. Clearly, the progress in the different branches of the applied arts outlined in this short survey could hardly have been attained without the protection and encouragement given to artists by the rulers of the time.

8

THE EDO PERIOD

The Edo period covers the two and a half centuries from the downfall of the Toyotomi family (1615) to the Meiji Restoration of 1868. It was a period of peace and prosperity under the firm rule of the Tokugawa shogunate founded by Tokugawa Ieyasu (1542–1616), who established the headquarters of his feudal government in Edo, present-day Tokyo.

During the first twenty years after the establishment of the new regime, Japan remained open to Western influences as it had been during the Momoyama period, but when the shoguns began to suspect that the ideas brought in by Christian priests were inimical to their continued feudal control, they suppressed Christianity and closed off Japan's contact with all foreign countries. Confucianism was adopted as the orthodox philosophy of the period and Buddhism declined. Consequently, much of the art of this period was influenced by the tastes and demands of the *daimyō*, or feudal lords, who enjoyed power and wealth under their all-powerful master, the shogun. With the development of commerce and industry, however, the rising merchant class began to make its influence felt, and toward the middle of the Edo period, the patronage of art came to be gradually transferred to wealthy merchants; from this it was only a step to the production of popular art.

Architecture in the early part of the Edo period continued in the Momoyama tradition, but after the Genroku era (1688–1704) it tended to become merely repetitive and its artistic merit gradually declined. In the late Edo period the shogunate not only prevented the *daimyō* from building castles, but even prohibited repairs. Accordingly, no further development was seen in castle architecture.

The famous Katsura Imperial Villa in Kyoto, construction of which began during Momoyama times, was completed early in the Edo period. The principal building and the tea houses in the garden are graceful in themselves and in delightful harmony with the landscaped setting, but it is the garden which deserves the greatest praise. Similarly, the Shugaku-in Imperial Villa in Kyoto, which was started in 1655 and completed in 1665, is famous for the elegant beauty of its vast garden.

Of all the arts, painting proved to be the most creative during the Edo period. Many new schools of painting were founded and a number of distinctive styles were created. The Kanō school, with Kanō Tan'yū (Morinobu) (1602–74) at its head, maintained a preeminent position in the world of painting, and enjoyed the position of official artists to the shogunate. The feudal lords in the provinces also vied with each other to obtain the services of Kanō school painters, so that their fame spread nationwide and lasted throughout the eighteenth and most of the nineteenth centuries. Certain painters who were dissatisfied with the artistic canon of the Kanō school, such as Kusumi Morikage (active latter half of 17th century) (Pl. 121), a pupil of Tan'yū, and Hanabusa Itchō (1652–1724), a pupil of Kanō Yasunobu, attempted original presentations, and are said to have been expelled from the Kanō school as a result. After the move of Tan'yū and his group to the new capital of Edo, the descendants of Sanraku, known as the Kyō-Kanō school, remained in Kyoto.

Undoubtedly the most important development in art during the early Edo period was the rise of the Sōtatsu school of decorative painting which succeeded in revivifying *Yamato-e*, at this time all but moribund. The new form of art was the product of the combined talents of the gifted artist Hon'ami Kōetsu (1558–1637) and the great painter Tawaraya Sōtatsu (first half of 17th century). These two distinguished men grew up during the Momoyama period and had absorbed the exuberant spirit of Momoyama decorative art. In the early Edo period they established a school based on *Yamato-e*, to which they added new decorative elements. The movement they founded produced some of Japan's greatest works of art (Pls. 122–26) and influenced not only painting but also lacquerware, pottery, and other branches of the applied arts throughout the Edo period. Ogata Kōrin (1658–1716), who succeeded Sōtatsu and took over the leadership of the school, came to be the outstanding decorative painter of Edo times (Pls. 127–29). Like Kōetsu, he demonstrated great versatility and was gifted in the craft of *maki-e* lacquerwork and handicraft design generally. Kōrin's younger brother Kenzan (1663–

1743) was famous as a potter, but he also painted pictures of great originality and taste. A century later, Sakai Hōitsu (1761–1828), an ardent admirer of Kōrin's painting, continued to work in the same style and painted some exquisite masterpieces (Pl. 131).

The second half of the Edo period saw the rise of the so-called literati school (*bunjin-ga*, or "literati painting"), which derived mostly from the Southern School paintings of China and was therefore also known as *Nanga* ("Southern painting"). *Nanga* was a school of subjective expression which held that painting should be the reflection of the noble spirit and poetic sentiments of the artist. As opposed to the strong and severe *Hokuga* ("Northern painting") style, *Nanga* is free from conventionalism, and surviving examples include some unconstrained and tasteful works done in monochrome or light color. Japanese *Nanga* painting first became popular in the early eighteenth century and reached the height of its development during the Meiwa and An'ei eras (1764–80) with the appearance of Ike-no-Taiga, Yosa-no-Buson and others associated with them. Taiga (1723–76) painted in a poetic and highly unconventional manner, a reflection of his lofty character (Pl. 130). Buson (1716–83), a distinguished poet of *haiku* (seventeen-syllable verse form), was also a painter and had a style much more objective and realistic than the *Nanga* artists preceding him. Following Taiga and Buson, in the Bunka and Bunsei eras (1804–29), Aoki Mokubei (1767–1833) (Pl. 135), Uragami Gyokudō (1745–1820) (Pl. 134), and Tanomura Chikuden (1777–1835) came into prominence, and each created his own individual style. The *Nanga* of the capital of Edo started with Tani Bunchō (1763–1840), about a generation later than the Kyoto painters. He had studied the Kanō school and the Chinese painter Shên Nan-p'in, who had come to Nagasaki, before he took up *Nanga*. He even studied the realism of European paintings arriving in Japan at the time.

The development of realistic painting was also of great importance during the Edo period. Even the strict isolation policies of the shogunate could not completely exclude the knowledge of Western culture and science, and the impact of Western thought was not without its effect on Japanese art in general. Maruyama Ōkyo (1733–95), who established the new school of realism in art, broke away from the idealized depiction so long practiced by the Kanō artists, and through study and actual sketching from nature arrived at a fresh, familiar style consonant with the Japanese attitude toward natural things. In Ōkyo's style the influence of Chinese realistic art, particularly the works of Ch'ien Shun-chü, the Yüan academy artist, and Shên Nan-p'in of the Ch'ing dynasty, is apparent. Ōkyo also learned the technique of Western-style perspective, anatomy, and the use of light and shade (Pl. 132). Matsumura Goshun (Gekkei) (1752–1811) inherited the style of Ōkyo, and the Shijō school which he founded subsequently became the most prominent school of painting in Kyoto.

If the painting of the Maruyama-Shijō school developed in response to the demands of the rich merchant class in Kyoto and Osaka, *ukiyo-e* was born out of the plebeian tastes of the common people of Edo (Tokyo). The origin of *ukiyo-e* is closely associated with genre painting and the woodcut illustrated storybooks which had been fashionable since the beginning of the Edo period. During the Keichō to Kambun eras (1596–1672), early in the Edo period, a new type of painting came into vogue, now known as early genre painting (Pls. 116, 118–20). While the subject matter of these works was noticeably plebeian, they were still designed for the edification of the nobility and the warrior class. The stern Confucian tradition of these upper classes evidently was not a fertile ground for the growth of genre art. But with the gradual emergence of commoners as a new financial and social power in the society, genre painting, which dealt with the lives and enjoyments of this class, was destined to develop anyway, and it culminated in mature *ukiyo-e*. Furthermore, it was quite logical that such popular art as *ukiyo-e* would eventually find woodblock printing the most suitable form of expression. In this way the great fashion of *ukiyo-e* color prints in the second half of the Edo period arose.

With the rise of popular literature in the Edo period, storybooks with woodcut illustrations were published in great numbers. These illustrated books later developed into picture books and eventually, in about the Empō to Tenna eras (1673–83), gave rise to single-leaf prints. Thus was born the *ukiyo-e* print. Inspiration from Chinese woodblock prints may also have been instrumental in the establishment of the color-printing technique, but it is generally believed that the originator of the *ukiyo-e* print was Hishikawa Moronobu (1618?–94). Moronobu studied painting in Kyoto, and after moving to Edo he achieved immediate popular success through his portrayal of charming amorous scenes with simple linear representation and rough, clear compositions. Some remarkable brushwork paintings by him exist, but his most important contributions to Japanese art are to be found among woodcut illustrations for books.

After Moronobu's death, many talented print artists appeared, including Torii Kiyonobu (1664–1729) and other Torii masters, Okumura Masanobu (1686–1764), Ishikawa Toyonobu (1711–85), and others. *Ukiyo-e* prints swiftly became favored. Printing techniques progressed from the early *sumizuri-e* (black monochrome line prints) to the *tan-e* (black line prints with vermilion color added in brushwork), *beni-e* (black line prints with a few colors, principally

pinkish red, in brushwork), and *urushi-e* (a variety of *beni-e* embellished with glossy black formed by mixing *sumi* with a kind of glue). Following these, in about the Kampō era (1741–43), hand-colored prints appeared. In 1765, Suzuki Harunobu (1725–70), in collaboration with engravers and printers, devised a method of producing polychrome prints (*nishiki-e*) in ten or more colors, the ultimate technical achievement of color printing. Harunobu specialized in the romantic representation of young, lovely girls against a background of their everyday life (Pl. 140). After his death, the central figure in the world of *ukiyo-e* prints was Torii Kiyonaga (1752–1815). In contrast to the poetic mood of Harunobu, Kiyonaga specialized in the portrayal of groups of tall, healthy-looking young women drawn with fluent lines and bright clear colors (Pl. 141). He was followed by Kitagawa Utamaro (1753–1806) who, although at first influenced by Kiyonaga, later created a distinctive type of *bijin-ga* ("pictures of feminine beauty") which are regarded as the finest ever produced (Pl. 142).

In the rendering of *yakusha-e* ("portraits of Kabuki actors") which, together with *bijin-ga*, comprised the great majority of *ukiyo-e*, the Torii family, which had a special financial connection with the theatrical world, enjoyed a monopoly. However, Katsukawa Shunshō (1726–92), a contemporary of Harunobu, broke away from the standard manner of the Torii school, which had portrayed all actors with uniform facial features, and created the realistic type, termed *nigao-e* ("likeness pictures"), which aimed to express the facial expression and stage manner of individual actors. Even more impressionistic and exaggerated in portraying the characteristics of different actors was Tōshūsai Sharaku (dates of birth and death unknown; active 1794–95) (Pl. 143).

The Kansei era (1789–1801), in which Utamaro and Sharaku were active, saw the height of the development of *ukiyo-e*, and after that the art entered a period of decline. Toward the end of the feudal age, however, the last chapter of the history of *ukiyo-e* was made glorious by two great landscapists, Katsushika Hokusai (1760–1849) and Andō Hiroshige (1797–1858), who have left many masterly landscape prints (Pls. 144, 145).

While the majority of *ukiyo-e* pictures were prints, there were some artists who specialized in brush paintings. Among them the most outstanding were perhaps Kaigetsudō Ando (active 1688–1715; Pl. 138) and Miyagawa Chōshun (1682–1752).

It would not be right to end this chapter without considering the influence exerted on Edo period painting by foreign art. As already mentioned, a consequence of the policy of national isolation adopted by the Tokugawa feudal government was that foreign trade, which had flourished during Momoyama times and in the first years of the Edo period, was suspended, and the port of Nagasaki became the only authorized door by which foreign ideas and artifacts could trickle into Japan. In 1720, during the rule of Tokugawa Yoshimune, the eighth of the Tokugawa shoguns, the strict prohibition of overseas intercourse was relaxed and the import of Dutch books other than religious ones was permitted. The copper-plate engravings found in these imported Dutch books were an incentive to Japanese artists, leading to a second surge of Western-style painting. Hiraga Gennai (1729–79), though not a painter, was a pioneer of this period. He studied the theory of Western painting and under his guidance a number of artists tried it. Shiba Kōkan (1738–1818) was the first Japanese to make copper-plate prints after the examples in the Dutch books, and he also tried his hand at oil painting.

Undoubtedly the outstanding development in applied art of this period occurred in ceramics. In China, and also in Korea, the potter's art had reached an advanced stage of development as early as the tenth or eleventh century, while in Japan, where utensils of wood and lacquer were in general use, it lagged far behind. From the beginning of the Edo period, however, a number of interesting types of technically advanced ceramic wares, derived from Korean pottery but of distinctive styles, began to be made under the influence of immigrant Korean potters, many of whom were brought to Japan after the Korean wars toward the end of the sixteenth century. Karatsu ware (Pl. 156), which flourished in Momoyama and early Edo times, owed its origins to this factor. Hagi and Satsuma wares were also originated by Korean potters brought back to Japan after Toyotomi Hideyoshi's military expedition to the Korean peninsula. The early products of the Hagi and Satsuma factories were tea bowls imitating coarse Korean utensils.

In Owari and Mino provinces (Aichi and Gifu prefectures), which had been centers of pottery manufacture from the earliest times, the ceramic industry during the Edo period thrived as never before under the patronage of the local feudal rulers. In Kyoto, the *raku* type pottery, a low-fired ware, introduced by the Korean Chōjirō in the Momoyama period, continued to enjoy favor among devotees of the tea ceremony, and the tea bowls of this ware made by Dō'nyū, or Raku III (1599–1656), popularly known as Nonkō, are particularly famous for their soft forms and the warm texture of their glazes. Hon'ami Kōetsu, an artistic giant of great versatility, also made *raku* tea bowls, which are notable for a distinctively powerful and noble style (Pl. 154). Nonomura Ninsei (died ca. 1660 or 1666) applied the Arita technique of overglaze enameling to pottery, on which he painted graceful graphic designs in *Yamato-e*

style (Pl. 155). *Kyō-yaki*, or "Kyoto ware," owes its origin to Ninsei; it was thereafter produced at Awataguchi and Kiyomizu in Kyoto and flourished notably in and after the middle of the Edo period. Ogata Kenzan, Kōrin's younger brother, started a new line of pottery by applying enamel decoration on the *raku* body.

In 1616, according to tradition, the first true porcelain to be made in Japan was turned out at Izumiyama in Arita by Ree San Pei, a Korean immigrant. It was a rather crude ware decorated in underglaze blue in the manner of the Yi dynasty wares. From this time, the porcelain industry of Arita expanded until about the middle of the seventeenth century when an Arita potter, Sakaida Kakiemon (1596–1666), inspired by the Chinese method of overglaze decoration, created the first enamel-decorated porcelain in Japan. From this small beginning the world-famous Kakiemon wares (Pl. 161) developed. The technique invented by Kakiemon was copied by many porcelain factories of Hizen (Saga Prefecture), which thereafter turned out large quantities of "Kakiemon style" ware, much of which was exported to Europe through the medium of the Dutch traders established at Nagasaki. Early in the eighteenth century, in the same district, the elegant Nabeshima decorated porcelain (Pl. 160) appeared. Sometime about the middle of the seventeenth century the technique of making enameled porcelain was introduced from Arita to Kaga (Ishikawa Prefecture), where a distinctive type of porcelain decorated in strong colors with bold imaginative designs known as Kutani ware was created (Pl. 158). The Kutani kilns were active for less than half a century and ceased production sometime during the Genroku era (1688–1704). More than one hundred and fifty years later, production of wares of a similar type was resumed in the Kutani district. The products of this later period are known as Yoshidaya type, to distinguish them from the early wares, which are known as *Ko* ("Old") Kutani. The manufacture of porcelain ware in Kyoto was started by Okuda Eisen (1753–1811) and his colleagues, who acquired the techniques from Arita. Eisen's remarkable skill was displayed in the decoration of porcelain with enamels in the Chinese manner. Aoki Mokubei (1767–1833) and Takahashi (Nin'ami) Dōhachi (1783–1855) were among the most able of his pupils.

The art of textile making also saw remarkable progress during the Edo period. The weaving industry at Sakai in Izumi province (Osaka), which had thrived during the previous period, declined, and Nishijin in Kyoto became a new center of the industry.

The manufacture of lacquerware in this period tended to stress technical versatility, so that while the product attained a stage of technical perfection, some falling off is observable in artistic quality. Exceptions to this rule were the creations of such unconventional artists as Hon'ami Kōetsu in the beginning and Ogata Kōrin in the middle part of the period, both of whom made remarkable lacquer works of great refinement manifesting bold forms and designs (Pl. 153).

In the field of metalwork, sword accessories (*kodōgu*) and sword guards (*tsuba*) showed a rich variety of techniques of metal carving (openwork, engraving, relief carving, and inlay), reflecting the taste of the warrior class in an age when swords were more for ornament than for use as weapons.

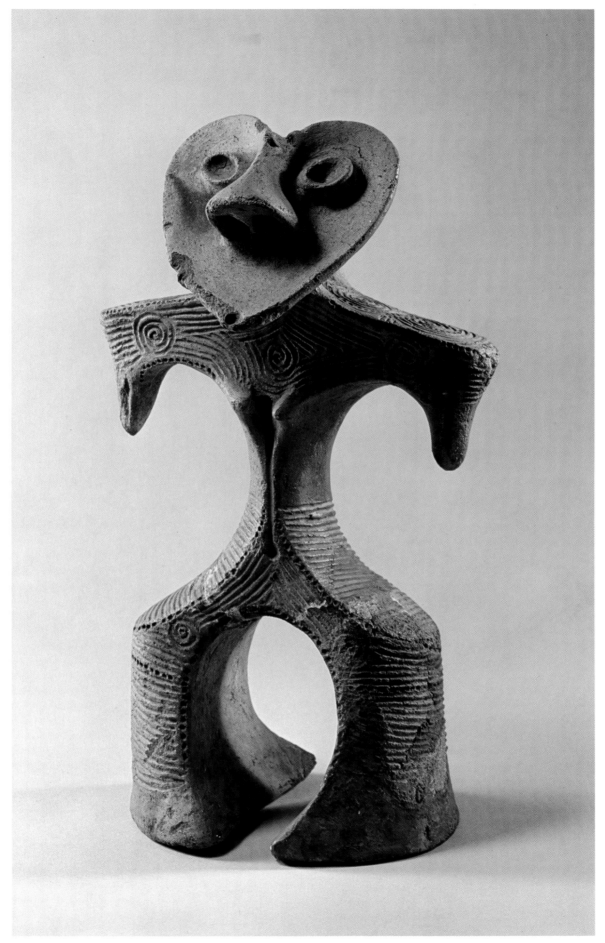

The inhabitants of the mountainous region of central Japan of the Jōmon period made clay figurines with strange shapes, undoubtedly inspired by some form of primitive religion. This piece is definitely human in its proportions, but the mysterious expression on the heart-shaped face appears to symbolize a superhuman power. The definition of the shoulders, trunk, waist, and legs is achieved by simple modeling and the repetition of more or less similar curves.

Pl. 1
Figurine,
excavated in Gumma Prefecture,
Jōmon period,
fired clay, Jōmon pottery.
H. 30.5 cm.
Private collection.

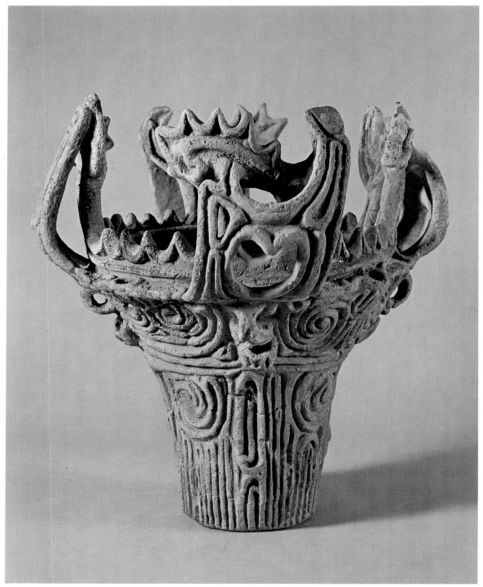

Pl. 2
Urn,
excavated in Niigata
Prefecture,
Jōmon period,
fired clay, Jōmon pottery.
H. 29.3 cm.
Private collection.

The basketwork form of this urn is apparent, and it is specially notable for its effective use of the corded clay ornaments with their flowing curves. The vessel was evidently not made to be carried about, and it was probably intended to be placed on the floor inside a house.

The Japanese *dōtaku* resemble the Chinese *chung* ("bells") in shape, but evidence suggests that they were not intended to be used as bells but were objects of some religious significance, possibly as instruments to pray for a good harvest. This *kesa-dasuki-dōtaku* is so named because the decorative grid formed by horizontal and vertical belts with spiral designs in between resembles the pattern of a Buddhist monk's vestment (*kesa*).

Pl. 3 (*opposite*)
Dōtaku,
excavated in Hyōgo Prefecture,
Yayoi period,
2nd–3rd century A.D.,
bronze.
H. 47.5 cm.
Tokyo National Museum.

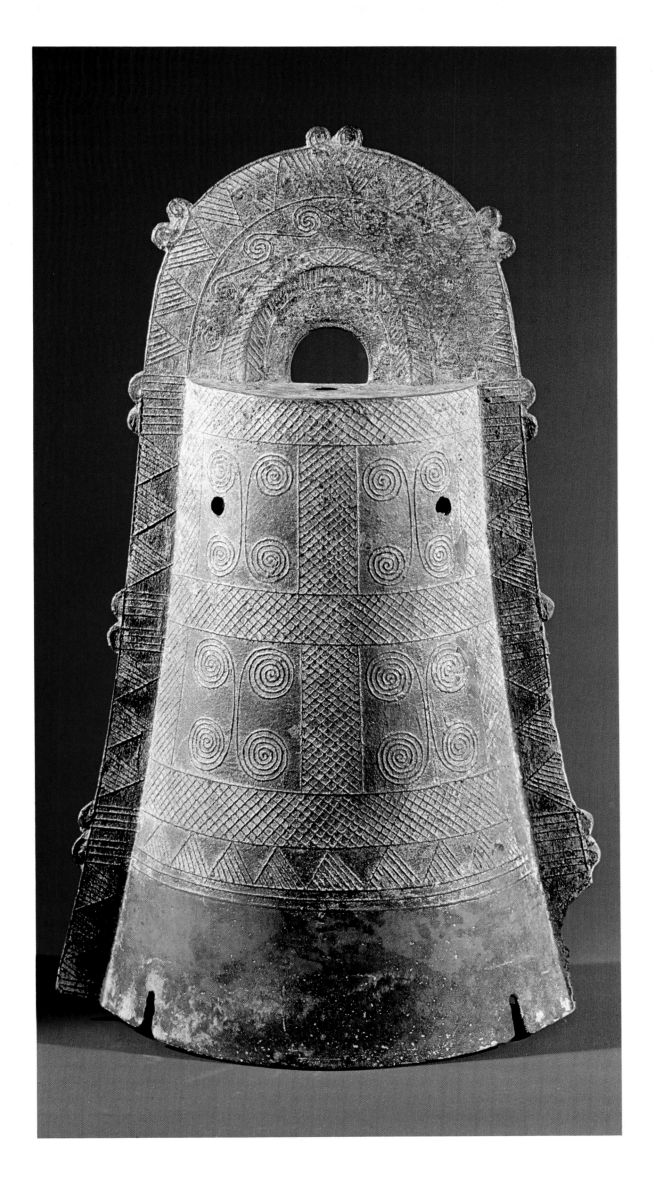

Pl. 4
Sword blade,
4th century,
iron.
L. 74.9 cm.
Isonokami Shrine, Nara.

In the Isonokami Shrine near Nara are stored many swords, often paired with shields, which have belonged to the imperial family since ancient times. Thus this shrine has proved a veritable treasury of arms in an excellent state of preservation; if these had been buried and only discovered through excavation, their condition would have been considerably impaired. The three branches on either side of this sword have been the object of much speculation, so far without any satisfactory conclusion. From an inscription inlaid in the iron blade in gold, we might infer that it was presented by the king of Paekche in Korea.

The innate Japanese tendency to favor the simple and the lucid could not long be satisfied with the intricate and mysterious designs of imported Chinese mirrors of the Han and Six Dynasties periods. Consequently, in due course original designs developed such as the one on this mirror-back, consisting of a combination of arcs and straight lines. Such decorative patterns were probably credited with some magical power.

Pl. 5 (*opposite*)
Mirror with a geometric design, excavated in Nara Prefecture, 5th–6th century, bronze.
D. 27.9 cm.
Imperial Household Agency.

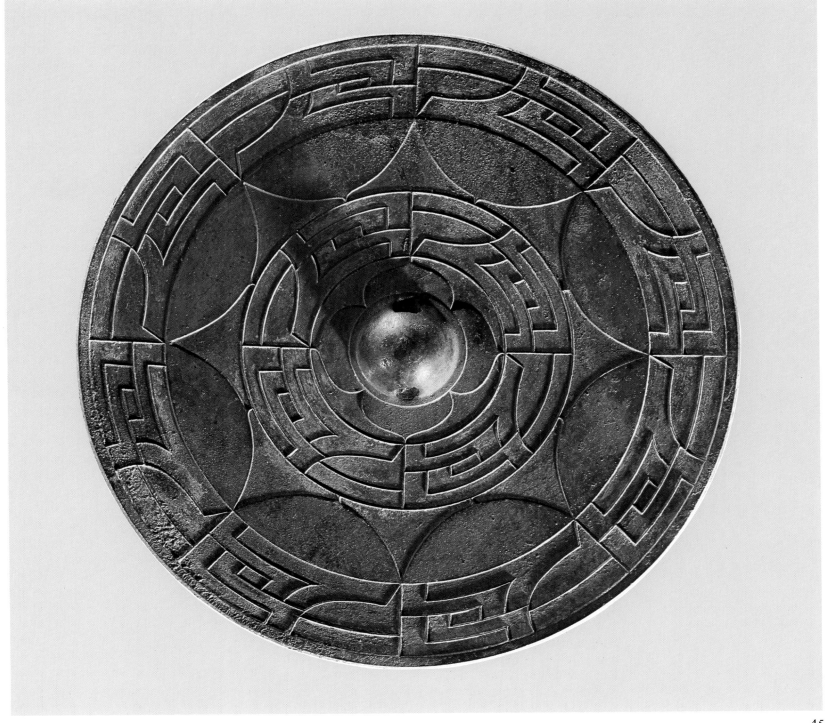

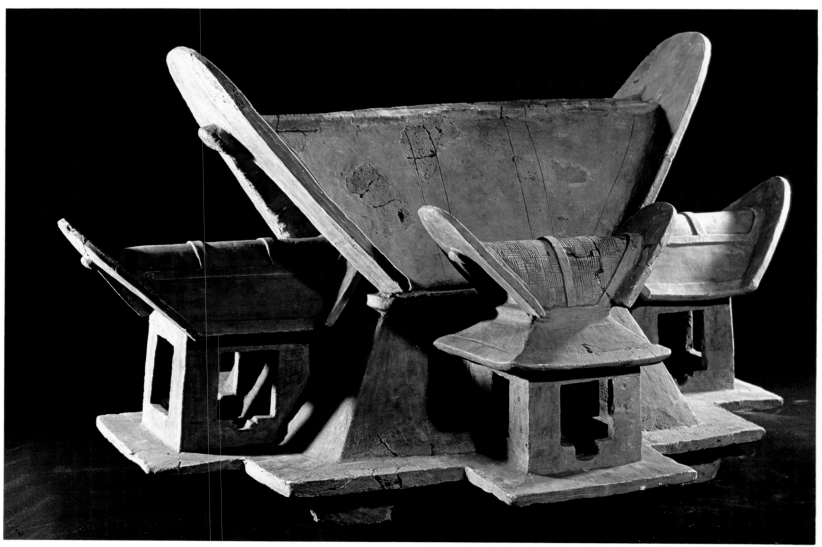

Pl. 6
Haniwa model of a cluster of houses, excavated in Miyazaki Prefecture, 5th century, fired clay. H. 54.5 cm. Tokyo National Museum.

Haniwa models of houses are valuable sources of information about ancient Japanese architecture. This particular piece is a unique example of a large central house with a smaller building on each side. It may well represent the mansion of a clan leader.

In the fifth and sixth centuries a new kind of hard gray-black stoneware came into use, termed Sue pottery. Fashioned on the potter's wheel, these pots had thin walls, and because it was a high-quality ware it seems to have been reserved for ceremonial occasions. Shapes are generally simple and symmetrical, but some, such as the piece shown here, are more elaborate. This jar is ornamented with diminutive jars as well as with figures of humans and animals suggestive of a hunting scene.

Pl. 7 (*opposite*)
Jar with sculptured ornaments, excavated in Hyōgo Prefecture, 5th century, fired clay, Sue pottery. H. 37.4 cm. Kyoto National Museum.

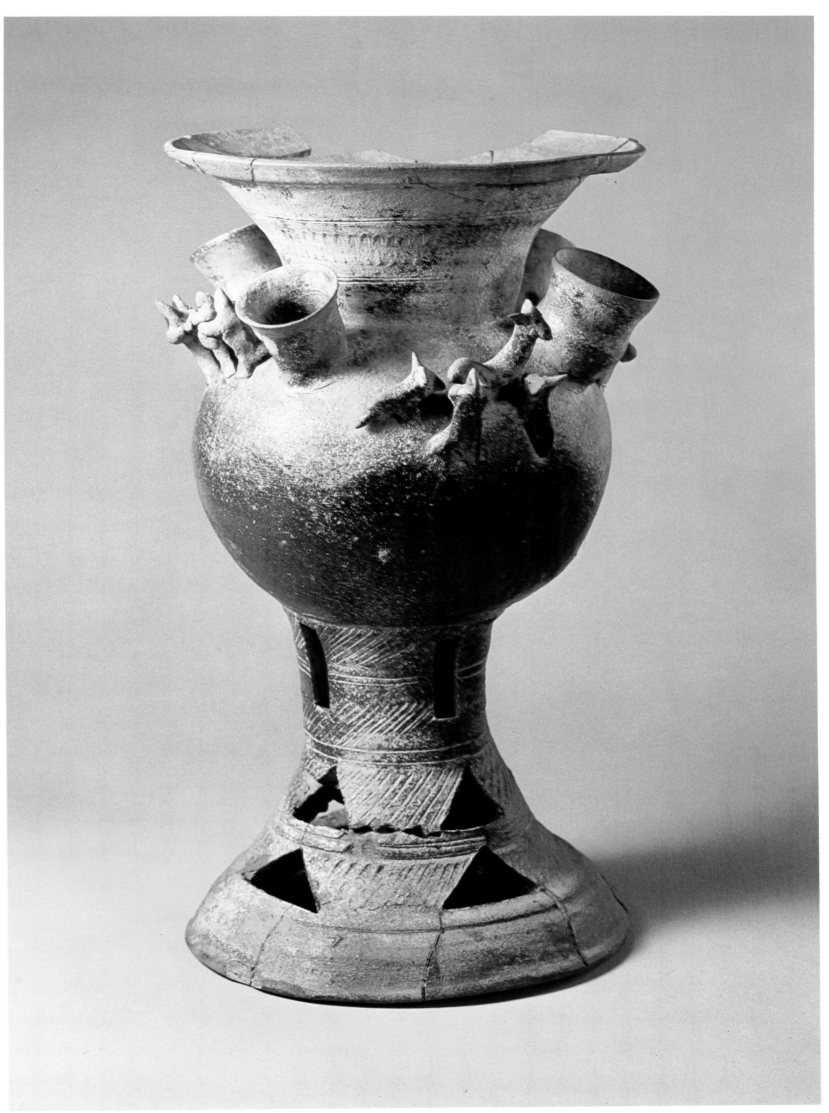

47

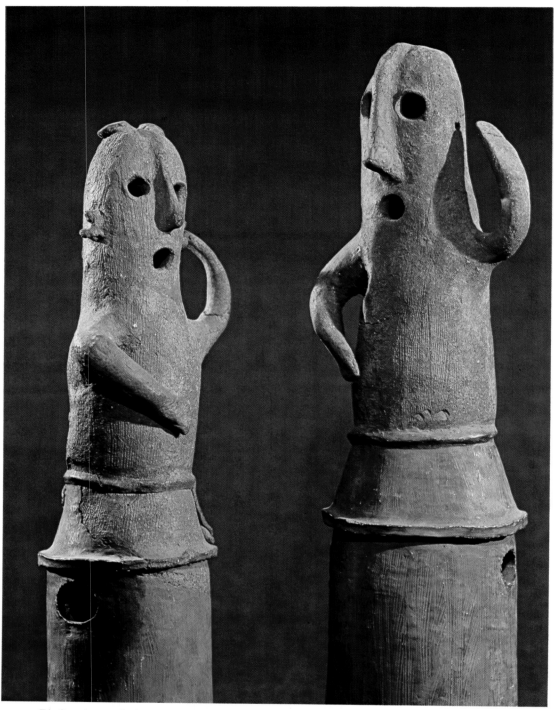

Pl. 8
Haniwa figures of a man
and a woman,
excavated in Saitama Prefecture,
6th century,
fired clay.
H. (man) 63.9 cm.,
(woman) 56.6 cm.
Tokyo National Museum.

Around the burial mounds (*kofun*) of people of rank and power in the early centuries A.D. were placed large hollow clay figurines (*haniwa*). These two *haniwa* figures, similar in form but of slightly different sizes, probably represent a man and woman dancing. In both figures, the head, neck, and body form an almost straight-sided cylinder, and the treatment of the features is likewise simple.

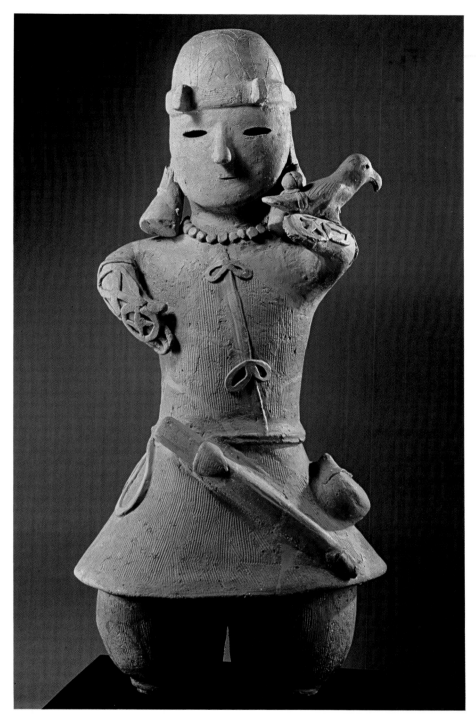

As the technique of making *haniwa* developed, sculptors sought a greater variety of subject matter. This figure of a man with a falcon on his arm, a crowned head, a beaded necklace, and a sword at his waist, is not intended to represent a professional falconer but a member of the nobility enjoying the sport. The purpose of the bell tied to the tail of the falcon was to frighten its prey, and the round object at the man's waist is a wrist protector used in archery.

Pl. 9
Haniwa figure of a falconer, excavated in Gumma Prefecture, 6th century, fired clay.
H. 75.8 cm.
The Museum Yamato Bunkakan, Nara.

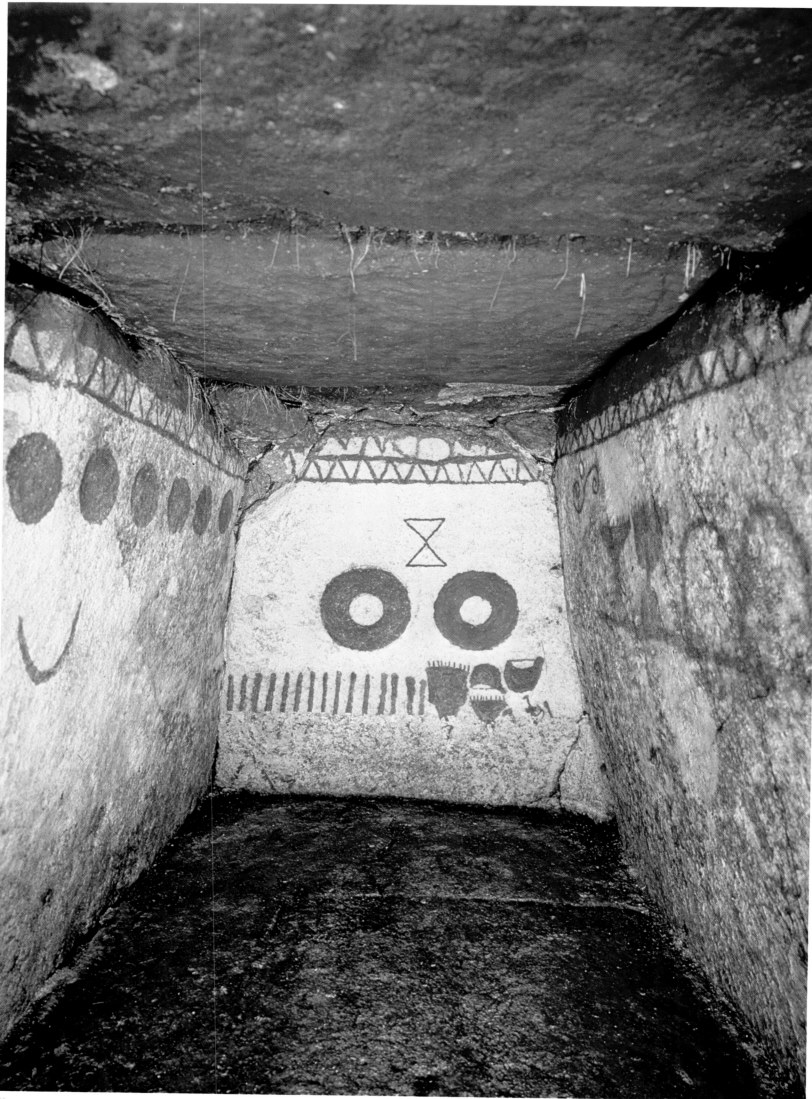

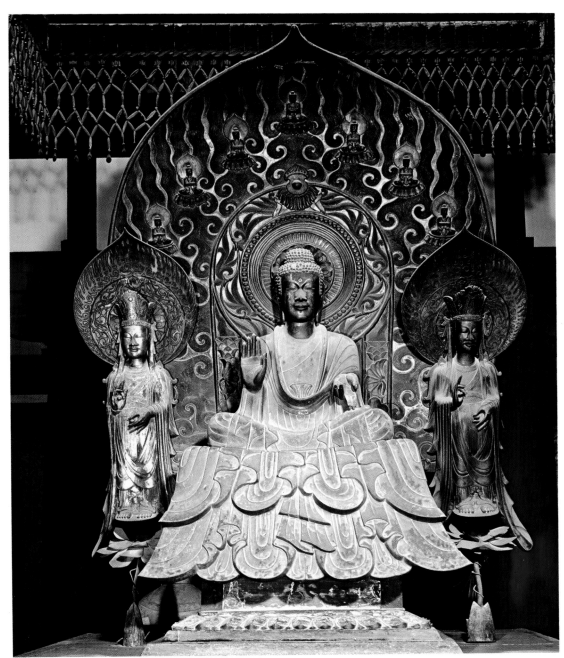

According to a contemporary inscription engraved on the back of the halo, this triad was begun in supplication for the recovery from a serious illness of Prince Shōtoku, who, however, died before it was completed. It is rare to find an authentically dated statue and this triad is in fact the oldest dated example of Japanese sculpture known. The inscription also includes the name of the sculptor, Tori, believed to have been the descendant of a Chinese immigrant. The style shows the general influence of sixth-century Chinese sculpture, modified as it passed through the Korean peninsula.

Pl. 11
Shaka triad,
by Tori,
Asuka period, dated to 623,
bronze.
H. of Shaka 86.4 cm.
Kondō, Hōryū-ji, Nara.

Pl. 10 (*opposite*)
Wall painting
from Torazuka Kofun,
excavated in Ibaraki Prefecture,
7th century.
W. app. 3 m.
Katsuta, Ibaraki.

In ancient Japan, inside the tombs (*kofun*) of influential people were painted many decorative pictures. This kind of painting is found extensively in the Kyushu and Kinai districts, but this particular one found at Torazuka Kofun in the Kantō area of central Japan is quite unique. Red circles and lines painted on the walls form a striking contrast to the whiteness of the clay, and the patterns are rich in their variety.

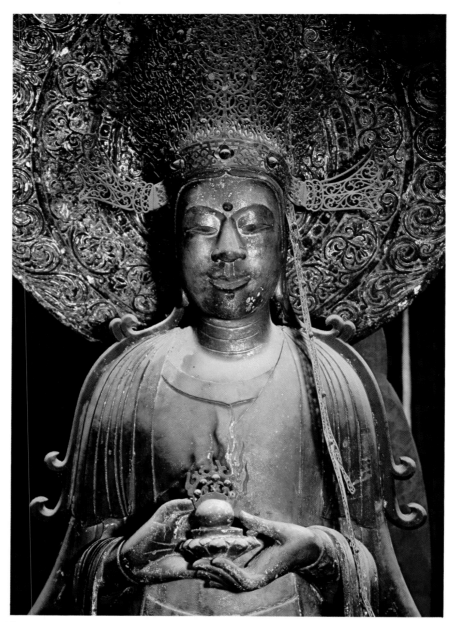

Pl. 12
Kuze Kannon,
Asuka period, 7th century,
wood, covered with gold leaf.
H. 178.8 cm.
Yumedono, Hōryū-ji, Nara.

This statue, which has certain stylistic features in common with the attendants of the Shaka triad in the Kondō (Pl. 11), is of camphor wood. However, the carving is so sharp that it gives the impression of being cast in bronze. Age has imparted a rich, dark color to the gold leaf which covers the whole surface of the statue. The piece may well be modeled on a sixth-century Chinese or Korean bronze statue.

Perhaps because this is a painted camphor-wood statue, the lines of the drapery folds and the contours of the eyes and lips are much softer than those of the Kannon in the previous plate, and the general effect is one of remarkable serenity. The body is well rounded and the treatment of the drapery represents a technical advance over the Kuze Kannon (Pl. 12). Kudara was the Japanese name for the seventh-century Korean kingdom of Paekche and, as the name of the statue suggests, some scholars formerly considered that this statue was either made in Korea and imported to Japan or carved by one of the many Korean immigrants. The former theory, however, seems untenable because of the lack in Korea of camphor wood and because of the Japanese flavor of the work.

Pl. 13 (*opposite*)
Kudara Kannon,
Asuka period, 7th century,
wood, painted.
H. 209.4 cm.
Hōzō-den (Treasure Gallery),
Hōryū-ji, Nara.

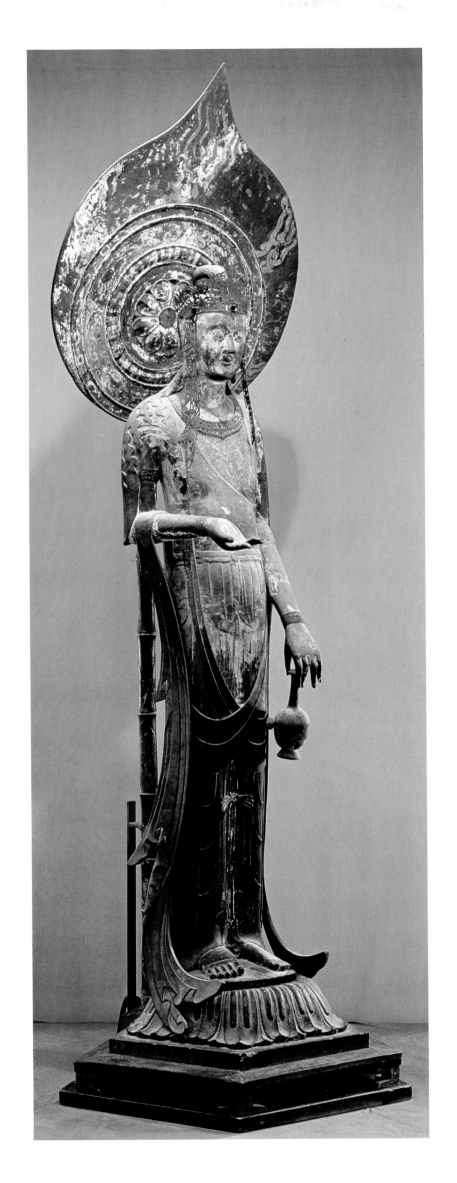

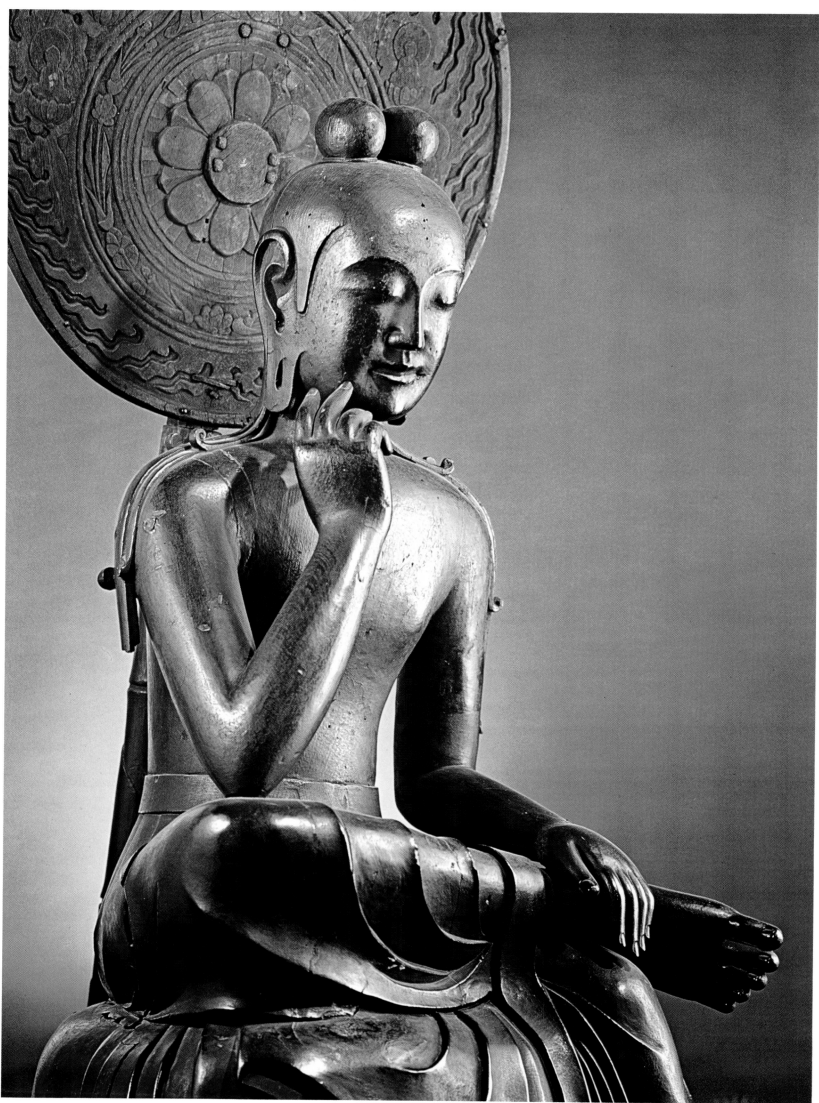

54

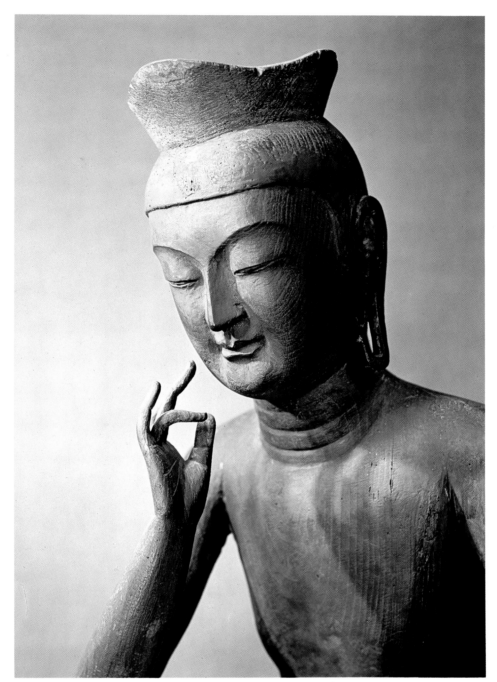

The style of this statue of Miroku (Sanskrit: Maitreya) is quite unlike most contemporary statues, which reflect the influence of Chinese sculpture of the Northern Wei dynasty. Most notable are the fine lines employed in portraying the eyes and eyebrows, and the whole sculptural approach seems to presage the arrival of a new artistic spirit. Already elements of the elegant and fuller style of the early Nara period, itself a reflection of Chinese Sui and T'ang art, are apparent.

Pl. 15
Miroku Bosatsu,
Asuka period, 7th century,
wood.
H. 84.3 cm.
Kōryū-ji, Kyoto.

Pl. 14 (*opposite*)
Bodhisattva,
Asuka period, 7th century,
wood, painted.
H. 87.0 cm.
Chūgū-ji, Nara.

This statue, one of the best known of all Japanese sculptures, is popularly called the Nyoirin Kannon (Sanskrit: Cintāmaṇicakra). In comparison with the severity and heaviness of the Tori style, which may be regarded as the main current of Asuka period sculpture, this figure, seated in the *hanka shiyui* ("half cross-legged in meditation") pose, is more rounded and better proportioned, suggesting that the style was derived from a different source. The touch of realism in the representation and the large, complex, and fluent folds of the drapery hanging over the pedestal indicate the latter part of the Asuka period.

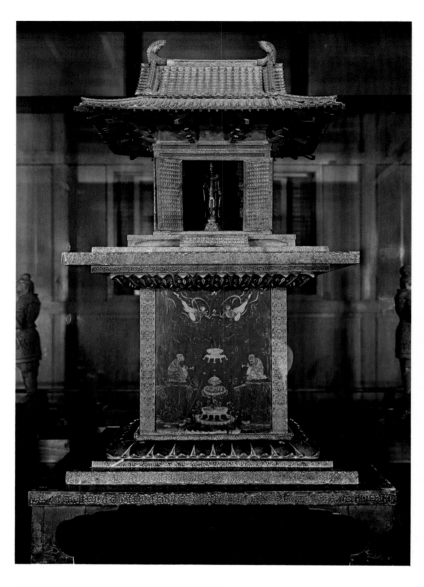

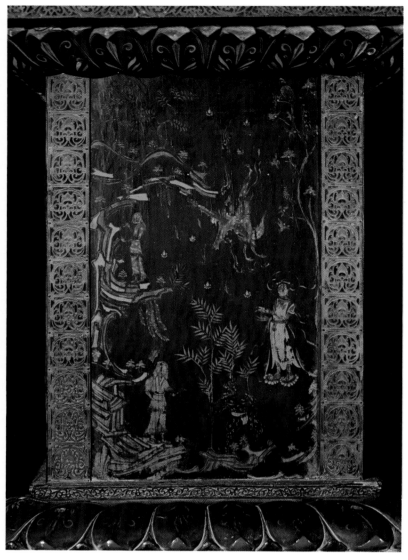

Pls. 16, 17 (*opposite above*)
Tamamushi Shrine,
Asuka period, 7th century,
wood, with colored lacquer
painting.
Total H. 233.3 cm.
Hōzō-den (Treasure Gallery),
Hōryū-ji, Nara.

This miniature temple, formerly housed in the Kondō at Hōryū-ji, has long been known as the Tamamushi Shrine because numerous wings of the beautiful *tamamushi* beetle are set beneath the openwork gilt bronze mounts on the edges. The shrine consists of two parts: the lower half is a box-form pedestal; and the upper part is in the shape of a temple. The latter is thought to be a copy of the original Kondō of Hōryū-ji. The paintings on the sides are executed in colored lacquers on a lacquered ground. The scene reproduced shows Prince Makasatta (Sanskrit: Mahāsattva), one of the former reincarnations of the Buddha, giving up his life to feed a tigress and her seven cubs which are about to die of hunger in a bamboo grove. It is noteworthy that several stages of the story are shown sequentially within one painting.

Pl. 18 (*opposite below*)
Incense burner,
Asuka period,
bronze, gold-plated.
Total L. 36.4 cm.; D. of burner
13.4 cm., H. 10.1 cm.
Tokyo National Museum.

This type of incense burner with a handle (*egoro*) is used by a priest to offer burning incense to the Buddha image of a temple. It has been suggested that this particular one belonged to Shōtoku Taishi, since in paintings of him as a young boy he is shown holding one very similar in shape, with the same "magpie's tail"-shaped handle.

Pl. 19
Kanjō-ban,
Asuka period, 7th century,
bronze, gold-plated.
Total L. 515.0 cm.; L. of panel
illustrated 76.0 cm.
Tokyo National Museum.

A *kanjō-ban* is an ornamental pendant hung from a beam inside a Buddhist sanctuary and originally used at the *kanjō* ("pouring on the head"), a Buddhist ritual resembling anointment. For the most part they were made of fabric, but this example was evidently made of metal to give a specially magnificent effect. The section reproduced shows a reliquary for the Buddha's ashes and angels among clouds.

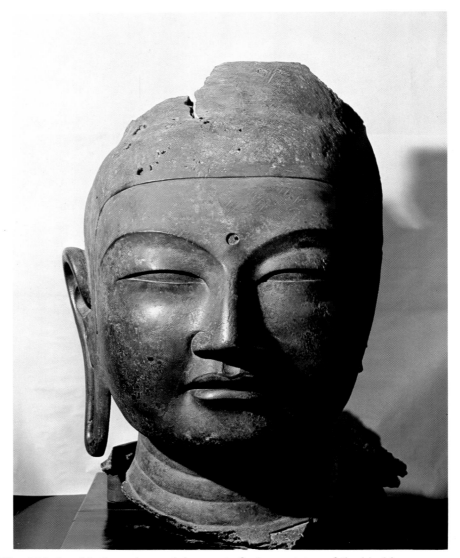

Pl. 20
Head of Yakushi Nyorai,
Nara period, 685,
bronze.
H. 97.3 cm.
Kōfuku-ji, Nara.

This head is the only surviving part of a large statue of the kind known as *jōroku* (meaning "sixteen feet," the standard height of a Buddha image). The statue to which it belonged was originally the principal object of worship in the Lecture Hall (Kōdō) of Yamada-dera before being moved to Kōfuku-ji in the Kamakura period. The body was destroyed by fire in 1411 but fortunately the head, a fine example of bronze casting of the early Nara (Hakuhō) period, has survived. The well-rounded face with its powerful expression is of the Chinese early T'ang (seventh-century) type.

This statue of Yakushi Nyorai, the Buddha of Healing (Sanskrit: Bhaiṣajyaguru), flanked by two bodhisattvas not illustrated, was originally gilded all over, but the surface has darkened over the centuries into a lustrous and beautiful black. The mature modeling of the face and body and the realistic treatment of the drapery folds reflect the influence of Chinese sculpture of the Sui and T'ang dynasties. The elaborate rectangular bronze pedestal is believed to have been made at the same time as the figure.

Pl. 21 (*opposite*)
Yakushi Nyorai,
Nara period,
late 7th to early 8th century,
bronze.
H. 254.8 cm.
Kondō, Yakushi-ji, Nara.

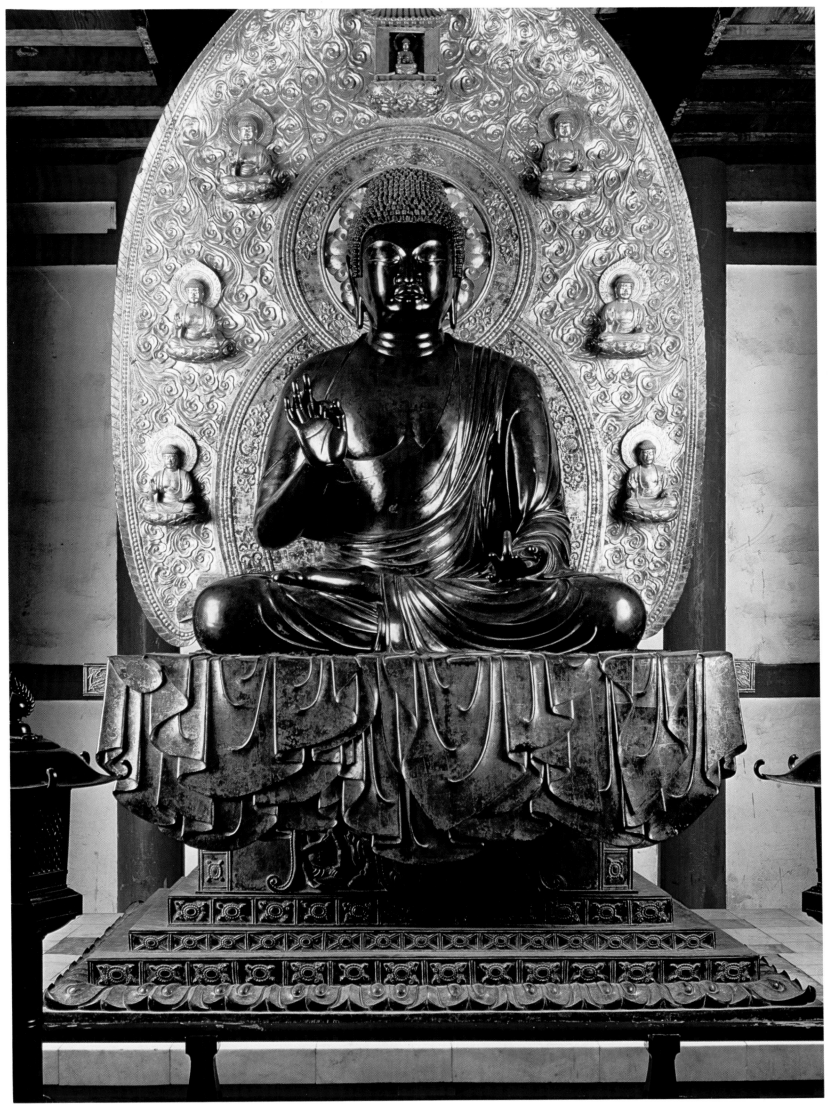

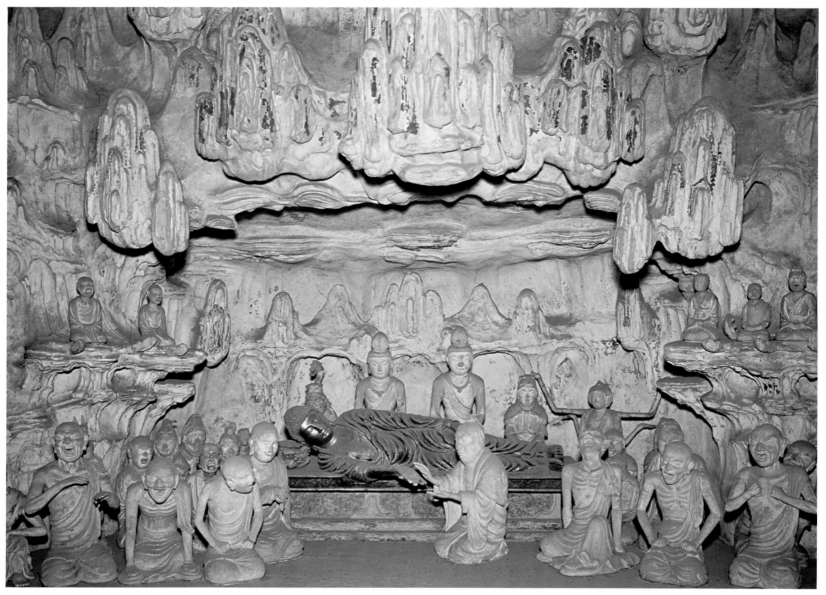

Pl. 22
Group of figures,
Nara period, 711,
clay.
H. of *rakan* figure at extreme
left 47.0 cm.
The Five-storied Pagoda,
Hōryū-ji, Nara.

The practice of placing a group of clay figures in the first floor of a pagoda originated in China, and by the seventh century had evidently spread to Japan. One of the four groups of figures in the Five-storied Pagoda represents the scene of the Nirvana, or passing away of the Buddha. It is interesting to note that the mountains, also made of clay, with "camel's back" peaks resemble those found in landscape paintings of the time. In contrast to the dignified countenance of the Buddha, the *rakan* (arhats, or Buddha's disciples) figures on the left, are modeled with rather exaggerated expressions.

This majestic and stern-faced Fukūkensaku Kannon (Sanskrit: Amoghapāśa), with a bejeweled silver crown on his head and a copper nimbus on his back shooting out rays in all directions, is the principal image of the Hokke-dō of Tōdai-ji and an outstanding example of the dry-lacquer technique. The form of the figure, with its four pairs of arms, is unusual for this period and reflects the influence of Esoteric or Tantric Buddhism, then gaining strength in India and China. The two attendants Nikkō (Sanskrit: Sūryaprabhāsa) and Gakkō (Sanskrit: Candraprabha) are made of unbaked clay and modeled with a graceful dignity.

Pl. 23 (*opposite*)
Fukūkensaku Kannon,
attributed to Kuninaka-no-
muraji Kimimaro (d. 774),
Nara period, 746,
dry lacquer, covered with gold
leaf.
H. 362.1 cm.
Hokke-dō, Tōdai-ji, Nara.

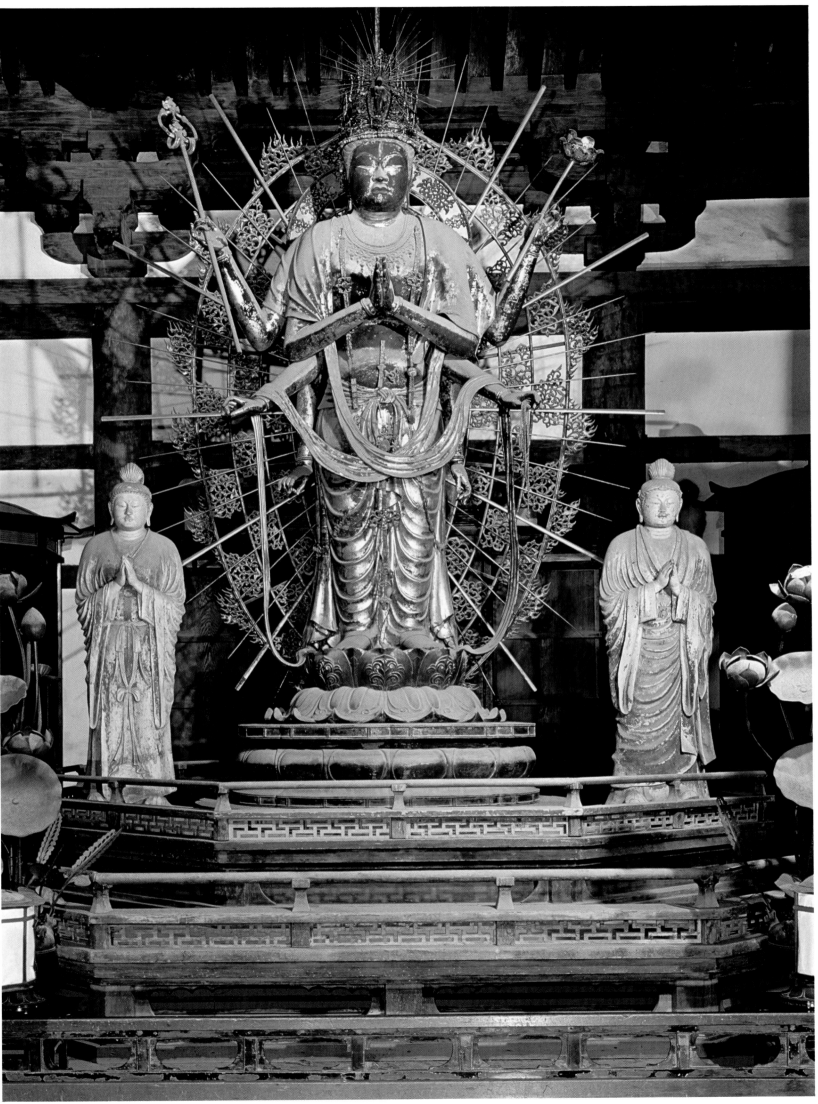

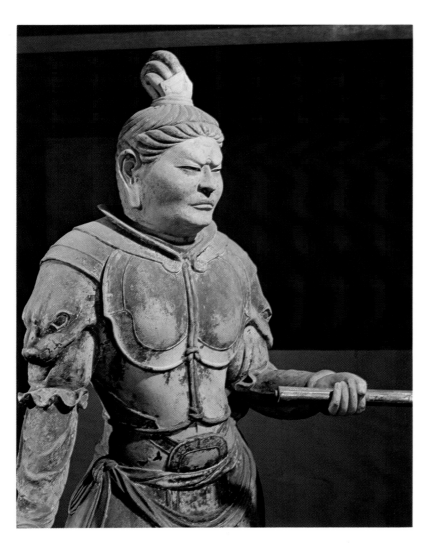

Pl. 24
Kōmoku-ten,
Nara period, 8th century,
clay, painted.
H. 162.7 cm.
Kaidan-in, Tōdai-ji, Nara.

This statue is of Kōmoku-ten (Sanskrit: Virūpākṣa), one of the Four Deva Kings, warrior guardians usually placed at the four corners of a Buddhist temple to guard against evil spirits. Its modeling reveals a very refined technique of clay statuary. The way in which the different textiles of the clothing and the hide of the armor is reproduced is particularly successful.

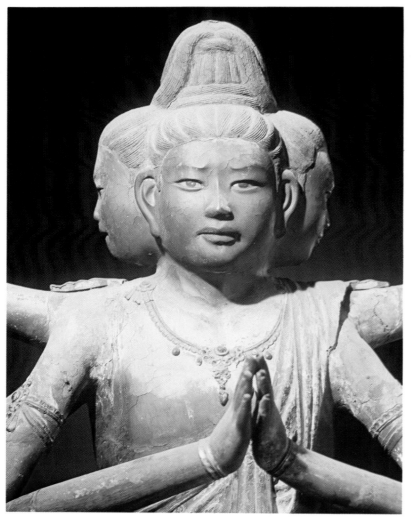

Pl. 25
Ashura,
Nara period, 8th century,
dry lacquer, painted.
H. 153.0 cm.
Kōfuku-ji, Nara.

Derived from the Ashuras of Indian mythology, who were hordes of demons who fought the benevolent Hindu gods, they were adapted by Buddhist mythology to become one of the Eight Guardians (Hachibu-shū) of the Buddha. The supernatural appearance of this statue, with its three heads and six arms, conveys a feeling of mystic power and lightness, for Ashura is said to be able to fly through the air at unimaginable speed. The face with the eyebrows slightly knit is both youthful and innocent.

Pl. 26 (*opposite*)
Shubodai,
Nara period, 8th century,
dry lacquer, painted.
H. 147.6 cm.
Kōfuku-ji, Nara.

This statue of Shubodai (Sanskrit: Subhūti) is from a group of the Shaka Jūdai Deshi (Ten Great Disciples of the Buddha Shaka), of which only six now remain and which makes a set with the Hachibu-shū of Pl. 25. Here the disciples are portrayed as monks (Sanskrit: *bhikṣú*), who are religious mendicants or spiritual offspring of the Buddha. Modeled in dry lacquer, this and the remaining statues are represented with strong individual qualities of character and age, reflecting the concern which realism held for artists of this century.

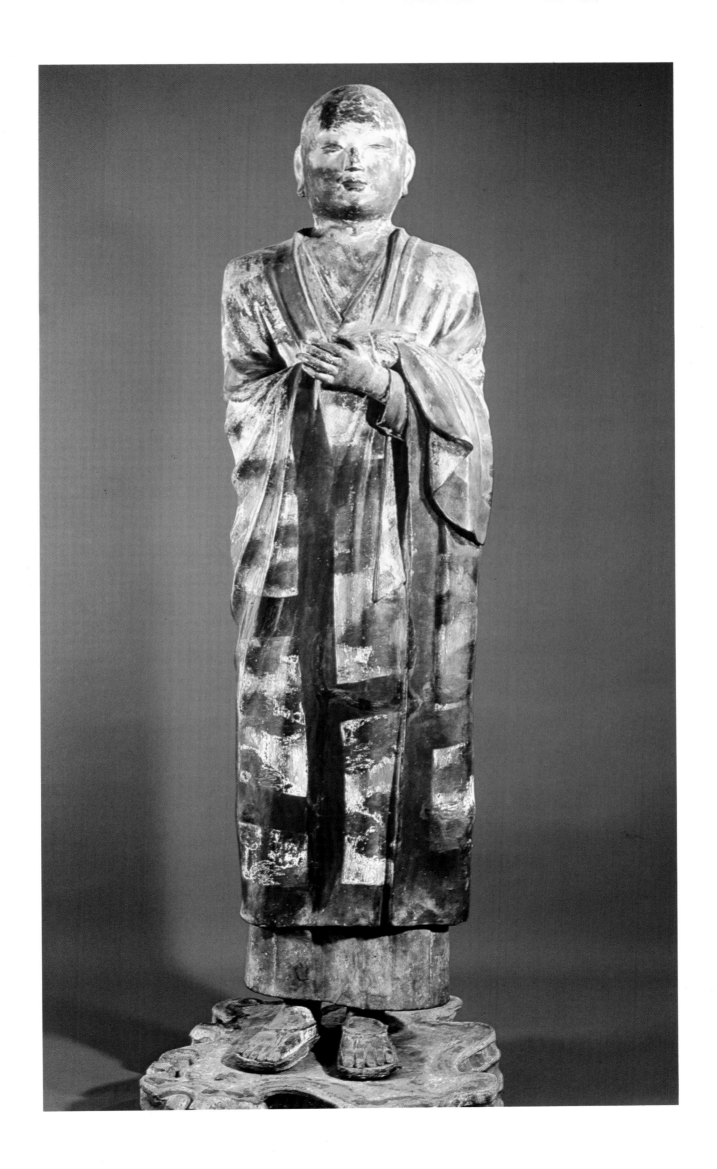

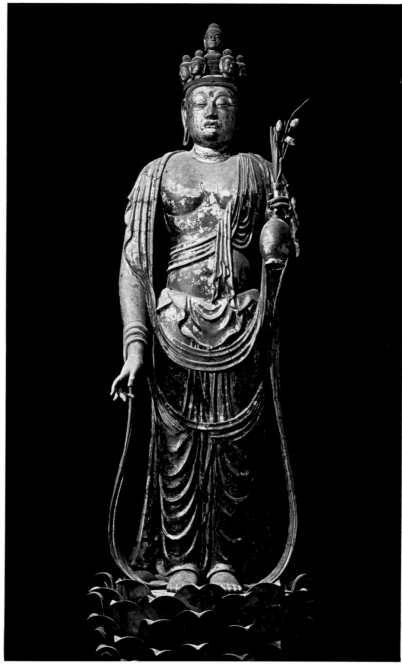

Pl. 27
Eleven-headed Kannon,
Nara period, 8th century,
dry lacquer over wood,
covered with gold leaf.
H. 210.0 cm.
Shōrin-ji, Nara.

The making of this marvelous statue in dry lacquer follows the technique of T'ang China but with some Japanese adaptations. The core of the statue is carved from a single block of cypress wood, hollowed out at the front and back to prevent the wood from cracking. The hollow spaces were then boarded over with thin planks and the entire surface of the core was covered with cloth, over which dry lacquer (*kanshitsu*) was applied.

In a sutra it is related that directly after his birth Prince Siddhārta (later the Buddha Shaka), descended to the ground, walked seven steps, raised his right arm and declared: "In heaven above and on earth below, I am the only honored one." Thus, the face and body of this image, the largest and finest of the numerous images that depict this moment, are those of an infant. The basin is actually used in the annual birthday service of the Buddha on April 8, in front of the Great Buddha Hall in the temple.

Pl. 28 (*opposite above*)
Buddha at birth,
Nara period, 8th century,
bronze, covered with gold leaf.
Statue: H. 47.8 cm.; Basin: D. 89.4 cm.
Tōdai-ji, Nara.

Ganjin (Chinese: Chien-chên) was a Chinese priest of the T'ang dynasty who came to Japan in the year 754 and founded Tōshōdai-ji in Nara. According to his biography, Ganjin made five unsuccessful attempts to cross to Japan, and when he finally succeeded on his sixth attempt he had lost his eyesight as a result of his many hardships. This statue vividly represents both his gentle personality and his indomitable willpower.

Pl. 29 (*opposite below*)
Ganjin,
Nara period, 8th century,
dry lacquer, painted.
H. 81.7 cm.
Tōshōdai-ji, Nara.

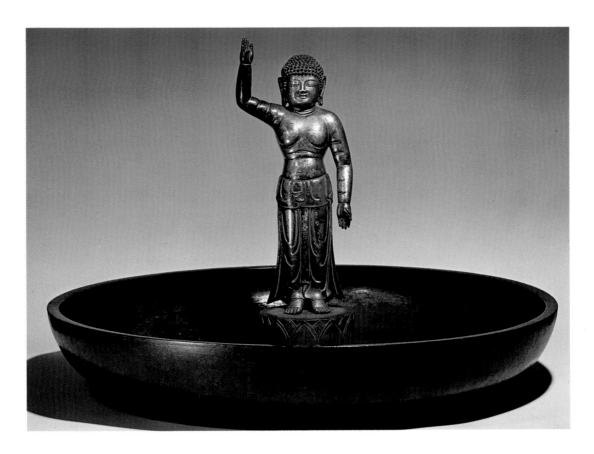

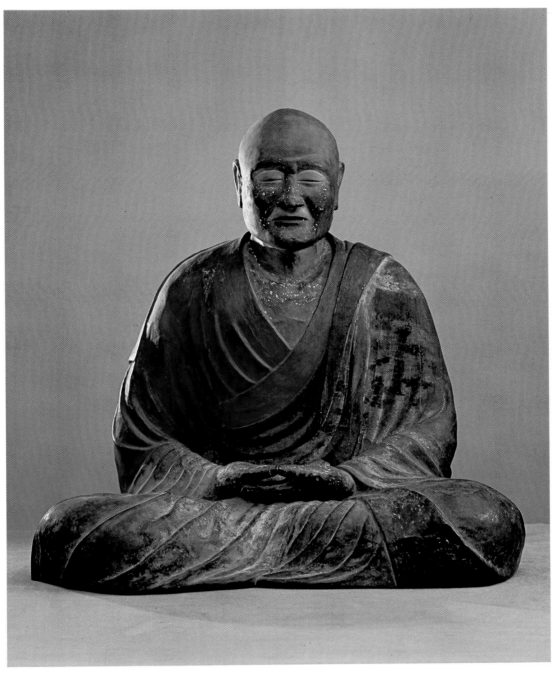

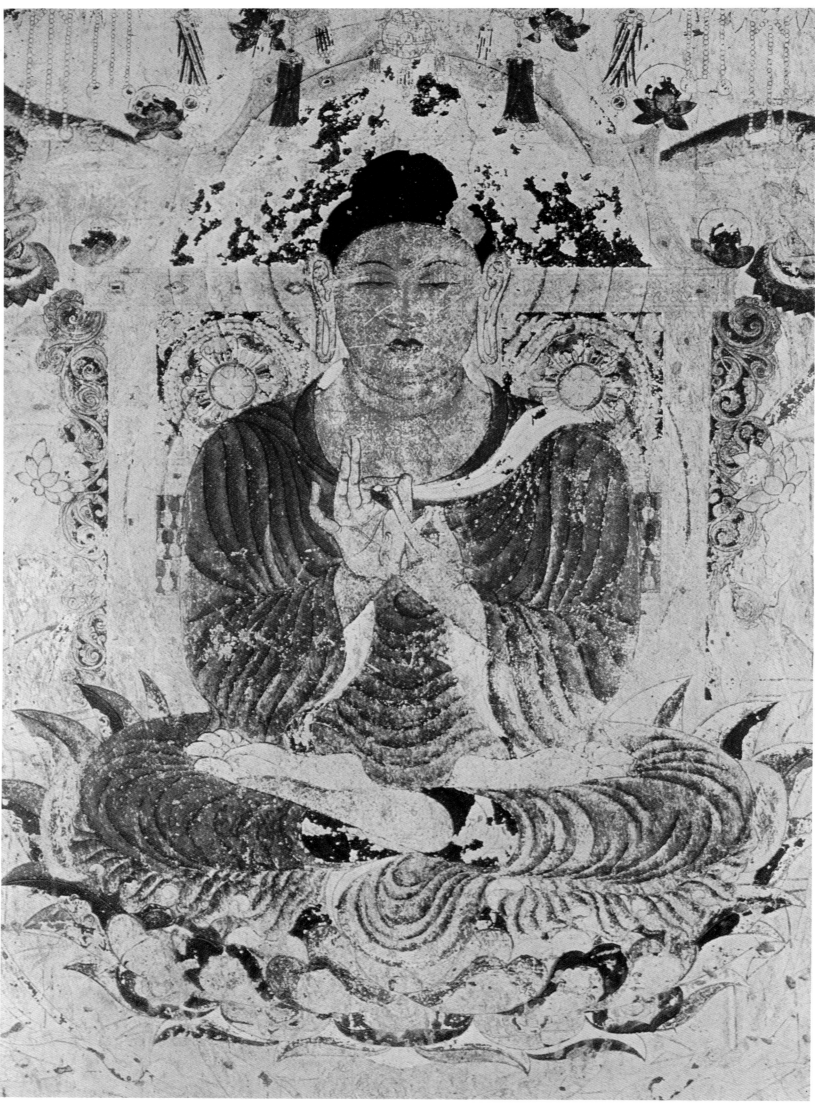

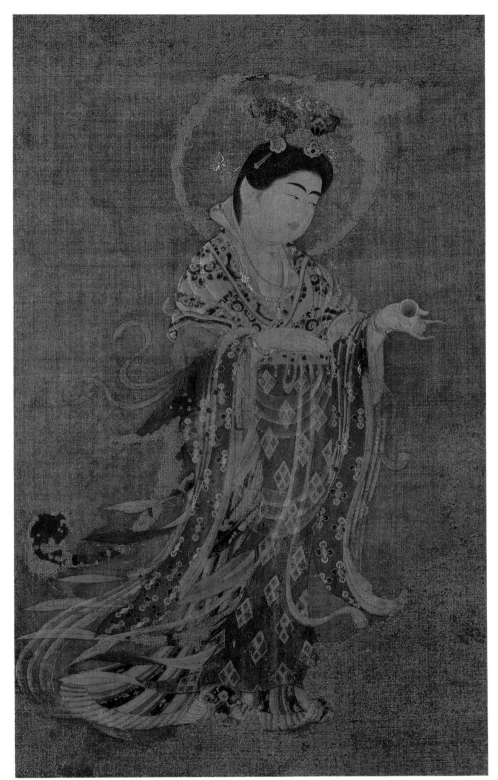

Kichijō-ten (Sanskrit: Mahāśrī), the Buddhist goddess of wealth and beauty, was frequently given the guise of a handsome court lady. The unknown artist has lavished great care in depicting the jewelry with gold leaf and showing the embroidery patterns in the exquisite T'ang-style costume. Note, too, the slight undulation in the transparent gauze veil. The goddess is shown stepping forward, holding the "sacred pearl of happiness" in her left hand. The hemp was prepared with a priming of white, on which the drawing, the colors, and the final outlines were applied in turn.

Pl. 31
Kichijō-ten,
Nara period, 8th century,
color on hemp.
53.3 × 32.0 cm.
Yakushi-ji, Nara.

Pl. 30 (*opposite*)
The Land of Amida,
Nara period,
late 7th or early 8th century,
wall painting, painted in color on
white clay priming.
313.0 × 260.0 cm.
Formerly in the Kondō,
Hōryū-ji, Nara.

This painting, all but destroyed by the disastrous fire of 1949, has usually been taken to represent the Western Pure Land, the Land of Amida (Sanskrit: Amitābha). The painting shows Amida in the center, seated on lotus flowers with his hands forming the *mudrā* ("finger sign") of "turning the wheel of Buddhist Law," that is, explaining the teachings of Buddha. The contours of the figure are drawn with fine and even lines, along which heavy shading in the Indian manner is applied.

受作此言已即便捨
水奈將世尊哩駄受
之說偈呪顉

若人能布施　斷除於慳貪
若人能忍辱　永離於瞋恚
若人能造善　則遠於愚癡
能具此三行　速至般涅槃

若有貧窮人　无財可布施
見他修施時　而生隨喜心
隨喜之福報　與施等元異

介時婆羅門大臣及
餘人民見王奉施如
來僧伽藍皆悉踊躍
生隨喜介時頻北
心大歡喜頭面礼已
婆羅王施僧伽藍已
退還所住閻浮提中

Pl. 32
Inga-kyō scroll,
Nara period, 8th century,
text in ink, illustrations in
color on paper.
26.4×1098.6 cm.
Tokyo University of Art.

The *Inga-kyō*, or to be more exact the *Kako Genzai Inga-kyō* (Sutra of Past and Present Karma), is a Buddhist scripture in four volumes describing the lives of the Buddha Shaka in his past and present incarnations. This particular set consists of eight scrolls, of which only parts have survived, now scattered in different collections. They are the oldest extant examples of Japanese painting in the horizontal scroll form, and are the forerunners of the unique Japanese art form known as *e-makimono* ("picture scroll" or "scroll painting"). The stylistic archaicism could reflect an older prototype, possibly of the Six Dynasties. In the scene shown here, King Bimbisāra donates the Veṇuvana, or Bamboo Park Monastery, to the Buddha.

垢自然香淨鞞者得
聽惡者能言盲者得
視狂者得正拘癖疾
病普皆除愈枯木菱
華腐草榮秀凋池曾
瀾香風清靡鳳雀孔
翠鳥鷹鴛鴛異類
衆鳥繽紛翔集出和
雅音有如是等種種
祥瑞既入城已典頻
此娑羅王俱注竹園
尒時諸天滿虛空中
時王即便手執寶祇
感以香水灑如來前
而作是言我今以此竹
園奉上如來及此丘
曾催頻襄慈為我納

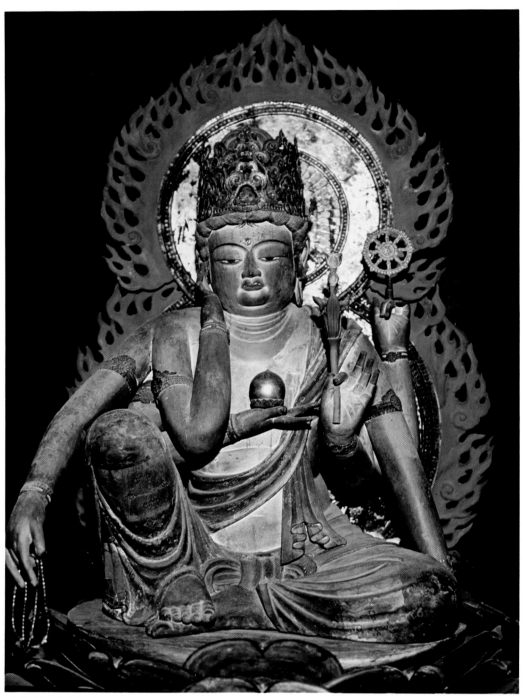

Pl. 33
Nyoirin Kannon,
Heian period, 9th century,
wood, painted.
H. 108.8 cm.
Kanshin-ji, Osaka.

This image embodies the spirit of Esoteric Buddhism, combining sensuous enchantment and spiritual mystery. Except for the raised knee and six arms, the statue is carved out of a single block (*ichiboku*) of Japanese cypress. The preservation of the richness of the color is probably due to the fact that the statue has been piously kept in its shrine for centuries as a sacred "hidden image." Despite the supernatural aspect of its six arms, the figure is represented with a certain voluptuous, feminine charm. The modeling of the body is ample and the drapery folds are firmly carved in the style known as "rolling waves" (*hompa*), with deep and assured chisel work.

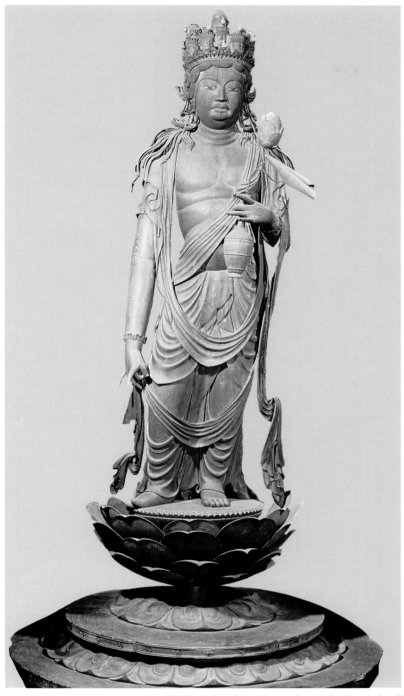

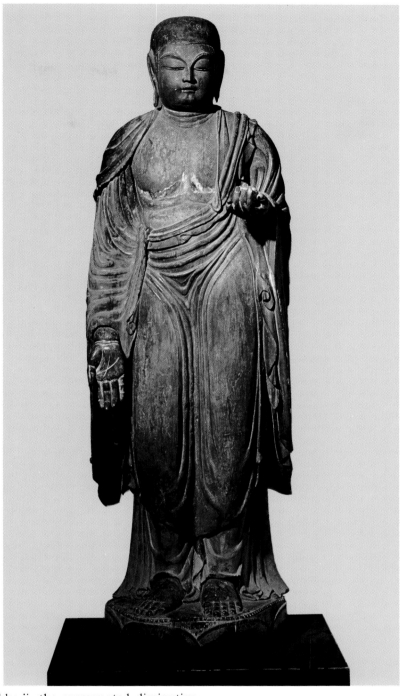

Pl. 34
Eleven-headed Kannon,
Heian period, 9th century,
wood, unpainted.
H. 100.0 cm.
Hokke-ji, Nara.

In this, the principal statue in Hokke-ji, the surmounted diminutive heads and the left hand were carved separately, but the rest, including the right arm, the veil draped about the body, and the main portion of the lotus pedestal, was carved out of a single block of wood. The statue is undecorated except for the painting of the features. The beautiful human face of the Kannon, the ample body, and the sharpness of the carving all proclaim the style of the ninth century.

Nichira was a Buddhist priest who came to Japan from Korea during the Asuka period. It is not clear, however, why this statue came to be known as Nichira, since iconographically it seems more likely to be Jizō Bosatsu (Sanskrit: Kṣitigarbha). If the latter identification is correct, it would be one of the oldest Jizō statues in Japan. The image and the central part of the lotus pedestal are carved from a single large block of cypress wood. The asymmetric yet well-balanced pose and the parallel folds of the drapery make this one of the more naturalistic statues of the period. Originally the statue was painted with colors, which have now almost all disappeared. The hands are later replacements.

Pl. 35
Statue of Nichira,
Heian period, 9th century,
wood, painted.
H. 144.0 cm.
Tachibana-dera, Nara.

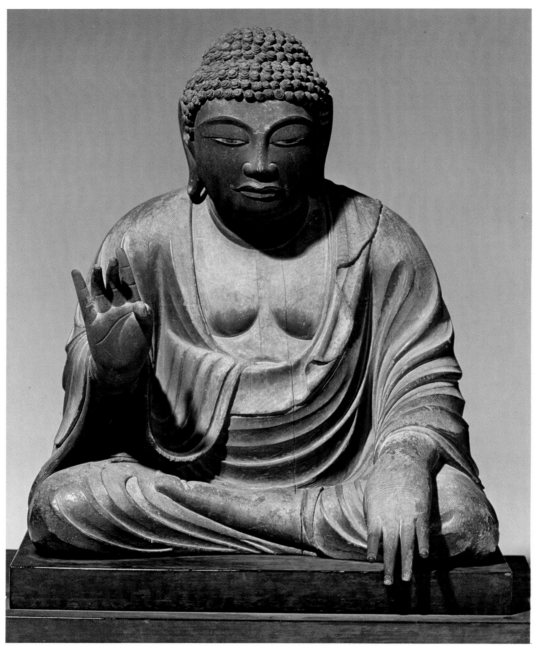

Pl. 36
Miroku Bosatsu,
Heian period, 9th century,
wood.
H. 39.0 cm.
Tōdai-ji, Nara.

This statue has a power and spiritual intensity that belies its small size. With the exception of the hands and the spiral locks of hair (*rahotsu*), it is carved out of a single block of Japanese cypress wood. The sweeping curve of the eyebrows, the long upturned eyes, and the sharply ridged drapery folds in the "rolling wave" style are characteristic of wood sculpture of the early Heian (Jōgan) period. The strong chisel work in the deeply carved ears and the treatment of the left hand, with the middle fingers reaching lower than the undersurface of the knees, are particularly noteworthy.

Jōchō was a great artist who broke away from the tradition of the previously dominant T'ang style and established a style of sculpture more expressive of native Japanese taste. The famous statue illustrated here is unfortunately the only authentic example of his work still extant. The expression of the image, which is tender and merciful, differs from that of older statues in that the eyes are directed down toward the worshiper, establishing a direct and intimate psychological relationship between him and the Buddha.

Pl. 37 (*opposite*)
Amida Nyorai,
by Jōchō (?–1057),
Heian period, 1053,
wood covered with gold leaf.
H. 295.0 cm.
Phoenix Hall (Hōō-dō),
Byōdō-in, Kyoto.

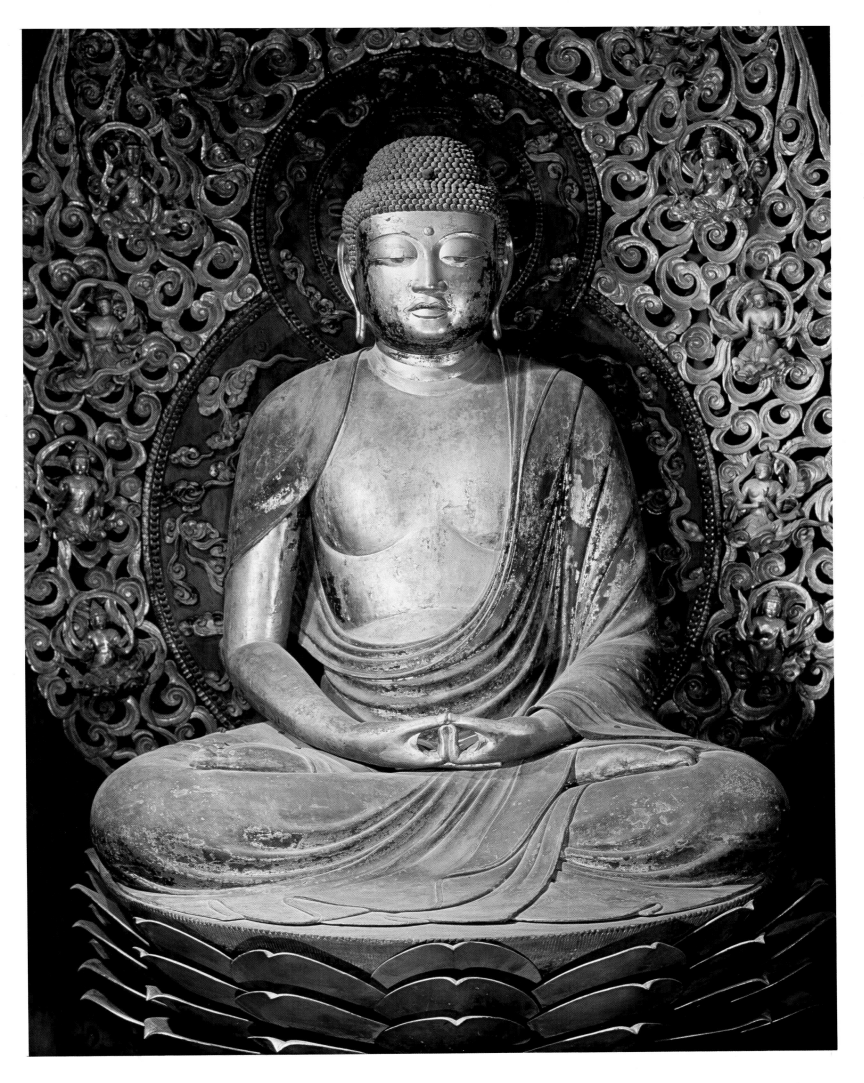

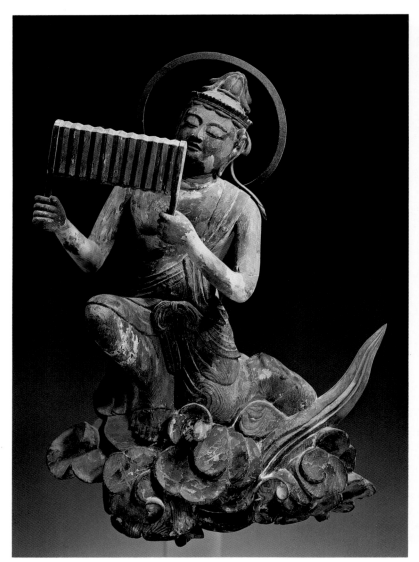 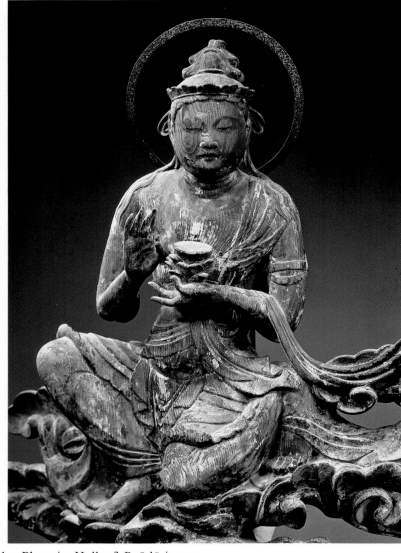

Pls. 38, 39
Bodhisattvas on clouds,
by the school of Jōchō,
Heian period, 1053,
wood, painted.
H. app. 50.0 cm.
Phoenix Hall (Hōō-dō),
Byōdō-in, Kyoto.

On the walls near the ceiling of the Phoenix Hall of Byōdō-in are affixed fifty-two wooden images of celestial beings on clouds, dancing, playing music, praying, or making offerings. These animated figures are virtually carved in the round, but with suppressed treatment of the third dimension which is subtle and well suited to the relieflike arrangement on a plane. Though badly discolored now, the images were originally painted in gay pigments and decorated with threadlike strips of gold leaf (kirikane).

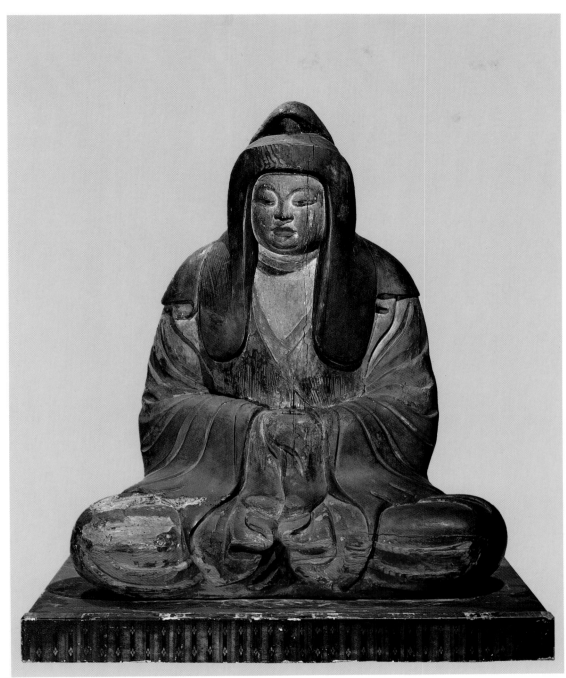

This Shinto goddess is carved of Japanese cypress wood in the "single block" technique. As most Shinto deities are conceived of as ancestors of the Japanese people, they are represented realistically as human beings, usually with costumes of the period in which the statues were made. At the same time, the artists tried to give them a godlike dignity either by expression or by gesture.

Pl. 40
Shinto goddess,
Heian period, 9th century,
wood, painted.
H. 87.6 cm.
Matsunoo Shrine, Kyoto.

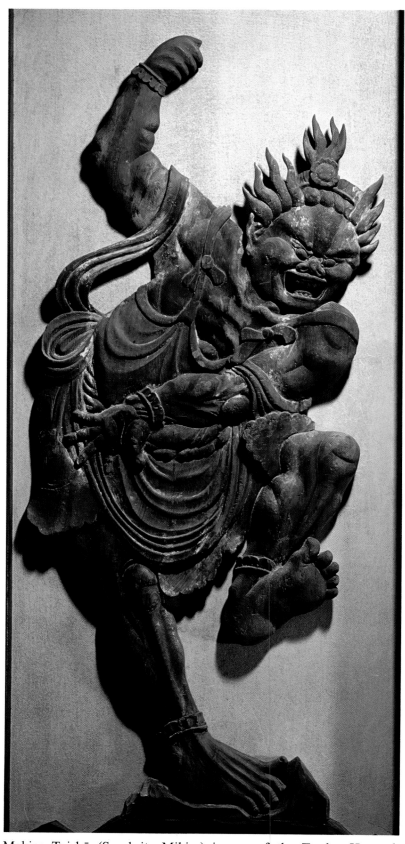

Pl. 41
Mekira Taishō,
Heian period, 10th century,
wood, carved in low relief
and painted.
H. 100.3 cm.
Kōfuku-ji, Nara.

Mekira Taishō (Sanskrit: Mihira) is one of the Twelve Heavenly
Generals (Jūni Shinshō), who are either manifestations or messengers
of Yakushi Nyorai, and are in fact the guardians of the Buddhist
faith. The low-relief carving in Japanese cypress wood of this image
is sharp and fluent.

The blue of Fudō's body and the green of his loincloth and the rock
pedestal contrast beautifully with the dark and bright reds of the
flames, giving an impression of the sublime and the austere. The
leaping tongues of fire are depicted in a realistic and vivid manner.
On the basis of records at Daigo-ji in Kyoto, the painting might be
attributable to Genchō, a priest-painter at Gangō-ji in Nara who
was active during the last part of the tenth century.

Pl. 42 (*opposite*)
Fudō Myō-ō (Blue Fudō)
and two messengers,
Heian period, 11th century,
color on silk.
203.3 × 148.5 cm.
Shōren-in, Kyoto.

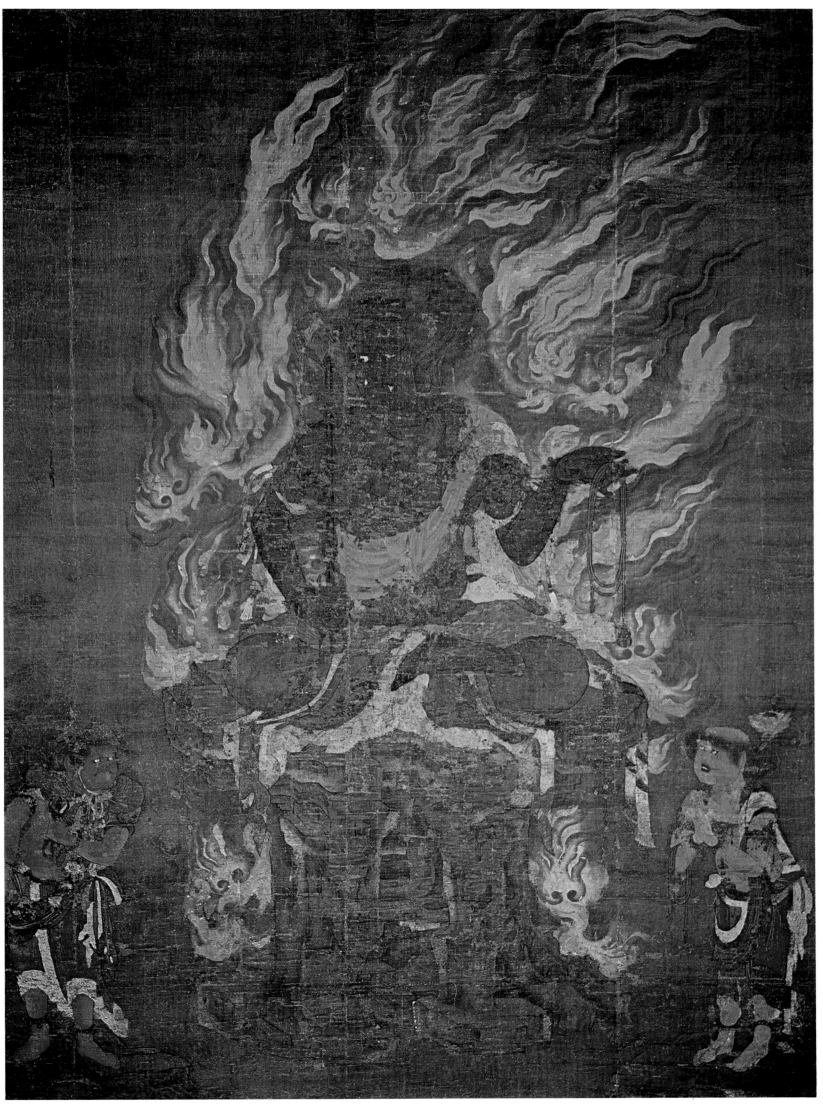

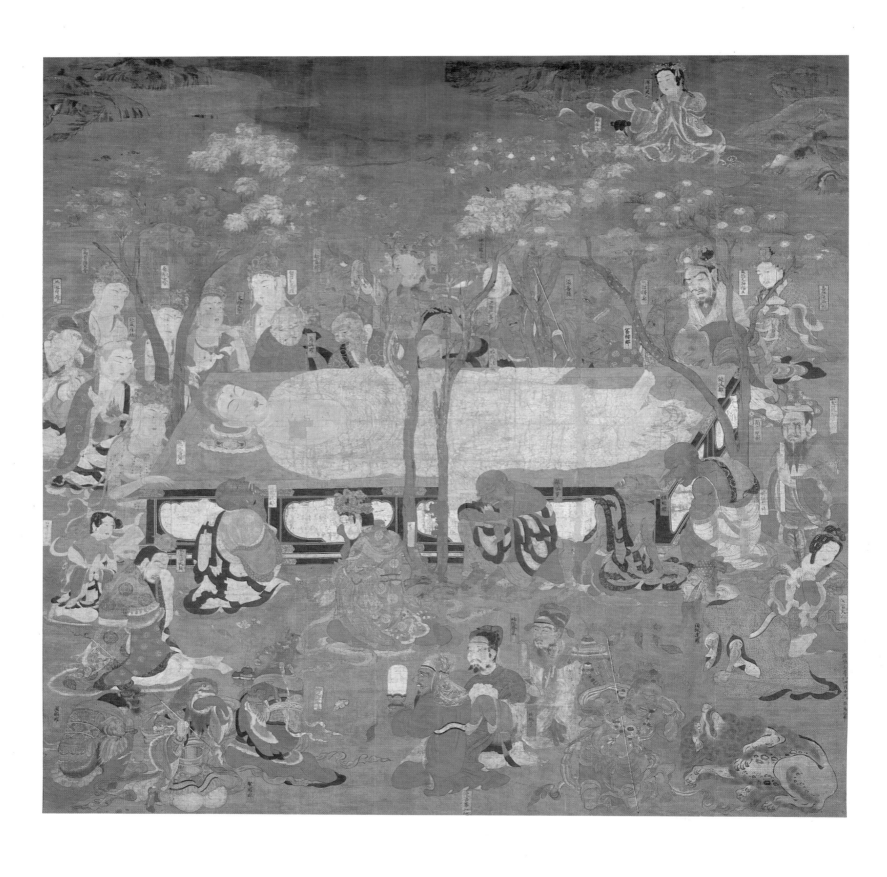

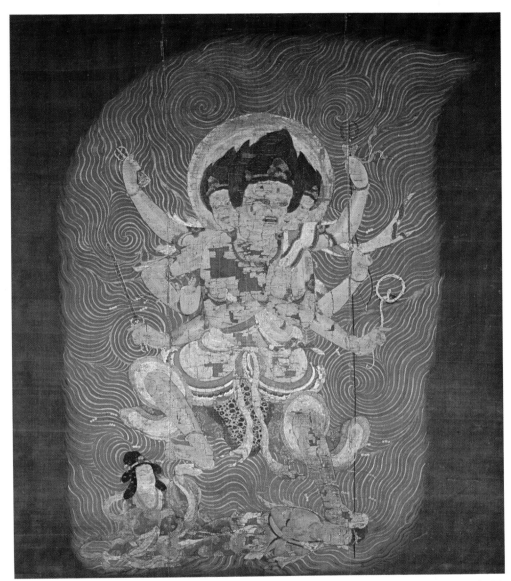

Gōsanze Myō-ō (Sanskrit: Trailokyavijaya) is one of the Go Dai Myō-ō (Five Great Rajas), of which the central divinity is Fudō Myō-ō (Acala). Although this painting of Gōsanze has a fierce face and a bluish body, it still expresses the innocence and softness of a young child. There were wood sculptures of the Go Dai Myō-ō in Kyōōgokoku-ji upon which the paintings were based.

Pl. 44
Gōsanze Myō-ō,
attributed to Kakunin,
Heian period, 1127,
color on silk.
154.0 × 129.3 cm.
Kyōōgokoku-ji (Tō-ji), Kyoto.

Pl. 43 (*opposite*)
Nirvana,
Heian period, 1086,
color on silk.
266.2 × 270.9 cm.
Kongōbu-ji, Kōya-san,
Wakayama.

Nirvana paintings are illustrations of the Buddha Shaka (Śākyamuni) attaining Nirvana, or more exactly, *parinirvāṇa* (absolute extinction of individual existence) ". . . under the *śala* trees near the River Vati," as described in the sutras. Early paintings dealing with this subject are rather rare, and thus this painting is important as it is the oldest surviving example of nirvana painting in Japan. Moreover, the fact that it is dated in the inscription allows it to serve as a standard of Buddhist painting in the Heian period. Around the incumbent figure of Shaka are various bodhisattvas, guardian demigods, the Ten Great Disciples, a king and his court and other human beings, and even a lion representing the animal kingdom. In the upper right Māyā, Shaka's mother, hurries down from heaven. The Buddha and bodhisattvas have soft vermilion contours of unvarying breadth, while the other figures are drawn with strong black lines with pronounced touches. In this way a contrast is effected between the stillness—that of nirvana—at the center and the commotion and despair of the surroundings.

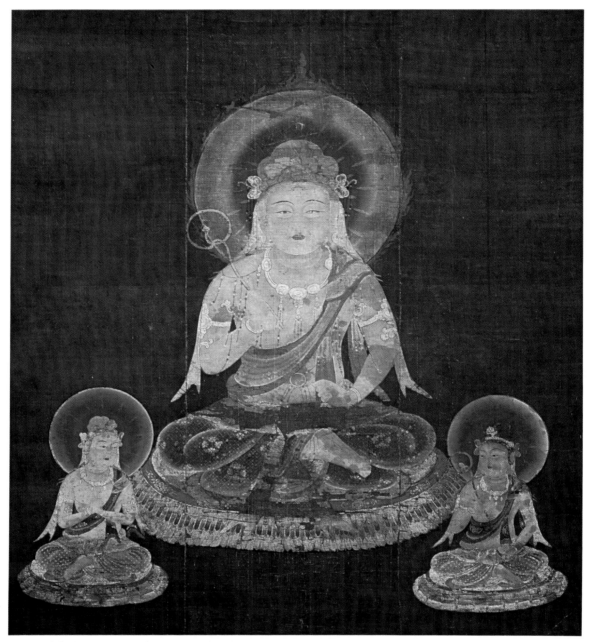

Pl. 45
Sui-ten,
attributed to Kakunin,
Heian period, 1127,
color on silk.
145.2 × 127.2 cm.
Kyoto National Museum.

Sui-ten (Sanskrit: Varuṇa), the god of the water realm, is one of the Twelve Devas (Jūni-ten). The tortoise on which Sui-ten is usually mounted is omitted here, and the deity is shown seated cross-legged on a round seat, holding a snake, which is his symbol, in his right hand. The body parts of this painting, and of the remaining eleven in the series, are painted in a faint pink color outlined with vermilion. The more conspicuous of the decorative patterns on the draperies and also some of the metal ornaments such as the crown, necklaces, and bracelets are applied in the *kirikane* technique of cut gold or silver leaf.

Kujaku Myō-ō (Sanskrit: Mahāmayūrī), or the Peacock King, is a god of Esoteric Buddhism worshiped in the Heian period as a benefactor who could bring about the termination of various calamities. The most fervent prayers addressed to Kujaku Myō-ō were for rain, which was, of course, of vital importance for crops. Here the god's clothing, the lotus pedestal, and the peacock feathers are all painted in rich colors, over which elaborate decorative patterns are applied in "cut gold" (*kirikane*).

Pl. 46 (*opposite*)
Kujaku Myō-ō,
Heian period, 12th century,
color on silk.
148.8 × 99.8 cm.
Tokyo National Museum.

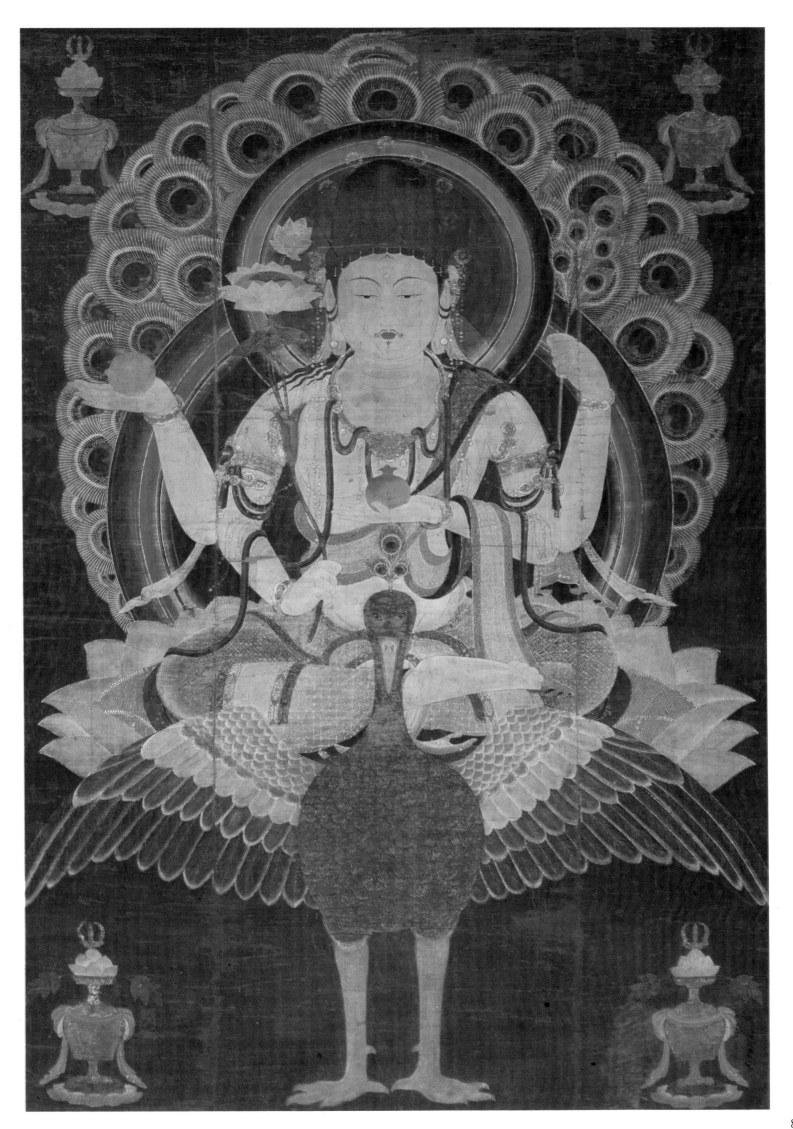

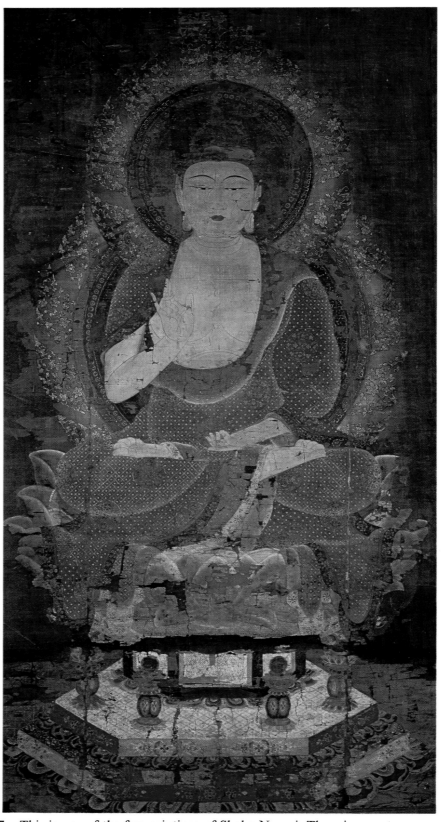

Pl. 47
Shaka Nyorai,
Heian period, 12th century,
color on silk.
159.4 × 85.5 cm.
Jingo-ji, Kyoto.

This is one of the few paintings of Shaka Nyorai. There is an extreme sensitivity to detail in this work, for example, the area of lighter gradation around the edge of the garment as well as along the drapery folds, perhaps for the purpose of creating a sense of volume. The restraint in the decoration marks it for a work of the late Heian period, and it is thought to date from around the same time as Plate 45, since the painting style is similar. Usually Shaka is represented with the two bodhisattvas Monju and Fugen, and the fact that he appears alone in this painting makes it a particularly rare example.

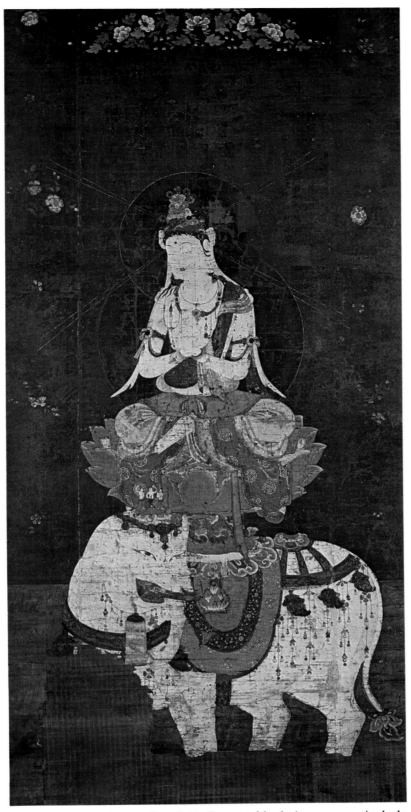

The bodhisattva Fugen (Sanskrit: Samantabhadra) was a particularly popular Buddhist divinity among the court ladies of the Heian period because he was the protector of devotees of the *Hoke-kyō* (*Lotus Sutra*), which promised the salvation of women. Accordingly, images of Fugen were carved or painted very frequently in the eleventh and twelfth centuries, commissioned by the aristocracy of the time, among whom the influence of women was very strong. In this painting, the clothing and ornaments on Fugen's immaculate white body are decorated with the most delicately harmonized color combinations.

Pl. 48
Fugen Bosatsu,
Heian period, 12th century,
color on silk.
159.4 × 74.6 cm.
Tokyo National Museum.

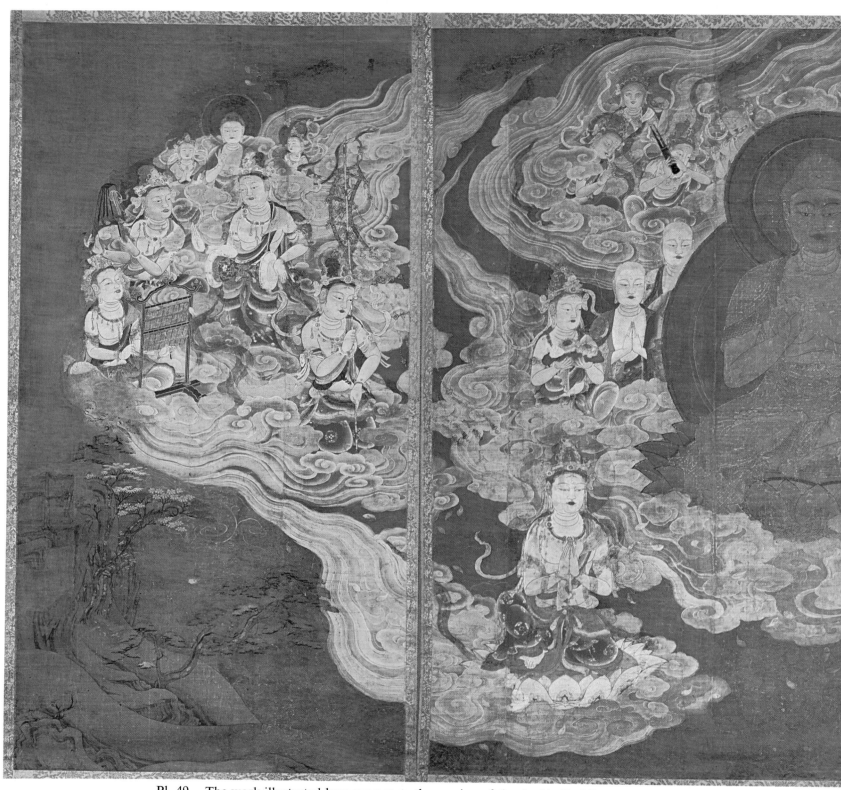

Pl. 49
Amida Raigō (The Coming of
Amida in Welcome),
Heian period, 12th century,
color on silk.
H. 210.0 cm.; W: middle scroll
210.0 cm., left and right scrolls
105.0 cm.
Jūhakka-in of the Yūshi
Hachiman Association,
Kōya-san, Wakayama.

The work illustrated here represents the coming of the Amida Buddha
to this world to welcome the soul of a deceased devotee and is the
most famous of all the paintings on this subject, which was very
popular in the late Heian and Kamakura periods. The concept of
raigō existed in China, but the subsequent popularity of the doctrine
in Japan is due to its enthusiastic propagation by the priest-painter
Eshin, a devotee of the cult of Amida.

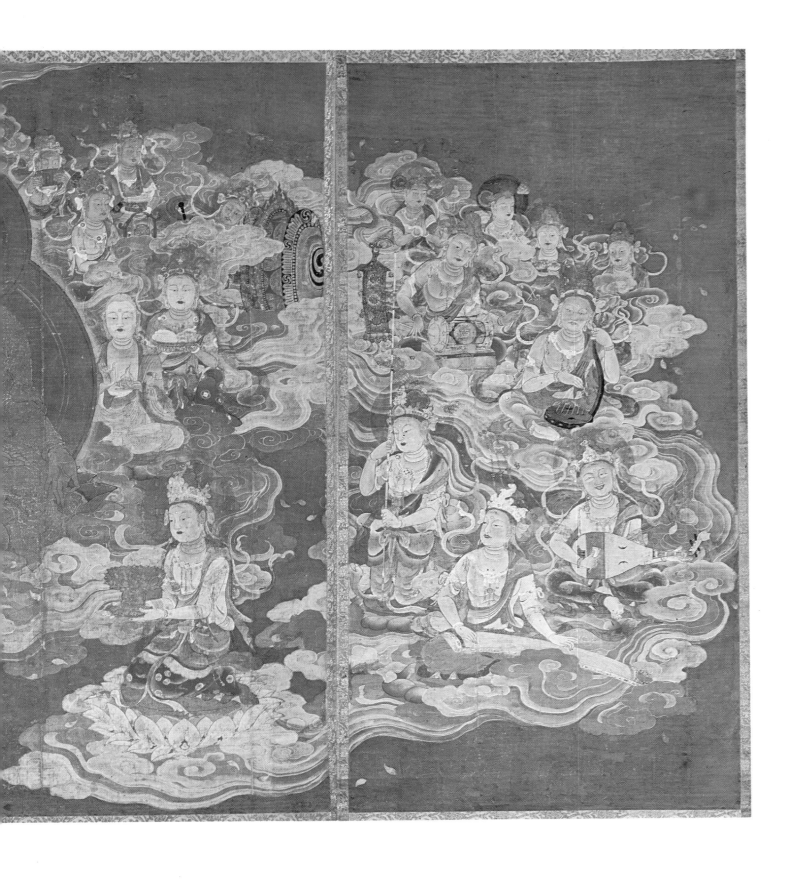

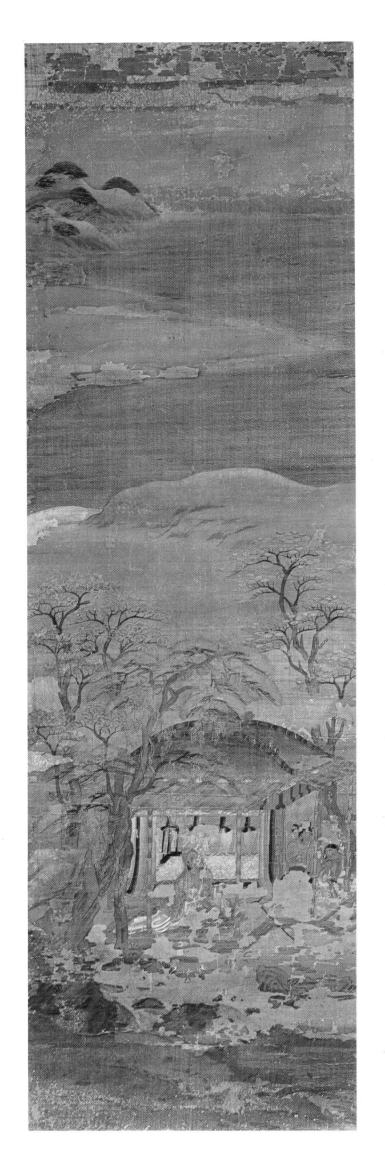

Pl. 50 (*opposite*)
Landscape with figures
(*Senzui-byōbu*),
Heian period, 11th century,
two panels of a six-fold screen,
color on silk.
Each panel: 146.4 × 42.7 cm.
Kyoto National Museum.

The interiors of the palaces and houses of the nobility in the Heian period were often decorated with painted sliding doors and folding screens. Before the tenth century these paintings depicted either incidents in the lives of persons famous in Chinese history and literature, or Chinese-style landscapes; thereafter, Japanese artists began to paint scenes from nature and genre scenes of the four seasons, or famous scenic views in Japan. For more official or ceremonial buildings, however, even after the tenth century, Chinese-style paintings (*kara-e*) continued to be favored. This *kara-e* screen, known as "*Senzui-byōbu*" (Mountain and Water Screen) is the only surviving example of screen painting of the Heian period. In the center, an old poet sits composing poems under a pine tree outside a cottage. It has been interpreted as representing the life of happy seclusion enjoyed by the great T'ang poet Pai Lo-t'ien, popular in Japan in Heian times.

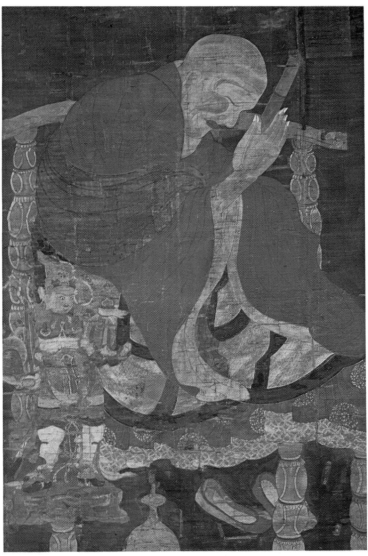

This portrait of Zemmui is one of a series of portraits of the "Ten Patriarchs of the Tendai Sect." Zemmui was an Indian monk who renounced the world, studied Esoteric Buddhism under Ryūchi, became a priest, and during the T'ang dynasty traveled to China. In painting this portrait the Japanese artist must have copied a Chinese original, probably brought to Japan in the Heian period. The strong coloring, the most unusual composition, and certain interesting decorative treatments somewhat foreign to Japanese aesthetics all suggest derivation from a Chinese prototype. In this painting, Zemmui is shown holding a sutra scroll, and the guardian god Tamon-ten (Vaiśravaṇa) appears in order to protect the patriarch.

Pl. 51
Portrait of the priest Zemmui,
Heian period, 12th century,
color on silk.
162.2 × 75.3 cm.
Ichijō-ji, Hyōgo.

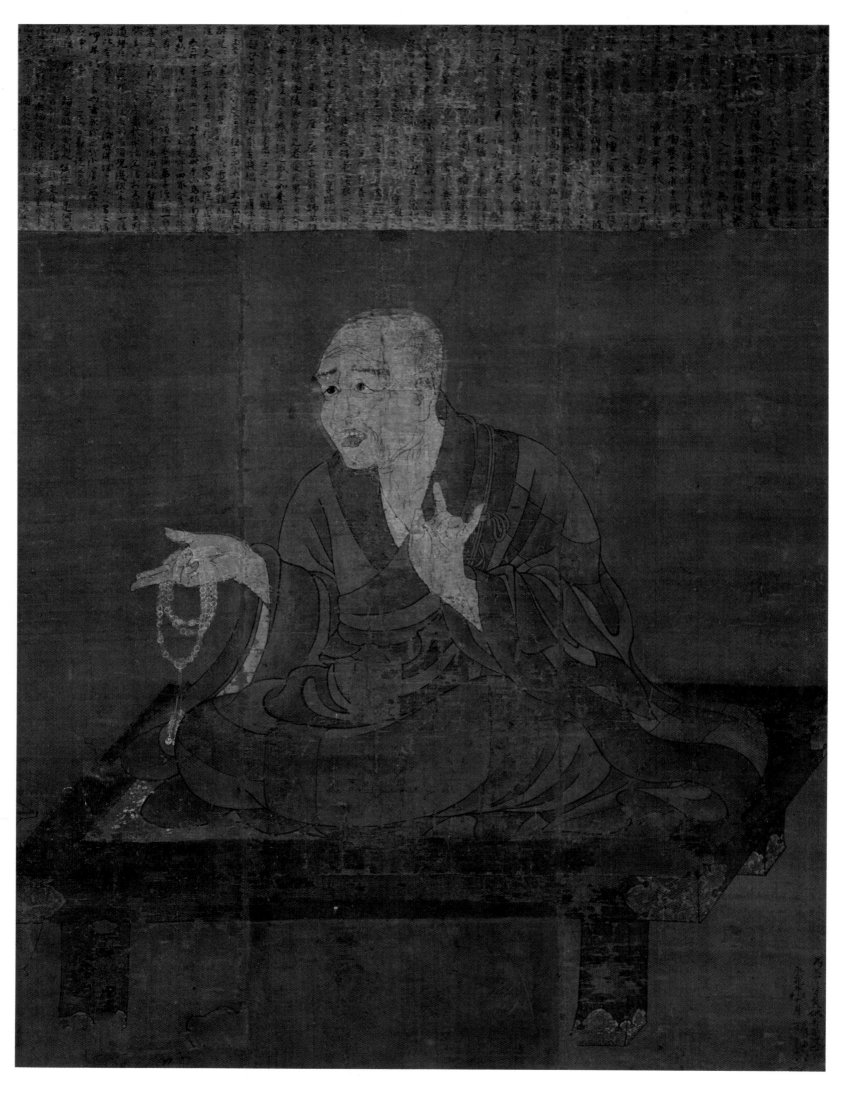

The *Genji Monogatari* (*The Tale of Genji*) is a series of romantic love stories in fifty-four chapters written by the court lady Murasaki Shikibu in the early eleventh century. The *Genji Monogatari E-maki* (scroll illustrating the *Genji Monogatari*), painted during the first half of the twelfth century, is the oldest example not only of the illustrations of this work but also of all existing scroll paintings treating such romances. Each segment illustrates between one and three scenes from each chapter. It is thought that the work originally consisted of some eighty to ninety scenes in about ten horizontal scrolls. However, only nineteen sections of painting and some fragmentary remnants of text now·remain. The third section of the Kashiwagi Chapter reproduced here shows the *fukinuki yatai* ("roofless house") perspective.

Pl. 53
Genji Monogatari E-maki:
Section III of the Kashiwagi Chapter,
Heian period, 12th century, section of a scroll painting, color on paper.
21.9 × 48.1 cm.
Tokugawa Reimeikai Foundation, Tokyo.

Pl. 52 (*opposite*)
Portrait of the priest Gonzō,
Heian period, 12th century,
color on silk.
166.4 × 136.4 cm.
Fumon-in, Kōya-san,
Wakayama.

Priest Gonzō (d. 827) of Sekien-ji was the teacher of the famous exponent of Esoteric Buddhism Kōbō Daishi. The latter wrote a eulogy for his master which is inscribed in the upper part of the painting shown here. This work is evidently a faithful copy of an earlier portrait which presents something of the technique of the ninth-century original.

Pls. 54, 55 (*opposite and below*)
Shigi-san Engi E-maki,
Heian period, 12th century,
color on paper.
H. 31.7 cm.
Chōgosonshi-ji, Nara.

These Shigi-san scroll paintings (*e-makimono*) are distinguishable from the Genji scrolls by the predominant use of line drawing, to the virtual exclusion of color, and by the almost symbolic illustrations of the story. The *Shigi-san Engi E-maki* comprises three scrolls that recount the legends about Myōren, a Buddhist monk who established the temple of Chōgosonshi-ji on Mt. Shigi. The scene shown to the left is from the second scroll entitled "The Story of Exorcism for the Engi Emperor." It tells the story of Myōren dispatching a boy clad in a robe of swords (Ken-no-Gohō), upon sight of whom in a vision the emperor duly recovered from his illness. The scene shown below is from the first scroll, known as "The Story of the Flying Granary," illustrating the story of a granary flying through the air on top of Myōren's magic alms bowl. The consternation on the faces of the crowd is particularly well depicted.

Kōzan-ji owns a set of four scroll paintings in ink known as *Chōjū Giga* ("Animals at Play" or "The Animal Scrolls") showing anthropomorphic animals of various kinds playing games, engaging in sports, or frolicking in some humorous or mischievous way. Illustrated here is a scene showing archery practice, where the target is a lotus leaf, and a hare chasing a monkey. In some parts of the scrolls there is a note of sarcasm, but it is never too obvious or vulgar. All these representations are executed in free-flowing, animated line drawing in black ink. The set has traditionally been attributed to Kakuyū (popularly known as Toba Sōjō), a priest of Mii-dera (Onjō-ji).

Pls. 56, 57 (*overleaf*)
Chōjū Giga,
attributed to
Toba Sōjō (1053–1140),
Heian period, 12th century,
ink on paper.
H. 30.3 cm.
Kōzan-ji, Kyoto.

Pl. 58
Kegon Gojūgo-sho scroll,
Heian period, 12th century,
color on paper.
29.8 × 1287.0 cm.
Tōdai-ji, Nara.

The last chapter of the *Daihōkōbutsu Kegon-kyō* sutra recounts the pilgrimage of a young boy named Zenzai Dōji (Sudhana), who on the instructions of Monju Bosatsu (Mañjuśrī) traveled to the south and visited fifty-five saints, from each of whom he obtained one teaching. Shown here is the last section of the famous scroll painting, when he encountered Fugen Bosatsu (Samantabhadra) at an assembly under Birushana Nyorai (Vairocana) and attained Enlightenment. There is no text, but near each saint is a cartouche proclaiming his identity and including a poem in adoration of him.

This fan-shaped *Hoke-kyō* of Shitennō-ji is one of the most unusual of the numerous decorated versions of the sutra and consists of a set of booklets with fan-shaped pages. Many of the pictures show genre scenes of commoners, none of which has anything to do with the text of the sutra. The page reproduced here shows a scene at a communal well, with two women drawing water, a woman carrying a water pail on her head and dragging a reluctant child by the hand, and a woman traveler stopping by the well for a drink. The contour lines of the picture were printed by means of woodblocks and the coloring was added later by hand so that the pictures appear to be brush paintings.

Pl. 59 (*opposite above*)
Fan-shaped *Hoke-kyō*,
Heian period, late 12th century,
color on paper, with text in ink.
H. 25.6 cm., W. (upper) 49.1 cm.,
(lower) 19.1 cm.
Shitennō-ji, Osaka.

This decorated sutra scroll is popularly known as the *Ichiji Rendai Hoke-kyō* because each character (*ichiji*) of its text rests on the lotus flower pedestal (*rendai*). The frontispiece of the scroll illustrated here shows a private hall of worship where priests, a nobleman, and ladies are gathered together to recite the holy scripture. The naturalistic representation of the figures suggests that the date of this painting approaches the Kamakura period, although it still retains the grace and delicacy of the Heian period.

Pl. 60 (*opposite below*)
Ichiji Rendai Hoke-kyō,
Heian period, 12th century,
color on paper, with text in ink.
H. 21.1 cm.
The Museum Yamato Bunkakan,
Nara.

Pl. 61
Nezame Monogatari E-maki,
Heian period, 12th century,
color on paper.
H. 25.0 cm.
The Museum Yamato Bunkakan,
Nara.

Another example of romantic fiction written by an unknown lady of
noble birth from the Heian period is the *Nezame Monogatari* (Nezame
Tales). This work is noteworthy as the most graceful example of
scroll painting since the Genji scrolls. In such pictures of the Heian
romances the background depicts the seasonal aspects of the ro-
mance. Indeed, in many scenes of the *Nezame Monogatari E-maki,*
such as the frontispiece illustrated here, the figures are markedly
small compared to the scenery, which is emphasized.

The design of this lacquered box, the "Katawa-guruma" ("Broken
Wheels" or "Imperfect Wheels"), can be considered on two levels: it
obviously depicts a familiar scene at the time in Kyoto when the
wheels of oxcarts were soaked in a river to prevent the wood from
drying or cracking. However, the design also symbolizes the large
lotus leaf of the *Hoke-kyō* sutra. This is the oldest existing example
of a *maki-e* cosmetic box.

Pl. 62 (*opposite below*)
"Katawa-guruma" cosmetic box,
Heian period, 12th century,
wood, black-lacquered, with
maki-e and mother-of-pearl
inlay.
L. of cover, 22.4 cm., W.
30.6 cm. Total H. of box
13.5 cm.
Tokyo National Museum.

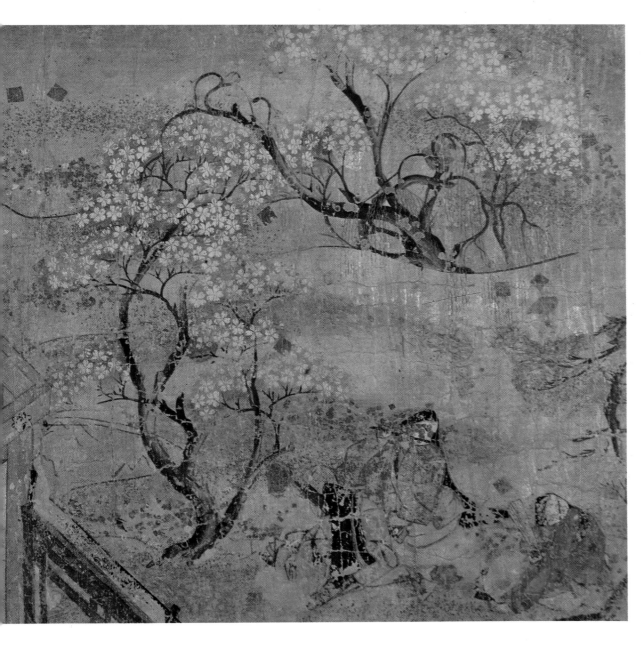

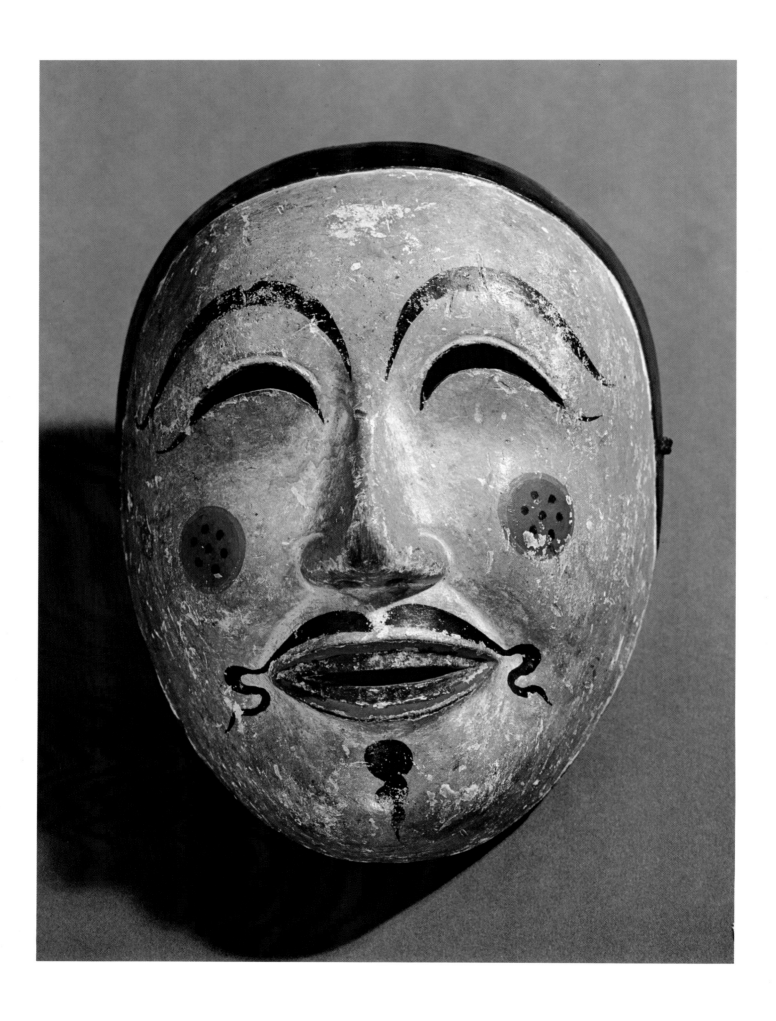

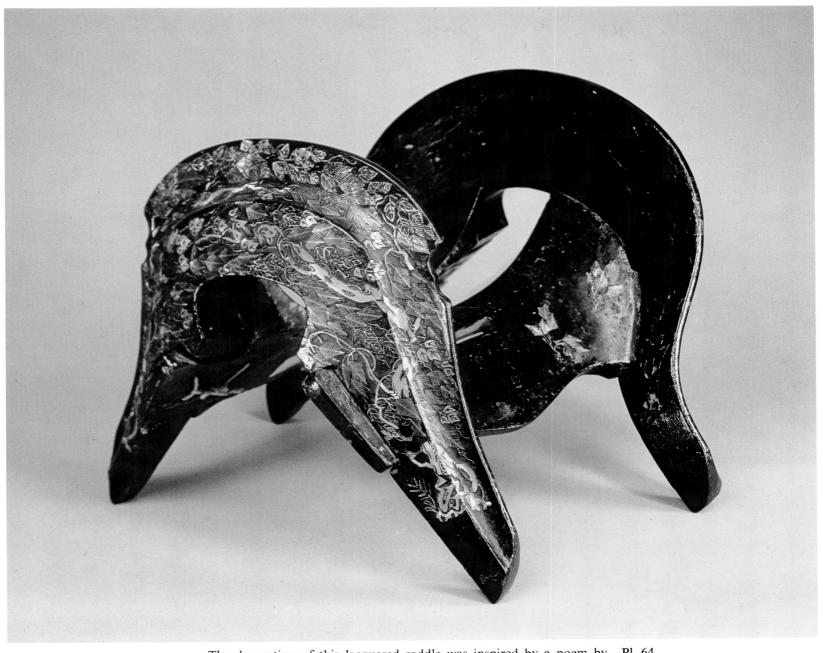

The decoration of this lacquered saddle was inspired by a poem by the priest Jichin, which, freely translated, means: "My love is like the autumn shower which failed to tint (with red) the evergreen pine. My heart trembles with despair, at the melancholy sound of the autumnal wind ruffling the ivy leaves of the Miyagino plain." Interspersed in the inlaid design of the windswept leaves and branches of a tree can be found characters in beautiful calligraphy signifying *shigure* (autumn shower), which calls to mind the implications of the poem.

Pl. 64
Saddle,
Heian period, 12th century,
wood, lacquered,
with mother-of-pearl inlay.
H. of pommel 32.3 cm., H. of cantle, 36.3 cm.
Eisei Bunko Foundation, Tokyo.

Pl. 63 (*opposite*)
"Shin Toriso" Bugaku mask,
Heian period, dated 1185,
wood, painted.
H. 23.1 cm., W. 17.8 cm.
Kasuga Shrine, Nara.

The mask dance known as Bugaku was introduced from China during the eighth century and contained elements from other Asian countries. It was popular among the aristocracy of the eleventh century and was frequently performed in the imperial court as well as at Shinto shrines and Buddhist temples. This period saw remarkable progress in the techniques of Buddhist wood sculpture, and fine Bugaku masks were produced with similar techniques. This mask shows a style derived from masks of southern Asia.

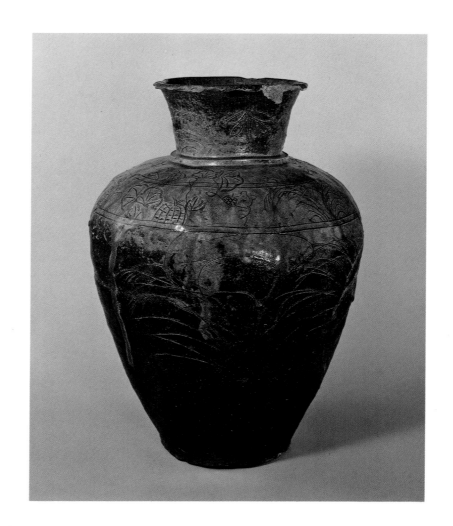

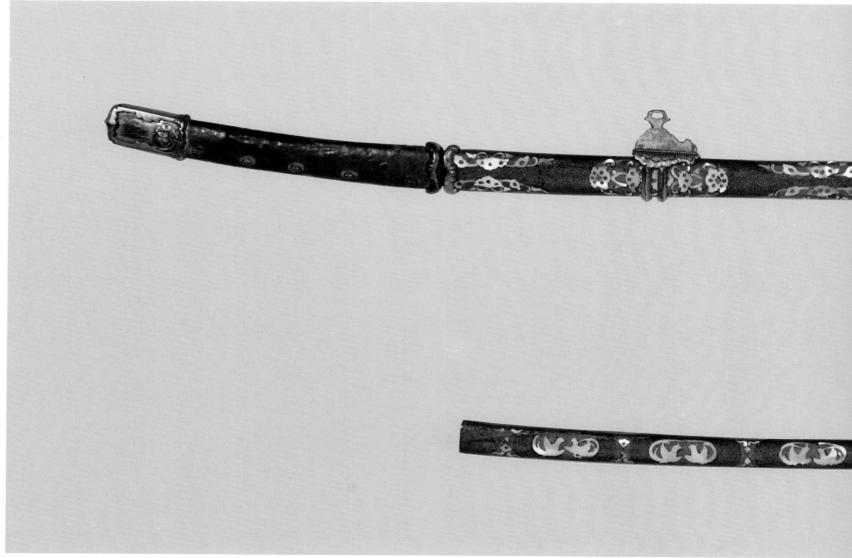

Pl. 65 (*opposite above*)
Jar,
late Heian to Kamakura period,
stoneware, natural ash glaze,
incised decoration.
H. 41.5 cm., D. of body 29.4 cm.
Keiō Gijuku University, Tokyo.

This very impressive jar was evidently made as a funerary urn for some distinguished personage. Its form, with a trumpet mouth, swelling shoulders, and tapering base, is one that recurs frequently in early Japanese ceramics, but the raised band at the base of the neck is unusual. The engraved decoration is quite exceptional and very beautifully executed, with a willow tree, melons, three pampas grass plants swaying in the breeze, leaf patterns, and a dragonfly on the neck of the jar. The dark green so-called natural ash glaze—an accidental effect caused by wood ash of the fuel falling on the surface of the pot during firing and combining with feldspar contained in the clay—has run in small rivulets down the sides in three or four places. It is considered to have been made during the late Heian to Kamakura period, and is a unique example of early Japanese pottery.

The hilt of the upper sword, which has lost its sword guard (*tsuba*), is covered with sheet silver, while the sheath is inlaid with mother-of-pearl designs of an imaginary flower similar to the peony. The lower sword, which has lost both sword guard and hilt, is inlaid with mother-of-pearl designs of facing phoenixes and flowers. These swords were votive gifts to the Itsukushima Shrine, and they are smaller than those customarily worn.

Pl. 66
Sword mountings,
late Heian period, 12th century,
lacquer, with mother-of-pearl
inlay.
L. of upper sword 64.2 cm.
Itsukushima Shrine, Hiroshima.

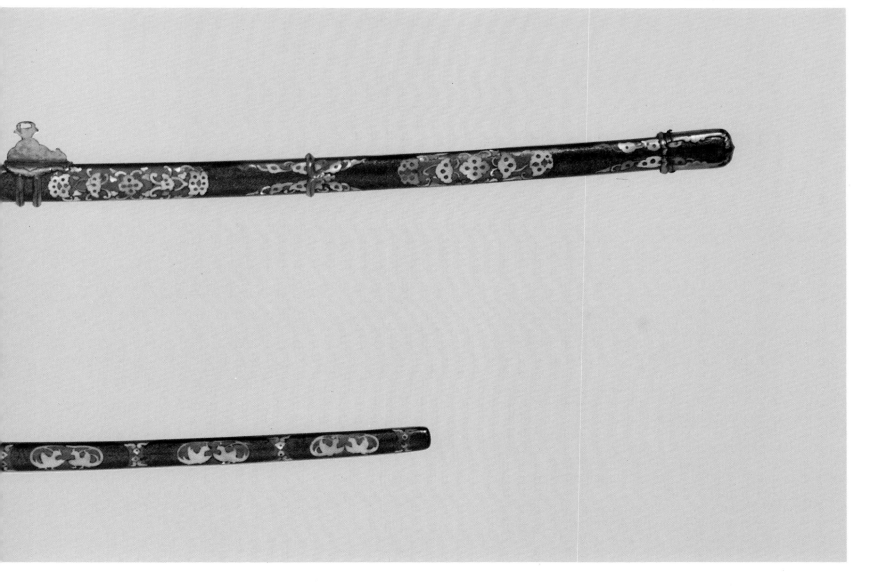

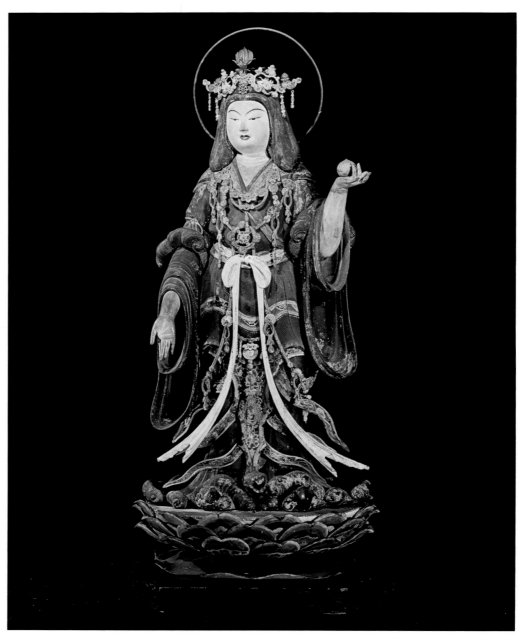

Pl. 67
Kichijō-ten,
Kamakura period, dated 1212,
wood, painted.
H. 90.0 cm.
Jōruri-ji, Kyoto.

This graceful statue of Kichijō-ten (Sanskrit: Mahāśrī), goddess of wealth, takes the form of a noblewoman of the Fujiwara period and was formerly attributed to that period. It is distinguishable from the elegant but comparatively simple style of Fujiwara, however, by the excessive decoration, which approaches the baroque. The gentle manner popular in late Fujiwara times was continued in the early part of the Kamakura period by the sculptor Kaikei. This statue is typical of his style, which evidently remained in favor notwithstanding the rise of the new, more vigorous approach of the Unkei school.

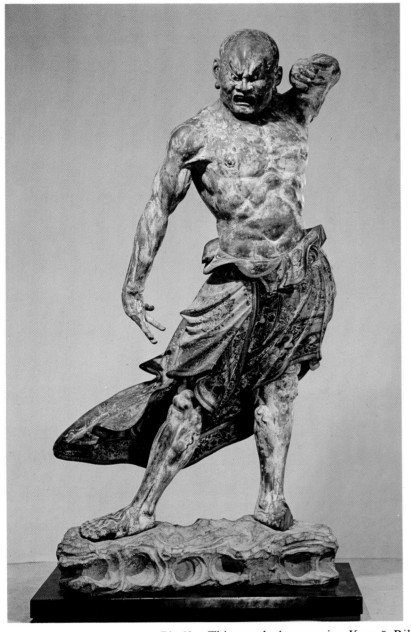

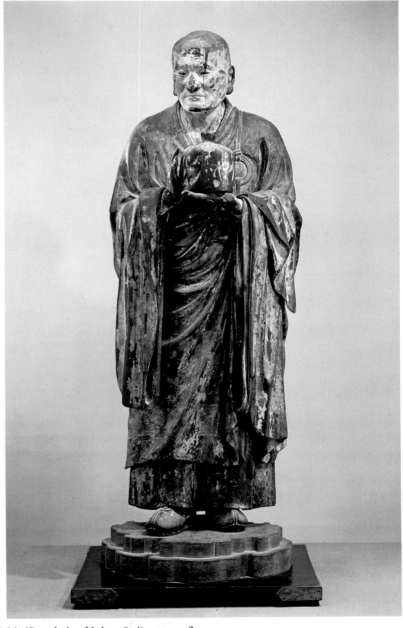

Pl. 68
Kongō Rikishi,
Kamakura period, 12th century,
wood, painted.
H. 161.5 cm.
Kōfuku-ji, Nara.

This nearly human-size Kongō Rikishi (Sanskrit: Vajrapāṇi), one of a pair in Kōfuku-ji, is unusually small. The body is painted red and the colored clothing is decorated with intricate designs; the inlaid eyes are of rock crystal. In the fashioning of this pair of statues the sculptor has given free play to his chisel and achieved an effect of exaggerated realism. The veins swollen with anger, the muscles bulging, and the tension of the skin emphasize the lifelike representation.

This famous image of Muchaku (Sanskrit: Asaṅga) is one of two attendants of Miroku (Maitreya) in the Hokuen-dō (North Octagonal Hall) of Kōfuku-ji. The trio was carved in 1208, together with a number of other statues, during the course of major restoration at Kōfuku-ji. The almost overpowering rendering of these two lofty-minded saints, in which neither technical hesitation nor premature rigidness of treatment are perceptible, is testimony to the artistic maturity of the sculptor.

Pl. 69
Muchaku,
by Unkei (d. 1223),
Kamakura period, 1208,
wood, painted.
H. 188.0 cm.
Kōfuku-ji, Nara.

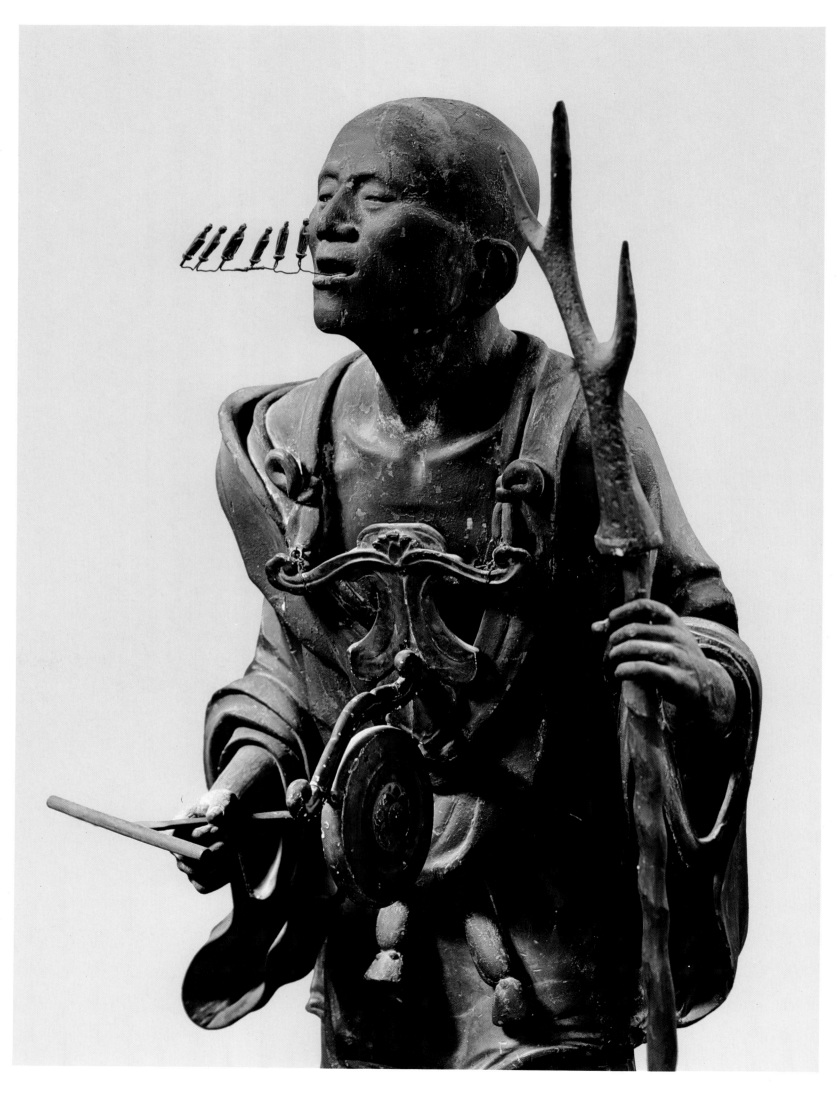

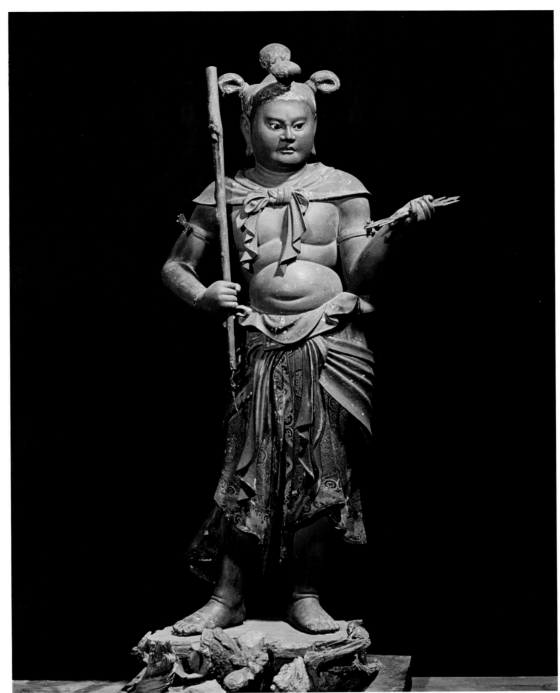

Seitaka-dōji is one of the eight "powerful pages" of Fudō, all of whom are represented as young boys. The statue, executed with a high degree of realism, seems to radiate health and energy. The fresh face and powerful yet still childlike body make this statue an excellent example of naturalistic Kamakura sculpture.

Pl. 71
Seitaka-dōji,
Kamakura period, 12th century,
wood, painted.
H. 103.0 cm.
Kongōbu-ji, Kōya-san,
Wakayama.

Pl. 70 (*opposite*)
The priest Kūya,
by Kōshō,
Kamakura period,
early 13th century,
wood, painted.
H. 117.6 cm.
Rokuharamitsu-ji, Kyoto.

Kōshō was the fourth son of Unkei, the famous Kamakura-period sculptor. This work is reputed to portray Kūya, founder of the temple of Rokuharamitsu-ji, who is said to have walked around the city of Kyoto invoking the name of Buddha as he mourned the death of his beloved deer. The animal's antler is on his walking-stick and its skin is wrapped around the priest's waist. The small images of the Buddha emerging from his mouth symbolize the chanting of prayers.

Pl. 72
Haya Raigō (The Rapid Coming of Amida and His Host in Welcome), Kamakura period, 14th century, color on silk. 144.3 × 155.8 cm. Chion-in, Kyoto.

This *raigō* painting is popularly known as the Haya ("rapid") Raigō because Amida and his heavenly host are depicted in strikingly swift motion as they descend to receive the soul of a devotee and transport it to paradise. The dying man is here shown as a monk with a shaven head. The artist has taken great care in the detail of the background landscape.

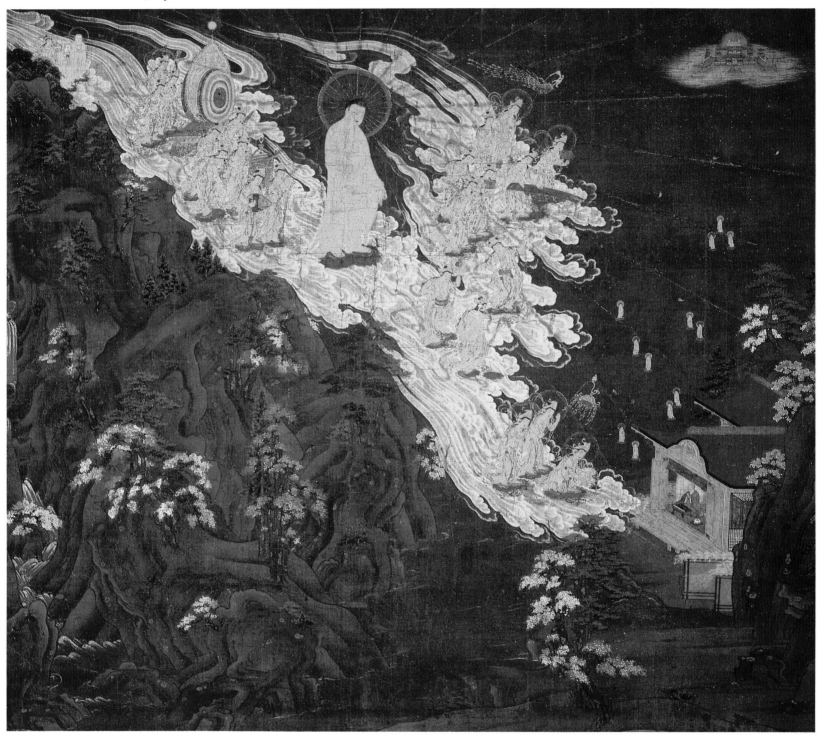

The "Coming in Welcome" (*raigō*) of Amida was painted in several compositions. Usually Buddha is shown riding a cloud and descending to earth. Here, however, the head of the procession has already reached earth rand two attendant bodhisattvas, two youthful messengers, and the Four Deva Kings are shown on this side of the mountains. In the gentle postures and expressions of the divinities and the graceful color scheme it is possible to detect the tradition of earlier times. The Sanskrit character *Ā*, associated with Esoteric Buddhist teaching, is introduced into the picture in a circle at the upper left corner.

Pl. 73 (*opposite*)
Yamagoshi Amida (Amida Coming Over the Mountains), Kamakura period, 13th century, color on silk. 138.0 × 117.0 cm. Zenrin-ji, Kyoto.

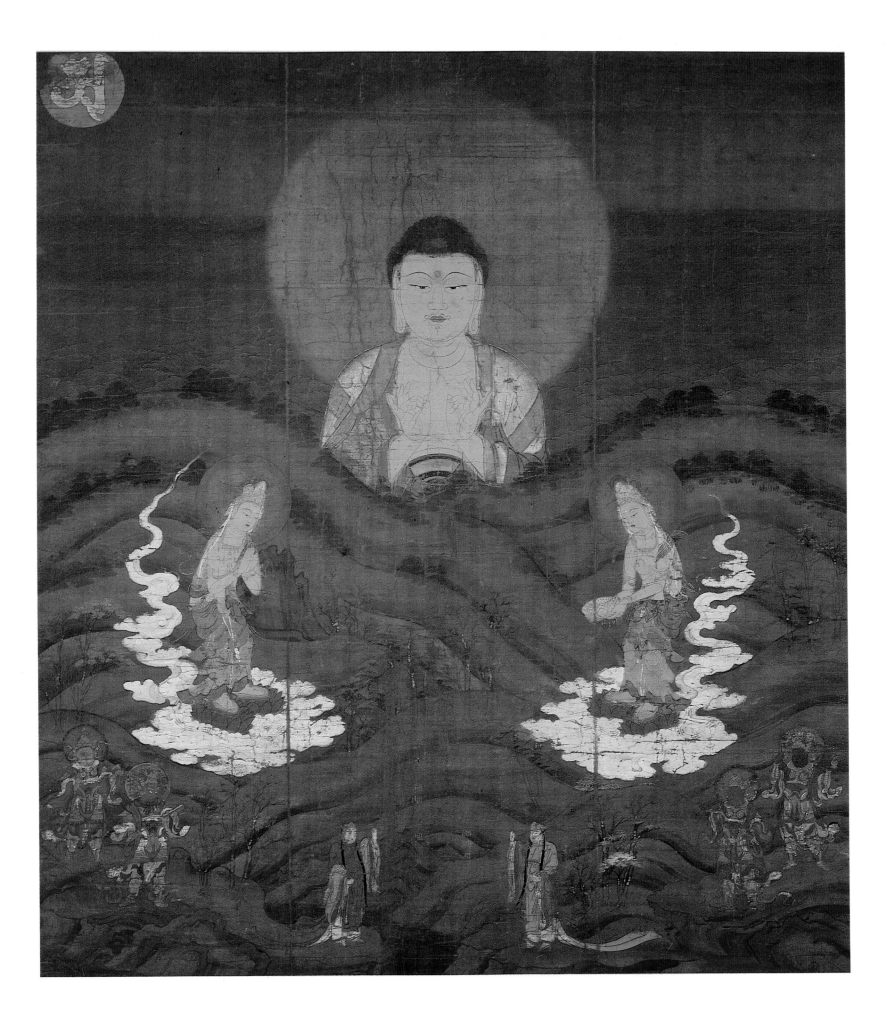

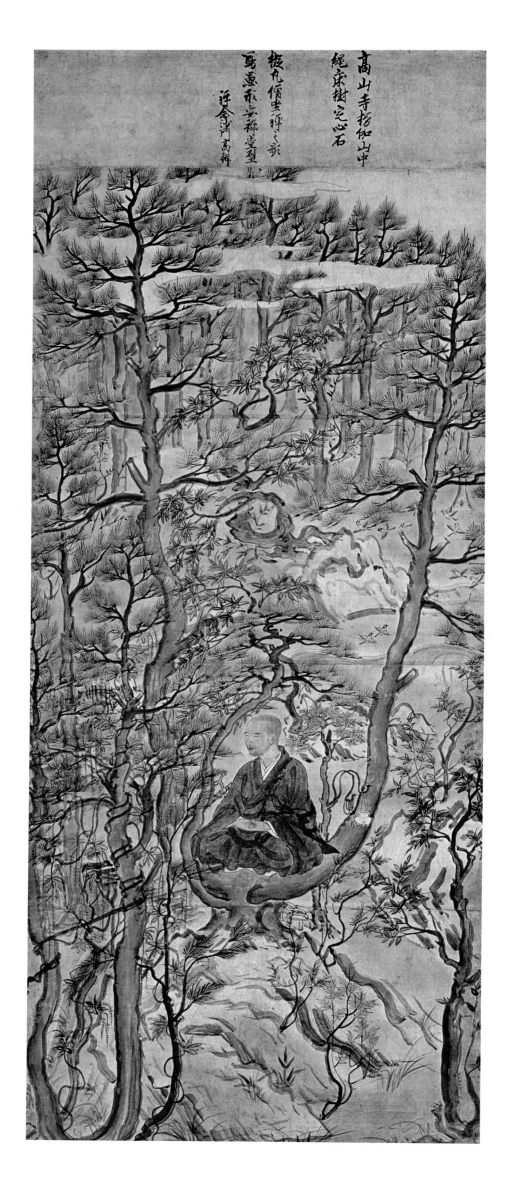

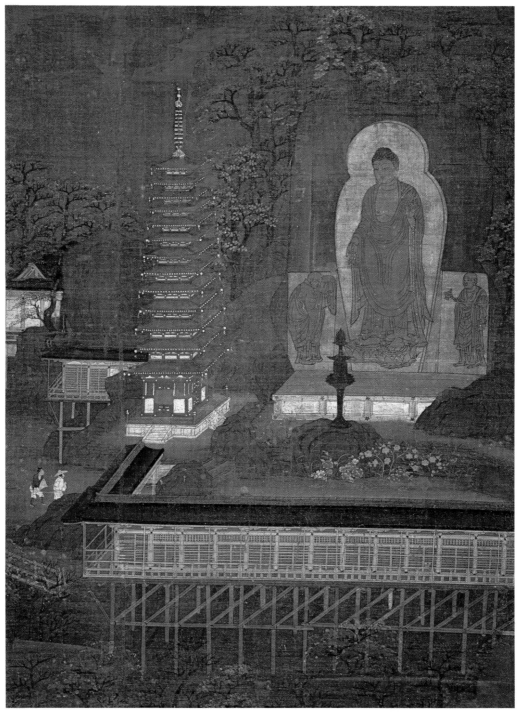

This Kasagi Mandala is thought to be a faithful representation of the former Kasagi-dera, which was built at the top of the mountain of Kasagi in front of the miracle-working, rock-carved figure of Miroku (Sanskrit: Maitreya); both temple and figure have now disappeared. The Miroku in this picture unmistakably retains the Chinese T'ang sculptural style. Paintings of this kind were originally intended to encourage the veneration of a religious institution. Gradually, however, the natural setting of the buildings began to figure more importantly in the composition, and in this way religious paintings of the precincts of temples or shrines became the early precursors of Japanese landscape painting.

Pl. 75
Kasagi Mandala,
Kamakura period, 13th century,
color on silk.
75.7 × 54.8 cm.
The Museum Yamato Bunkakan,
Nara.

Pl. 74 (*opposite*)
The priest Myōe seated in a tree in meditation, attributed to Enichibō Jōnin, Kamakura period, 13th century, color on paper. 145.7 × 58.8 cm. Kōzan-ji, Kyoto.

Myōe (1173–1232), who founded Kōzan-ji where this painting is preserved, was the priest responsible for the revival of Kegon Buddhism in the early Kamakura period. Myōe was given to meditating while sitting on the branch of a pine tree on the hill behind his temple, a scene that this painting vividly portrays. The portrayal of an eminent priest in his everyday life in this way is very exceptional in the history of Japanese art. The work is attributed to the priest-painter Enichibō Jōnin, a disciple of Myōe, who is reputed to have painted a number of portraits of his master.

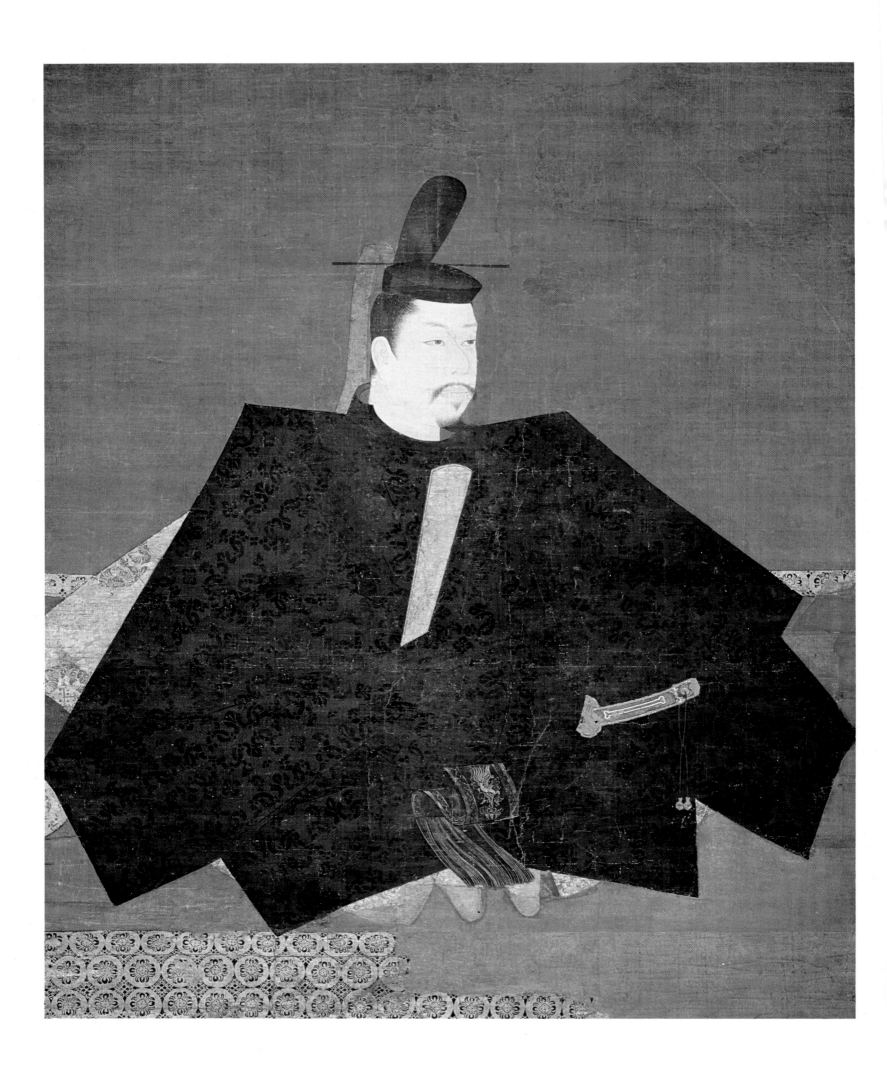

Pl. 76 (*opposite*)
Minamoto-no-Yoritomo,
by Fujiwara-no-Takanobu
(1142–1205),
Kamakura period, 12th century,
color on silk.
141.0×112.2 cm.
Jingo-ji, Kyoto.

After the defeat of the powerful Taira clan in the late Heian period, Minamoto-no-Yoritomo (1147–99), the celebrated warrior, became the supreme commander and founded the new capital at Kamakura. This portrait of him is believed to be one of a group listed in a record associated with Jingo-ji as being by Fujiwara-no-Takanobu, a courtier and noted portrait painter. The outstanding feature of this work is the well-balanced harmony between the two contrasting elements of realism and formalism. It is both an accurate portrayal of the character of this haughty warrior and shrewd statesman, achieved with a few strong lines, and a formal representation of him in ceremonial costume that is imbued with authority and dignity.

Pl. 77
Nachi Waterfall,
Kamakura period,
late 13th to early 14th century,
color on silk.
159.4×57.9 cm.
Nezu Art Museum, Tokyo.

During the Kamakura period, worship at Kumano Sanzan, the three Shinto shrines at Kumano in Wakayama Prefecture, gave rise to the practice in south-central Japan of worshiping Kumano Mandala paintings. These paintings usually illustrate the shrine buildings and the images of Buddhist deities there, which were believed to be manifestations of the Shinto gods of the shrines. Mountainous landscape is a common background element. This work is a rare example in that the landscape almost fills the entire picture. The only indications that it is a painting based on the concept of *suijaku* (unity of Shinto and Buddhism) are the roof of the worship hall at the bottom of the painting and the sun rising from behind the high cliff, both of which attest to the deified nature of the waterfall itself.

小大君

三條院東宮時女藏人左とをや武宣旨眠

醍醐天皇孫三品…號よ坤明親王女眞信

去女一条院御以人

いそ…しみるわろさもも絶ぬよて

すそ…ワ…きかでつ…乱籍

Pl. 78
Portrait of Kodai-no-Kimi, or
Koōgimi,
attributed to Fujiwara-no-
Nobuzane (1176–?),
Kamakura period, 13th century,
color on paper.
35.4 × 59.5 cm.
The Museum Yamato Bunkakan,
Nara.

The Satake version of the *Sanjūroku Kasen* (Thirty-six Immortal Poets), regarded as the finest of all paintings on this subject, originally consisted of a pair of scrolls which were handed from one generation to the next in the Satake family. In recent years the scrolls were cut into segments, which were mounted separately. This segment portraying Kodai-no-Kimi, a poetess of the late tenth century, is valued as a fine representation of a typical young court lady.

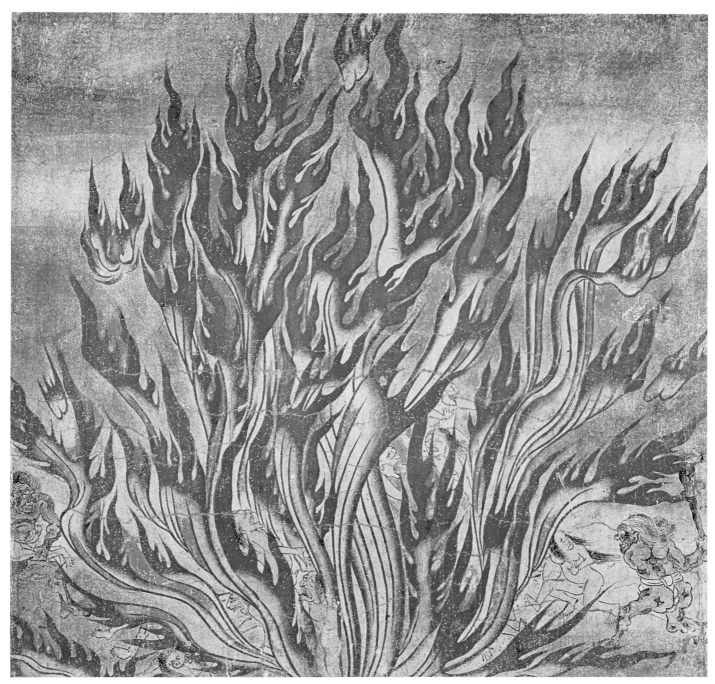

The *Jigoku Zōshi* (Scrolls of Hells) is a set of scroll paintings illustrating scenes in the Buddhist hells. These scrolls are interpreted by some as being connected with the contemporary Buddhist concept of *rokudō* (six aspects of reincarnation—hell, the world of hungry ghosts, the world of animals, the world of malevolent spirits, the world of human existence, and heaven). From the technical point of view, in this scroll emphasis is laid on the line drawing, and coloring is of secondary importance, even though some scenes are presented in rich pigments. The scene shown depicts the Hell of Smoke, Fire, and Fog, where those who forced the faithful to drink wine against the commandments of the Buddhist scriptures are thrown into the flames of infernal fire.

Pl. 79
The Scrolls of Hells,
Kamakura period, 12th century,
color on paper.
H. 26.1 cm.
Tokyo National Museum.

Pl. 80
The Scrolls of Hungry Ghosts,
Kamakura period, 12th century,
color on paper.
H. 27.3 cm.
Kyoto National Museum.

Shown here is a scene from the *Gaki Zōshi* (Scrolls of Hungry Ghosts) portraying the grisly figures of *gaki*, ghosts who are punished with eternal hunger and thirst, based on detailed descriptions in the sutras. Such scrolls also appear to stem from the *rokudō* concept of Buddhism (see Pl. 79), which arose from the social unrest that afflicted Japan in the late twelfth century. These *gaki* scrolls also resemble the "Scrolls of Diseases" and the "Scrolls of Hells" in the coloring. This section depicts a kind of memorial service, with people pouring water on the monuments of their forbears while thirsty ghosts lick up the few drops that trickle from the stones. To the right is a vivid representation of the gateway to a temple, with a throng of monks, visitors, beggars, and so on.

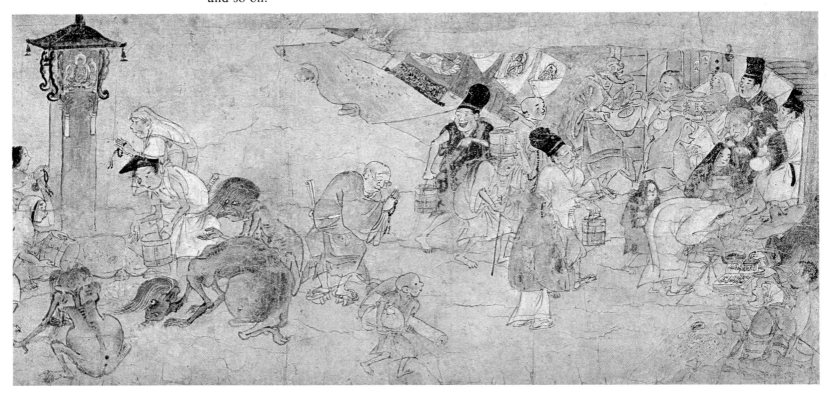

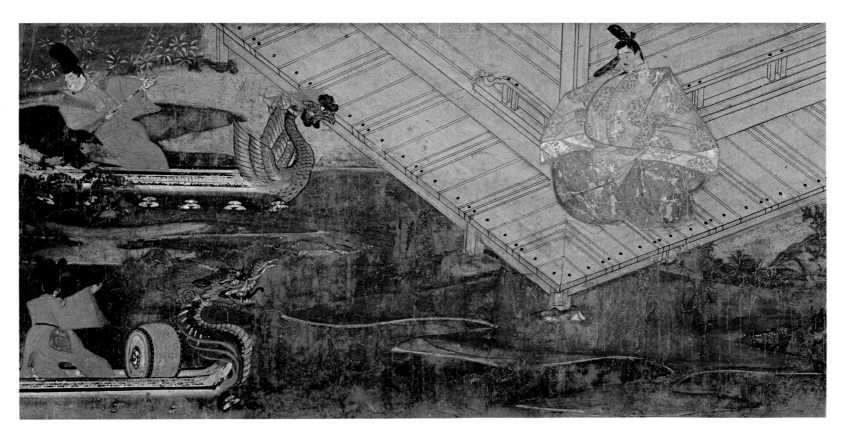

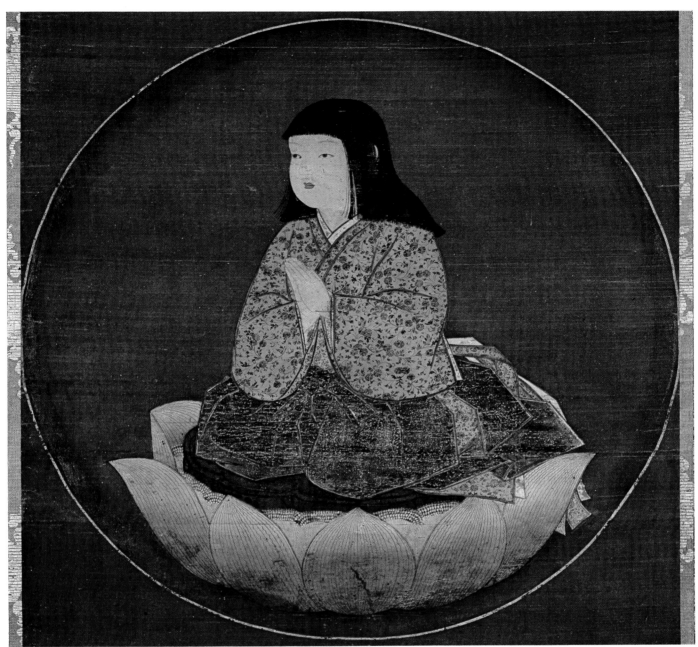

This painting depicts the priest Kūkai (Kōbō Daishi) at the age of five or six, when he dreamed he was seated on a lotus flower talking with Buddhist divinities. The custom of representing Buddhist saints as infants had existed from early times, though the device was only used infrequently. The appealing mood of realism in the Kamakura period results in a naturalistic rendering of a beautiful and intelligent child, full of piety and pathos.

Pl. 82
Kōbō Daishi as a child,
Kamakura period,
late 13th to early 14th century,
color on silk.
77.0 × 42.7 cm.
Kōsetsu Museum of Art,
Hyōgo.

Pl. 81 (*opposite below*)
Illustrated diary of Lady Murasaki,
Kamakura period, 13th century,
one section of four scroll paintings, color on paper.
H. 24.0 cm.
Fujita Art Museum, Osaka.

The scroll painting *Murasaki Shikibu Nikki E-maki* depicts episodes recorded in the diary of the court lady Murasaki Shikibu, the authoress of *The Tale of Genji*, when she was in the service of Shōshi, consort of the Emperor Ichijō. The work is now a set of four scrolls in which are described events connected with the birth of a prince to Shōshi at the house of her father, Fujiwara-no-Michinaga, who is shown on the veranda. Richly colored, the scroll follows the manner of the Genji scrolls of the Heian period, but the figures here show greater movement and have more facial expression.

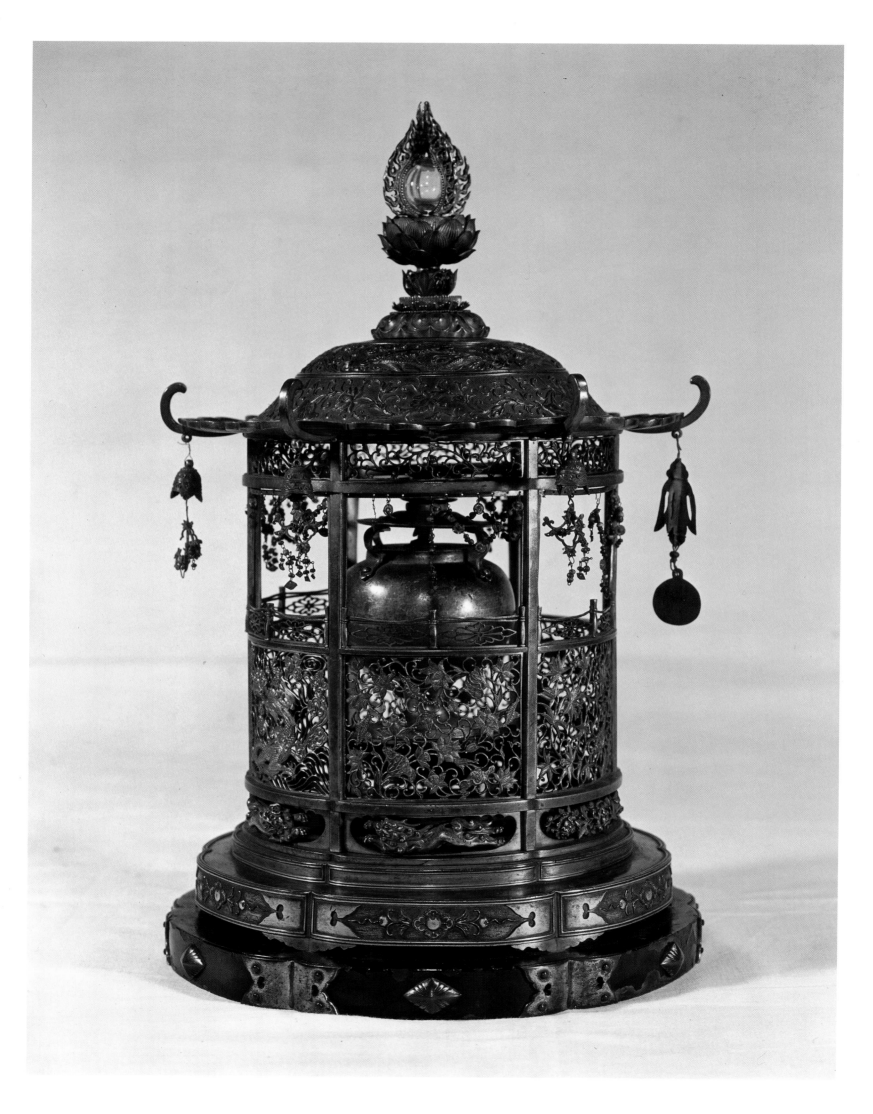

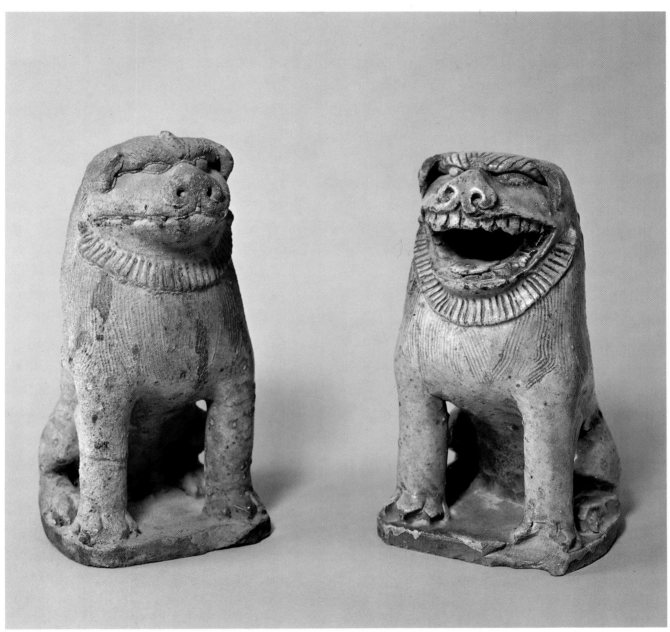

Koma-inu, literally "Korean dogs," are legendary beasts derived from the lion, usually made in pairs and by tradition placed to the right and left of the entrance to a Shinto sanctuary. Models of *koma-inu* carved in wood were in use in Japan from early times, but with the improvement in ceramic techniques during the Kamakura period they came to be made of glazed stoneware at Seto, one of the ancient centers of ceramic manufacture in Japan.

Pl. 84
Pair of *koma-inu*, late Kamakura to Muromachi period, pottery, Seto ware with yellow-green glaze.
H. (left) 18.6 cm., (right) 17.9 cm.
Honda Collection, Aichi.

Pl. 83 (*opposite*)
Reliquary in the shape of a pagoda,
Kamakura period, 13th century, gilt copper, with openwork and relief.
H. 37.0 cm., D. of body 18.2 cm.
Saidai-ji, Nara.

A *shari-tō* is a miniature pagoda (*tō*) intended to contain the *shari* (Sanskrit: *śarīra*, "sacred ashes") of the Buddha. The veneration of *śarīra* began in India in early times and provided the main stimulus for the building of pagodas. *Śarīra* worship spread, and the cult became so fashionable in Japan at the end of the Heian and the beginning of the Kamakura period that numerous fine *shari-tō* were made, such as the one illustrated here, unrivaled for the delicacy and precision of its workmanship.

Pl. 85
Catching a catfish with a gourd,
by Josetsu (active ca. 1405–
ca. 1430),
Muromachi period, 15th century,
ink and light color wash on
paper.
122.1 × 83.5 cm.
Taizō-in, Kyoto.

This picture was originally mounted as a standing screen, on the reverse side of which were inscribed poems inspired by the subject of the painting. The theme of how to set about catching an elusive catfish using a narrow-necked gourd perhaps illustrates the difficulty of grasping the Truth. The artist, Josetsu, a priest-painter at the Zen temple of Shōkoku-ji in Kyoto, was the teacher of Shūbun (see Pl. 87), and may be regarded as the forebear of this great line of Japanese *suiboku* ("water and ink") painters.

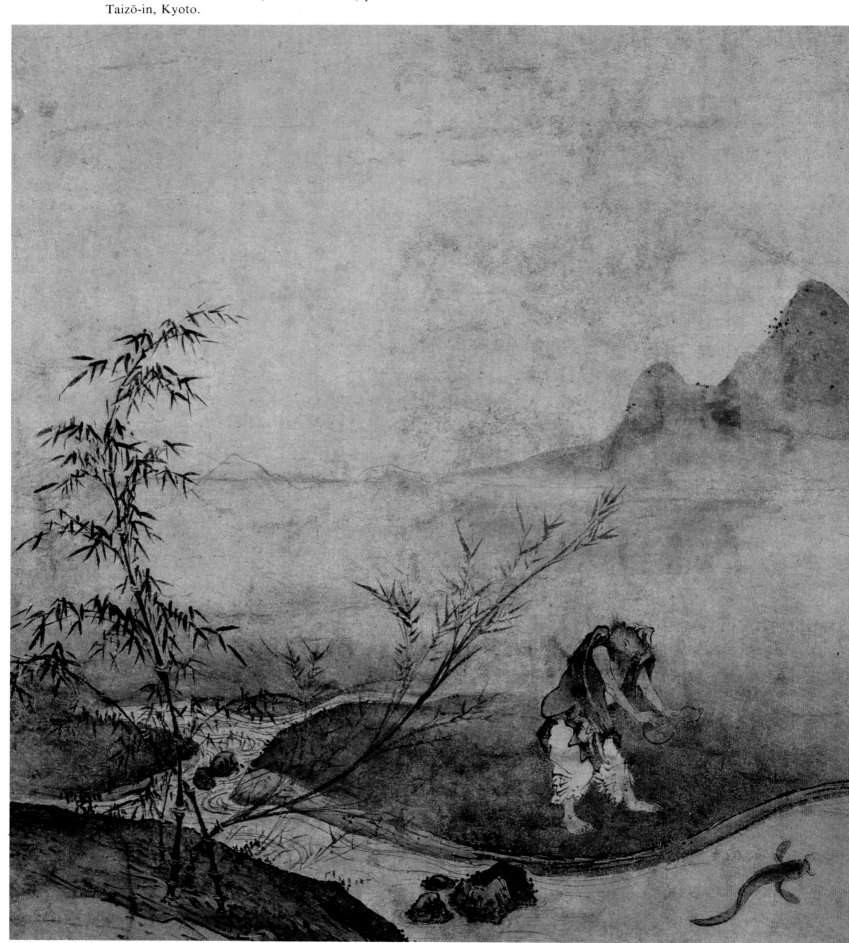

Kaō, often referred to as Kaō Ninga, was a priest-painter active about the middle of the fourteenth century. An important characteristic of his work is that, unlike the professional painters in the service of Buddhist temples (*e-busshi*), he seems to have preferred subjects illustrating profound Zen teachings, which were beyond the understanding of the ordinary professional painters. The outstanding feature of the work reproduced here is its ample use of space and its economical brushwork.

Pl. 86
Bamboos and sparrow,
by Kaō (active mid-14th century),
Muromachi period, ca. 1350,
ink on paper.
90.9 × 30.3 cm.
The Museum Yamato Bunkakan,
Nara.

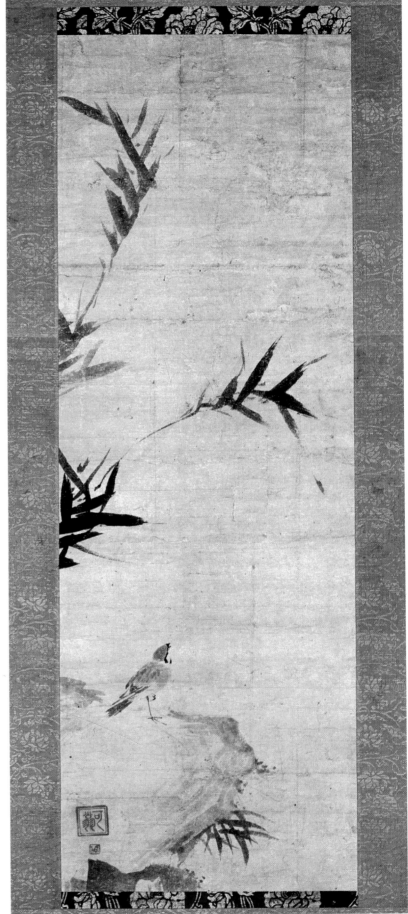

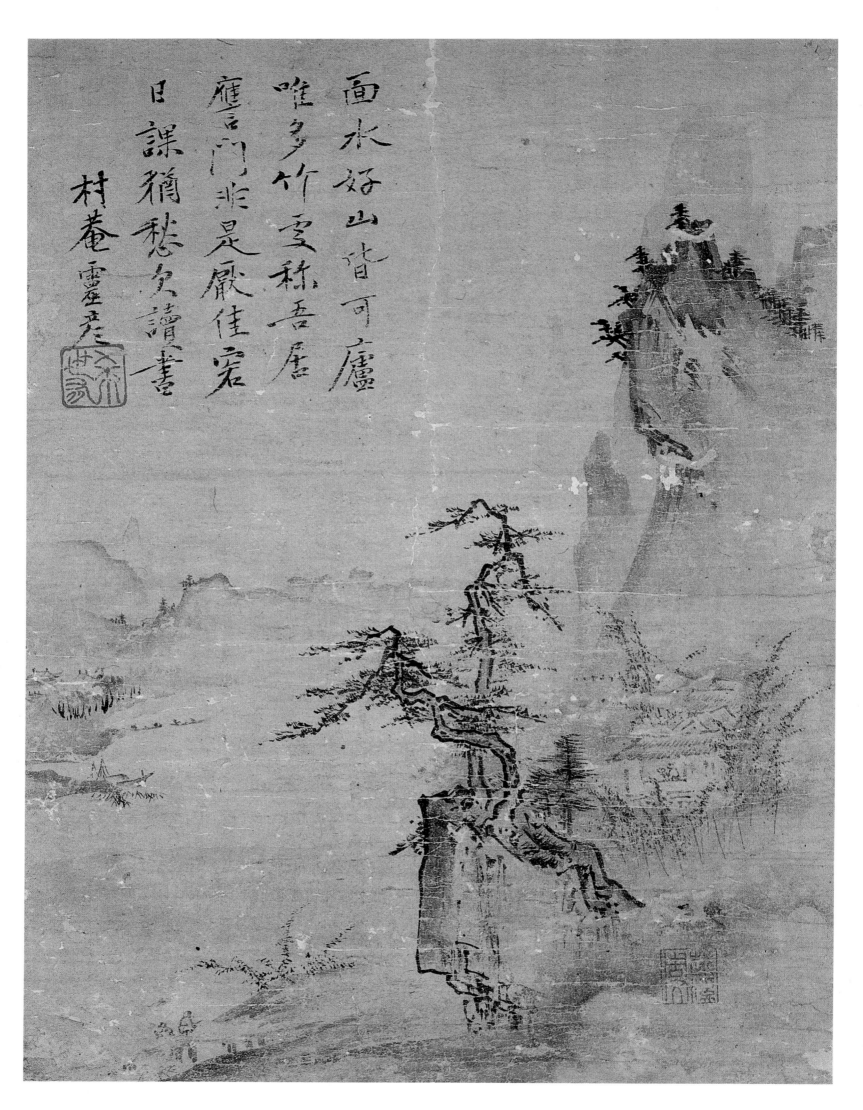

面水好山皆可廬
唯多竹處稱吾居
應言門非是嚴佳宅
日課猶愁久讀書
村菴靈昆

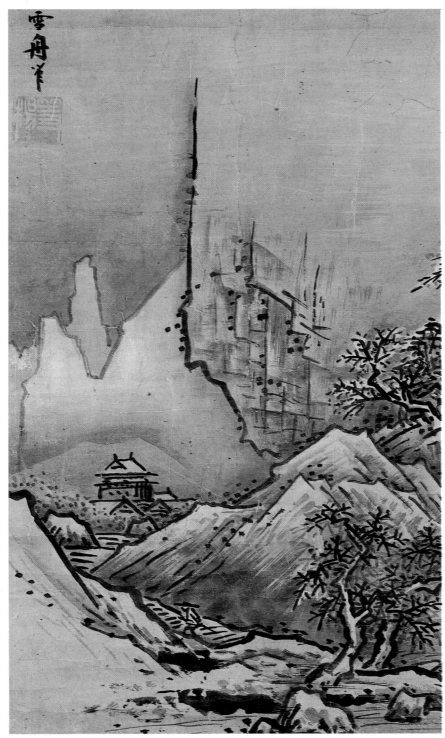

This was originally one of a set of landscapes of the four seasons, of which only those of autumn and winter are extant. In the winter landscape illustrated here, Sesshū retains the main features of the style of Hsia Kuei, the Southern Sung master, with strong calligraphic brushwork and a powerful composition. Instead of merely describing the scene he has attempted to capture a stark and austere mood of nature and has thus succeeded in translating Hsia Kuei's cult of objective delineation into a subjective creation.

Pl. 88
Winter landscape,
by Sesshū (1420–1506),
Muromachi period, 15th century
(ca. 1470–80),
ink on paper.
46.4×29.4 cm.
Tokyo National Museum.

Pl. 87 (*opposite*)
Reading in a bamboo grove
retreat,
attributed to Shūbun (d. ca. 1462),
Muromachi period, 15th century,
ink on paper.
134.8×33.3 cm.
Tokyo National Museum.

This landscape depicts the ideal setting for the abode of a Zen monk, with the hermit seated reading amid nature in the shelter of a secluded dwelling. The composition shows characteristics of the Shūbun style, with high mountain peaks in the upper right corner, a wide expanse of water and a hint of shore to the left, and with plants and rocks rendered by strong brushwork.

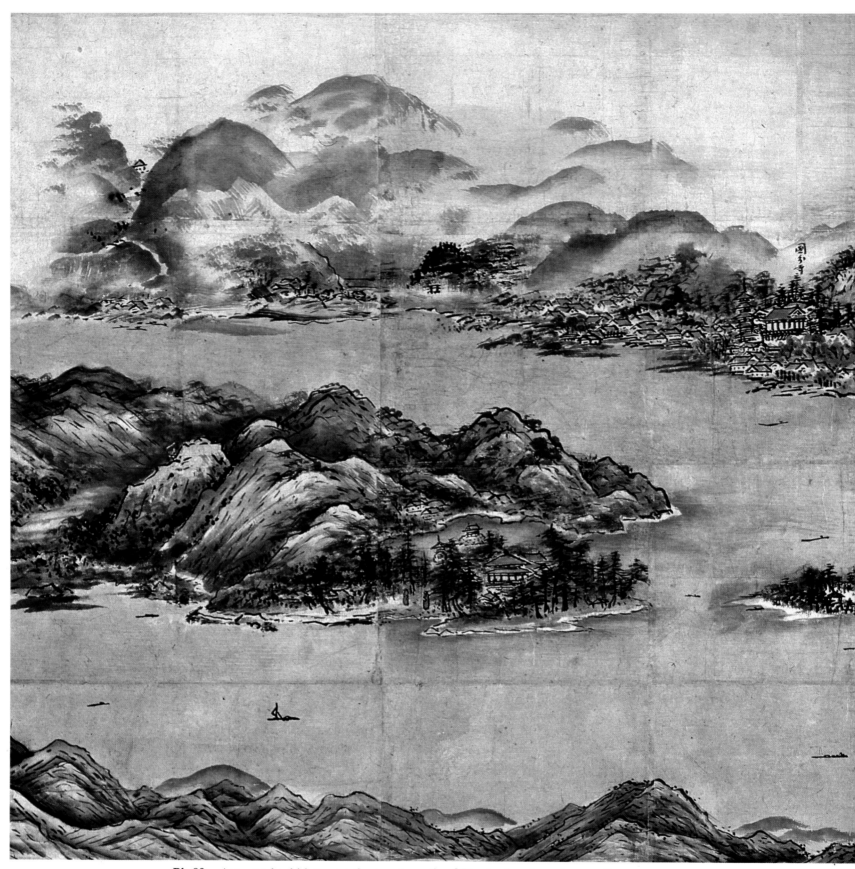

Pl. 89
Ama-no-hashidate,
by Sesshū (1420–1506),
Muromachi period, 16th century
(between 1501 and 1506),
ink and faint color on paper.
88.9×178.2 cm.
Kyoto National Museum.

Ama-no-hashidate, on the coast north of Kyoto, has been known for centuries as one of the three most celebrated and beautiful spots in Japan. The fact that the picture is unsigned and that it is executed on several sheets of paper joined irregularly both vertically and horizontally indicates that it was intended only as a study, not as a finished work, and this may be the reason for its fresh, spontaneous impact.

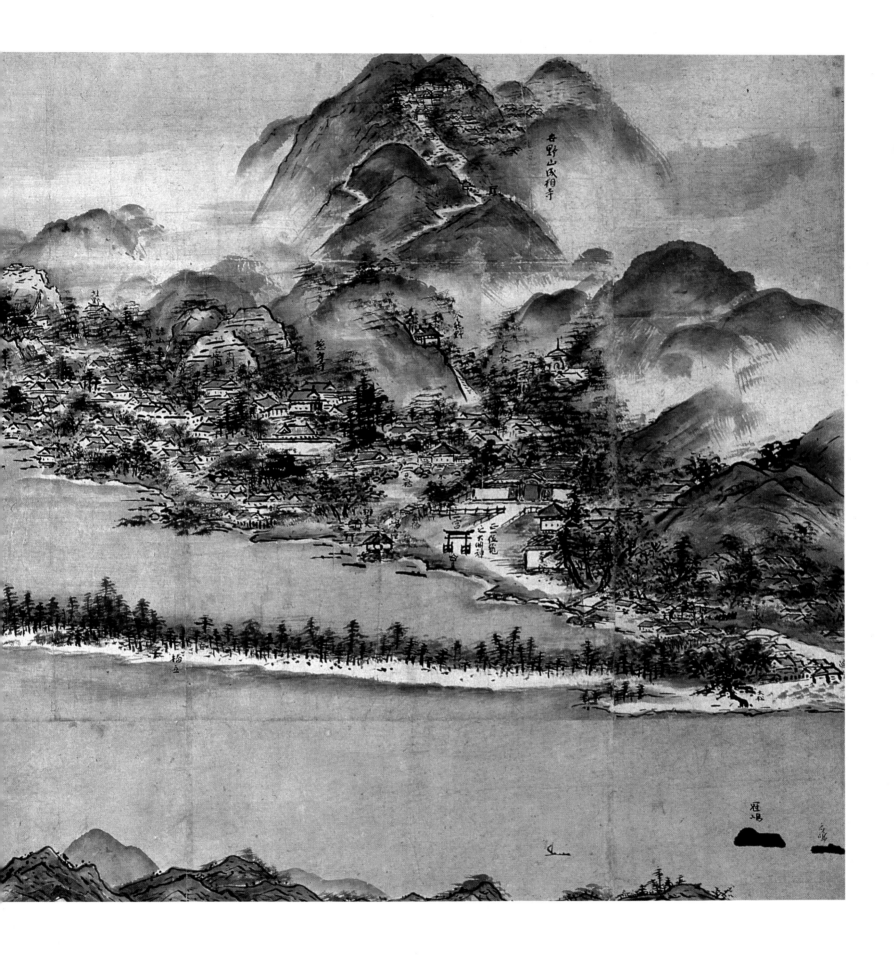

123

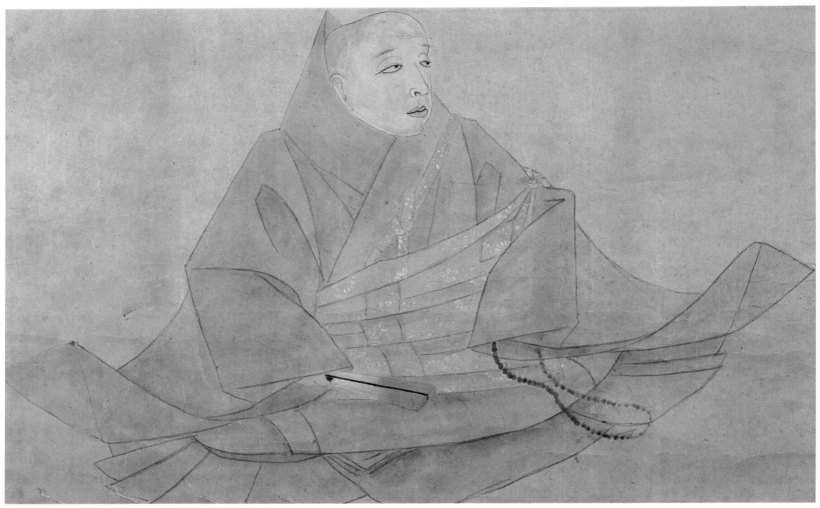

This portrait of the Emperor Hanazono (r. 1308–18) after he had retired is by Gōshin, a priest-painter of the Tendai sect of Buddhism. It is an example of *nise-e* ("likeness pictures"), which were naturalistic portraits by artists in the service of the imperial court. They were often accompanied by poems connected with the subject or details of his life.

Ikkyū Sōjun (1394–1481) was a Zen priest renowned for his disregard of convention. It seems likely that this was a preliminary sketch intended as the study for a painting, perhaps for the portrait by the priest-painter Bokusai, a pupil of Sōjun's, with an autographic inscription added by Sōjun himself, now preserved in Shūon-an, Kyoto.

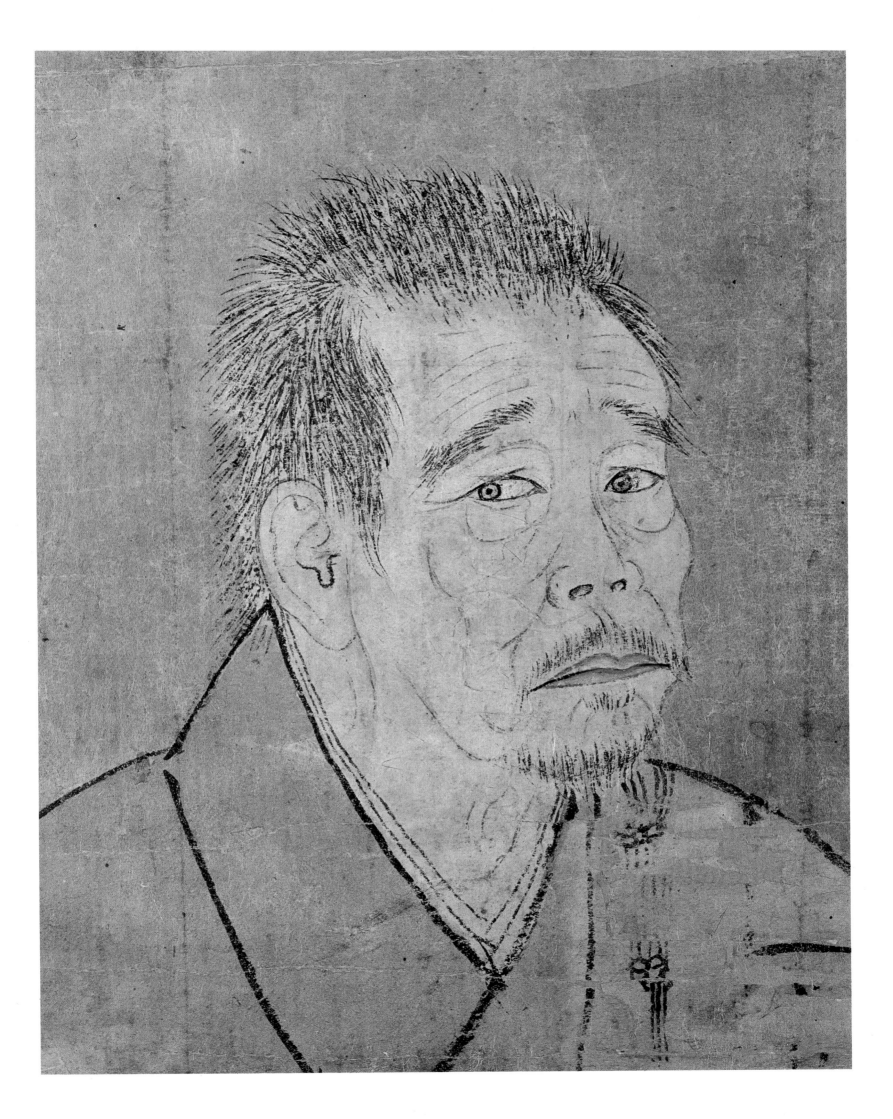

125

This is one of the last masterpieces of the *dōshaku* (depicting the deeds and anecdotes of Zen priests and hermits) type of painting in Japanese *suiboku* art. Ryodōhin (Chinese: Lü Tung-pin), a legendary figure of late T'ang, was a Taoist saint with supernatural power over dragons, which he employed to do his bidding. Here the aged saint stands with his arms outstretched, having just opened the magic bottle in which he keeps his dragons.

Like Shūbun and Sesshū, Kanō Masanobu learned from the styles of the Chinese artists Ma Yüan and Hsia Kuei, but his paintings, as typified by this masterpiece, tend to be more lighthearted than the weighty works of Shūbun and Sesshū. Masanobu was among the first painters to use black and white to represent nature purely for its beauty, freed from the restrictions of Zen Buddhism. After Masanobu, ink painting developed in the direction of beauty and realism, hence his great significance as a secular painter and founder of the Kanō school. The subject of this painting is Shū Moshuku (Chinese: Chou Mao-shu), a noted Confucian scholar of the Sung dynasty and a lover of lotus flowers.

Pl. 93 (*opposite left*)
Ryodōhin,
by Sesson (1504–ca. 1589),
Muromachi period, ca. 1550–60,
ink on paper.
118.5 × 59.7 cm.
The Museum Yamato Bunkakan,
Nara.

Pl. 94 (*opposite right*)
Shū Moshuku viewing lotus flowers,
by Kanō Masanobu (1434–1530),
Muromachi period, 15th century,
ink and faint color on paper.
84.5 × 33.0 cm.
Private collection, Tokyo.

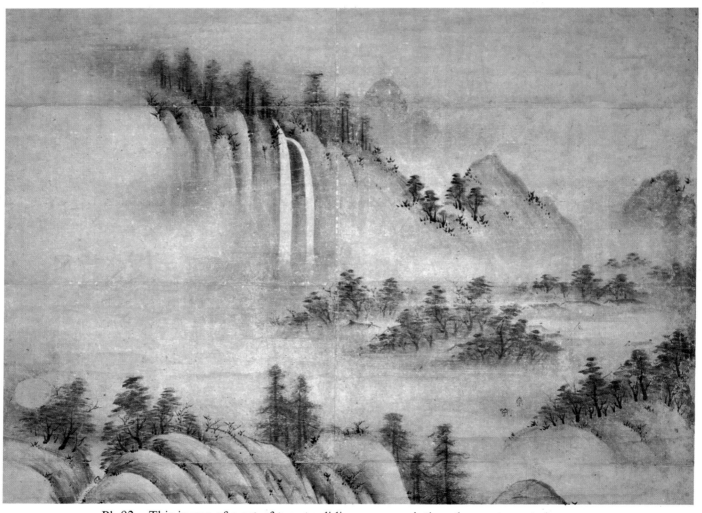

Pl. 92
Landscape,
by Sōami (?–1525),
Muromachi period, 16th century,
ink on paper.
174.0 × 135.0 cm.
Daisen-in, Kyoto.

This is one of a set of twenty sliding-screen paintings (now remounted as sixteen hanging pictures) belonging to the temple of Daisen-in. The paintings show the eight views of the Hsiao and Hsiang rivers in China. The subject of the paintings was undoubtedly derived from similar landscapes by the Chinese artists Mu Ch'i and Yü Chien, among others. While they are not direct copies of Chinese landscapes, the artist has employed the Chinese style and enriched his work by the addition of Japanese poetic sentiment and sense of beauty.

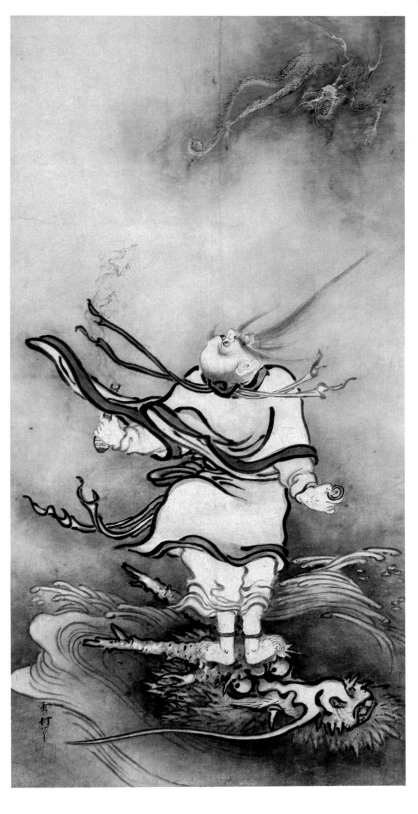

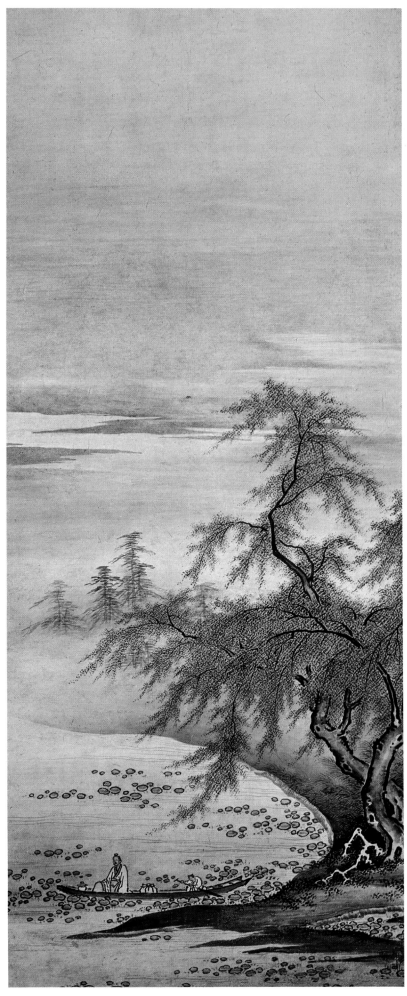

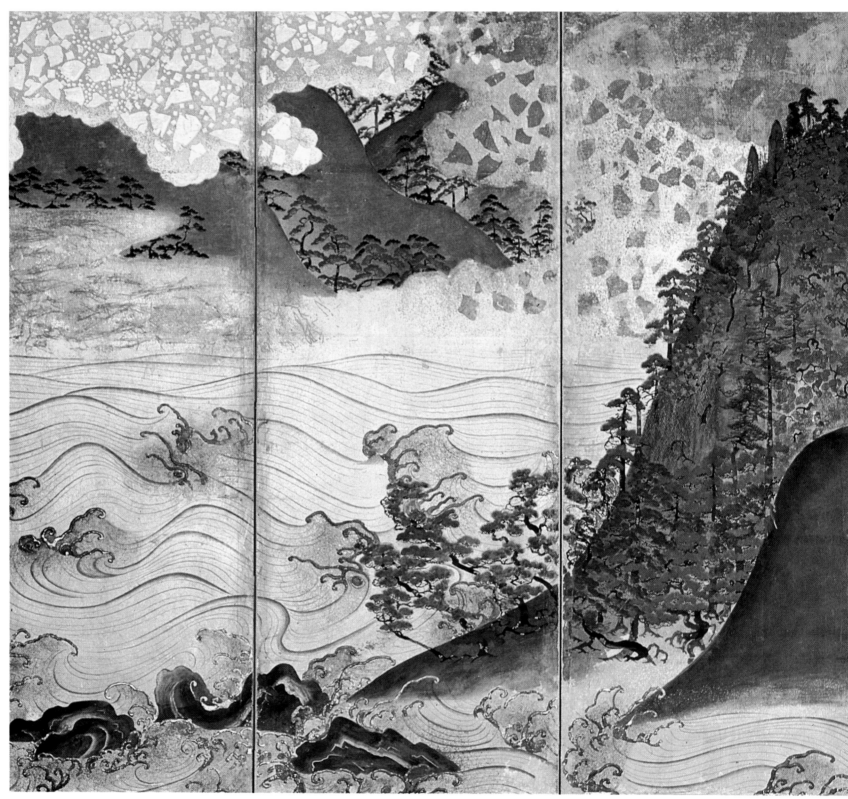

Pl. 95
Sun and moon landscape,
Muromachi period, 16th century,
one of a pair of six-fold screens,
color on paper.
Each screen: 147.0×316.0 cm
Kongō-ji, Osaka.

These folding screens might have been used for Buddhist services, but their value lies in their beautiful landscapes, which are quite unlike any other decorative painting of the period, rather than in their religious significance. The bold composition and rich color scheme with abundant use of gold and silver are eloquent testimony to the extraordinary talent of the artist.

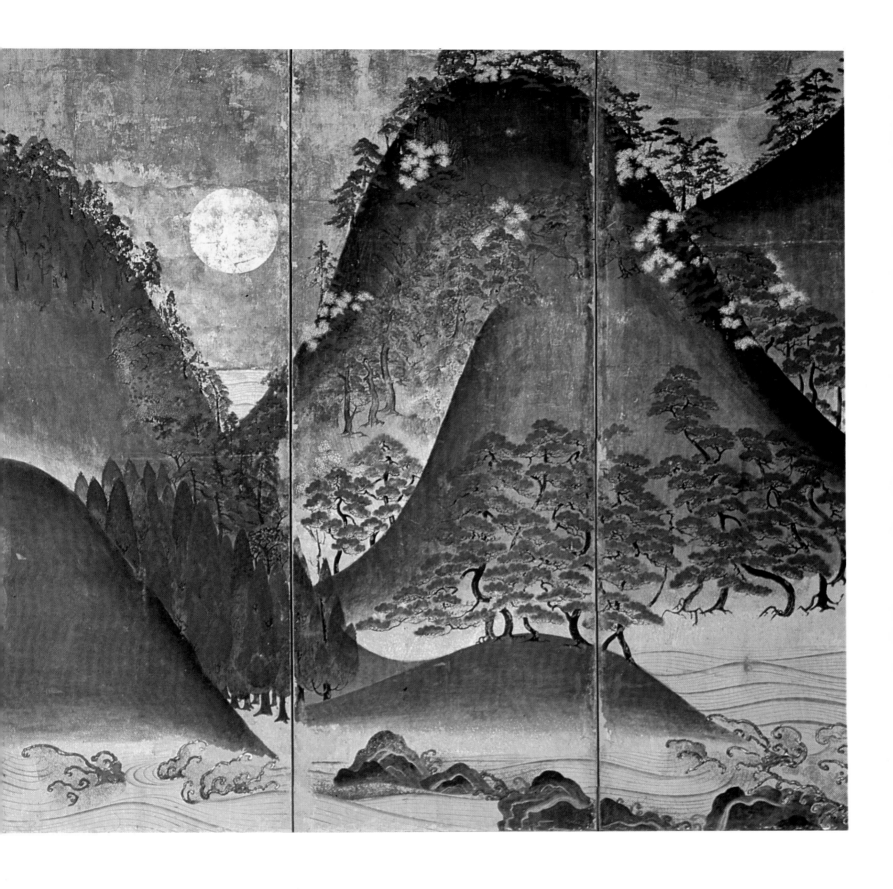

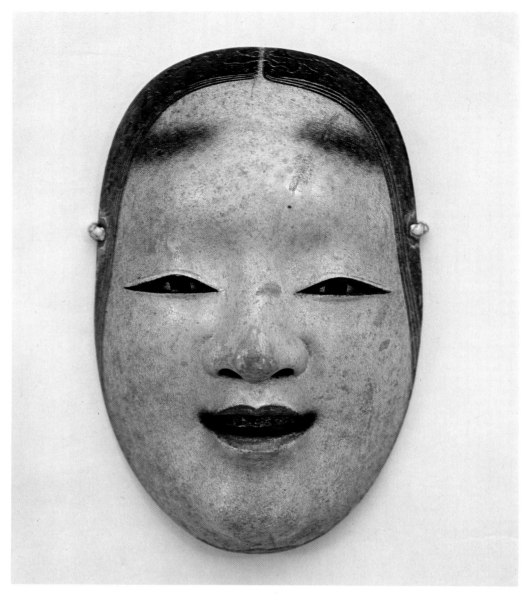

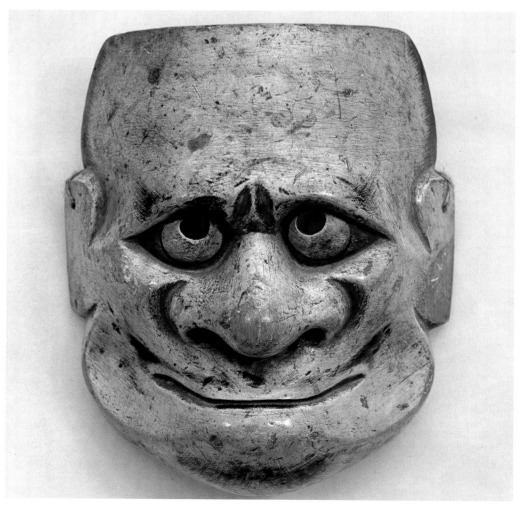

The design on this writing box is based on a *tanka* (a poem of thirty-one syllables) in the *Kokin-shū* (an anthology of poems collected by imperial order in 905) and depicts a night scene. The mountain is of gold lacquer, the moon of sheet silver, and the deer, rocks, and autumn flowers are created in relief *maki-e*.

Pl. 98
Writing box
named "Kasugayama,"
Muromachi period,
wood, with *maki-e* lacquer.
Total H. 4.5 cm.,
cover 22.7×20.6 cm.
Nezu Art Museum, Tokyo.

Pls. 96, 97 (*opposite*)
Noh mask, *ko-omote*;
Kyōgen mask, *ko bu-aku*;
Muromachi period, 15th century,
wood, painted.
Ko-omote 21.2×13.6 cm.,
ko bu-aku 18.9×15.7 cm.
Tokyo National Museum.

During the fourteenth century, two types of mask plays developed together in Japan, the tragic Noh and the farcical Kyōgen, which were usually staged in combination. At first they were entertainments for commoners, but soon they came to enjoy the favor of the Ashikaga shoguns, who became patrons of Noh and Kyōgen actors. Eventually the plays became established as the authorized dramatic art for the ruling class. The *ko-omote* mask represents a young lady of the nobility and typifies the ideal of feminine grace. It is rendered with what is known as an "intermediate expression," one which is capable of expressing joy, sadness, or even anger, according to the movements of the wearer and through the changes of light falling on the mask. The *ko bu-aku* mask is worn in the comic Kyōgen plays, in the roles of either divinities or evil spirits.

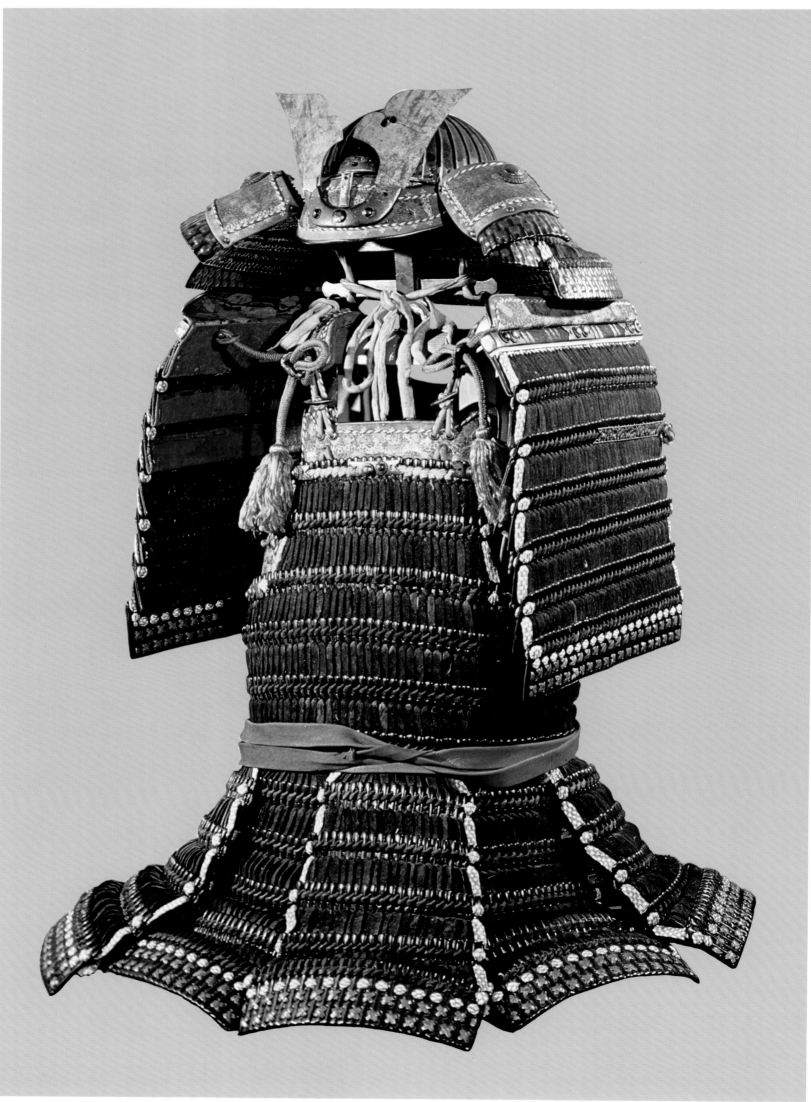

Pl. 99 (*opposite*)
Suit of armor,
Muromachi period.
H. of central section 71.5 cm., H. of cap 10.6 cm.
Itsukushima Shrine, Hiroshima.

This style of armor, called *dō-maru*, was used by infantrymen from the Heian period onward. Because of its convenience—it was simply fastened under the right arm—and its lightness, even warlords came to wear it by the end of the Kamakura period, though the helmet and the side flaps were slightly modified. In this suit, small black-lacquered iron plates and leather sheets are laced alternately with indigo strings. Apart from one repaired section, this *dō-maru* remains in its original state, a masterpiece of exquisite workmanship.

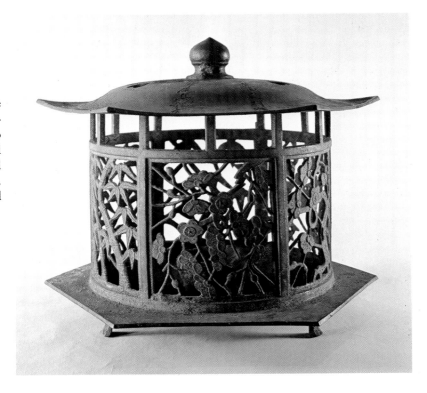

Pl. 100
Hanging lantern,
Muromachi period, dated 1550,
cast bronze.
Total H. 31.0 cm.,
D. of base 30.0 cm.
Tokyo National Museum.

This hanging lantern, popularly known as the "Lantern of Chiba Temple," is covered with a fine green-blue patina and is in an excellent state of preservation. The only part missing is an iron ring originally attached to the hole in the "sacred pearl" finial. The panels are ornamented with openwork and low relief, three of them depicting flowering plum trees and three, bamboo shoots. One of the panels with bamboo is the door.

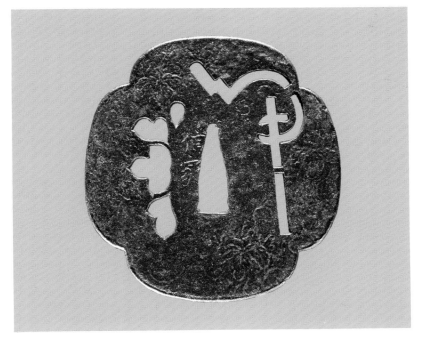

Pl. 101
Sword guard,
by Nobuie,
late Muromachi period, 16th century,
iron.
9.2 × 8.6 cm.
Tokyo National Museum.

Sword guards (*tsuba*) were first made by armorers and later by metalwork artists engaged in the manufacture of sword accessories. Nobuie was one of the earliest of such specialists. This guard has the four-lobed shape called *mokkō* (the cross-section of a quince fruit), which was his favorite form. On a ground of hammered iron it has engraved patterns of paulownia sprays and perforated designs. Because of the design of the cross, this sword guard might well have been made for a warrior who had been converted to Christianity.

Pl. 102
Sword guard,
by Hōan,
late Muromachi period, 16th century,
iron.
8.6 × 8.2 cm.
Tokyo National Museum.

This guard, with a popular openwork wheel design, was made by Hōan, who lived in the Owari area of Aichi Prefecture.

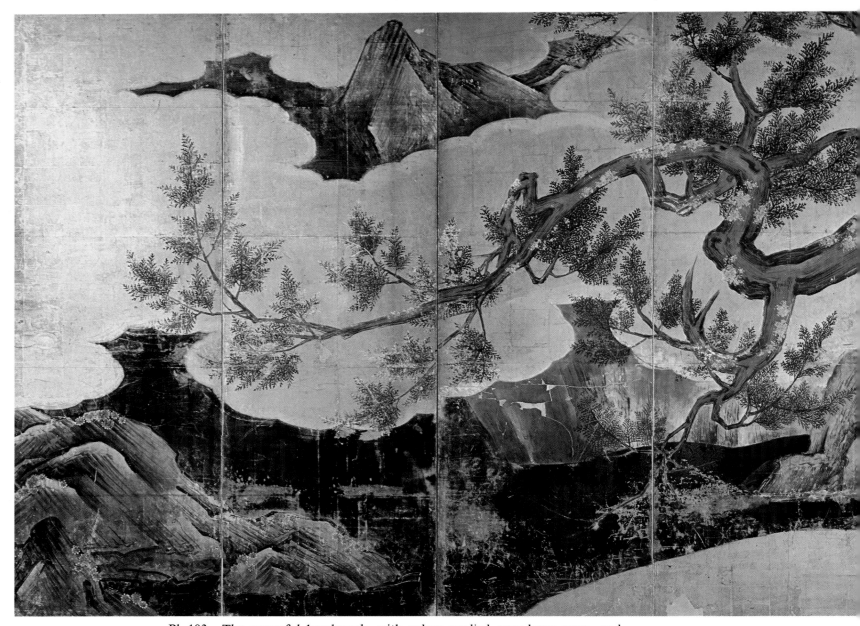

Pl. 103
Cypresses,
attributed to Kanō Eitoku
(1543–90),
Momoyama period, 16th century,
eight-fold screen,
color and gold leaf on paper.
168.0×456.0 cm.
Tokyo National Museum.

The powerful brushwork, with colors applied over large areas, and the sweeping composition in which the mighty trunks of huge old cypress trees dominate a wide expanse of gold and blue are typical of the brilliant decorative effects which Kanō Eitoku achieved to suit the taste of his wealthy and powerful patrons, Oda Nobunaga and Toyotomi Hideyoshi. This eight-paneled screen is unusually large in size and bears the traces of door-fittings, which suggest that the panels were originally parts of sliding doors in a palace.

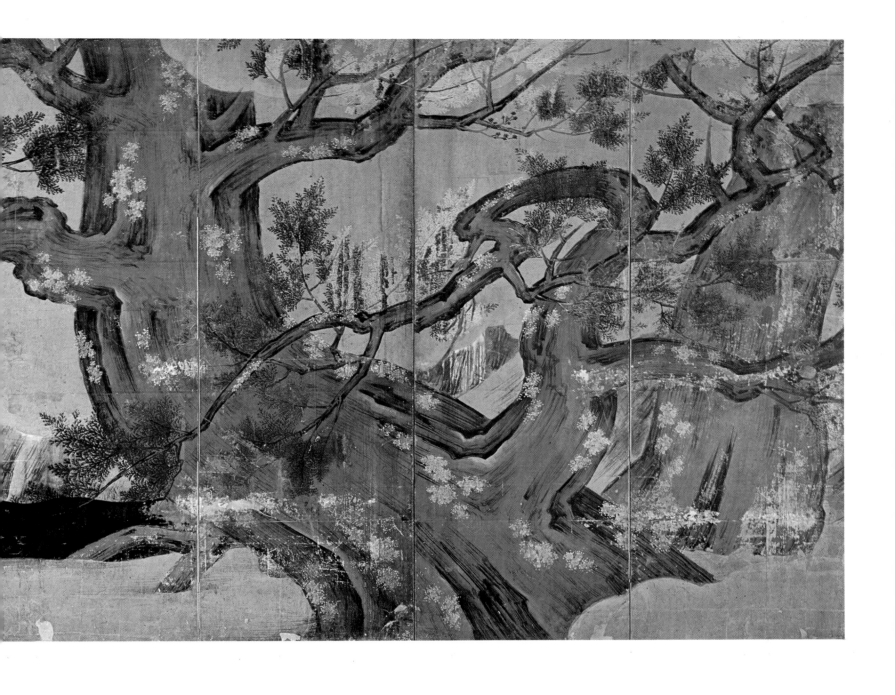

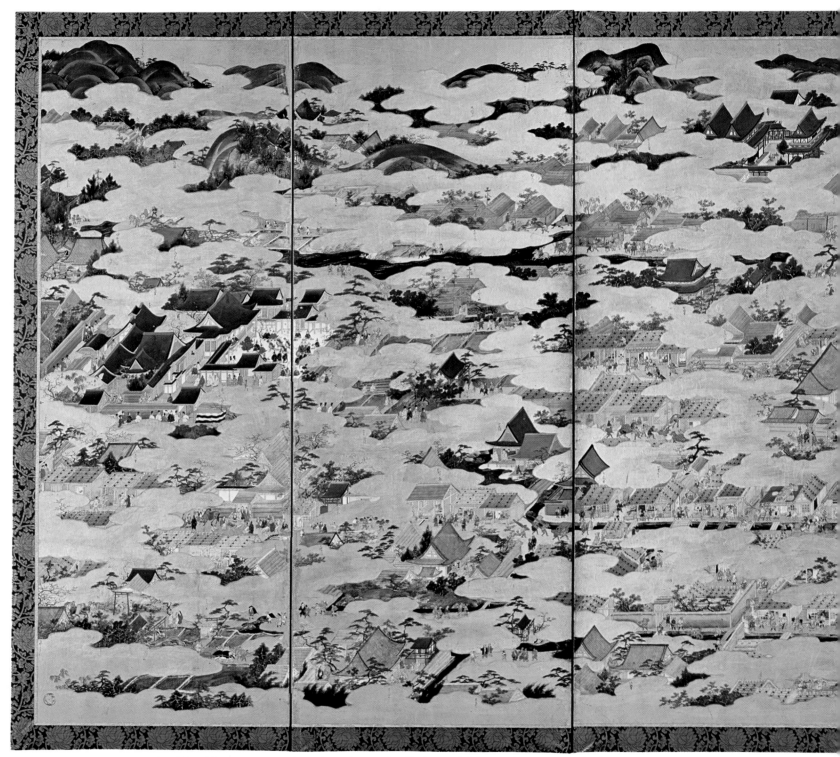

Pl. 104
Rakuchū-rakugai
(Scenes in and around Kyoto),
by Kanō Eitoku (1543–90),
Momoyama period, 16th century,
one of a pair of six-fold screens,
color and gold leaf on paper.
Each screen: 159.4×363.3 cm.
Uesugi Collection, Yamagata.

These screens show in minute detail the activities and customs of all classes of people in and near Kyoto through the four seasons of the year. This magnificent work is believed to date from around 1560, in which case Eitoku would only have been a few years over twenty when he painted it.

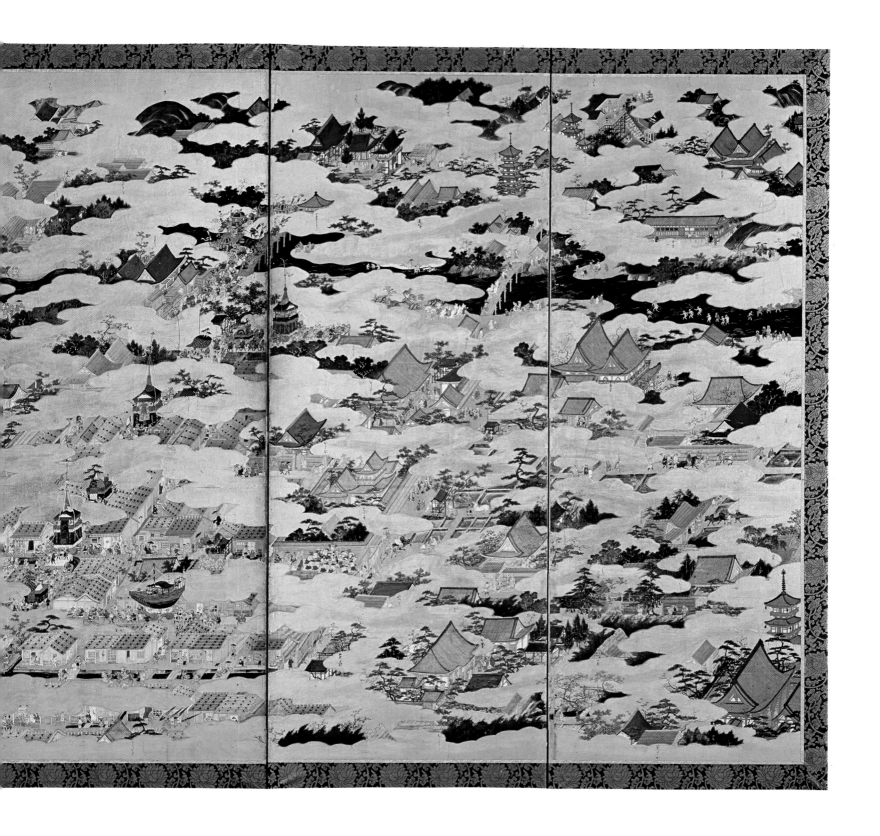

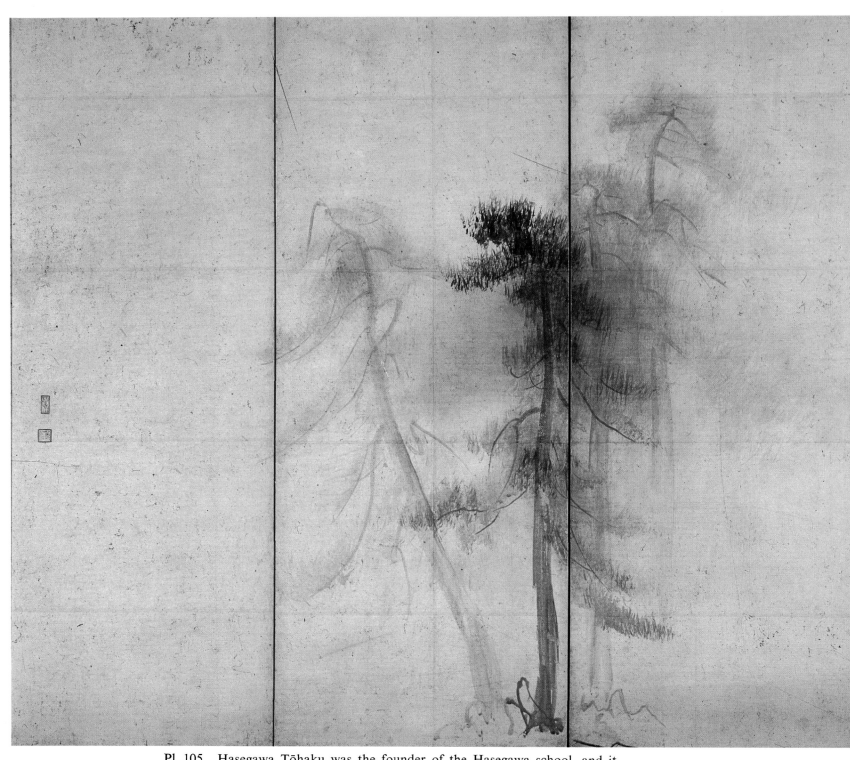

Pl. 105
Pines,
attributed to Hasegawa Tōhaku
(1539–1610),
Momoyama period,
late 16th century,
one of a pair of six-fold screens,
ink on paper.
156.0 × 347.0 cm.
Tokyo National Museum.

Hasegawa Tōhaku was the founder of the Hasegawa school, and it was his study of the wonderful monochrome paintings of Mu Ch'i, the Chinese painter of the Yüan dynasty, at the temple of Daitoku-ji in Kyoto that helped him realize the full possibilities of the art of *suiboku*. This famous pair of screens of pine trees looming out of misty rain demonstrates a thorough mastery of Mu Ch'i's technique. Although the influence of Mu Ch'i is evident in this work, the painting, nevertheless, springs spontaneously from the artist's native soil.

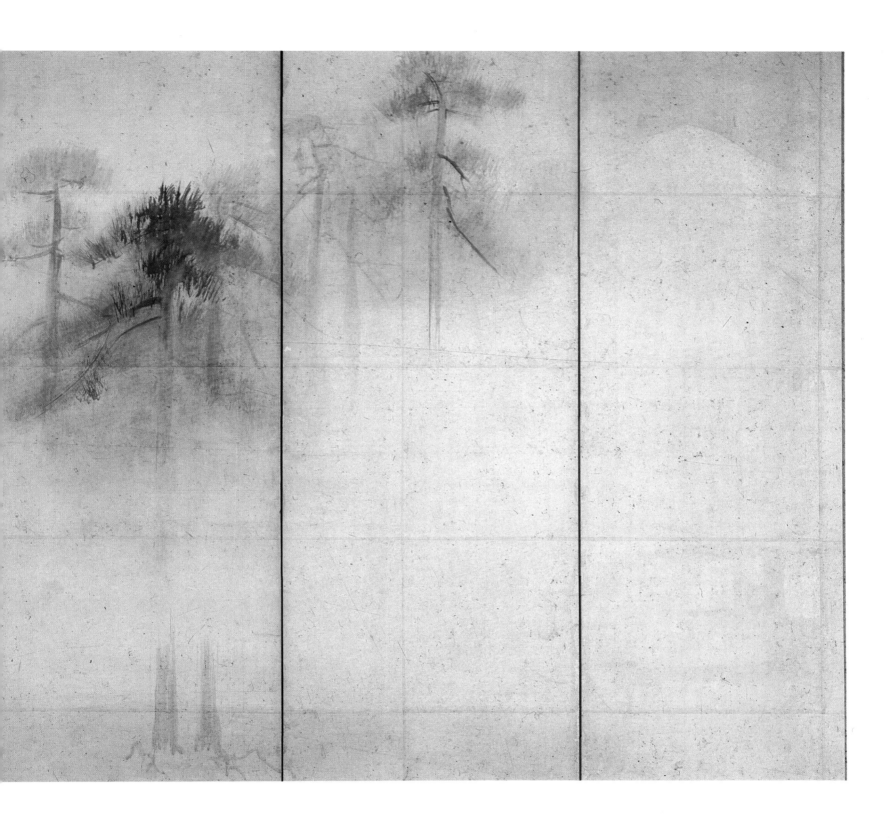

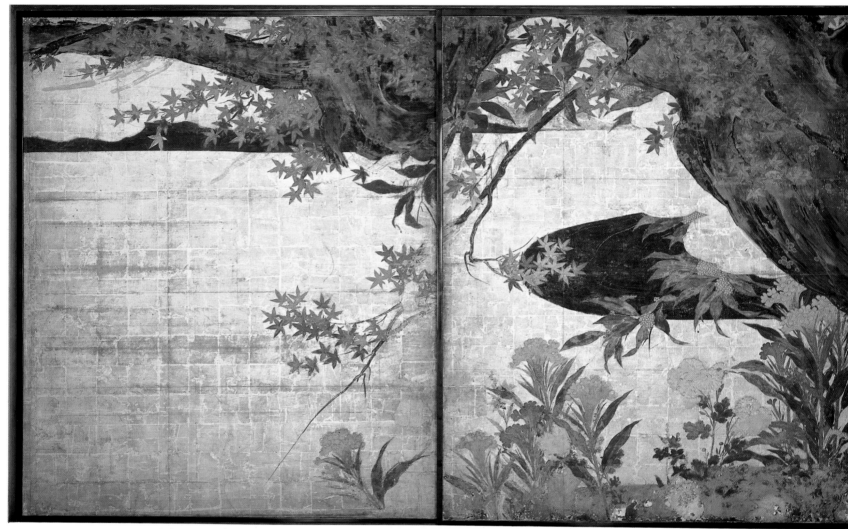

Pl. 106
Maple,
attributed to Hasegawa Tōhaku
(1539–1610),
Momoyama period,
late 16th century,
four sliding doors,
color and gold leaf on paper.
Each door: H. 172.5 cm.
Chishaku-in, Kyoto.

The paintings illustrated here were originally in Shōun-ji, a temple built in 1592 by Toyotomi Hideyoshi, and were transferred in later years to Chishaku-in. The composition follows the grand style of Kanō Eitoku, but the bright colors and decorative arrangement of the luxuriant growth of flowering bush clover and other autumnal grasses are thought to betray the hand of Hasegawa Tōhaku, who enlarged the heroic grandeur of Eitoku to encompass a livelier and even more splendid decorative style. Two other sliding-door paintings, which appear to be continuations of the right-hand side of this set, are preserved in Chishaku-in, and it seems likely that there were originally two more on the left-hand side. There is reason to believe that all these paintings were once taller, and have been cut off at the top, presumably to fit a hall other than the building they were first made for.

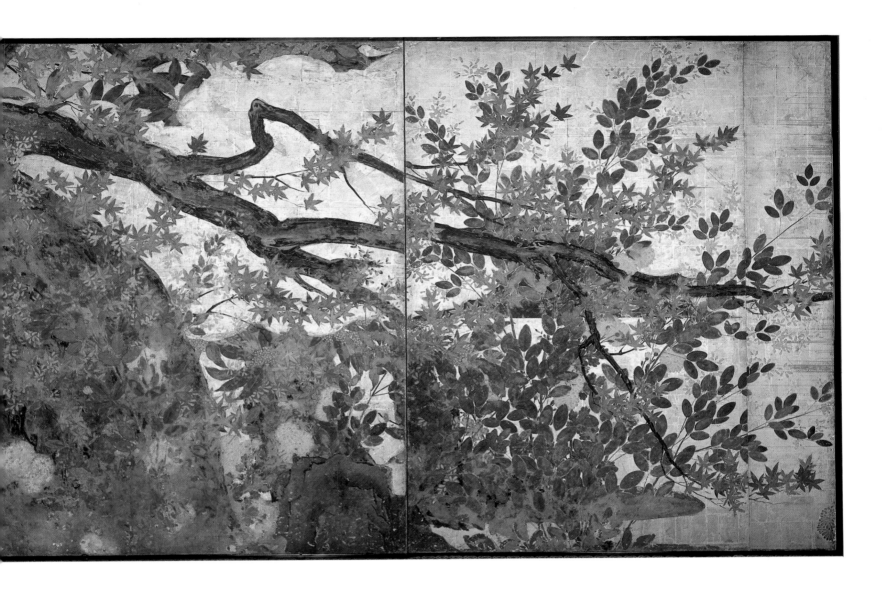

These paintings, now mounted as scrolls, were originally on a pair of screens owned by the feudal lord Maeda Toshinaga. It is evident that this work was inspired by the superb triptych "Kannon, Crane, and Monkeys" by Mu Ch'i in Daitoku-ji, also in Kyoto, but the style is interpreted freely. Mu Ch'i's monkeys are invested with a dignified air, while Tōhaku depicted his monkeys in their natural playful attitudes.

Pl. 107 (*overleaf*)
Monkeys,
by Hasegawa Tōhaku (1539–1610),
Momoyama period,
late 16th century,
pair of hanging scrolls,
ink on paper.
Each scroll: 155.0×115.0 cm.
Ryūsen-an, Myōshin-ji, Kyoto.

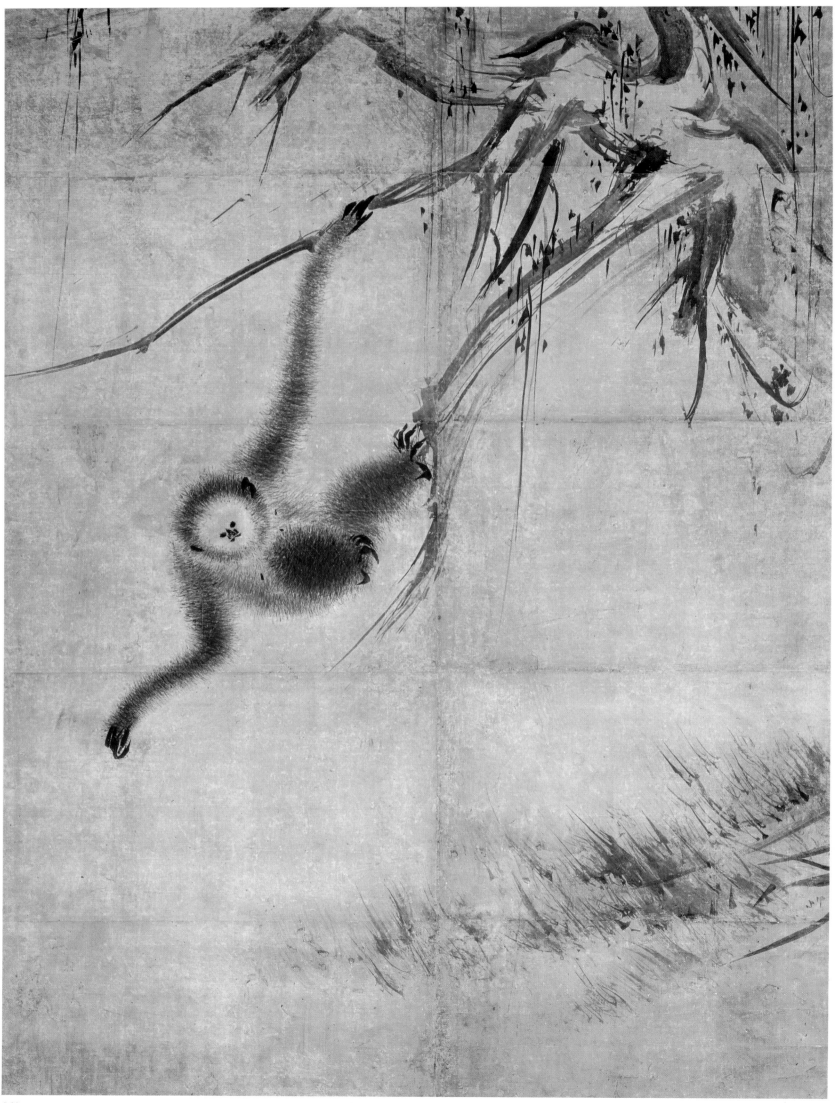

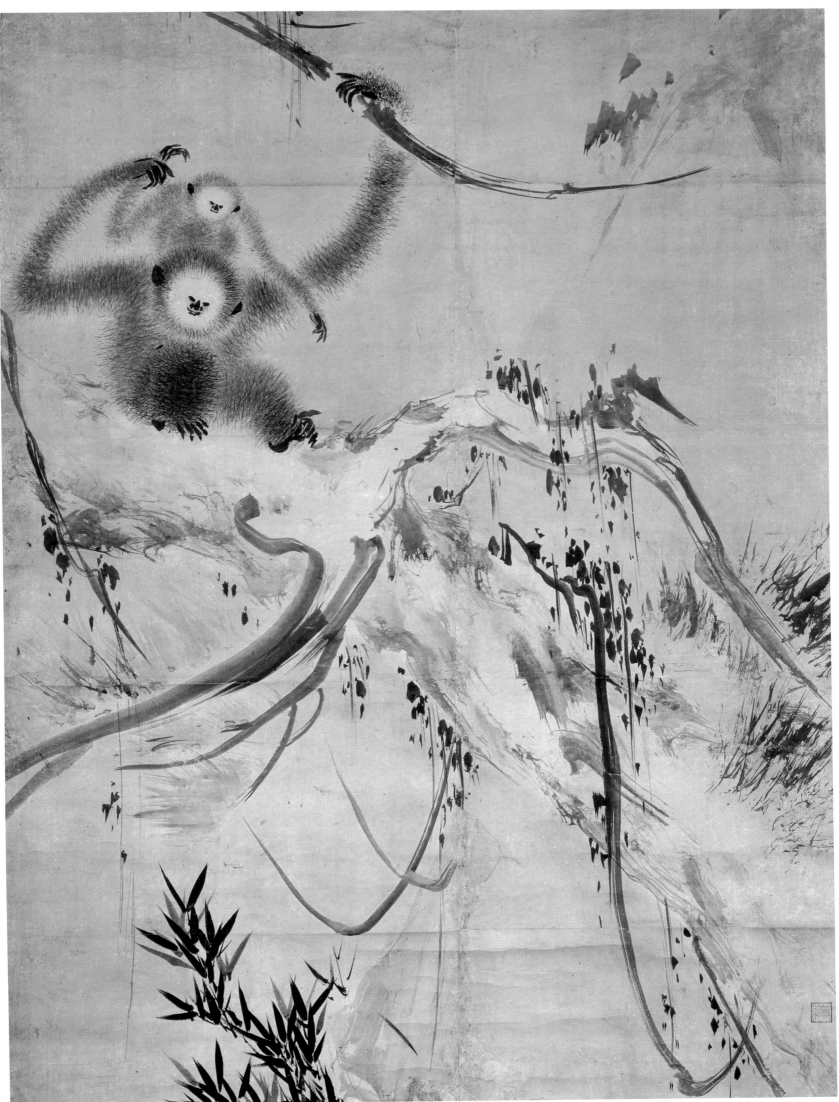

143

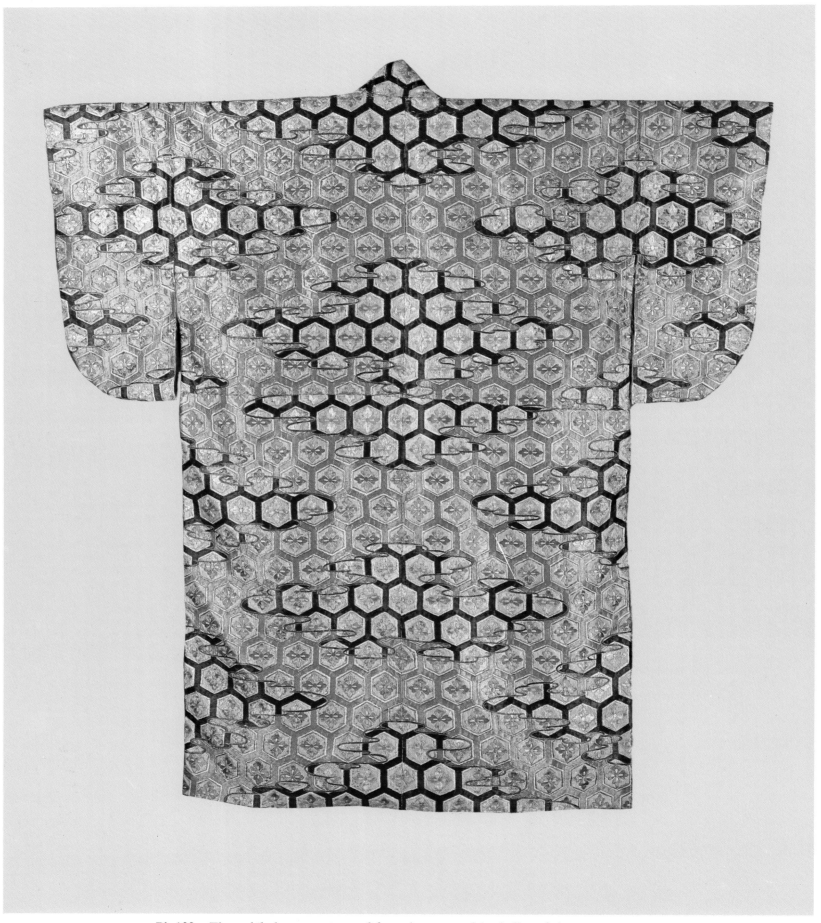

Pl. 108
Uchikake,
Momoyama period, 16th century,
silk, embroidery and imprinted
silver leaf.
H. 120.0 cm.
Kōdai-ji, Kyoto.

The *uchikake* was a type of formal wear used by ladies of the upper classes from the Muromachi period on. This robe with a design of "tortoiseshell" hexagons and rhomboid-shaped flowers is said to have been worn by Kita-no-Mandokoro, the wife of Toyotomi Hideyoshi. The simple yet skillfully composed motifs made this robe a masterpiece of the period.

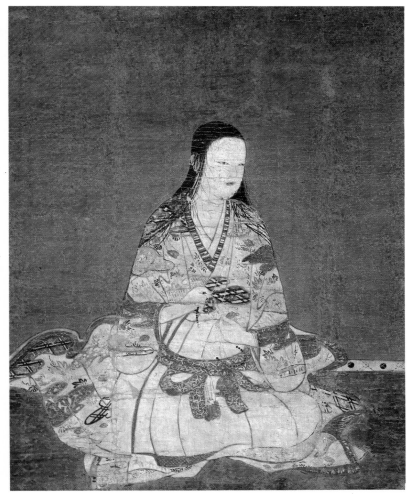

Pl. 109
Fragment of a *tsujigahana*
design,
Momoyama period, 16th century,
silk.
W. 38.5 cm.
Private collection.

The design in this fragment of textile is effected by means of hand-painting and *shibori* ("tie dyeing"), a technique called *tsujigahana* which reached a peak of perfection during the Momoyama period and has never since been surpassed in textiles. In this technique the fabric is tied in tiny knots following a desired pattern and soaked in different colored dyes, section by section; the outlines of the superimposed design are then drawn with extremely fine lines in black ink, creating a total effect which is at once delicate and sumptuous.

This portrait represents an upper-class lady of the Momoyama period. She is depicted in a devout pose seated on a raised dais, and we may infer from the rosary held in her hands that it is a posthumous portrait. In works of this kind it is usual to find an inscription on the picture relating something about the person portrayed, but here the long inscriptions which once existed have all been erased and there is nothing in the picture to offer a clue to the lady's identity. The artist probably belonged to the Kyoto branch of the Kanō school.

Pl. 110
Portrait of a lady,
Momoyama period,
color on paper.
54.0 × 38.0 cm.
The Museum Yamato Bunkakan,
Nara.

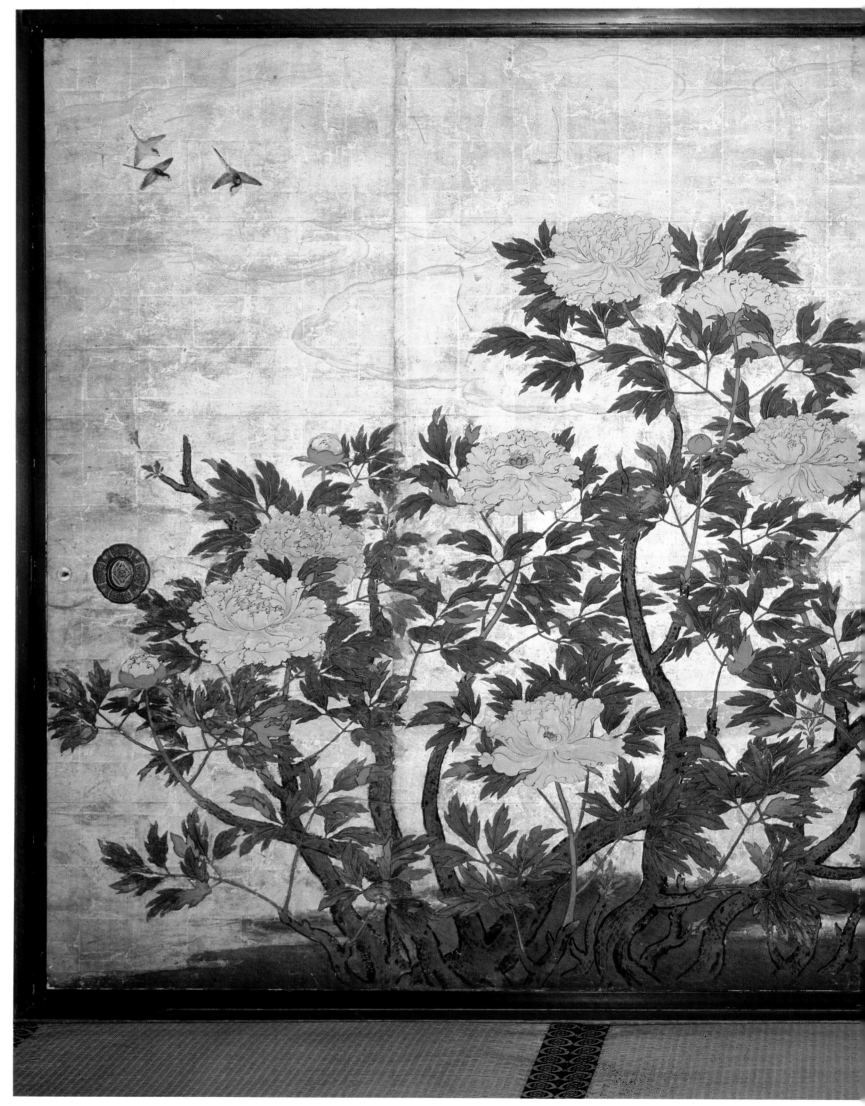

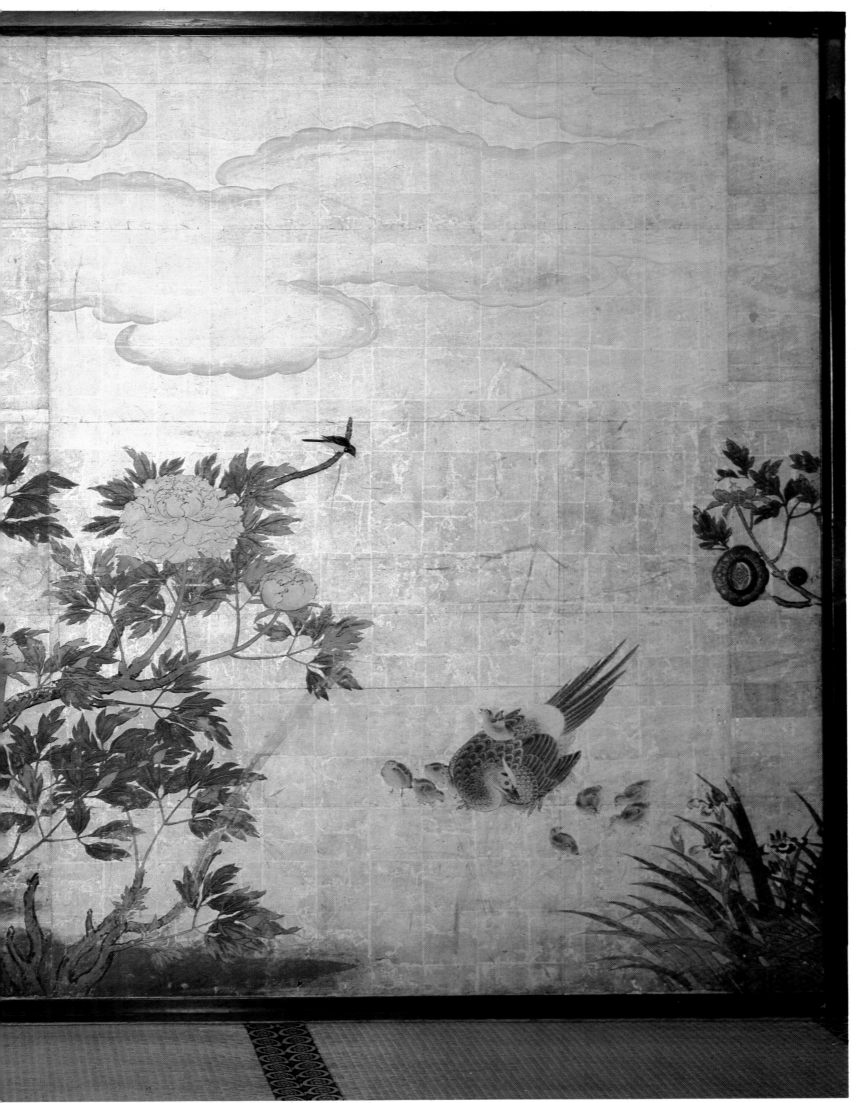

Pl. 111 (*previous pages*)
Peonies,
by Kanō Sanraku (1559–1635),
Momoyama period,
early 17th century,
two of eighteen sliding doors,
color and gold leaf on paper.
Each door: 185.0 × 153.0 cm.
Daikaku-ji, Kyoto.

Illustrated here are two of the sliding doors from the famous "Room of Peonies" in Daikaku-ji. From ancient times the peony was regarded in China as the symbol of nobility and wealth, and for centuries it was a favorite painting subject. The fashion caught on in Japan, and peonies came to be frequently represented in Japanese painting and applied art. This work is remarkable for its artistic realism and for the loving representation of detail in the decorative composition.

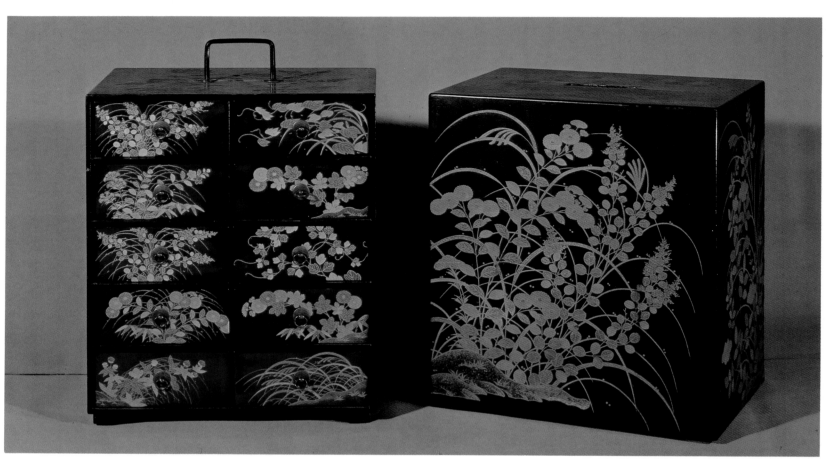

Pl. 112
Cabinet for poems and letters,
Momoyama period,
early 17th century,
wood, black-lacquered with
gold *maki-e*.
39.4 × 33.0 × 23.5 cm.
Kōdai-ji, Kyoto.

This is a representative example of *Kōdai-ji maki-e*, a fresh and original style of lacquerwork developed during the Momoyama period. The word *Kōdai-ji* is from the temple of that name in Kyoto, built in 1606 by the widow of Toyotomi Hideyoshi in memory of her husband. The temple owns many personal effects of the Toyotomi family, including the cabinet illustrated here. The autumn grasses which decorate the box with fresh and free drawings in gold were the favorite designs of the age and typical of Kōdai-ji lacquerwork.

Oribe ware was produced in Mino province under the guidance of
Furuta Oribe, a distinguished tea master of the late sixteenth century.
For the most part products comprised utensils for the tea ceremony.
The object illustrated here, however, is an interesting example of the
taste for exoticism often to be noted in Oribe wares, and is also a
testimony to the versatility of the Oribe potters. It is a candlestick in
the shape of a European of those times, a novel sight in Japan which
must have excited the curiosity of many people.

Pl. 113
Candlestick,
Momoyama period,
late 16th century,
Oribe ware.
H. 22.6 cm., D. 10.0 cm.
Umezawa Memorial Gallery,
Tokyo.

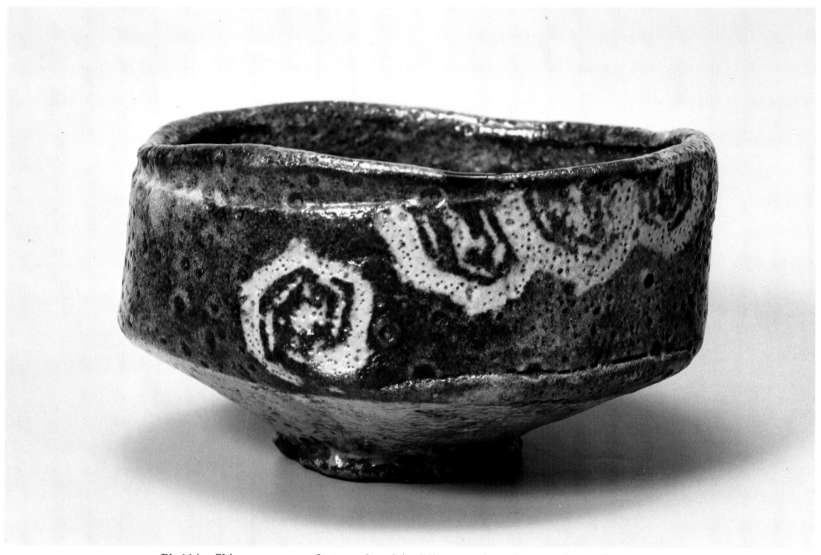

Pl. 114
Tea bowl named "Mine no Momiji," Momoyama period, Shino ware.
H. 8.7 cm., D. 13.6 cm.
Gotō Art Museum, Tokyo.

Shino ware was first produced in Mino province (present-day Gifu Prefecture) for use in the tea ceremony, and in its softness and warmth it surpasses every other type of Japanese pottery. This tea bowl, with its hexagonal "tortoiseshell" pattern, is among the best of the ware. Its name in translation means "Red Maple Leaves on the Ridge," and derives from the specks of red that appear in the light gray glaze.

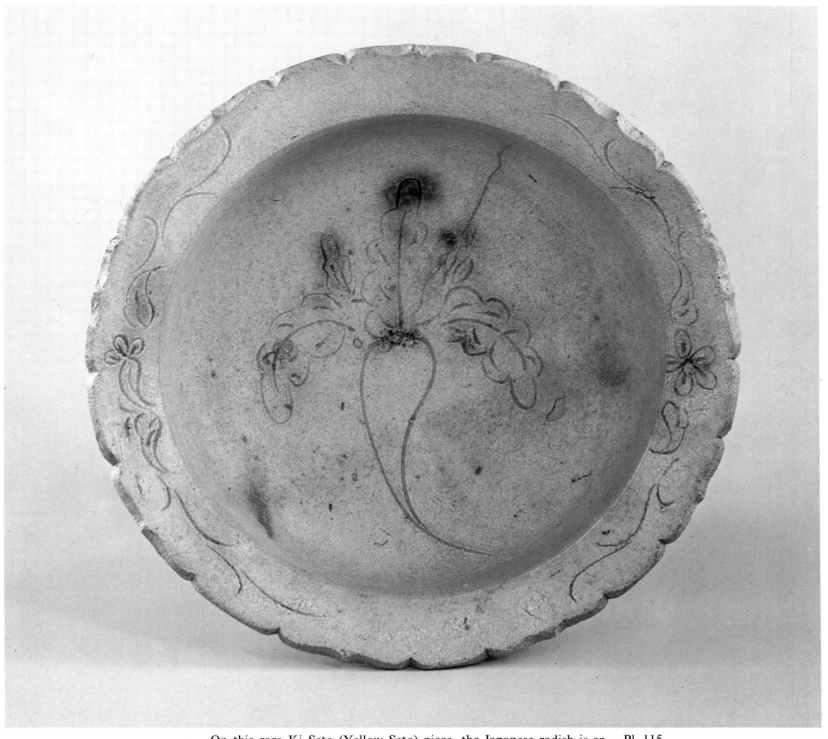

On this rare Ki Seto (Yellow Seto) piece, the Japanese radish is engraved in a free and easy style, and contrasts beautifully with the yellow ground. The petal-shaped rim, which the Japanese adopted from the Chinese with slight modification, was popular in the Momoyama period.

Pl. 115
Dish,
Momoyama period,
Mino ware, Ki Seto.
H. 7.3 cm., D. 25.5 cm.
Manno Collection, Hyōgo.

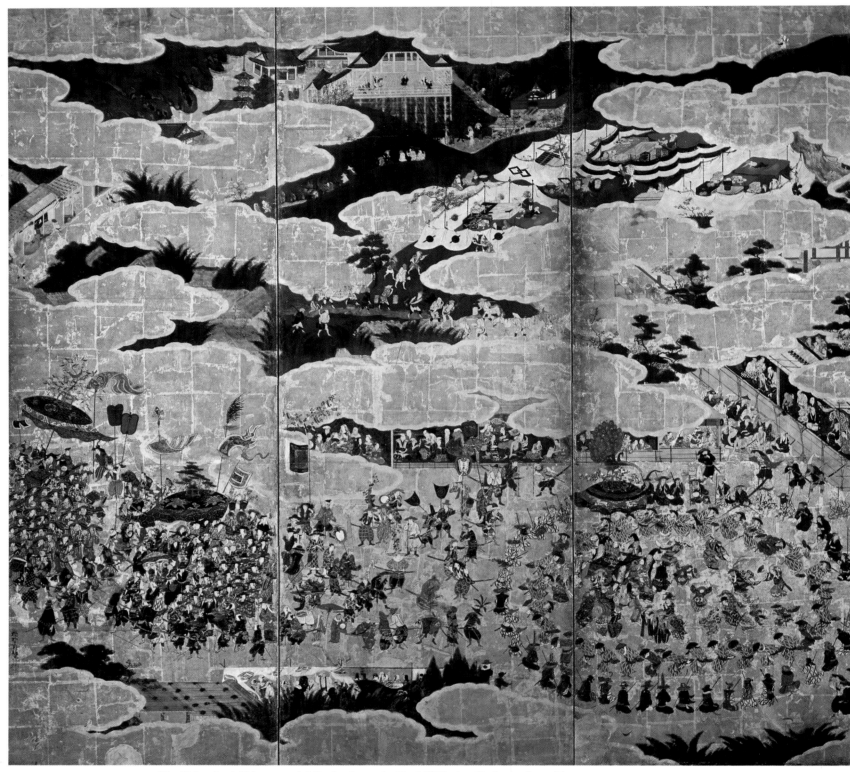

Pl. 116
Hōkoku Festival,
by Kanō Naizen (1570–1616),
early Edo period,
early 17th century,
one of a pair of six-fold screens,
color and gold leaf on paper.
Each screen: 167.5 × 365.0 cm.
Hōkoku Shrine, Kyoto.

In 1604, a special festival was held at Hōkoku Shrine, where Toyotomo Hideyoshi was enshrined, to commemorate the seventh anniversary of his death. The festival began on August 14 and lasted several days, and special performances of *dengaku* and *sarugaku* (two types of folk dances) were given. On August 15, five hundred citizens of Kyoto held a procession in front of the Daibutsu, or Main, Hall. All these events are portrayed in minute detail on this pair of screens, the dances being on the screen shown here. The meticulous depiction of this festival is invaluable as an historical record of this unusual event.

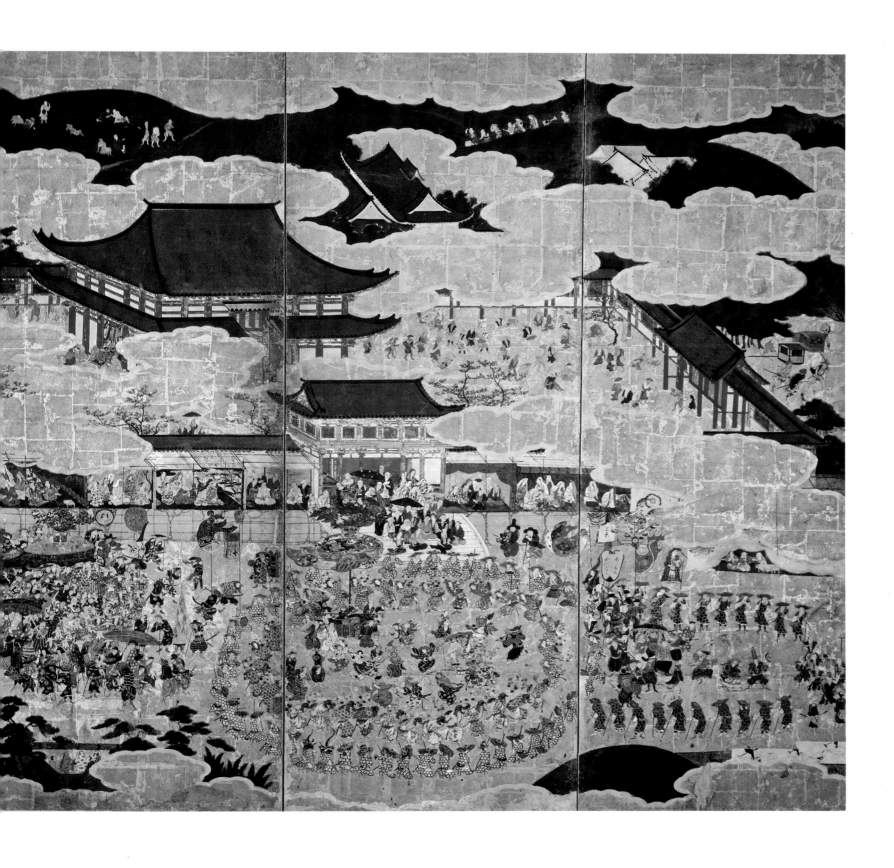

The arrival of the Jesuits in Japan in 1542 and the beginning of trade with Portugal the following year stimulated great interest in the ways and customs of foreigners from the West. This interest found artistic expression in the painting of the *Namban-byōbu* (Southern Barbarian screens). The Europeans were called "Southern Barbarians" because they arrived in Japan from the south. More than forty examples of these screens are known to exist, but they show few individual touches and seem to have been painted within a short period, from about 1590 to about 1630, probably by a group of Kyoto artists working together.

Pl. 117 (*opposite above*)
Namban screen,
by Kanō Naizen (1570–1616),
early Edo period,
four panels of
a pair of six-fold screens,
color and gold leaf on paper,
Each screen: 155.5×364.5 cm.
Kobe City Museum of
Namban Art, Hyōgo.

Pl. 118
Merrymaking under the cherry
blossoms,
by Kanō Naganobu (1577–1654),
early Edo period,
early 17th century,
one of a pair of six-fold screens,
color on paper.
Each screen: 149.0×494.0 cm.
Tokyo National Museum.

This is a typical genre scene, showing young people of the prosperous middle class merrymaking at cherry-blossom time in the spring. The brushwork shows the technical discipline and the polished taste of the orthodox Kanō school. This painting is interesting as a venture into genre painting by a painter of a school that usually confined itself to landscapes and figure paintings in the classical Chinese style. This is one of the earliest of the genre paintings portraying feminine beauty; such paintings were destined to flourish later under the name of *ukiyo-e*.

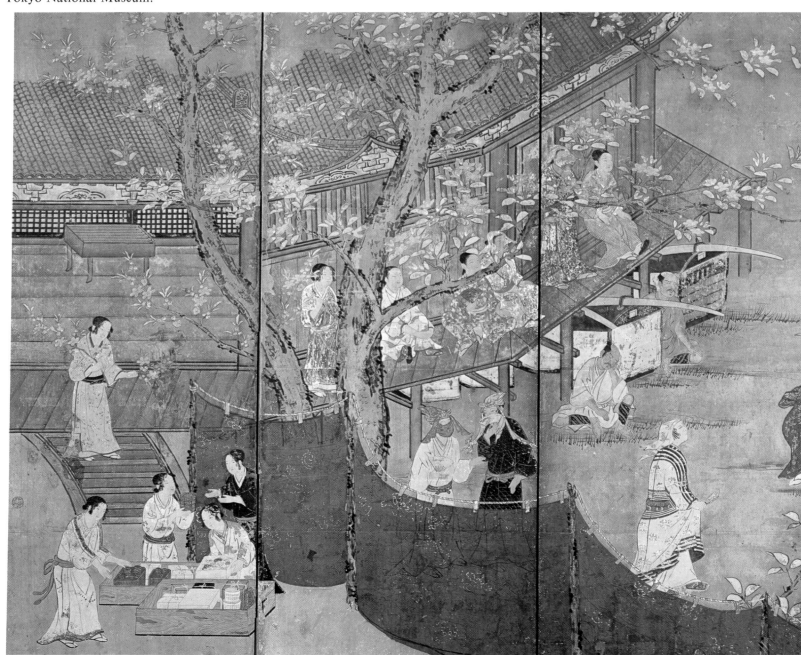

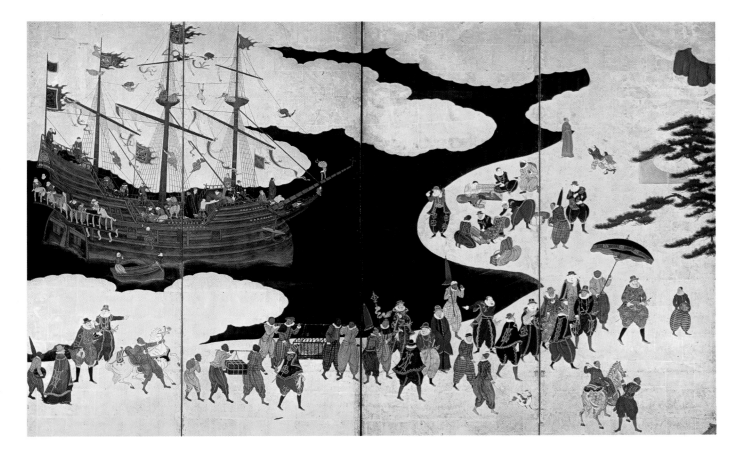

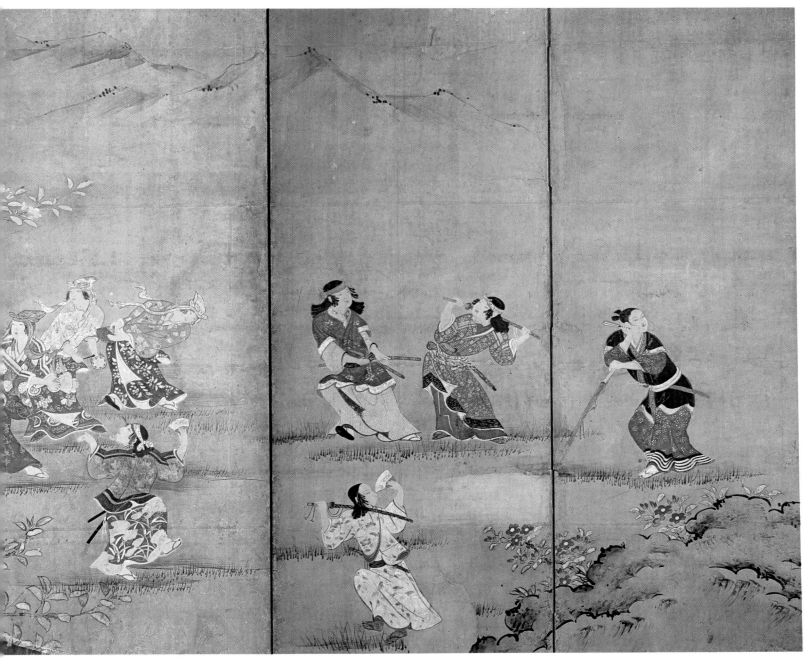

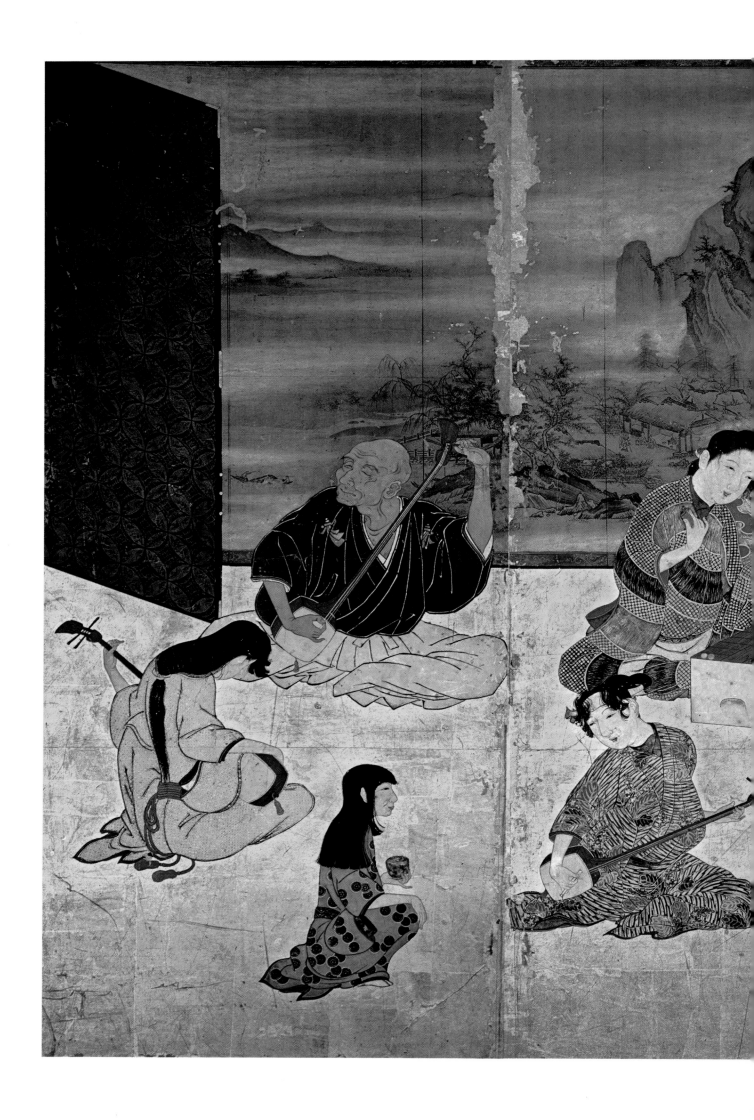

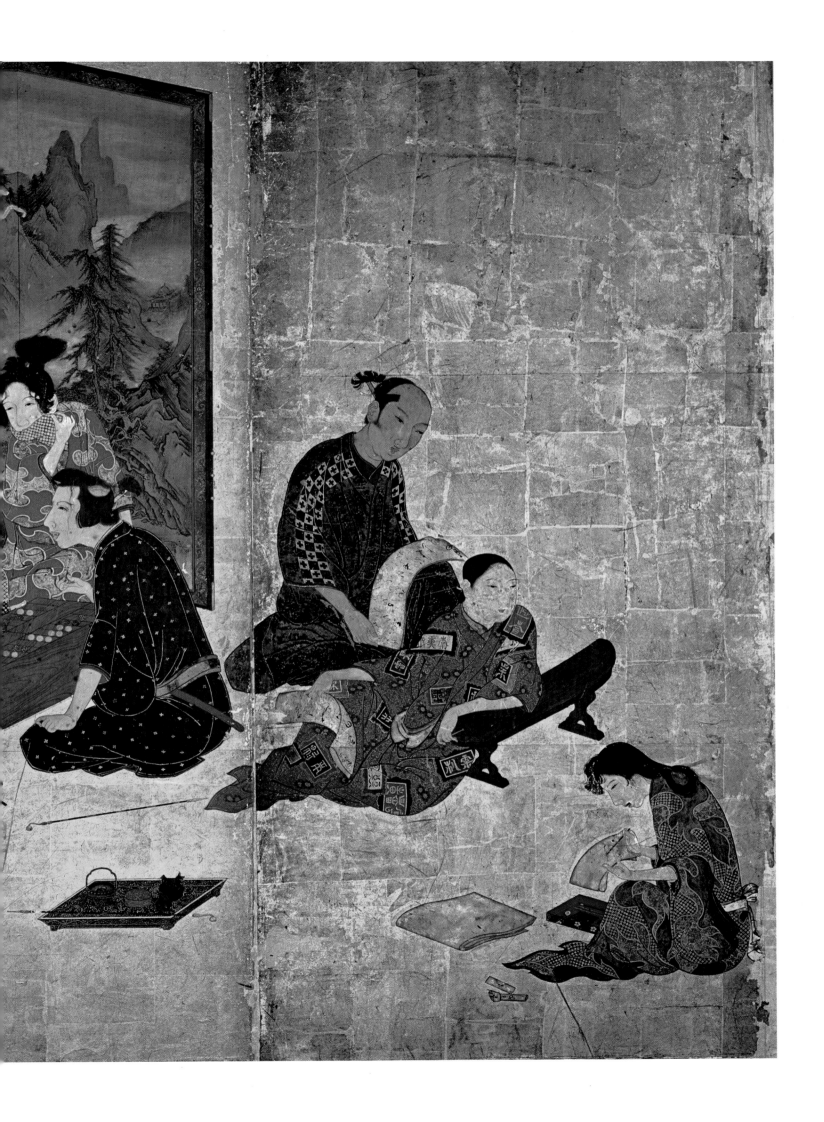

Pl. 119 (*previous pages*)
The Hikone screen,
early Edo period, 17th century,
left half of a six-fold screen,
color on paper.
Whole screen: 94.0 × 274.0 cm.
Ii Collection, Shiga.

This screen, which has always been in the possession of the Ii family, the former lords of Hikone, comprises one continuous composition showing three separate scenes depicting the pleasures of the gay quarters. The work is a play on the classical theme of the "Four Pastimes." It is colorful yet refined, and probably the work of a painter with the classical training of the Kanō school. On the right is depicted a man reading a love letter and a woman writing another, while the two left-hand panels show people playing chess and making music.

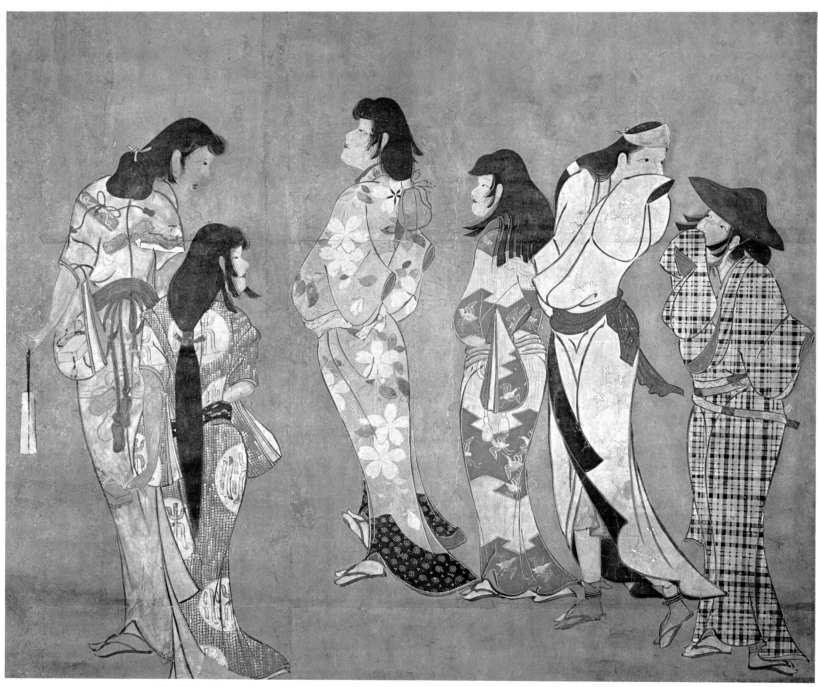

Pl. 120
Yuna (bath-house women),
early Edo period, 17th century,
color on paper.
72.6 × 80.3 cm.
MOA Museum of Art, Shizuoka.

Yuna were women who worked in public bath-houses and catered to the pleasure of customers. In this painting we see six of them giggling and gossiping as they stroll along. The second woman from the left wears a costume with a decorative pattern based on the Chinese character for "bath." The shameless character of these women is depicted in a fascinating and lifelike manner.

This charming picture shows a family enjoying the cool of a summer evening under a trellis on which gourd plants are growing. Under the strict rules of the academic Kanō school of painting it was unusual for the life of the common people to be depicted, and Morikage, a pupil of Kanō Tan'yū, must have been a bold person to turn his hand to such a bucolic subject as this.

Pl. 121
Summer evening under the gourd plants,
by Kusumi Morikage (active latter half of 17th century),
early Edo period, 17th century,
two-fold screen, ink and
light color on paper.
151.0 × 168.0 cm.
Tokyo National Museum.

Pls. 122, 123
Sections of a poem scroll, painting by Tawaraya Sōtatsu (active ca. 1600–40), calligraphy by Hon'ami Kōetsu (1558–1637), early Edo period, 17th century, gold and silver paint on colored paper, calligraphy in *sumi*. H. 33.7 cm. Hatakeyama Collection, Tokyo.

This poem scroll by Sōtatsu and Kōetsu is executed on a polychromatic ground made by joining together many sheets of colored paper. In the first detail, the poems are from the *Kokinwaka-shū* anthology and set on a ground of plum blossoms. In the second section illustrated, decorated with azaleas and ivies, the black characters written by Kōetsu are also taken from the *Kokinwaka-shū*, an anthology compiled in the Heian period.

Pl. 124
Fan-painting of rural cottages in
spring,
by Tawaraya Sōtatsu (active
ca. 1600–40),
early Edo period, 17th century,
detail of a pair of two-fold
screens, color on fan-shaped
paper.
Fan paper: 17.6 × 56.2 cm.
Sanbō-in, Daigo-ji, Kyoto.

The "Tawaraya" of Sōtatsu's name has led us to assume that he was
connected with a workshop of that name in Kyoto which was noted
for its production of fans. This would in turn explain why many of
his works are preserved in the form of decorative folding screens with
fan-shaped paintings pasted on them. This illustration shows one of
eleven painted fans affixed to two folding screens. To compose a
painting within such an awkwardly shaped area is not easy, but Sōtatsu
has succeeded admirably. It is particularly interesting to see how he
has arranged the conventionalized stream eddies and the cherry trees
to create a subtle balance between the three farmhouses.

The Tawaraya workshop connected with Sōtatsu produced ink paint-
ings for pasting onto folding screens, and the painting illustrated here
is almost certainly one of the few examples which can be definitely
attributed to Sōtatsu himself. After mastering the art of *Yamato-e*
painting, Sōtatsu reverted to ink painting and enthusiastically studied
the techniques of the Sung and Yüan dynasties. The painting shows
unusual applications of the *sumi* painting technique peculiar to Sōtatsu,
especially in the execution of the lotus leaves.

Pl. 125 (*opposite*)
Waterfowl on a lotus pond,
by Tawaraya Sōtatsu (active
ca. 1600–40),
early Edo period, 17th century,
ink on paper.
115.0 × 51.0 cm.
Kyoto National Museum.

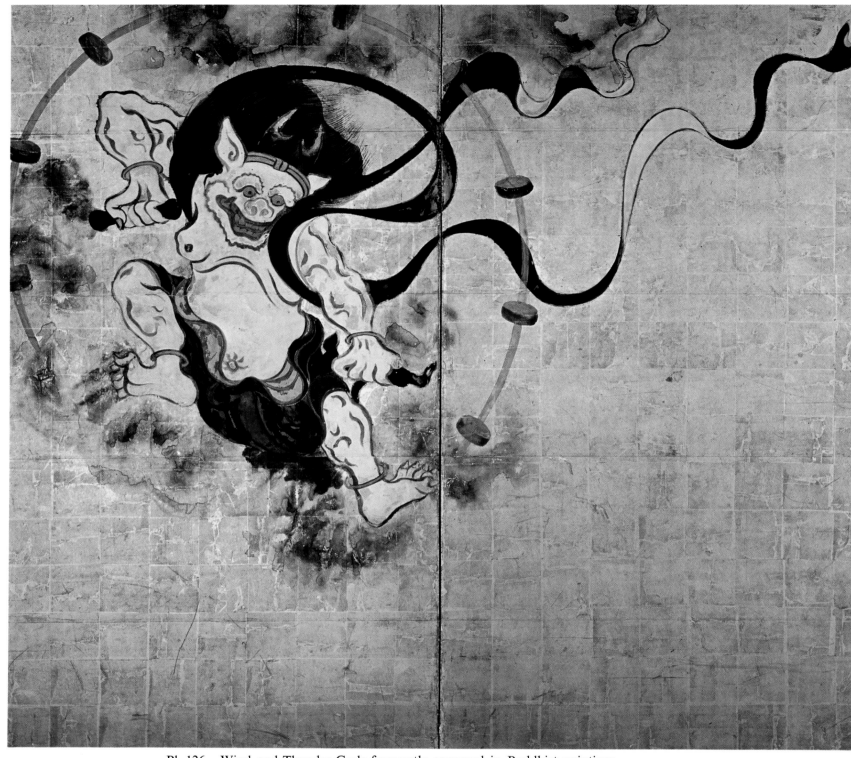

Pl. 126
Wind and Thunder Gods,
by Tawaraya Sōtatsu (active
ca. 1600–40),
early Edo period, 17th century,
pair of two-fold screens,
color and gold leaf on paper.
Each screen: 157.0 × 173.0 cm.
Ken'nin-ji, Kyoto.

Wind and Thunder Gods frequently appeared in Buddhist paintings, and even occasionally in scroll paintings, but only as minor figures. Sōtatsu, however, broke with tradition by representing the two divinities as independent figures and not mere accessories. He may have been inspired by the famous pair of Wind and Thunder Gods carved in wood by Kaikei, the great sculptor of the Kamakura period, belonging to Renge-ō-in, more generally known as Sanjūsangen-dō. This masterpiece by Sōtatsu achieved such popularity that his successor, Kōrin, even made a facsimile copy, and later Hōitsu made a copy from that.

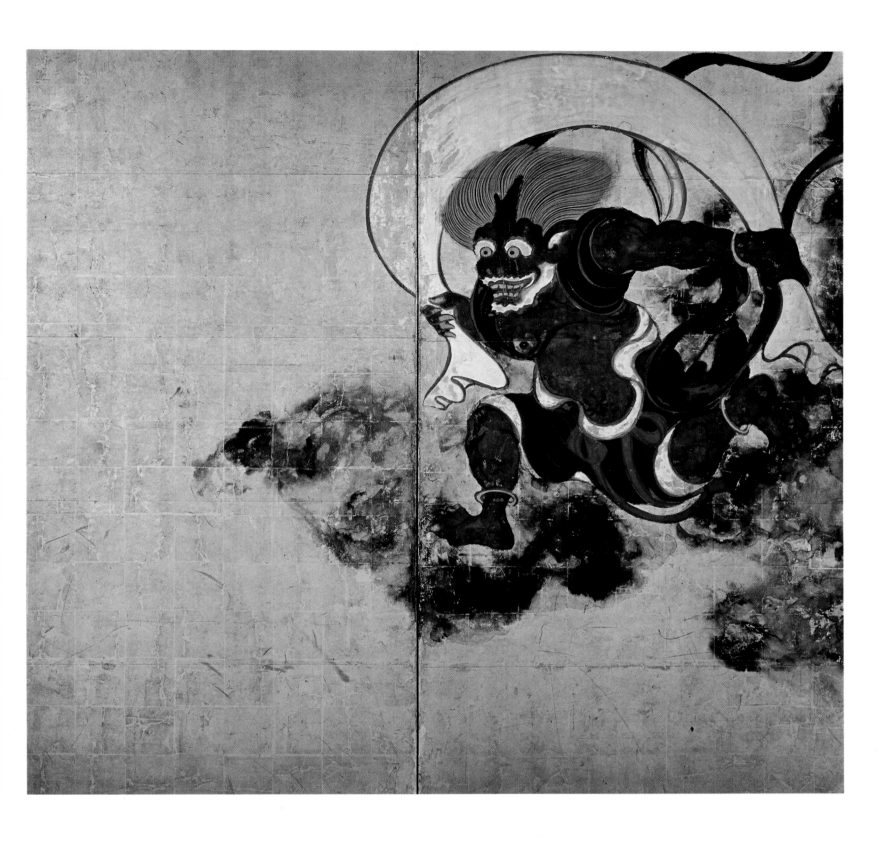

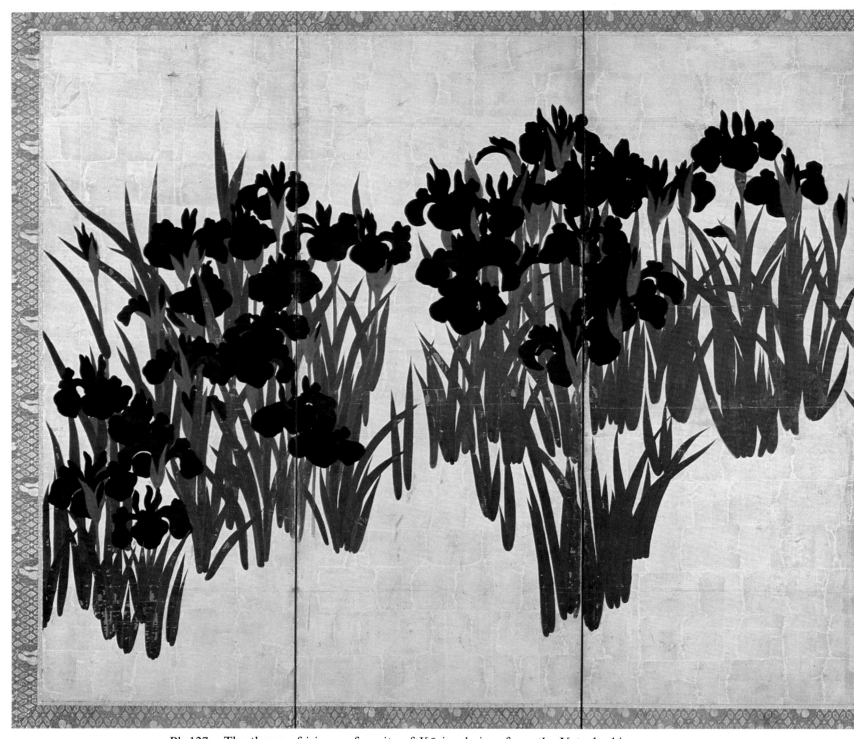

Pl. 127
Irises,
by Ogata Kōrin (1658–1716),
mid-Edo period,
early 18th century,
one of a pair of six-fold screens,
color and gold leaf on paper.
Each screen: 151.2×358.5 cm.
Nezu Art Museum, Tokyo.

The theme of irises, a favorite of Kōrin, derives from the Yatsuhashi (Eight Bridges) Chapter of the *Ise Monogatari* (Tales of Ise). Although truly dazzling in its splendor, technically this brilliant effect is attained very simply. The clumps of irises which fill the screen comprise only two colors—the deep blue of the flowers and the rich green of the leaves. There is no variation of color and no variety of tone.

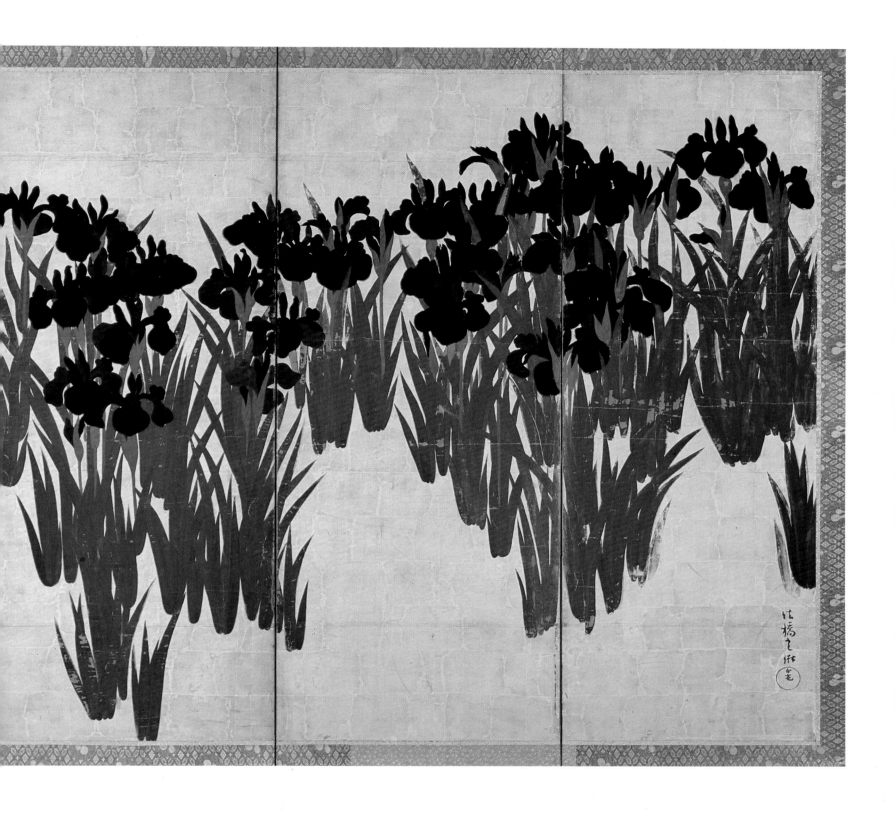

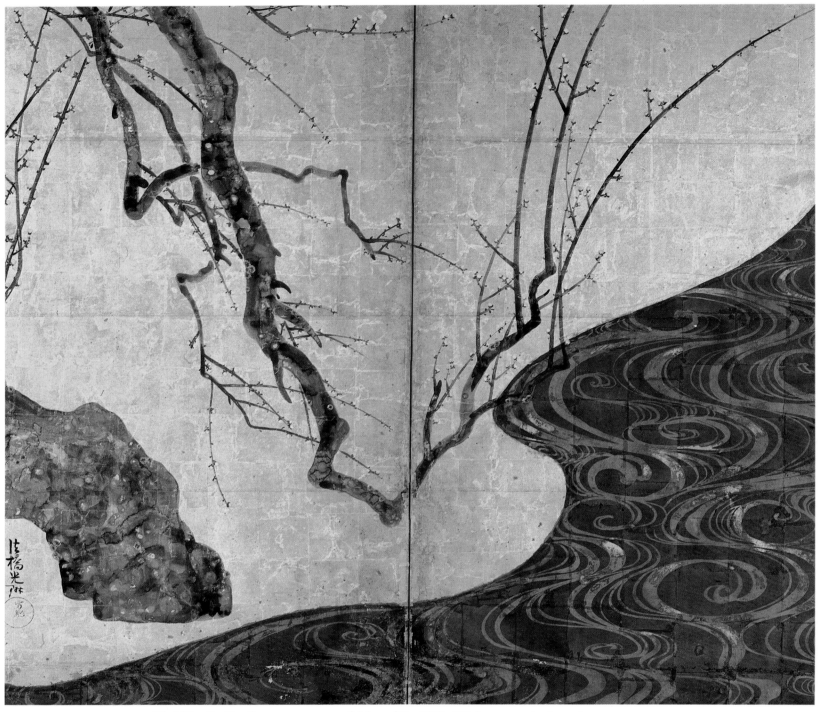

Pl. 128
Red and white plum trees,
by Ogata Kōrin (1658–1716),
mid-Edo period, 18th century,
pair of two-fold screens,
color and gold leaf on paper.
Each screen: 156.6 × 172.0 cm.
MOA Museum of Art, Shizuoka.

In the famous screens of irises (Pl. 127), Kōrin seems to have been preoccupied with the realistic aspects of the flowers and created a stupendous composition of unique decorative charm. In the case of these equally famous screens, Kōrin's attitude toward nature is very different: he has abandoned realism and given free rein to his creative sense.

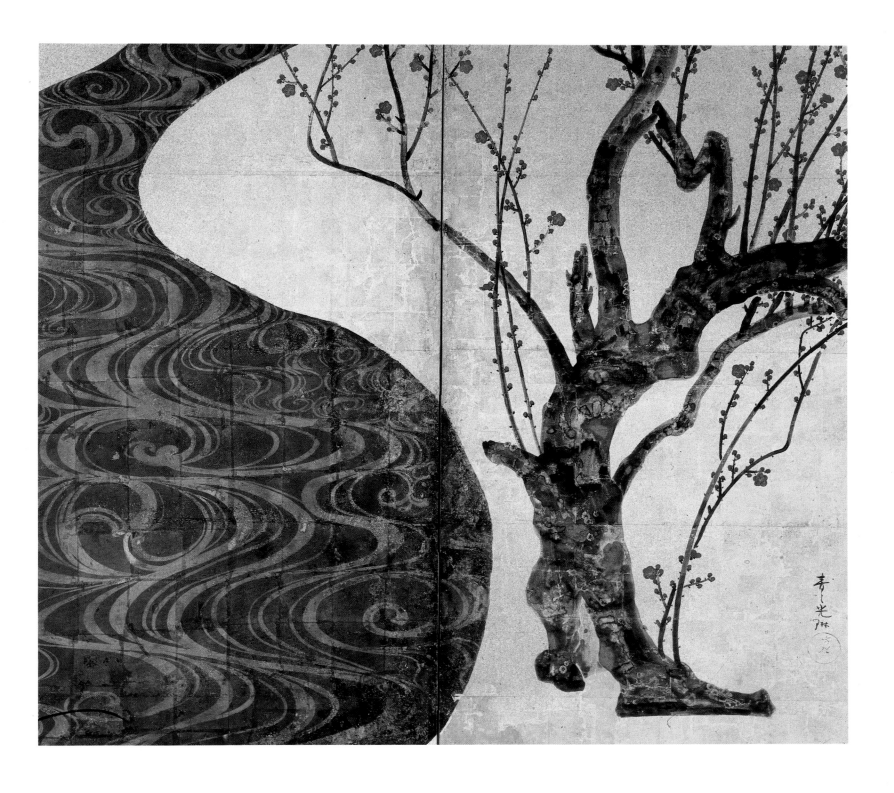

As far as is known, this is the sole existing example of a portrait painting by Kōrin. According to the inscription it is a portrait of Fujiwara Nobumitsu (1669–1730), popularly known as Nakamura Kuranosuke, a wealthy government official of the Ginza Mint in Kyoto and Kōrin's staunchest patron. In this picture Kuranosuke is represented in Noh costume, not surprisingly since both the sitter and the painter shared a common taste for Noh drama. The two were on close terms, and it was largely through Kuranosuke's financial backing that Kōrin was able to pursue his art.

Probably the best-known picture album of the *Nanga* style in Japan is the *Jūben-jūgi-chō* (Album of the Ten Conveniences and Ten Attractions), painted jointly by Ike-no-Taiga and Yosa-no-Buson. The subject matter was taken from a collection of poems by Li Yu, the celebrated Chinese poet of the Ming dynasty. In his poems Li Yu sang of the contentment and simple delights of his life in retirement at the I-en villa. The album consists of twenty pictures, of which ten concerned with *jūben* were painted by Taiga and the other ten dealing with *jūgi* were done by Buson. The picture reproduced here shows in a humorous and elegant manner Li Yu contentedly watering his garden. Each picture carried a fine autographic inscription by Taiga, describing the subject.

Pl. 131
Autumn and summer grasses,
by Sakai Hōitsu (1761–1828),
late Edo period, 19th century,
pair of two-fold screens,
color and silver leaf on paper.
Each screen: 164.5 × 182.0 cm.
Tokyo National Museum.

The last great master of the Sōtatsu–Kōrin school was Hōitsu, who
continued to work into the nineteenth century. He injected into the
school an increased degree of realism, which was the dominating force
in Japanese painting in general at that time. The screen depicting
summer grasses bending beneath the force of a rainstorm forms a pair
with that showing autumn grasses being buffeted by a strong wind.
These scenes of rain and wind are done in colors on a silver background
on the reverse of the two screens of "Wind and Thunder Gods" painted
by Kōrin in faithful imitation of the Sōtatsu originals (Pl. 126).

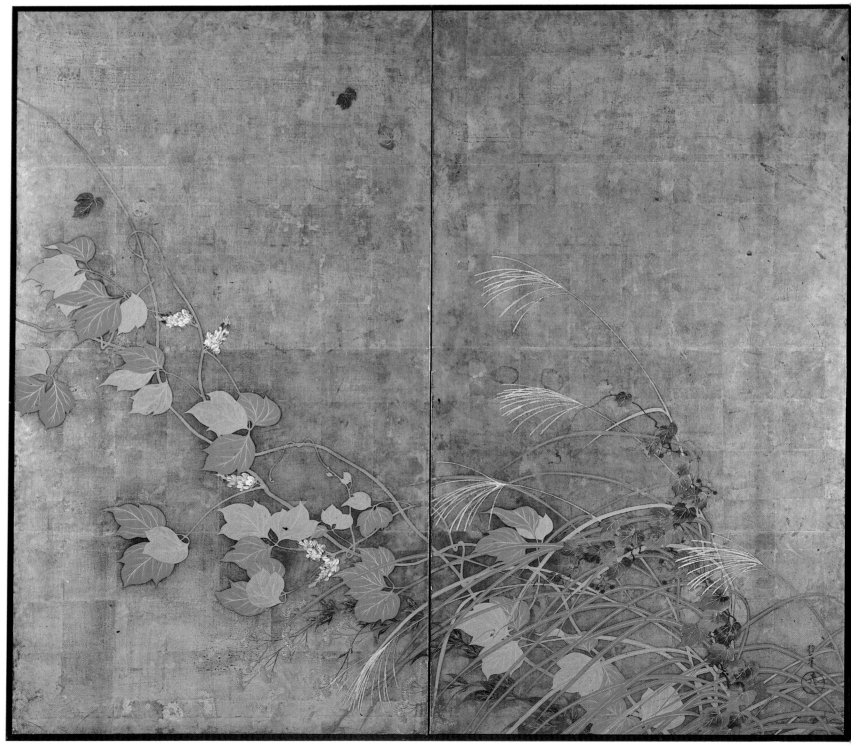

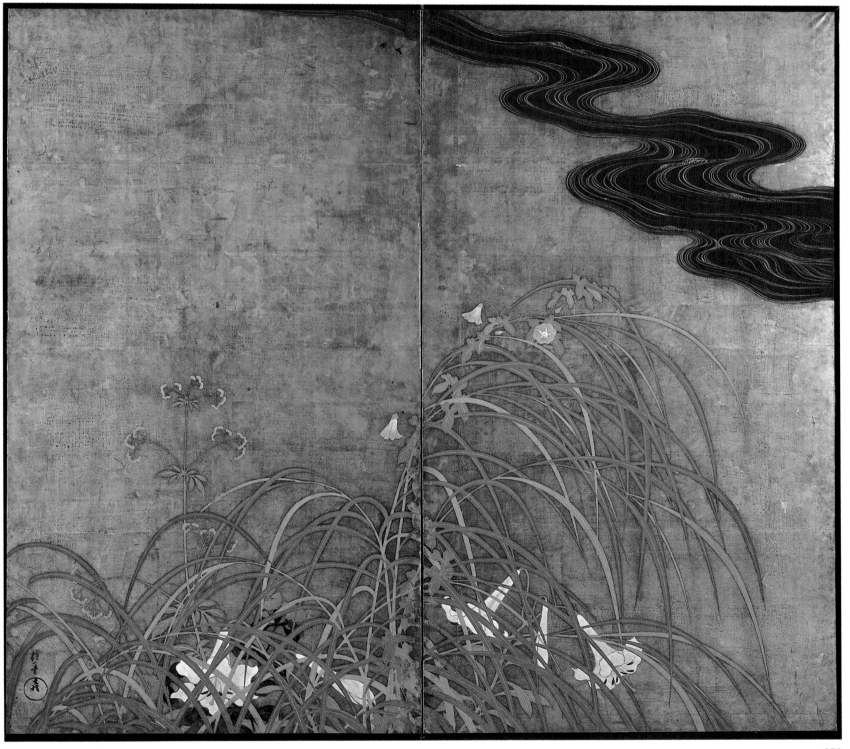

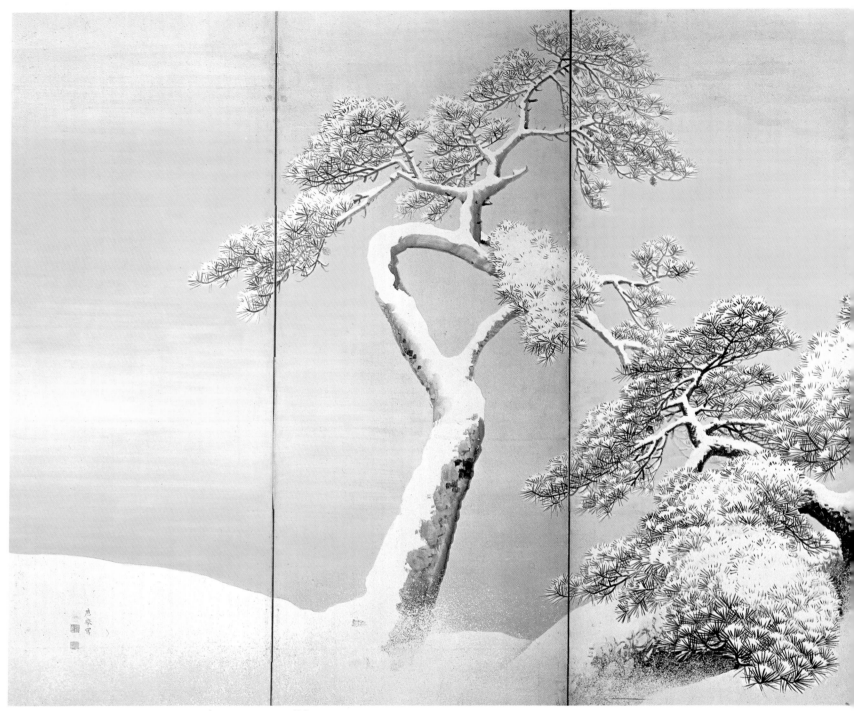

Pl. 132
Pine trees covered with snow,
by Maruyama Ōkyo (1733–95),
mid-Edo period,
late 18th century,
one of a pair of six-fold screens,
ink, color and gold dust on paper.
Each screen: 155.0 × 362.0 cm.
Mitsui Collection, Tokyo.

Maruyama Ōkyo is generally considered the foremost exponent of realism in Japanese painting. By his time, Western painting and illustrated books were filtering into the country through Nagasaki. These, together with Chinese paintings of the Ch'ing dynasty (some of which were extremely realistic) seem to have opened the eyes of Ōkyo to the importance of studying nature and copying it with scientific accuracy. At the same time, however, Ōkyo was brought up in the old traditions of Kyoto. His work as a whole is very decorative, and meticulous and accurate in its detail. This famous painting of "Pine trees covered with snow" demonstrates a scrupulous observation of nature combined with a fine decorative sense.

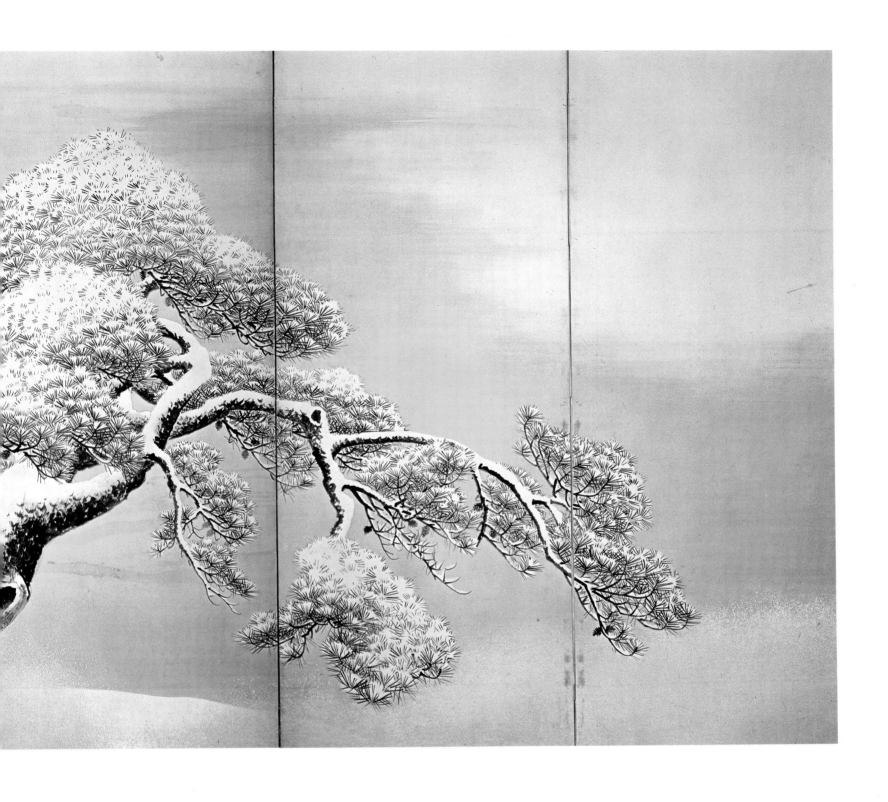

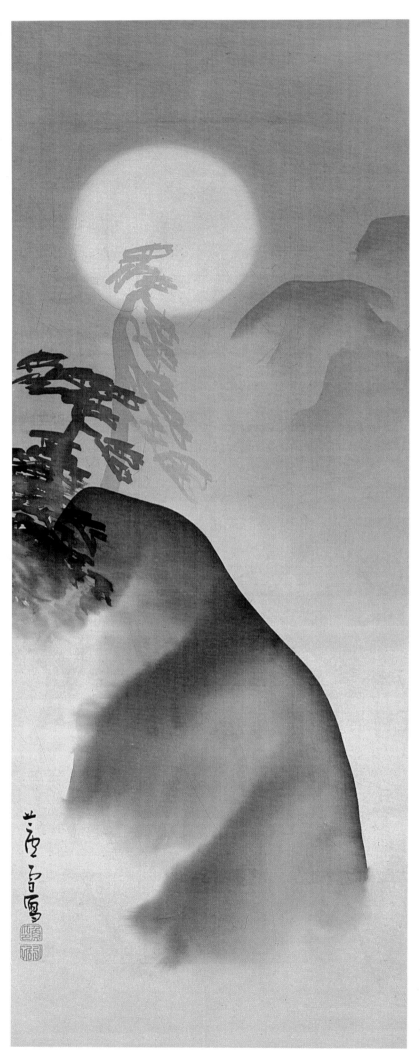

Pl. 133
Landscape in the moonlight,
by Nagasawa Rosetsu (1755–99),
mid-Edo period, 18th century,
ink on silk.
98.0 × 35.5 cm.
Egawa Museum of Art, Hyōgo.

Nagasawa Rosetsu was one of the best pupils of Maruyama Ōkyo. In this work, which is reminiscent of earlier Zen painting, the moon is left white, and the night sky, the mountains, and the pine trees are depicted with gradations of India ink.

Pl. 134 (*opposite*)
Winter clouds and sifting snow,
by Uragami Gyokudō (1745–1820),
late Edo period,
early 19th century,
ink and faint color on paper.
133.5 × 56.2 cm.
Kawabata Yasunari Foundation,
Kanagawa.

In the early nineteenth century, Gyokudō produced numerous paintings with the strange light effects that we see here. For this winter scene, set deep within the mountains, the artist has used gradations of ink to emphasize only the highlights. The inscription says the painting is "the work of the drunken Gyokudō Kinshi."

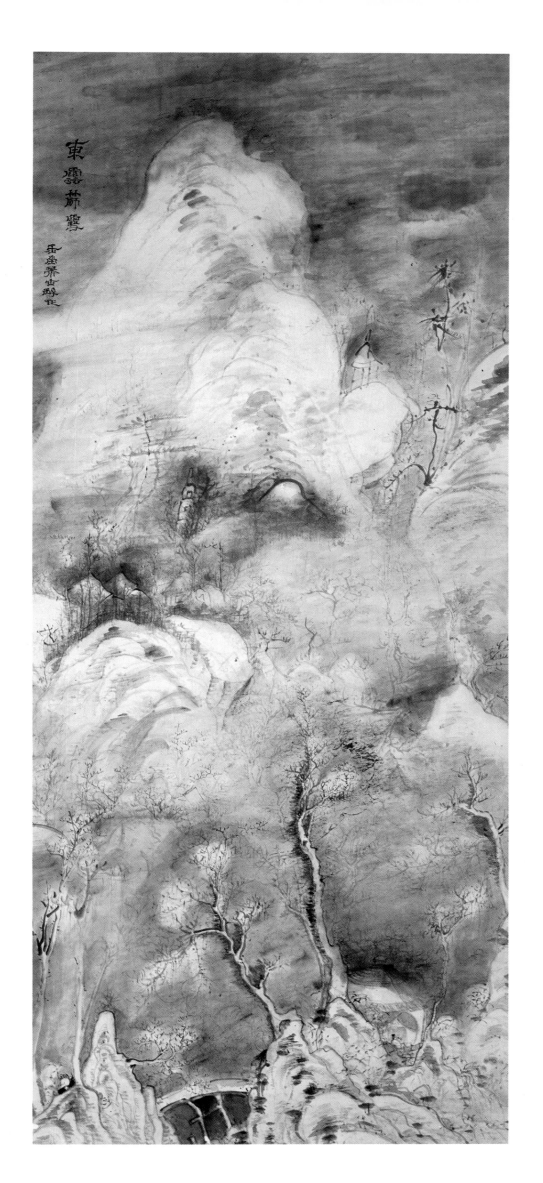

177

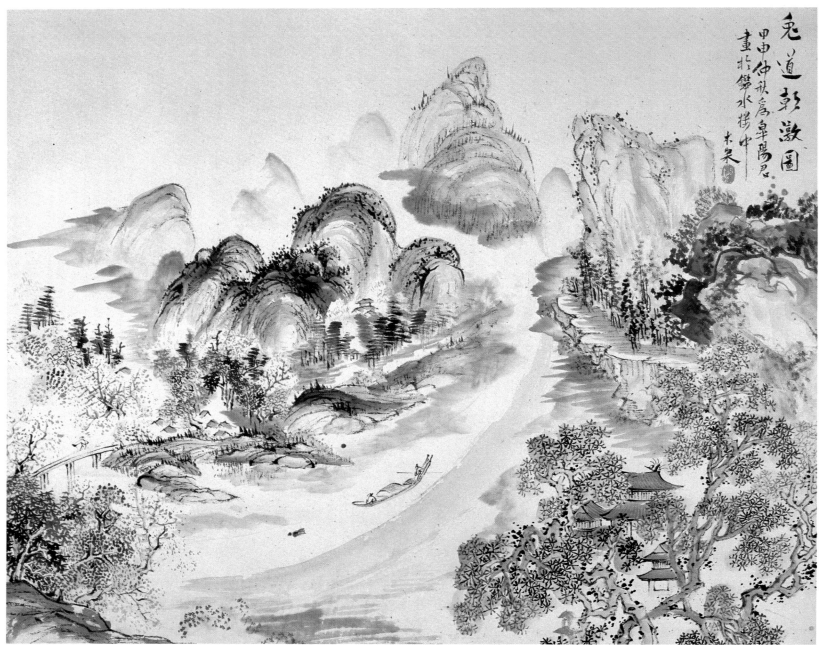

Pl. 135
Morning on the Uji River,
by Aoki Mokubei (1767–1833),
late Edo period, 1824,
color on paper.
50.0 × 60.7 cm.
Tokyo National Museum.

This work represents a view of the Uji River with the early morning sunlight coming over the mountains. It is not, of course, intended to be a realistic scene but rather a pictorial expression of an image visualized by the artist. In spite of its rather abrupt rendering, it has considerable depth and volume, and the brushwork is delicate. The painter, Aoki Mokubei, was by profession a distinguished potter.

Takami Senseki, the artist's friend and the chief retainer of the Koga clan as well as a distinguished scholar, is represented in the formal attire of an eminent samurai. Watanabe Kazan took a serious interest in Western learning and, despite the official prohibition, tried to study Western painting. His success in this is demonstrated by this very lifelike portrait. The realistic delineation of each feature of the face is achieved with delicate chiaroscuro in the Western manner, a technique previously unknown in Japanese painting.

Pl. 136 (opposite)
Portrait of Takami Senseki,
by Watanabe Kazan (1793–1841),
late Edo period, 1837,
hanging scroll, color on silk.
115.5 × 57.3 cm.
Tokyo National Museum.

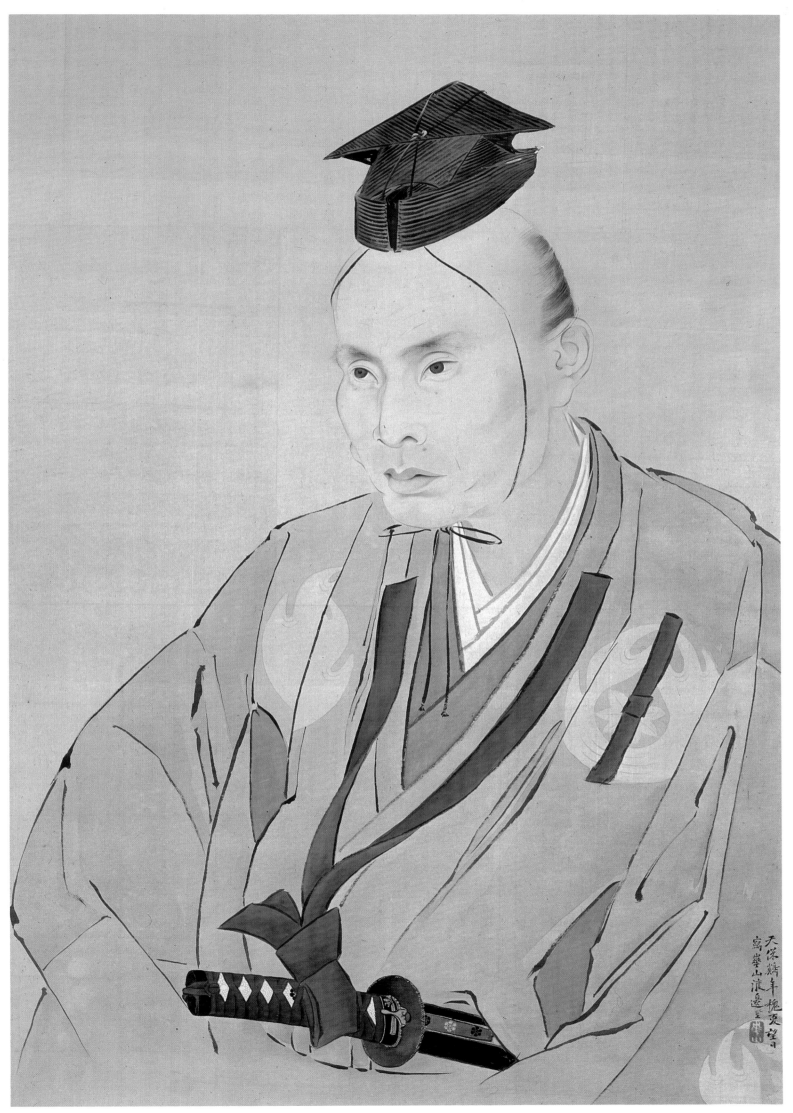

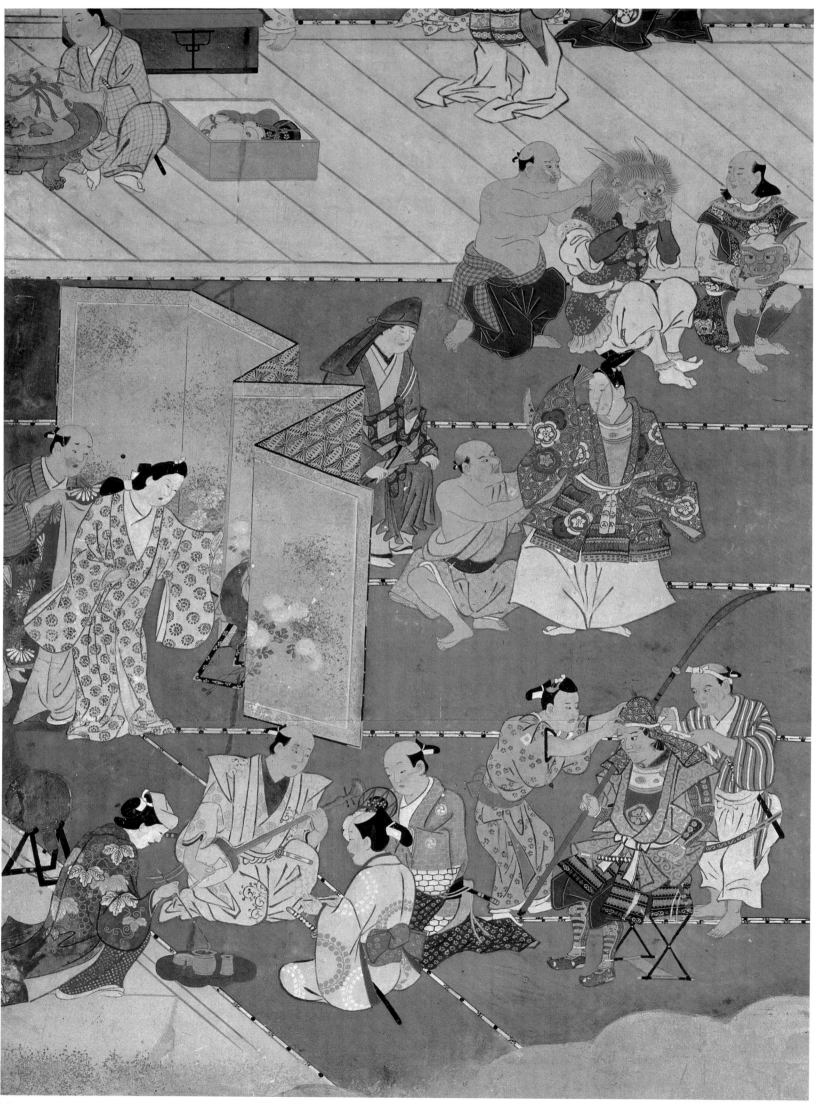

Pl. 137 (*opposite*)
Kabuki theater screen,
attributed to Hishikawa Moronobu
(1618?–94),
early Edo period, 17th century,
detail of a pair of six-fold screens,
color on paper.
Each screen: 170.0 × 397.0 cm.
Tokyo National Museum.

In this type of Kabuki screen painting, every aspect of the Kabuki
theater is depicted, from the audience in their seats to the actors behind
stage, and everything is arranged in one tightly organized whole. This
detail shows the actors and musicians busy making up for the play to
follow. The gay colors of the costumes and the bustle of behind-the-
scenes activity allow even those who have no knowledge of the Kabuki
theater to enjoy the painting to the full.

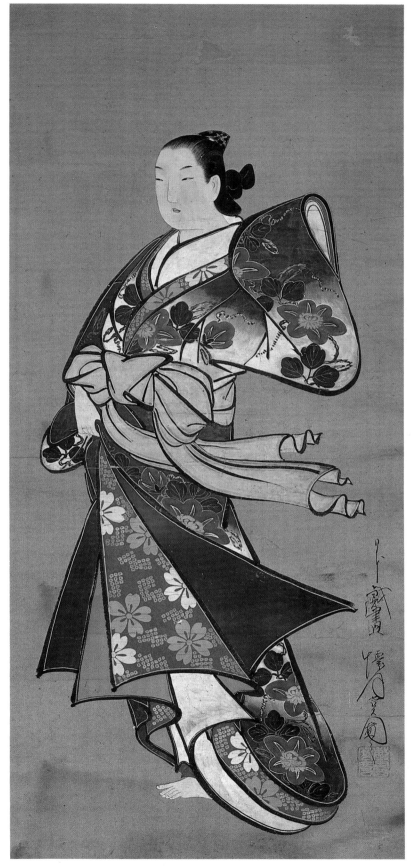

Pl. 138
A beauty in the wind,
by Kaigetsudō Ando (active 1688–1715),
mid-Edo period,
early 18th century,
color on paper.
94.8 × 42.7 cm.
Tokyo National Museum.

This is a typical *ukiyo-e* painting of a stately beauty, walking with
perfect composure with the hem of her kimono and the end of her sash
fluttering in a strong wind. The artist, Kaigetsudō Ando, lived in Edo
(present-day Tokyo) and is thought to have established a workshop
there. With the help of pupils, he produced a large number of paintings
of imposing beauties. His paintings are particularly notable for the bold
designs on the kimono, on which is also indicated the name of the
woman subject.

Osen, daughter of the proprietor of a teahouse in the grounds of the Kasamori Shrine, was immortalized by Harunobu as his ideal of a nubile woman. An Edo beauty, she is shown seated in front of the shop, conversing with a youthful fan-seller. Through this print both Harunobu and Osen became widely known in Edo. It was around this time that woodblock prints of actors and beautiful women began to increase in popularity.

Pl. 140
Kasamori Osen,
by Suzuki Harunobu (1725–70),
mid-Edo period, ca. 1769,
woodblock print, *nishiki-e*.
Middle print size, 27.5×19.5 cm.
Tokyo National Museum.

Pl. 139 (*opposite*)
Gorō uprooting a bamboo,
by Torii Kiyomasu
(active 1694–1716),
mid-Edo period, 1697,
woodblock print, hand-painted.
Large print size, 55.0×33.0 cm.
Tokyo National Museum.

Shown here in the role of Gorō is the actor Ichikawa Danjūrō (1658–1704), inventor of the so-called *aragoto-kabuki*. This style of Kabuki play had a heroic plot, with a valiant young man of matchless physical power helping the hero overcome the villain. The popularity of this type of play led to a demand for illustrations of scenes from the plays, and in this way arose the Torii school of painters which devoted itself to Kabuki subjects. This print demonstrates the special style Torii Kiyomasu devised for rendering *aragoto-kabuki* scenes. The exaggeratedly muscular legs and arms accord with a convention highly appreciated by theatergoers. As a woodblock print, this is still primitive: the key features of the figure are printed in strong black lines, over which only two colors—yellow-ochre and yellowish red—are hand-painted.

Pl. 141
Summer evening on the riverbank
at Hama-chō,
by Torii Kiyonaga (1752–1815),
mid-Edo period, ca. 1784,
woodblock print, *nishiki-e*.
Large print size, 37.9 × 26.3 cm.
Riccar Art Museum, Tokyo.

On hot summer evenings, the inhabitants of Edo would stroll beside the Sumida River, enjoying the cool breeze from the river. This custom became a favorite subject for *ukiyo-e* prints. This print is representative of Kiyonaga's style at its full maturity. Kiyonaga began his career as a pupil of Torii Kiyomitsu and succeeded him as the fourth head of the Torii school, whose traditional occupation was the painting of theatrical posters. Kiyonaga's greatest talent lay, however, in his pictures of female beauties, notable for his realistic treatment of the female form.

娘日時計午ノ刻
古代者女湯以甲刻
當二此圖ヲ

哥<麿筆

Of all *ukiyo-e* artists Utamaro was the most successful in portraying beautiful women. This is one of a series called "*Musume hidokei*" (Girls at Various Hours of the Day), representing a day in the life of young women in the gay quarters. This print shows a scene between noon and two o'clock, when the girls usually took a bath. Utamaro displays a rare sensitivity for the most delicate aspects of feminine beauty, and here we find one very interesting example of it in his rendering of the women's faces, which lack contour lines and are merely presented in relief against the yellow background—an ingenious way of giving an impression of the soft skin and delicate curves of the flesh of young girls.

Pl. 142
Girls after the bath,
by Kitagawa Utamaro (1753–1806),
mid-Edo period,
woodblock print, *nishiki-e*.
Large print size, 38.0 × 25.5 cm.
Tokyo National Museum.

This scene from Hiroshige's famous "Fifty-three Stations on the Tōkaidō" has both thick and fine oblique lines and admirably depicts the violence of the rain as the bamboos bend down in a sudden strong gust of wind. The picture skillfully catches the flurry of people making for shelter in a sudden shower.

Pl. 144
Rain at Shōno,
by Andō Hiroshige (1797–1858),
late Edo period, 1833,
woodblock print, *nishiki-e*.
Large print size, 27.0 × 39.5 cm.
Tokyo National Museum.

Pl. 143 (*opposite*)
The actor Ichikawa Ebizō,
by Tōshūsai Sharaku (active
1794–95),
mid-Edo period, 1794,
woodblock print, *nishiki-e*.
Large print size, 37.6 × 25.2 cm.
Tokyo National Museum.

With flashing eyes under raised eyebrows, a large nose, and screwed up mouth, this face of Ebizō gives an impression of grotesqueness. In most cases, actors' portraits were painted realistically or a little more flatteringly. However, Sharaku had a strongly individualistic style. He was adept at capturing the actor's characterization and stage manner by his use of flat patterns of color and the lines of the actor's features and costume. This portrait shows Ebizō in the role of Sadanoshin Takemura in the play *Koinyōbō Somewake Tazuna*, staged in 1794.

Pl. 145
Thunderstorm below the mountain,
by Katsushika Hokusai (1760–
1849),
late Edo period,
woodblock print, *nishiki-e*.
Large print size, 26.0 × 38.0 cm.
Private collection.

This print is from Hokusai's "Thirty-six Views of Mount Fuji," perhaps the most famous series of *ukiyo-e* prints. The series is actually composed of forty-six prints; in thirty-six of them, Mount Fuji is depicted from various places along the Tōkaidō highway to the south, and in the remaining ten the views are from the Kōshūkaidō highway to the north. Hokusai spent more than five years on this series, starting it when he was sixty-four or sixty-five and publishing the last print when he was seventy. Consequently, three different seals are used, and from this we can learn the period in which each print was produced. In this scene, a sharp chisel line captures a flash of lightning against the dark mountainside.

Inrō were small containers for medicine that were carried at one's waist; and *netsuke* are small carved pieces attached to *inrō*, or money or tobacco pouches, and inserted into the sash to hold them in place. Originating among the wealthy merchant classes, who were restricted by sumptuary laws as regards dress, they eventually came to be worn by men of all classes. Made of ivory, boxwood, pottery, metal, and so on, they are extremely intricately carved despite their small size. In modern times they have been more highly valued abroad than in Japan.

Pl. 146 (*opposite*)
Inrō and *netsuke*,
early Edo period, 17th century,
various materials.
The Museum Yamato Bunkakan,
Nara.

After becoming a priest when he was twenty-three years old, Enkū spent his life wandering around Japan, preaching and carving images of the Buddha. These vary in size from finger-length to larger than a man, and to sculpt them Enkū used a hatchet, which makes them look unfinished but endows their rough strong lines with a spontaneity that is very appealing. Enkū was extremely prolific, and it is said that he wanted to carve one hundred and twenty thousand images of the Buddha before he died. As it is, some two thousand of his statues have been preserved.

Pl. 147 (*overleaf*)
Statue of Fudō,
by Enkū (1632–95),
early Edo period, 17th century,
wood.
H. 88.9 cm.
Seiryū-ji, Tochigi.

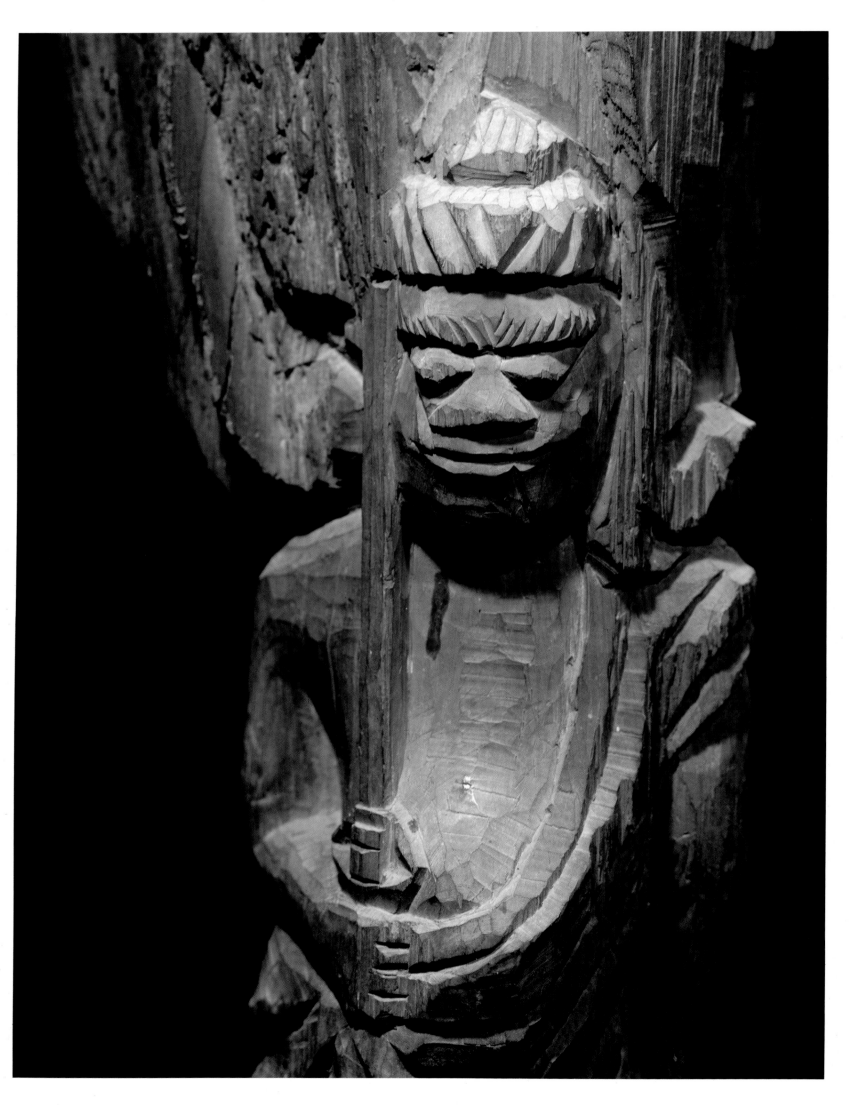

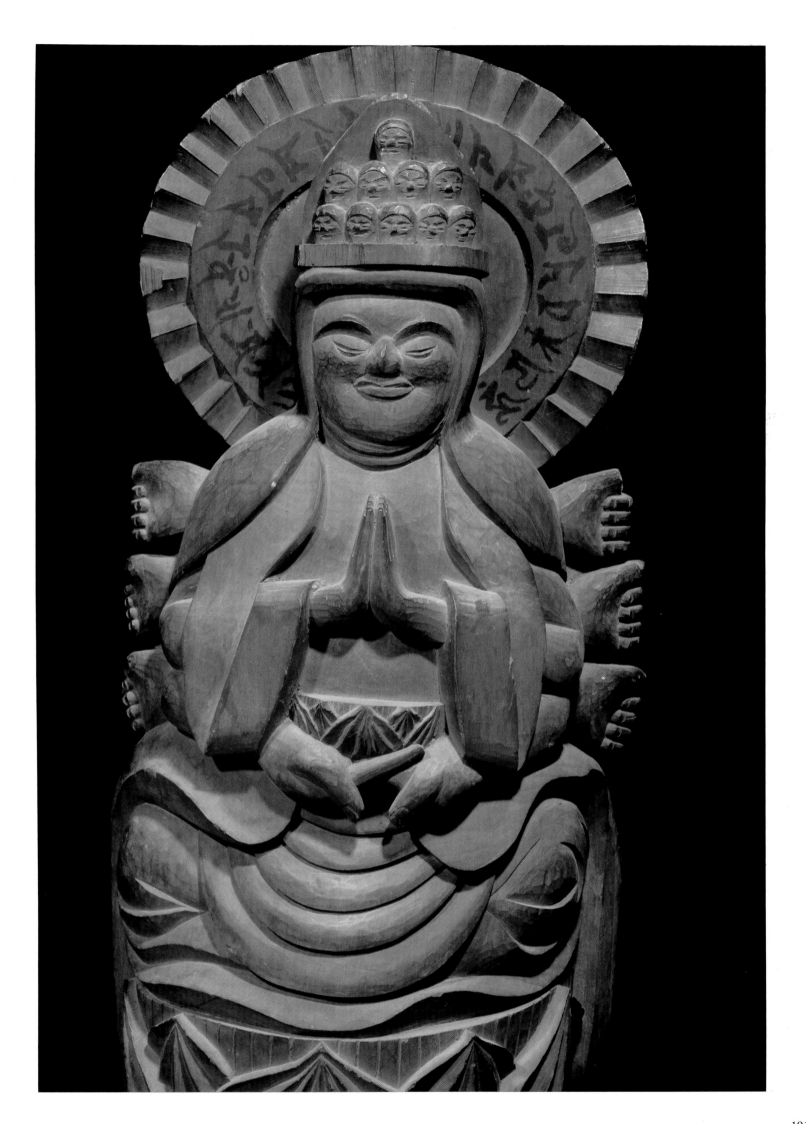

Mokujiki became a monk at the famous temple complex on Mount Kōya, and set off traveling around the countryside, collecting money and carving images for new temples. His work, like that of Enkū, has a naive and unsophisticated charm that has only come to be appreciated in the last fifty to sixty years in Japan, with the resurgence of interest in folkcraft.

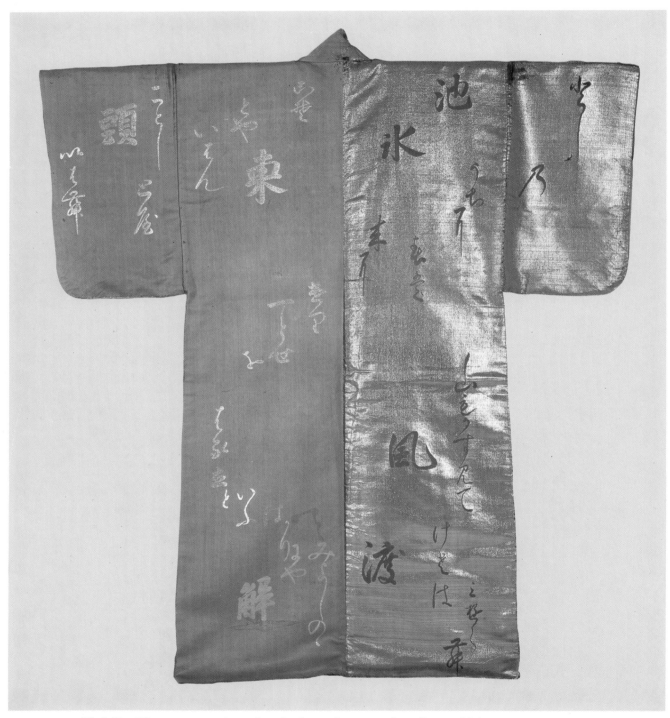

The term *atsu-ita* refers both to the type of textile—a thick compact plain or twill silk with patterns woven in twill—and to robes made of this that were used in the Noh theater for certain male roles. The robe illustrated is divided into two halves, one gold and the other red, and the calligraphic designs are asymmetrically balanced. The poems on the robe are on the theme of spring, and are taken from the *Wakan Rōei-shū* anthology of Chinese and Japanese poetry compiled in the middle of the Heian period.

The present-day kimono originated from this style of robe with narrow-cuffed hanging sleeves, called *kosode*. This particular robe is known as the "Kōrin *kosode*" or the "Fuyuki *kosode*" because the decorative design on it is known to have been painted by Ogata Kōrin for the wife of his patron, the rich merchant Fuyuki. Kōrin's favorite subject of autumn flowers and grasses is painted in *sumi* and light colors. The design is arranged with the practical purpose of the garment in mind, since the space that would be covered by the sash is left undecorated.

Pl. 150
Fuyuki *kosode*,
painted by Ogata Kōrin (1658–1716),
mid-Edo period,
ink and color on silk.
L. 147.2 cm., W. 65.1 cm.
Tokyo National Museum.

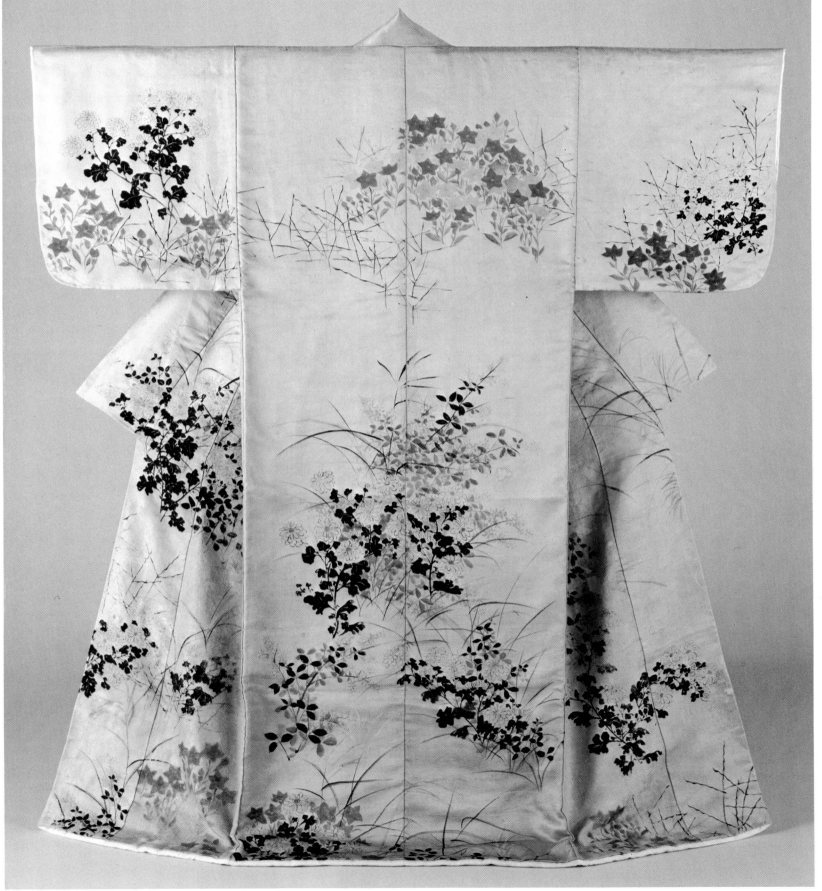

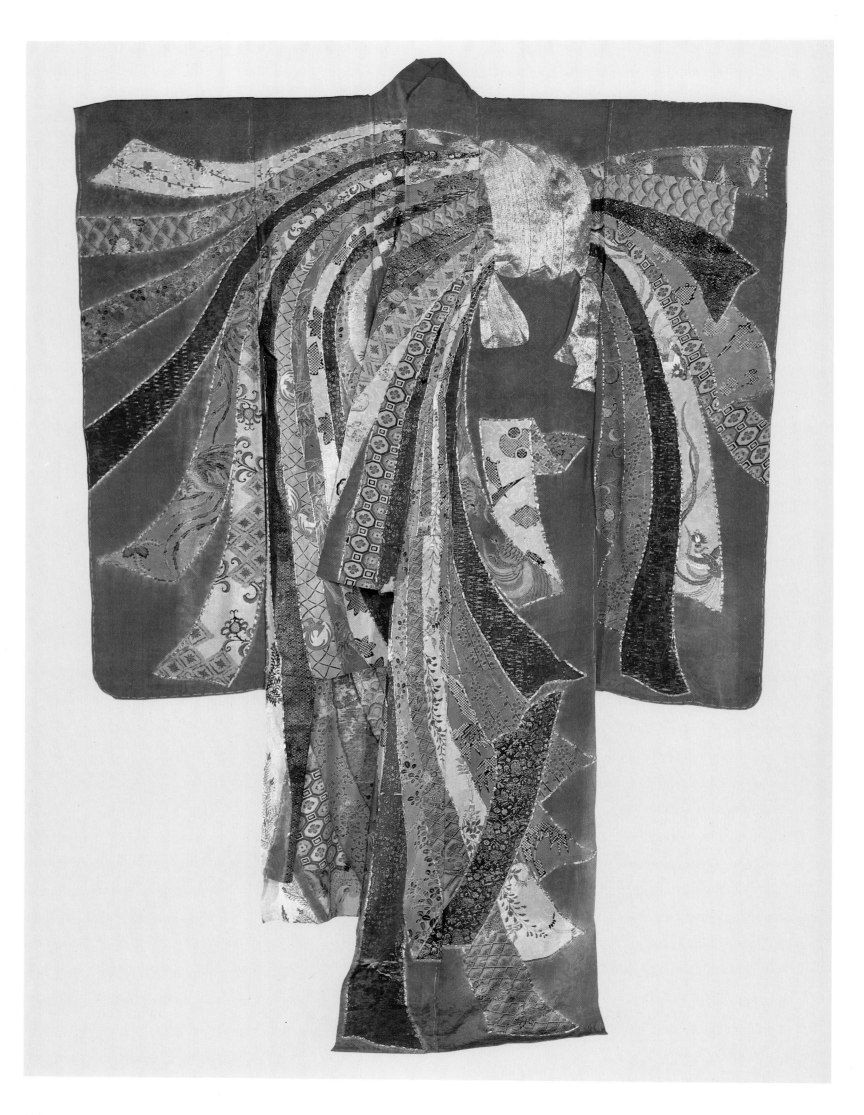

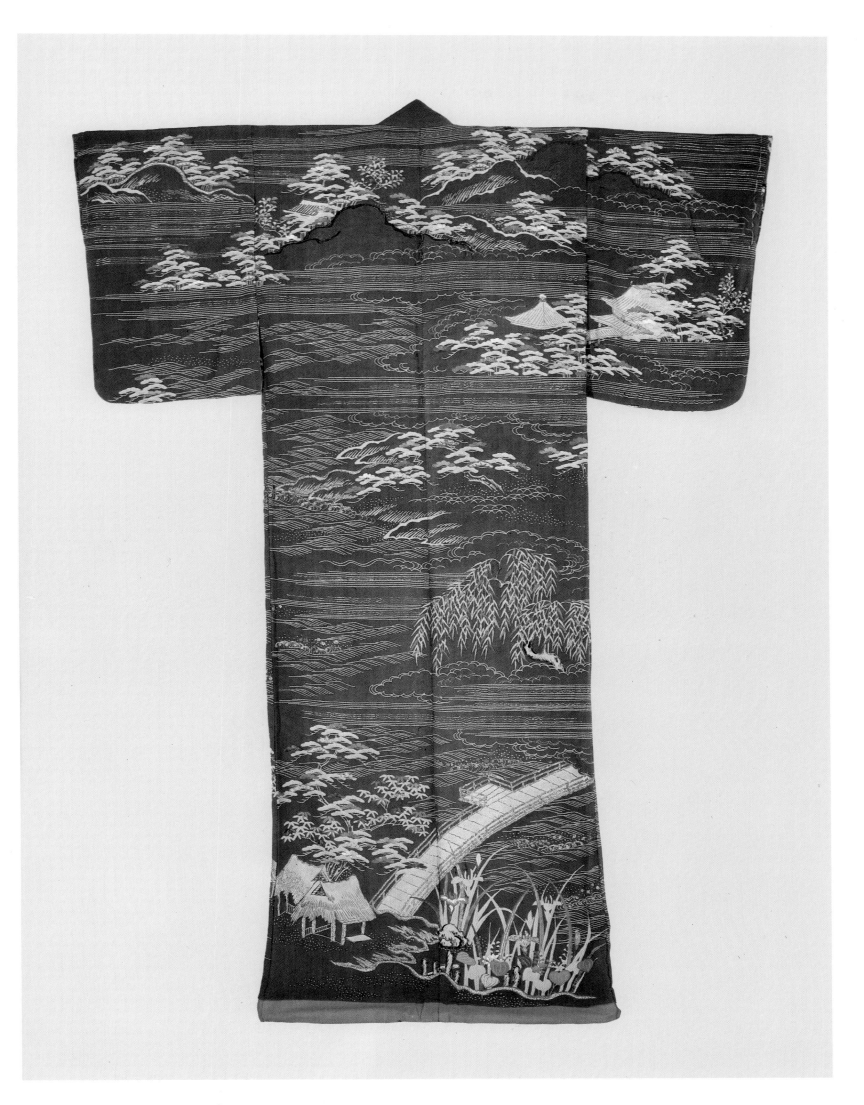

Pl. 151 (*p. 194*)
Furisode,
mid-Edo period, 17th century,
silk.
L. 156.5 cm., W. 58.5 cm.
Yūzen-shi-kai, Kyoto.

The *furisode* is the robe with long hanging sleeves that was worn by unmarried women in the Edo period. The complex decorative design of a *noshi*, which is a bundle of cloth tied in an ornamental knot and used as a congratulatory symbol, is achieved by the hand-painted starch-resist-dyeing technique called *yūzen*, after its originator, Miyazaki Yūzensai.

Pl. 152 (*p. 195*)
Kosode named "Uji-bashi,"
late Edo period,
late 18th–early 19th century.
L. 166.3 cm., W. 62.1 cm.
Tokyo National Museum.

On this *kosode*, which was originally a *furisode* until the sleeves were shortened, the principal motif is the Uji Bridge (*bashi*), south of Kyoto. As the Edo period passed the *yūzen* starch-resist-dyeing technique improved, and a wealth of *kosode* designs were devised.

Pl. 153
Writing box named "Funabashi,"
attributed to Hon'ami Kōetsu
(1558–1637),
Momoyama or early Edo period,
wood, with *maki-e* lacquer and
inlay.
H. 11.8 cm., cover 24.2 × 22.6 cm.
Tokyo National Museum.

This rectangular writing box with its arresting form and extremely bold and unconventional decoration represents a complete innovation in design. The exterior surfaces are coated with gold lacquer and bear a design of floating pontoons in *maki-e*, and over them is an inlaid bridge of a wide band of lead placed obliquely across the box. The characters of the poem which the box illustrates are inlaid in fairly thick sheet silver.

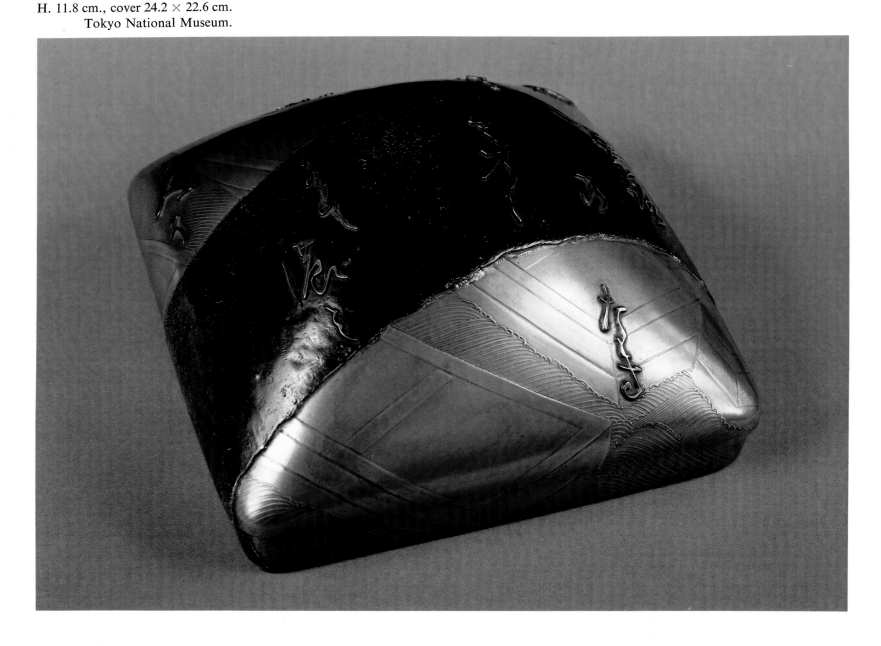

Kōetsu, who was famous for his calligraphy, also displayed extra-ordinary talent in other fields, particularly lacquerwork and pottery. As a potter he made a number of superb *raku* ware tea bowls, all of which have long been treasured by tea masters. *Raku* tea bowls are made of soft clay formed with the hands alone without being turned on a potter's wheel, and they are then fired at a comparatively low temperature. This tea bowl, whose name means "Rain Cloud," is one of Kōetsu's outstanding black *raku* works. Its glossy black glaze on the lower part is suggestive of rain clouds, whence comes its name.

Pl. 154
Tea bowl named "Amagumo," by Hon'ami Kōetsu (1558–1637), Momoyama or early Edo period. H. 8.8 cm., D. 12.3 cm. Mitsui Collection, Tokyo.

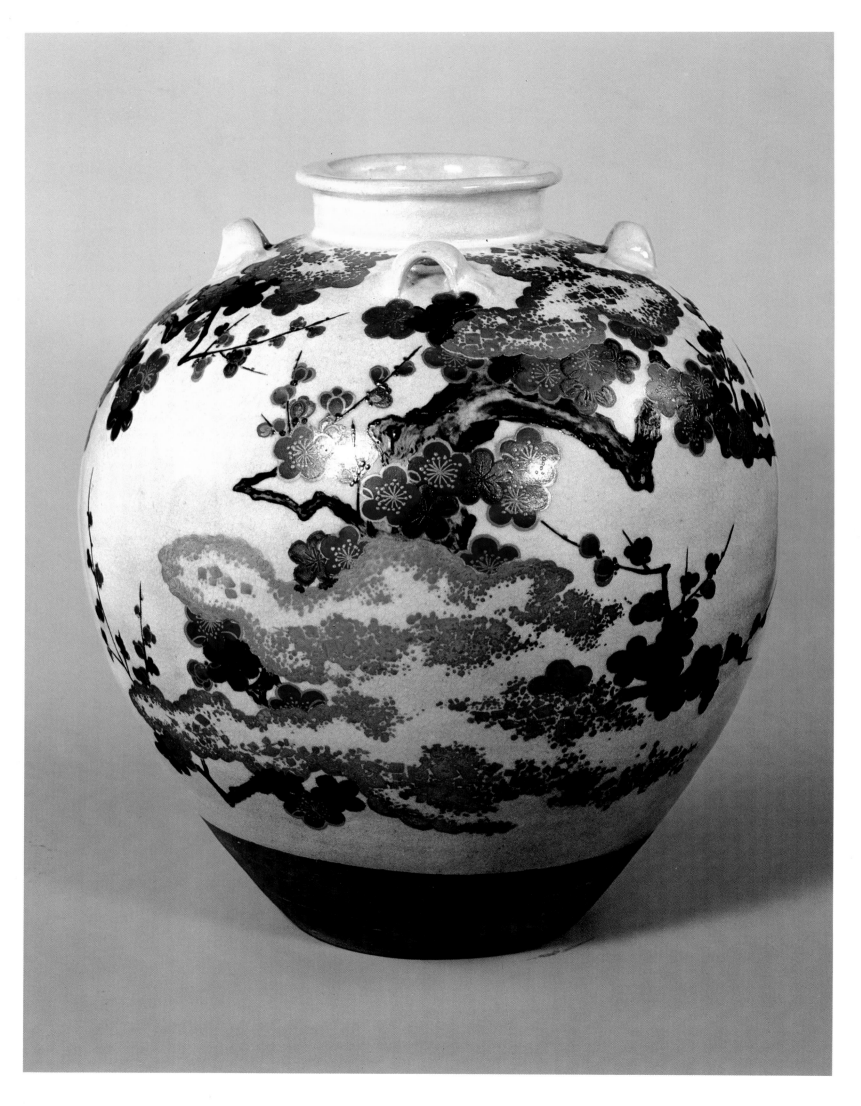

Nonomura Ninsei, who lived and worked in Kyoto early in the Edo period, is known for original designs in overglaze enamel decoration which, unlike the enameled wares of Arita or Kutani, were applied on pottery rather than on porcelain. This jar with four ears is covered almost to the base with a crackled translucent white glaze, over which is painted—in a style reminiscent of the Kanō school of painting—a flowering plum tree in red and green enamels, with touches of gold and silver in the cloud patterns, and a silvery full moon. This ornamental technique is not unlike that of *maki-e* lacquer.

Karatsu ware was made in Hizen province in northern Kyushu, and the best examples date from the late sixteenth and early seventeenth centuries. Ash glaze, opaque white glaze, blackish brown glaze, and a combination of black-brown and white glaze were all used. The decorative techniques demonstrate unmistakable Japanese features, even though the influence of Korean ceramic art is strong. This famous tea bowl is decorated with an underglaze iron design of an iris.

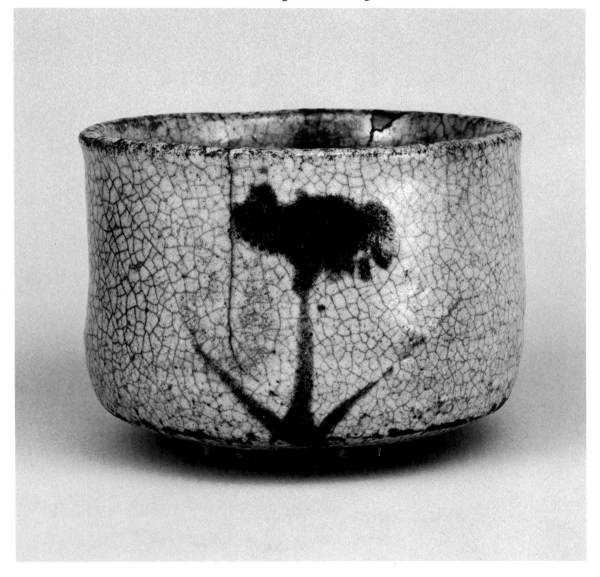

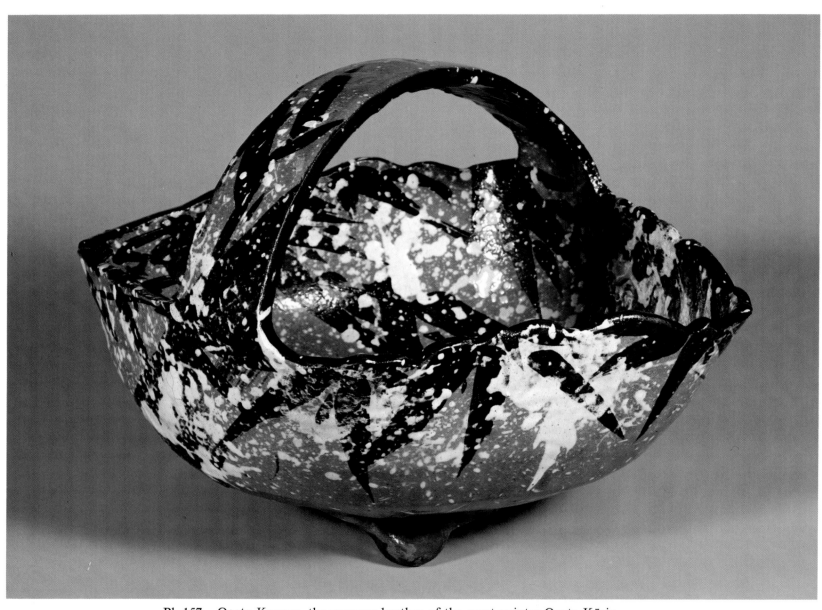

Pl. 157
Bowl with a handle,
by Ogata Kenzan (1663–1743),
mid-Edo period.
H. 17.7 cm., D. 26.5×24.4 cm.
Tekisui Art Museum, Hyōgo.

Ogata Kenzan, the younger brother of the great painter Ogata Kōrin (1658–1716), is as well known a potter as he is a painter. While he was still young he was inspired by the work of Hon'ami Kōetsu (1558–1637) to become a potter, and he studied under Nonomura Ninsei, the celebrated potter of Kyoto in the latter half of the seventeenth century. Kenzan's pottery is outstandingly vivid in its decorative design, which, though clearly influenced by his brother Kōrin, is nevertheless quite distinctly his own style. As a potter, he lived first in Kyoto in the district of Narutaki, then in the district of Nijō, also in Kyoto, and finally he settled in Edo, where he lived until his death. On this bowl, Kenzan has used a slip that was normally only employed for under-coating to depict a whirl of falling snow.

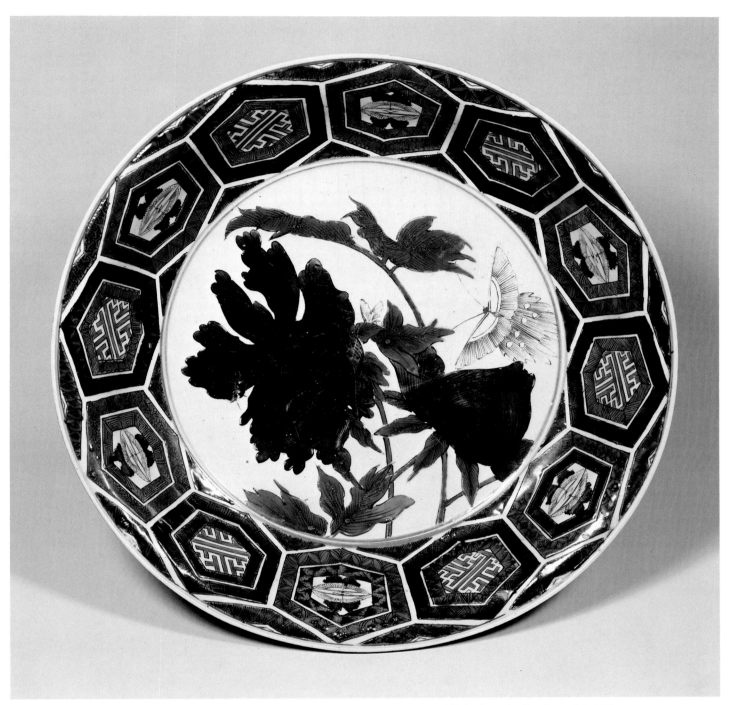

Tradition has it that the Kutani kilns were established early in the seventeenth century in Kyushu under the patronage of the powerful Maeda family, but it was only after about 1650 that porcelain began to be produced, richly decorated with colored enamels after the manner of Chinese K'ang-hsi wares but with strong designs of a peculiarly Japanese flavor. This large dish exemplifies the boldness of the designs, here consisting of peonies and butterflies surrounded by a border of hexagonal "tortoiseshell" pattern. The typical colors of a deep purple, green, and deep yellow contrast with the sparing use of red for the butterflies and the white of the background.

Pl. 158
Dish,
Old Kutani ware,
early Edo period,
porcelain.
H. 8.5 cm., D. 40.0 cm.
Umezawa Memorial Gallery,
Tokyo.

Nabeshima ware was produced at Ōkawachi in Hizen province (present-day Saga Prefecture) under the direct management of the Nabeshima clan. The decoration of this dish consists of the wave pattern, termed "*seigai-ha*," peaches—an auspicious fruit—and the design of "seven kinds of sacred treasures" (*shippō*). Between ten and twenty dishes with the same decoration were made. It was the custom of the kiln to discard imperfect pieces, so only high-quality works have survived.

Pl. 160
Dish,
Nabeshima ware,
mid-Edo period,
porcelain.
D. 20.0 cm.
Imaizumi Collection, Saga.

Pl. 159 (*opposite*)
Vase,
Old Imari ware,
mid-Edo period,
porcelain.
H. 38.5 cm., D. 29.5 cm.
Tanakamaru Collection,
Fukuoka.

An arabesque pattern, which has turned black since it was painted in silver, divides the body of this vase vertically into three sections, in each of which is painted a woman of the mid-Edo period. A similar vase is in the Rijksmuseum in Amsterdam. Imari ware was produced in Arita province in Kyushu, but it was named after the port of Imari from which it was exported in the mid-Edo period.

Pl. 161
Incense burner,
Imari ware, Kakiemon style,
mid-Edo period,
porcelain.
H. 15.0 cm., D. 17.3 cm.
Imai Collection, Kyoto.

Sakaida Kakiemon, a potter active in the first half of the seventeenth century at Arita in Hizen province, is credited with being the first to decorate porcelain with colored enamels on the glaze. Earlier Kakiemon pieces reveal influences of Chinese Ming and Ch'ing wares, but as time passed they became more Japanese in flavor. The Kakiemon family still produces fine porcelain at Arita today.

BIBLIOGRAPHY

Akiyama, Terukazu. *Japanese Painting*. 1961. Reprint. London: Macmillan, 1977.

Anesaki, Masaharu. *Art, Life and Nature in Japan*. 1933. Reprint. Westport, Conn.: Greenwood Press, 1971.

Cahill, James. *Scholar Painters of Japan: The Nanga School*. 1972. Reprint. New York: Arno Press, 1975.

Chibbett, David. *The History of Japanese Printing and Book Illustration*. New York and Tokyo: Kodansha International, 1977.

Cort, Louise Allison. *Shigaraki: Potters' Valley*. New York and Tokyo: Kodansha International, 1980.

Cultural Properties Protection Commission, ed. *Kokuhō Jiten* (National Treasure Dictionary). Tokyo: Benridō, 1961.

de Bary, William Theodore, ed. *Sources of Japanese Tradition*. 2 vols. New York: Columbia University Press, 1958.

Doi, Tsuguyoshi. *Momoyama Decorative Painting*. New York and Tokyo: John Weatherhill, 1977.

Fenollosa, Ernest F. *Epochs of Chinese and Japanese Art: An Outline History of East Asiatic Design*. 1921. Reprint. 2 vols. Gloucester, Mass.: Peter Smith Publisher.

Fontein, Jan, and Hickman, Money. *Zen Painting and Calligraphy*. Boston: New York Graphic Society, 1970.

Fujioka, Ryoichi. *Tea Ceremony Utensils*. New York and Tokyo: John Weatherhill, 1973.

————. *Shino and Oribe Ceramics*, trans. by S. C. Morse. Japan Arts Library series, vol. 1. New York and Tokyo: Kodansha International, 1977.

Grilli, Elise. *The Art of the Japanese Screen*. New York and Tokyo: John Weatherhill, 1970.

Hall, John Whitney. *Japan from Prehistory to Modern Times*. New York: Dell, 1970.

Hashimoto, Fumio. *Architecture in the Shoin Style*, trans. by H. Mack Horton. Japan Arts Library series, vol. 10. New York and Tokyo: Kodansha International, 1981.

Hayashiya, T.; Nakamura, M.; and Hayashiya, S. *Japanese Arts and the Tea Ceremony*. New York and Tokyo: John Weatherhill, 1975.

Henderson, Harold G., and Minamoto, Hoshu. *An Illustrated History of Japanese Art*. Kyoto: Hoshino, 1939.

Hillier, J. *The Uninhibited Brush: Japanese Art in the Shijo Style*. London: Hugh M. Moss, 1974.

Hosono, Masanobu. *Nagasaki Prints and Early Copperplates*, trans. by Lloyd R. Craighill. Japan Arts Library series, vol. 6. New York and Tokyo: Kodansha International, 1978.

Ishida, Mosaku. *Japanese Buddhist Prints*. New York and Tokyo: Kodansha International, 1973.

Itō, Toshiko. *Tsujigahana: The Flower of Japanese Textile Art*, trans. by Monica Bethe. New York and Tokyo: Kodansha International, 1981.

Japan Textile Color Design Center. *Textile Designs of Japan*. Vol. 1: Free-style Designs. Vol. 2: Geometric Designs. Vol. 3: Okinawan, Ainu, and Foreign Designs. New York and Tokyo: Kodansha International, 1980–81.

Jenkins, Donald. *The Ledoux Heritage: The Collecting of Ukiyo-e Master Prints*. New York: Japan Society, 1973.

Jenyns, Soame. *Japanese Pottery*. New York: Praeger Publications, 1971.

Kanazawa, Hiroshi. *Japanese Ink Painting*, trans. by Barbara Ford. Japan Arts Library series, vol. 8. New York and Tokyo: Kodansha International, 1979.

Kato, Shuichi. *Form, Style, Tradition: Reflections on Japanese Art and Society*. New York and Tokyo: Kodansha International, 1982.

Kidder, J. Edward. *Japanese Temples, Sculpture, Paintings, and Architecture*. London: Thames and Hudson, 1964.

Kidder, Edward J., and Esaka, Teruya. *Jōmon Pottery*. New York and Tokyo: Kodansha International, 1973.

Kitagawa, Joseph. *Religion in Japanese History*. New York: Columbia University Press, 1966.

Kobayashi, Tadashi. *Ukiyo-e*, trans. by Mark A. Harbison. Great Japanese Art series. New York and Tokyo: Kodansha International, 1982.

————. *Utamaro*, trans. by Mark A. Harbison. Great Japanese Art series. New York and Tokyo: Kodansha International, 1982.

Lane, Richard. *Masters of the Japanese Print*. London: Thames and Hudson, 1962.

Lee, Sherman E. *Japanese Decorative Style*. 1961. Reprint. New York: Harper and Row, 1972.

————. *Tea Taste in Japanese Art*. 1963. Reprint. New York: Arno Press, 1975.

————. *The Genius of Japanese Design*. New York and Tokyo: Kodansha International, 1981.

Matsushita, Takaaki. *Ink Painting*. New York and Tokyo: John Weatherhill, 1974.

Metropolitan Museum of Art. *Momoyama: Japanese Art in the Age of Grandeur*. New York: Metropolitan Museum of Art, 1975.

Michener, James A. *The Floating World*. New York: Random House, 1954.

Mikami, Tsugio. *The Art of Japanese Ceramics*. New York and Tokyo: John Weatherhill, 1972.

Miller, Roy Andrew. *Japanese Ceramics*. Tokyo: Toto Shuppan, 1960.

Mizoguchi, Saburō. *Design Motifs*. New York and Tokyo: John Weatherhill, 1973.

Mōri, Hisashi. *Japanese Portrait Sculpture*, trans. by W. Chie Ishibashi. Japan Arts Library series, vol. 2. New York and Tokyo: Kodansha International, 1977.

Munsterberg, Hugo. *The Arts of Japan*. Tokyo and Rutland, Vt.: Charles E. Tuttle, 1956.

————. *The Ceramic Art of Japan*. Tokyo and Rutland, Vt.: Charles E. Tuttle, 1964.

Murase, Miyeko. *Byōbu: Japanese Screens from New York Collections*. Boston: New York Graphic Society, 1971.

Nakagawa, Sensaku. *Kutani Ware*, trans. by John Bester. Japan Arts Library series, vol. 7. New York and Tokyo: Kodansha International, 1979.

Narazaki, Muneshige. *The Japanese Print: Its Evolution and Essence*. New York and Tokyo: Kodansha International, 1966.

Nishikawa, Kyōtarō. *Bugaku Masks*, trans. by Monica Bethe. Japan Arts Library series, vol. 5. New York and Tokyo: Kodansha International, 1978.

Noma, Seiroku. *Japanese Costume and Textile Arts*. New York and Tokyo: John Weatherhill, 1975.

———. *The Arts of Japan*. Vol. 1: Ancient and Medieval, trans. by John Rosenfield. Vol. 2: Late Medieval to Modern, trans. by Glenn T. Webb. New York and Tokyo: Kodansha International, 1978.

Oka, Isaburō. *Hiroshige*, trans. by Stanleigh H. Jones. Great Japanese Art series. New York and Tokyo: Kodansha International, 1982.

Okamoto, Yoshitomo. *The Namban Art of Japan*. New York and Tokyo: John Weatherhill, 1972.

Okazaki, Jōji. *Pure Land Buddhist Painting*, trans. by Elizabeth ten Grotenhuis. Japan Arts Library series, vol. 4. New York and Tokyo: Kodansha International, 1977.

Papinot, Edmond. *Historical and Geographical Dictionary of Japan*. 1910. Reprint. Tokyo and Rutland, Vt.: Charles E. Tuttle, 1972.

Roberts, Laurence P. *A Dictionary of Japanese Artists: Painting, Sculpture, Ceramics, Prints, Lacquer*. New York and Tokyo: John Weatherhill, 1976.

Sansom, George. *Japan: A Short Cultural History*. Rev. ed. Englewood Cliffs, N.J.: Prentice-Hall, 1962.

———. *A History of Japan, 1615–1867*. Stanford: Stanford University Press, 1963.

Sato, Masahiko. *Kyoto Ceramics*. New York and Tokyo: John Weatherhill, 1973.

Shimizu, Yoshiaki, ed. *Japanese Ink Painting from American Collections: The Muromachi Period*. Princeton: Princeton University Press, 1976.

Suzuki, Kakichi. *Early Buddhist Architecture in Japan*, trans. by Nancy Shatzman. Japan Arts Library series, vol. 9. New York and Tokyo: Kodansha International, 1980.

Swann, Peter. *An Introduction to the Arts of Japan*. Rev. ed. New York and Tokyo: Kodansha International, 1979.

Takahashi, Seiichiro. *Traditional Woodblock Prints of Japan*. New York and Tokyo: John Weatherhill, 1972.

Takeda, Tsuneo. *Kanō Eitoku*, trans. by H. Mack Horton and C. Kaputa. Japan Arts Library series, vol. 3. New York and Tokyo: Kodansha International, 1977.

Tazawa, Yutaka, ed. *Biographical Dictionary of Japanese Art*. New York and Tokyo: Kodansha International, 1982.

Terada, Toru. *Japanese Art in World Perspective*. New York and Tokyo: John Weatherhill, 1976.

Tokyo National Museum, ed. *Pageant of Japanese Art*. 6 vols. Tokyo: Toto Shuppan, 1952.

Ueda, Makoto. *Literary and Art Theories in Japan*. Cleveland: Press of Case Western Reserve University, 1967.

Varley, H. Paul. *Japanese Culture: A Short History*. New York: Praeger Publications, 1973.

Warner, Langdon: *The Enduring Art of Japan*. 1952. Reprint. New York: Grove Press, 1958.

Yamada, Chisaburoh, ed. *Decorative Arts of Japan*. New York and Tokyo: Kodansha International, 1964.

Yamane, Yūzō. *Momoyama Genre Painting*. New York and Tokyo: John Weatherhill, 1973.

Yashiro, Yukio. *2,000 Years of Japanese Art*. New York: Harry N. Abrams, 1958.

Yonezawa, Yoshiho, and Yoshizawa, Chū. *Japanese Painting in the Literati Style*. New York and Tokyo: John Weatherhill, 1974.

Yoshikawa, Itsuji. *Major Themes in Japanese Art*. New York and Tokyo: John Weatherhill, 1975.

INDEX

The numbers in italics refer to plate numbers.